# THE DESERT IS NO LADY

# The Desert

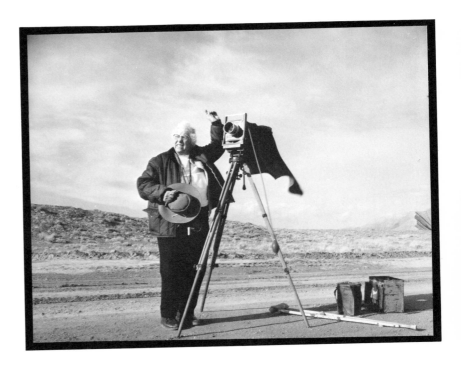

# Is No Lady

SOUTHWESTERN LANDSCAPES

IN WOMEN'S WRITING AND ART

EDITED BY VERA NORWOOD AND JANICE MONK

YALE UNIVERSITY PRESS    NEW HAVEN AND LONDON

Designed by Sally Harris
and set in Galliard type by
The Composing Room of Michigan, Inc.
Printed in the United States of America by
Vail-Ballou Press, Binghamton, N.Y.

Library of Congress Cataloging-in-Publication Data

The Desert is no lady.

Includes index.
1. Southwest, New, in art.  2. Arts, American—
Southwest, New.  3. Arts, Modern—20th century—
Southwest, New.  4. Women artists—Southwest, New.
I. Norwood, Vera.  II. Monk, Janice J.
NX653.S68D4  1987     700'.88042      86—28265
ISBN 0—300—03688—4

The paper in this book meets the guidelines for permanence
and durability of the Committee on Production Guidelines
for Book Longevity of the Council on Library Resources.

10  9  8  7  6  5  4  3  2  1

*Frontispiece:* Laura Gilpin. (Photo: Fred E. Mange, Jr.)

UNREFINED

*The desert is no lady.*
*She screams at the spring sky,*
*dances with her skirts high,*
*kicks sand, flings tumbleweeds,*
*digs her nails into all flesh.*
*Her unveiled lust fascinates the sun.*

Pat Mora

# CONTENTS

# ILLUSTRATIONS

# ACKNOWLEDGMENTS

This book was initially conceived as a project of the Southwest Institute for Research on Women at the University of Arizona, which has assisted our work in invaluable and numerous ways. The Rockefeller Foundation provided a grant partially funding the research and the New Mexico Humanities Council supported a conference allowing contributors to present their work in progress to each other and to the public. We appreciate their interest and aid, without which the book could not have been written. We are also grateful to Annette Kolodny and Lillian Schlissel for their support, to Judy Metro, our editor, for her advice and encouragement, to the writers and artists who have been generous in sharing their work, to Roxane Martell Jones and Laraine Frischmann, whose clerical assistance was critical in completing the project, and to Lynn Fleishman, who prepared the index.

Vera Norwood
Janice Monk

VERA NORWOOD AND JANICE MONK

# *Introduction*

## PERSPECTIVES ON GENDER AND LANDSCAPE

*Charlotte and I knew the outdoors a little. Though we were middle-aged, mothers of families and deeply involved in the historic struggle for the vote, we sometimes looked at the sky. . . . It was our habit to tell large and assorted audiences that freedom consists in casting a ballot at regular intervals and taking your rightful place in a great democracy; nor did it seem anomalous, as perhaps it should have, that our chiefest desire was to escape from every manifestation of democracy in the solitariness of some wild and lonely place far from city halls, smokestacks, national organizations, and streets of little houses all alike. . . . Our real craving . . . was for the wild and lonely place and a different kind of freedom from that about which we had been preaching. —Edna Brush Perkins,* The White Heart of Mojave

The place Edna Perkins found was Death Valley; her new freedom consisted of risking her life exploring a difficult, yet beautiful landscape, one traditionally viewed as inimical to women.[1] As Mary Austin observed, pioneer women in the Mojave "hate implicitly . . . the land, stretching interminably whitey-brown, dim and shadowy hills that hem it, glimmering pale waters of mirage that creep and crawl about its edges."[2] Yet Austin loved that desert and became one of the region's best-known champions, arguing that in the high deserts of the Southwest Americans could reinvigorate their culture. Like her, many women writers and artists of the nineteenth and twentieth centuries found their voices and images in the region. Women as diverse as Willa Cather, Georgia O'Keeffe, and Laura Gilpin discovered there an environment conducive to their art. The art of such Anglo newcomers added to the already well-established traditions of Hispanic, Mexican-American, and American Indian women.[3]

I

The domestic craft arts of weaving and pottery were strongly represented in the older southwestern cultures, and American Indians, Hispanics, and Mexican-Americans had long histories as storytellers. Southwestern women artists have continued to build national reputations throughout the twentieth century. For example, Joan Didion's meditations on southern California lifestyles, Leslie Marmon Silko's forceful images of contemporary pueblo cultures, and Nancy Holt's concrete manipulations of sun and desert have received wide-ranging critical acclaim. This book explores not only how women have come to value the landscapes of the Southwest but also how their connections to the place shaped their artistic voices.

Although women's creative responses to the Southwest play a significant part in defining the region, no overview of that artistic outpouring exists. We initiate that overview by asking what the landscape has meant to women of the three major cultures in the Southwest from 1880 to 1980, and how that environment has liberated women's creativity and shaped their art. We also explore the importance of such factors as ethnicity, historical period, and the diversity of landscapes within the region, the different experiences of "insiders," and "outsiders," and the conventions of genre. The essays offer new visions of women's engagement with the landscape and a fresh assessment of their part in defining the meaning of the region within American culture. Finally, the book extends our understanding of human response to place and landscape and offers women's perspectives on our responsibility to the landscape.

The chapters fall into two sections. The first addresses the two predominant Anglo responses to the region. Lois Rudnick, Judith Fryer, and MaLin Wilson discuss women who formulated the traditional Anglo visions of the Southwest. Coming from the East and Midwest, Mabel Dodge Luhan, Mary Austin, and Willa Cather are the most famous of this group, but other migrants too, such as Alice Corbin Henderson and Nancy Newhall, spoke of the freedom and beauty they found in an environment they believed to be unique. Next, Martha Sandweiss and Vera Norwood turn to women's developing place as insiders in the Southwest. Sandweiss' study of women photographers begins with Laura Gilpin, the first woman landscape photographer in America and a native daughter of the Southwest, and culminates with the newest work of such contemporary Southwesterners as Linda Connor. Norwood, working on writers, starts with nineteenth-century diaries and journals, considers the fiction of first- and second-generation settlers, and concludes with a discussion of Joan Didion, the great-great-granddaughter of an early California pioneer. Both chapters offer examples of female traditions in the context of the increasingly developed landscape. The first five chapters also show that southwestern women had overlapping concerns and interests; while Mary Austin's, Mabel Luhan's, and Willa Cather's connectedness has been established in other studies, these essays open up the broader circles of respect and influence among a wide variety of southwestern women. For example, Nancy Newhall, an environmentalist writer and photographer during the 1960s, found her own voice in part through rediscovering Mary Austin's early twentieth-century work in natural history, and Laura Gilpin found echoes of her photographic portrayals of the pueblos in Willa Cather's writings.

The second half of the book takes up a cross-cultural examination of women's

creative expressions. Well before the Anglos arrived in the Southwest, Hispanic, Mexican, and American Indian women were establishing artistic forms of response to the land on which they lived; these essays concern the changes in their productions over the century. Tey Diana Rebolledo's chapter on the development from early twentieth-century Hispanic writers to contemporary Chicana poets like Pat Mora, complements Marianne Stoller's analysis of how subregional contexts shape Chicanas' visual art forms. Both chapters discuss the impact of the change from agrarian to city landscapes and also reveal complex responses to the landscape that are somewhat different from Anglo women's visions. American Indian women's verbal and material arts contrast even more profoundly with the Anglos', as well with Chicanas' work. The survey of American Indian women's art by Nancy Parezo, Kelley Hays, and Barbara Slivac points out the paucity of knowledge about how traditional artists incorporate landscape into their creations, a paucity in part due to the application of Anglo aesthetics to the analysis of American Indian art forms. Parezo, Hays, and Slivac look at women's roles in their societies, their own comments about the meaning of their work, and various art forms such as weaving, pottery, jewelry, and contemporary easel art to begin analysis of the application of aesthetics to American Indian women's landscape experiences. Patricia Clark Smith shows how traditional American Indian stories are used by contemporary writers to structure their visions of new, more urban landscapes. Finally, some Anglo women have managed to locate their own creative voices in world views similar to, and connected with, those of Chicanas and American Indians. Elizabeth Duvert's study of the "archaic" in Georgia O'Keeffe's paintings and Nancy Holt's and Michelle Stuart's land art makes a strong statement of the connections among the cultures.

The book responds in part to the broad scholarly arena of landscape study. Before identifying some dimensions of the characteristic male orientations to landscape studies and showing why women's vision is important, we should examine the concept *landscape*.[4] Certain key ideas recur in the literature; the most important of these are that landscape incorporates the natural and cultural features we see around us, and that it has personal and cultural meaning.[5] The geographer D. W. Meinig identifies landscape as "an intimate intermingling of physical, biological, and cultural features." Edward C. Relph defines it even more broadly as "everything I see and sense when I am outdoors," including not only visible forms but also "the smell of gasoline fumes, the feel of the wind, and remembered experiences." Landscape provides the necessary context and background for life.[6] Further, in creating landscapes we express our social and personal identities so that landscapes come to reveal our "tastes, values, aspirations, and even our fears."[7] Yet landscape is more than an object to manipulate or a passive environment; it talks back to us and influences our behavior. This aspect of landscape is particularly critical when we study cultures or historical periods in which human, natural, and spirit worlds are blended in ways not conceptualized in the scientific, industrialized community.[8]

Landscape study is approached from humanistic, aesthetic, and scientific perspectives motivated by quests to understand, to appreciate, and to manipulate. Ultimately, these quests are related. The landscapes people create reflect their visions and experi-

ences. An extensive literature explores these relationships not only in American land-
scapes and particular American regions but also in other cultures and in broad historical
perspective.[9] Related research sheds light on how we learn about environments, why
we respond the way we do, and the implications of our perceptions for environmental
management and quality.[10] It suggests that human response to landscape is shaped by
personality, life stage, religion, class, and politics, by the sources of information avail-
able to us, and the circumstances of our encounter with the landscape; for example, it
matters a great deal whether people encounter a landscape as tourists or residents.[11] But
these studies focus almost entirely on men's interactions with the landscape.

The male orientation in landscape scholarship takes several forms.[12] Simplest to
identify is scholars' habitual reliance on literature and art created by men or the diaries,
journals, and reminiscences of male travelers and settlers. A second pattern provides
information about women but implies that men really speak for the culture; women's
material is therefore dismissed when it conflicts with male perceptions.[13] Finally,
environmental studies dependent on the literature and arts of "high" culture contain
both class and gender biases.[14] To understand women's responses often we must seek
out lesser-known works of literature and art, folk forms such as weaving, pottery,
embroidery, and quilting, and women's diaries, journals, reminiscences, and oral
histories.

So, while scholarship on landscape response provides fairly clear conceptual frame-
works for our study, such work does not help delineate the role of gender in that
response. In addressing this gap, we developed an approach that provides both breadth
and depth. First, we wanted to take up the issues of cultural differences among women,
insider/outsider experiences, life stage, and class. We were also interested in not only
the products of "elite" culture but also art forms more connected to ordinary or
vernacular voices and visions. By attempting such breadth, we hope to touch on a range
of issues concerning women's creative response to their environments, issues not pre-
viously examined in landscape scholarship. On the other hand, we were wary of creat-
ing a collection having little coherence except gender. People respond to specific places,
not to "place"; so we focus on one region, the Southwest, which also serves other
purposes of our study. The region is one of the few areas of the United States in which
three cultures have overlapped while maintaining strong internal integrity; thus study
of the Southwest provides valuable cross-cultural information. These cultures offer
many artistic contributions by women, encompassing not only fine but also folk art
traditions. Finally, in surveying previous scholarship on the region, we discovered an
impressive history of masculine bias. We therefore contribute to broad concerns in
general landscape study while deepening our understanding of women's response to a
specific landscape—the American Southwest of the past century.

Canonical literature on the region is steeped in references to great male adventures of
dominating a challenging environment. In *Coronado's Children* (1930), a series of
sketches on the Southwest, J. Frank Dobie argues that the legends most appropriate to
the New World are those of the great wealth to be found on the continent. The legends
spring both from the early Spanish expeditions to the New World and from early

adventures in what is known in twentieth-century America as the New Southwest. Dobie felt such legends could be distinguished from those of the Old World by their lack of any role for women:

> *The New World has been a world of men neither lured nor restrained by women. It has been a world of men exploring unknown continents, subduing wildernesses and savage tribes, felling forests, butchering buffaloes, trailing millions of longhorned cattle wilder than buffaloes, digging gold out of mountains, and pumping oil out of hot earth beneath the plains. It has been a world in which men expected, fought for, and took riches beyond computation—a world, indeed, if not of men without women, then of men into whose imaginings woman has hardly entered.*[15]

Dobie's version of gender roles in the Southwest in not unique. Frederick Jackson Turner's vision of the region (and of the frontier West in general) provides an equally masculine focus, as does Walter Prescott Webb's. To the extent that these descriptions concern themselves with the larger issue of the settlement of the continent, they are matched by the work of such cultural historians as Henry Nash Smith.[16]

As a new generation looks to the past for inspiration, descriptions of the region, and the West in general, as a male-dominated scene continue into current literature. In a series of essays on Texas, Larry McMurtry comments, "the frontier was not feminine, it was masculine. The Metropolis which has now engulfed it is feminine." Fred Turner's recent study of the impact of Christianity on the development of the American continent continues the masculine emphasis. Turner concludes with a biography of Buffalo Bill Cody, arguing that, by the end of his life, Cody had come to the "uneasy" realization that he had killed the wilderness he loved. Cody asked his estranged wife to bury him in Wyoming. In a wonderful revenge, she had him buried above Denver facing "a great city humming where once there had been nothing but a wild New World."[17] McMurtry's dichotomy is implicit in Turner's description.

We do not suggest that such commentators engage simply in a celebration of masculine dominance of the landscape; this literature discloses a deep ambivalence about both the Spanish and the Anglo arrivals. Indicative of this ambivalence is the continuing debate about the extent to which the natural environment of the West modified the imported cultural ideas of immigrants. Webb, like Frederick Jackson Turner, argued that the difficult environment of the Great Plains changed the Anglo people who came to live there. Fred Turner claims just the reverse, that Europeans (whether English, French, or Spanish) did not change as a result of their experience in the New World frontiers. Both question the ethics leading to exploitation of the natural environment and indigenous peoples, and both assume that the best landscape springs from human adaptation which takes into account the requirements of the natural environment.[18] That vision of the importance of the environment to any understanding of the Southwest is a strong theme in much of the literature about the region. Countering the theme of dominance are lyric accounts with an ecological orientation. Lawrence Clark Powell's list of "Southwest classics" provides the major voices in this tradition: John Van Dyke, Charles Lummis, Ross Calvin, Joseph Wood Krutch—and Mary Austin,

Erna Fergusson, Martha Summerhayes, Willa Cather. Yet no one asked why women, supposedly so opposed to the natural environment, came to be such strong advocates for its preservation.[19]

Writers who take an ecological focus have a special relationship with the region's past. McMurtry explains, for example, that Texas is engaged in a birth and a death. The birth is the urban landscape; the death is the loss of rural ways of life, like that exemplified by the cowboy: "From the birth I expect very little. . . . The death, however, moves me."[20] Concern for loss of the past marks writers of the "classic" Southwest. "Counter-classicists," however, resist the appeal to the past, concentrating instead on the region's growth into an urban area. Journalist Carey McWilliams and cultural geographer D. W. Meinig write about the great waves of migration to the region, both from the East and across the Mexican border; anthropologist Edward Spicer studies its continuing ethnic diversity; historian Gerald Nash is concerned with the emergence of "urban oases" very early in the history of the Southwest; and cultural geographer J. B. Jackson reveals how the vernacular landscape has developed unique and valuable characteristics as a result of the region's growth. These studies question the validity of such classic images of the West as the unfenced range, the mythic cowboy, or the Spanish mission. When they criticize the ethics of development, they do so out of a concern for the future rather than nostalgia for the past.[21]

Interested primarily in the twentieth century, these authors see different patterns of continuity and change, of cultural dominance and environmental determinism, than those more concerned with the earlier periods. McWilliams, Meinig, and Nash argue that there may have been patterns of continuity with eastern culture in the early settlement periods, but in the twentieth century the Southwest has become a harbinger of the nation's future as well as a carrier of its past. Spicer, looking at continuity of culture among American Indian populations, claims that patterns of continuity exist—changes in lifestyle do not necessarily indicate cultural assimilation. Jackson sees the emergence of a new kind of community in the mountains and deserts of the West, one that represents "a deliberate confrontation with the elements of the landscape that earlier generations sought to avoid." But these scholars ignore the meaning of gender, apparently assuming that men's and women's history is the same—what men see, feel, record, and do also explains women's experience. Though they do not remove women from the landscape, as Dobie did, neither do they suggest for them any special place in it.[22]

Only in scholarly studies of arts and literature do women consistently appear as actors. Surveys of regional writers, painters, and photographers invariably mention prominent women. Books on American Indian and Hispanic arts include the work of many women because much of the craft valued by Anglos is done by women. These studies provide a useful historical context; some of the more recent ones analyze dialectical interactions between artists and society crucial for understanding the cross-cultural Southwest. For the most part, however, they too overlook issues of gender.[23] Larry McMurtry, whose fiction reveals that he is a more sensitive reader of gender issues than some of his essays might indicate, asserts that we know very little about "sexual relations" in the Southwest. William Pilkington, in an otherwise fine

book on the writers of the region, himself becomes lost in the "virtually uncharted wilderness" of sexual attitudes.[24] As several literary historians have recently noted, those who have asked gender questions have tended to turn to male writers of Westerns in their attempts to answer them. Franklin Walker's *Literary History of Southern California* remains one of the few works to consider the artistic production of women in the context of gender roles.[25]

Thus, scholarship on the Southwest touches on many of the themes of this book without, however, providing any clues to the role of gender in the development of the region. We learn from reading these materials that it was home to a strong environmentalist movement, but we hear little of women's contributions to discussions of human responsibility to the land. We discover that various peoples have appreciated different landscapes over the period—from heroic wilderness to agrarian frontier to urban oases—but we have no idea whether women identify such categories of environment or place similar value on them. Finally, while women appear throughout scholarship on art and literature as primary movers in the creative response to the region, nowhere do we see any recognition that they may have developed artistic traditions different from those of men. These are the issues covered in the following chapters, and they constitute our particular contribution to scholarship on the region.

We want to acknowledge the research on gender role formation and on the significance of gender in environmental perception that is pertinent to this study. Psychologists Nancy Chodorow, Dorothy Dinnerstein, and Carol Gilligan suggest that gender is crucial in the formation of identity and values; Carolyn Merchant has used this psychological literature in her work on women's contributions to contemporary environmental movements.[26] Scholars have also shown the importance of gender in response to urban environments,[27] but they provide broad analyses rather than examining any specific context in depth or attempting to document the diversity in women's responses. Feminist scholarship has demonstrated that to understand women's perceptions and experiences we must consider the influences of time, place, class, ethnicity, and life stage.[28]

Historical studies of the West offer some limited examples of such contextual analyses. Julie Roy Jeffrey and Lillian Schlissel build a strong case for frontier women's continuity with the East, while others argue that the Western experience engendered new roles for women. Much of this literature suggests that there were differences between men's and women's visions of how the region should develop.[29] Schlissel in particular addresses the diversity of women's responses, revealing the importance of life stage in appraisals of trail landscapes. She contrasts the exuberant responses of adolescents celebrating adventures and freedom on the trail and describing natural grandeur with the darker feelings of women coping with pregnancy, childbirth, and the sick and dying. These women lament the awful road, the fearsome mountains, and "nothing in sight but nature."[30]

Annette Kolodny's examination of women's responses to the various American frontiers remains the major book on American women's landscape perceptions. In her revision of standard scholarship, Kolodny suggests that, rather than being repelled by the great open spaces of the plains, women found them more appealing than the earlier,

more heavily forested frontiers. Women, she asserts, did not advocate rapid develop-
ment of the wilderness into an urban environment, but supported an agricultural
"middle" landscape. Their ideal environment was one in which human occupation
adapted to the exigencies of the natural environment. Their response remained
grounded, however, in the domestic ideology of the time; they valued the environment
for its ability to support a traditional home. Kolodny's work to date does not extend
past 1860 and she does not consider the Southwest, but she questions masculine bias in
previous commentaries on men's and women's roles in the region.[31]

Most historical studies discuss the migration, settlement, and development patterns
of Anglo women in the West to the turn of the century. They offer little information
about Chicanas, American Indians, or changing gender roles in the twentieth century.
The limited work done on the roles of American Indians and Chicanas during the
nineteenth and twentieth centuries reveals significant cross-cultural differences among
women and raises questions about changing roles in the twentieth century.[32] Nev-
ertheless, as Joan Jensen and Darlis Miller have shown, the Southwest exists as a
"whisper" in Western history. Particularly lacking is any comprehensive look at the
meaning of the region, across cultures and time, to women.[33]

As D. W. Meinig points out, "regional delineations should emanate from the pur-
poses of the study."[34] The artists and writers considered in this book value both the
biophysical and cultural landscapes of the Southwest. Characteristic biophysical ele-
ments are basin and range and high plateau topography, a predominant aridity, and
associated plant and animal life. The biophysical landscape encompasses topography,
climate, and biota found predominantly in Arizona and New Mexico. The cultural
landscape is defined by the confluence of American Indian, Chicano, and Anglo peoples
living in Arizona and New Mexico. Therefore, the core region for this study includes
these two states. Significant aspects of both the biophysical and cultural landscapes
extend, however, into Texas, Oklahoma, and the southern areas of Colorado, Utah,
Nevada, and California, which are also characterized by areas of semi-arid climate
and/or large contemporary Chicano or American Indian populations. Additionally,
population mobility within these areas mitigates any sense of boundaries between the
states.

For many of the women considered here, this environment translates into sensations
of open space, light, altitude, and immense vistas occurring partially because of the arid
climate. The physical and biological landscape provide a sense of wonder and potential
characteristic of the region, a feeling shared by the cultural groups. Chicanas, American
Indians, and Anglos seek self-renewal in the natural environment; Leslie Silko's hero in
*Ceremony,* for example, restores his connections to ritual traditions by returning to the
natural environment.[35]

The cultural landscape is equally important to the artists and writers considered.
From 1880 to 1920, the cultural landscape included American Indian and Hispanic
architecture, crafts, folk arts, ceremonials, as well as territorial and cowboy culture.
Popular national periodicals such as *Scribner's, Harper's Monthly,* and *The Century* and
regional publications such as *New Mexico Magazine* and *Sunset* made both eastern and
southwestern readers aware of this unique landscape. Women writers of the period, like

Mary Austin and Mabel Dodge Luhan, were major voices in establishing the Southwest as a distinct cultural region within the nation. The material culture these Anglos praised was created by American Indian and Hispanic women and men.

Since the turn of the twentieth century, the cultural landscape has changed as urbanization, agribusiness, large-scale mining, industrialization, and increased numbers of "tourists and sojourners" have modified the region dramatically.[36] The effect of modernization on the landscape is reflected in the work of many writers and artists who record these changes. Important in establishing our contemporary visions of urban landscapes are the barrio painters, "freeway" writers, and American Indian and Chicana poets of such metropolitan areas as Los Angeles, Albuquerque, and El Paso. Joy Harjo's poems, for example, express the conflict experienced by American Indians as an urban environment defies organization in tribal terms:

> *in the albuquerque airport*
> *trying to find a flight*
> *to old oriabi, third mesa*
> *TWA*
> > *is the only desk open*
> *bright lights outline new york,*
> > > *chicago*
>
> *and the attendant doesn't know*
> *that third mesa*
> *is a part of the center*
> *of the world*
> *and who are we*
> *just two indians*
> *at three in the morning*
> *trying to find a way back*[37]

The Southwest's geography and culture are neither monolithic nor static in character; neither are the interpretations of women artists and writers of the region. The essays in this book reveal that women have valued the natural environment of the Southwest, have appreciated the history of human-created landscapes in the region, and have worked to build new landscapes in keeping with the exigencies of the environment. Women of all cultural groups have found in the landscape (both natural and constructed) a source of strength and personal identity, as Pat Mora's recent poem "Unrefined" graphically illustrates.[38] Mora provides a fitting epigraph to this book in her vibrant and challenging vision of the freedom women have located in the Southwest landscape.

# 1 · LOIS RUDNICK

# *Re-Naming the Land*

## ANGLO EXPATRIATE WOMEN IN THE SOUTHWEST

*A radical critique of literature, feminist in its impulse, would take the work first of all as a clue to how we live, how we have been living, how we have been led to imagine ourselves, how our language has trapped as well as liberated us, how the very act of naming has been till now a male prerogative, and how we can begin to see and name—and therefore live—afresh.—Adrienne Rich,* On Lies, Secrets, and Silence

Among the Anglo expatriates who settled in New Mexico during and after World War I, Alice Corbin Henderson, Mabel Dodge Luhan, and Mary Austin took the lead in generating a myth of the Southwest that revised traditional Anglo male perceptions of the West. Here, they claimed, was a New World whose terrain, climate, and indigenous peoples offered a model of ecological, spiritual, and artistic integration to an alienated and decadent Western civilization. Their perceptions were rooted in their ideal of a multi-ethnic democracy that recognized the long-ignored social, economic, and cultural contributions of women, Hispanics, and Indians to the life of the region and the nation.

Adolph Bandelier, Charles Lummis, and Edgar L. Hewitt were their most important regional predecessors, among the first to study and write about the Indian and Hispanic peoples of the Southwest with enthusiasm and sensitivity. Lummis, a journalist who has been called "the master publicist of the Southwest," was particularly important in setting the stage for their revisionist view in his book *The Land Of Poco Tiempo* (1893), a work that celebrates the richness of Indian and Hispanic cultures, whose communal ways and unhurried lifestyles he mockingly contrasts with that of the so-called Superior Race.[1] Henderson, Luhan, and Austin were also heirs of the nineteenth-century

naturists Emerson, Thoreau, and Muir, who helped shift American attitudes toward a view of wilderness as "sacred space," a place for the testing and renewal of the human spirit. The women, however, did not celebrate a solitary communion with a Nature segregated from human communities. Their most important influence was Walt Whitman, whose ideal of a multi-cultural democracy rooted in all regions of the continent inspired their lives and works. They continued the prophetic tradition he celebrated in the preface to his *Leaves of Grass* (1855).[2]

In her epilogue to *New World, New Earth,* a study of sacred and secular millennialist concepts of America as a reformed garden of Eden, Cecilia Tichi claims that Whitman was the last major literary voice to have believed in the possibility of America as a paradise regained. "Twentieth century writers who confront American landscape in fiction and poems offer very little hope for the spiritual and environmental redemption of the nation," she concludes.[3] When the Anglo male writers who have dominated the twentieth-century American literary canon—Fitzgerald, Hemingway, Eliot, Frost, and Faulkner—envision the land as redemptive, they write in an elegiac mode that describes and laments a lost possibility or, at best, offers a tentative personal salvation. For Henderson, Luhan, and Austin, however, the natural and cultural landscapes of the Southwest offered a yet-to-be-tested proving ground for America to fulfill its utopian promise.

Austin, Luhan, and Henderson also belong to the tradition of Anglo women writers who responded to the settlement of western frontiers with a significantly different set of myths about the land than the typical male pioneer. As Annette Kolodny points out in *The Land before Her,* "Women claimed the frontiers as a potential sanctuary for an idealized domesticity. Massive exploitation and alteration of the continent" were not part of their fantasies.[4] Henderson, Luhan, and Austin take this tradition much further, challenging masculine myths about the land and its inhabitants in bolder and more radical terms.

Their paradigm builds on the personal freedom of the male pioneer tradition, the ecological concerns of the male naturists, and the community interests of the female tradition to create a new myth of America. Its defining characteristics can be summed up as follows: a view of the land as masterless and a respect for the native populations' careful use of its limited resources; an appreciation for the communal aspects of tribal and village cultures that integrated work, play, and worship; and a belief that the myths and symbols of long-established, nonelitist folk cultures were necessary to the creation of a vital national art and literature.

Austin, Henderson, and Luhan opposed the concept of the land as virgin and the Judeo-Christian imprimatur that man must rule, tame, and reform "her." Instead, they envisioned the land as masterless. Alice Henderson named the key terms of this concept when she wrote that the environment of the Southwest was at once "primal and liberating." The vast, spacious, and thinly populated expanse of desert, mesa, and mountain stimulated the imagination. That no one had mastered it—indeed, that it could not be mastered—was attractive to their sense of themselves as women who were seeking to make their own imprint on American literature and as ecologists who

believed that their fellow Americans needed to learn how to engage in a nondestructive relationship with the land. Even when they envision the land in specifically female terms, "she" is not typically exploited or exploitable.[5]

Hand in hand with their view of the land as masterless went their opposition to the traditional Anglo male view of the land as an infinitely available resource, whose store of water, wood, minerals, and ores could not be depleted. In contrast, Henderson, Luhan, and Austin stressed the concept of limits. The fragile ecology of the Southwest, and the ways in which its indigenous populations had adjusted to it, provided important lessons in setting limits on human greed and will.

When Alice Corbin Henderson arrived in Santa Fe in March, 1916, she had a well-established national reputation as a poet and as the associate editor of *Poetry* magazine. Along with Harriet Monroe, she had championed and helped introduce the early works of Robert Frost, Carl Sandburg, Edgar Lee Masters, and T. S. Eliot, among others. The most traditional of these three writers in terms of her lifestyle and views on women, she was happily married to the artist William Henderson, with whom she lived in a life-long productive and cooperative relationship. But she did experience tensions between the demands of her household and her writing. As she wrote a few years after the birth of her only child:

> *What greater grief could be*
> *Than to be born a poet—and a woman!*
> *To have to mind the trivial daily tasks*
> *That bind the heart from revery and dream,*
> *Or else to earn the scorn of the whole world!*[6]

In spite of the demands of her household and other community activities that took her away from her writing, there is no doubt that Henderson's poetry was transformed by her move to New Mexico. Sent initially for her health (she was suffering from tuberculosis), she experienced literally a new lease on life, while the natural and cultural landscapes inspired dramatic changes in her writing. As T. M. Pearce has pointed out, Henderson did not find her authentic voice as a poet until she came to New Mexico. Prior to her move, she had published two not very distinguished volumes of verse; one derivative of Victorian poetry, produced in her last year of high school, the second, *The Spinning Woman of the Sky* (1912), a collection of lyric poems that relied for the most part on conventional tributes to nature and the Greek Isles.

Henderson's "A Litany in the Desert" (1918) was one of her first poems published after she moved to Santa Fe. It focuses on the Southwest as a place of healing in postwar America, as did many of the Anglo expatriates who came there in the 1920s. The East and Europe represent a civilization that is self-devouring:

> *On the other side of the Sangre de Cristo Mountains there*
> *is a great welter of steel and flame.   .   .   .*
>
> .   .   .   .   .   .   .   .   .   .   .   .   .   .   .   .   .   .   .   .
>
> *.   .   .   I know nothing of it here.*
> *On the other side of the water there is terrible carnage   .   .   .*
> *.   .   .   I know nothing of it here.*[7]

In *Red Earth* (1920), Henderson's finest volume of poetry, she created "a Southwestern poetic idiom to explore a new spectrum of imagery." Fourteen of the poems were inspired by Spanish-American motifs, twelve by Indian life and ceremonies, and thirty-one by her responses to the land that had brought new life to her body and to her visionary powers.[8]

The title of her volume is emblematic of the organic relationship that she felt existed between the land and the people who lived in intimate rapport with it. In her opening inscription, Henderson describes the contrast between the world of the desert and the city in terms of a male/female dichotomy that offers a new way of thinking about the metaphor of land as woman. The city is youthful, strident, aggressive, gigantic, noisy, and modern—the prototypical attributes of the American man who seeks to transform the landscape to match his visions. The desert, on the other hand, is female—ancient, peaceful, religious, its habitats of appropriate scale.

> *After the roar, after the fierce modern music*
> *Of rivets and hammers and trams,*
> *After the shout of the giant,*
> *Youthful and brawling and strong*
> *Building the cities of men,*
> *Here is the desert of silence,*
> *Blinking and blind in the sun—*
> *An old, old woman who mumbles her beads*
> *And crumbles to stone.*[9]

When Henderson projects her human consciousness onto the landscape, she does so in order to "think" or "feel" as the land does, not in order to appropriate it. Space, time, volume, light, sky, and wind often take the place of human will and passion. In "From the Stone Age," she tells us, "My thoughts now are the thoughts of a stone, / My substance now is the substance of life itself." (*RE*, 37). When she personifies the land she sees it as an old woman, who teaches lessons of humility and endurance. Unlike Robert Frost, who in "The Gift Outright" asserts, "The land was ours before we were the land's," Henderson does not assume that Anglo-Americans possessed a "virgin land" before they finally came to terms with it.[10] In the opening poem, "Red Earth," she gives title to the people who have lived long enough with the land to be rooted in it:

> *This valley is not ours, nor these mountains,*
> *Nor the names we give them—they belong,*
> *They, and this sweep of sun-washed air,*
> *Desert and hill and crumbling earth,*
> *To those who have lain here long years*
> *And felt the soak of the sun.* (RE, 13)

In "Los Conquistadores," Henderson uses a ballad form to express the lament of strangers come to conquer a land whose spirit of place is foreign to their lives and memories. In contrast is the story of her husband's trip into Navajo country, "Three Men Entered the Desert Alone." Two of the men are immune to the spirit of the desert,

but the third experiences the depth of vision and expansiveness that the desert landscape provided both Hendersons. He

>     . . . *felt his soul grow vast*
> *As the circle of sand and alkali.*
> *His soul extended and touched the sky,*
> *His old life dropped as a dream that is past,*
>
>     . . . . . . . . . . . .
>
> *While the far horizon widened and grew*
> *Into something he dimly felt he knew,*
> *And had always known, that had just come true. (RE, 15)* [11]

At times, Henderson knows the land as a lover, but she does not master or allow herself to be mastered by it. The land she loves releases an erotically charged energy that courses through human and nonhuman alike, empowering both.

> *Earth, your red canyons*
> *Are sluiced through me,*
> *The crests of your hills*
> *Break over me—*
> *I ride upward to meet them.* [12]

This immediate relationship with nature was sometimes for her (as it was for Luhan and most often for Austin) preferable to the more complicated and consuming demands of human love. Thus she tells us in another version of this poem,

> *Not love, not the intense moment of passion*
> *Not birth, is as poignant*
> *As the sudden flash that passes*
> *Like light reflected in a mirror*
> *From nature to us. (RE, 40)*

In her visionary "Prayer-Wands," Henderson dreams herself into the kind of mystical communion with nature that she believed engendered Indian poetry:

> *Now I am become as the least among you,*
> *As grass on the prairie,*
> *As dust on the earth.*
> *And, lest I grow proud, I strip myself,*
> *And sit naked and dirty*
> *So that the spirit may not forget   . . .*
>
>     . . . . . . . . . . . .
>
> *My song comes from the hills;*
> *It is clean with beauty.* [13]

Henderson transforms this unmediated flow of energy into metamorphic images that bring a freshness and vitality to her poetry rarely found in her earlier work. In a series of vignettes about desert life, the "Dust-Whorl" created by the wind is the "Faint spiral of

lives" lived there, for nothing is ever lost in the desert. New Mexico hills are "spotted like lizards, / They sinuously glide and dissemble; / If you take a forked stick / You may catch one and hold it." The Mexicans who bury their dead plant a wooden cross by the "cross of the desert cactus." Here, human and natural symbols are in accord, like the sun that dances to the fiesta drum of the Pueblo Indians. As they accommodate nature, so nature accommodates them: "The stars run to pick up / The eagle feathers / Dropped by the dancers" (*RE*, 31–35).

Mabel Luhan's move to New Mexico in December, 1917, also shaped the direction of her life and writing. But it had a more significant impact on her identity, because her new home was so intimately linked with her redefinition of self. During her years as patroness of the avant-garde in Greenwich Village, she had contributed to such journals as *Camera Work* and *The Masses,* but she had published little of distinction. Most of her energies had gone into playing the muse to men of creative genius. Not until she came to Taos did she find her own voice as a writer.

Luhan came to New Mexico as part of the postwar search for new systems of belief and modes of living. "My life broke in two right then," she later wrote, "and I entered into the second half, a new world . . . more strange and terrible and sweet than any I had ever been able to imagine."[14] She worked to create a new idiom that would express her revitalized relationship with the land, in particular with the Pueblo people. More frequently, however, she built upon Judeo-Christian and Anglo-American mythic patterns, which she invested with new meanings.

Luhan wrote within the tradition of Americans who apotheosized their dreams of settlement in the New World. She hoped to demonstrate the wisdom of rejecting the Old World—the East Coast as well as Europe. But in her eschatology the white man was the devil and the Indian, godly. Though related to the nostalgic "noble savage" tradition, hers was a dynamic view of a still thriving race that she offered as a model for America's future.

The image of Taos, New Mexico, as a garden of Eden inhabited by an unfallen tribe of men and women inspired most of Luhan's writing throughout the 1920s and 1930s. This thesis shaped her four volumes of memoirs, in which she created a symbolic self representing the decline and fall of Anglo-American civilization and its potential for regeneration in the Indian Southwest. In *Edge of Taos Desert,* the final volume, Luhan reveals how "the purity and freshness" of New Mexico's "undomesticated" landscape swept her clean of the waste and sickness of civilization. It was the first powerful influence on the rebirth of her imagination: "There was no disturbance in the scene, nothing to complicate the forms, no trees or houses, or any detail to confuse one. It was like a simple phrase in music or a single line of poetry, essential and reduced to the barest meaning" (*ETD*, 33, 59).

Unlike earlier Spanish and Anglo explorers, who had come to strip the earth of its riches, Luhan celebrates the land's life-giving powers: "Surely," she tells us, "no one had ever been able to dominate and overcome this country where life flowed unhampered. . . . Everything had its being—the water, the trees, the earth and the sky" (*ETD*, 33). Luhan felt she was witnessing the very origins of life in a land that promised she could break the chains of heredity and environment that had molded her and begin

again. The spareness of the landscape made the power of nature inescapable. "Sitting there on that stern hillside [outside Santa Fe], that had nothing soft and comfortable about it like other hills in milder places, I had a complete realization of the fullness of Nature here and how everything was intensified for one—sight, sound, and taste—and I felt that perhaps I was more awake and more aware than I had ever been before" (ETD, 18).

The landscape that reduced her life to fundamentals is reflected with dramatic effect in *Edge of Taos Desert*. Just as her sophisticated veneer is stripped away, so too are her words and syntax simplified, to allow us to view her new world unencumbered by the weight of "dead" philosophies and books. *Winter in Taos* (1935) is a more rhetorically lavish and lyrical celebration of her adopted land.[15] Structured around the seasonal cycle of death and rebirth, in a pattern reminiscent of *Walden, Winter in Taos* creates a vivid sense of the affinity between the natural and human worlds. Although the book idealizes her marriage, there are times when the natural sphere offers more than the human. Nature, Luhan tells us, is "strong and resourceful" enough to awaken "our trust and security." At times it "clasps us closer than human love can hold us" because, she implies, unlike parents and lovers, it never stops giving. If we learn to live by its rhythms, we can experience continual regeneration: "One lives from month to month all the year round, forgetting the future and what it will be like; then when it comes, with icicles or iris, sheaves of corn or violets in the shade, one's eternal recognition meets it with the same wonder and surprise. There is nothing so new in all eternity as this old earth, reborn every day like ourselves" (*WT,* 110).

Mary Austin's identification with the land as a means of personal renewal and self-definition was the strongest of the three writers. Austin found herself and her vocation a generation earlier than Henderson and Luhan, among the deserts, mountains, and valleys of central California. Having spent much of her young adulthood during the 1880s and 1890s in physical hardship and domestic misery as a homesteader, wife, and mother, she channeled her frustrations into "a passionate mystical identification with the land and an outrage against the misuse of women's gifts." Trained as a naturalist, she also brought aesthetic and religious perspectives to her precise and evocative observations. Through her self-imposed role of *chisera* (medicine woman), she hoped to transform her fellow Anglo-Americans' relationship with the land and its indigenous peoples.[16] Among her 27 books and over 250 articles are the most original—as well as the most explicitly feminist—contributions to the re-naming of the American landscape.

In *The Land of Little Rain* (1903), *California* (1914), and *The Land of Journey's Ending* (1924), Austin rejects Anglo names for geographic landmarks and uses the original Indian and Hispanic designations because they express the land's natural characteristics rather than the individual discoverer's ego. By "this fashion of naming," she informs us, "I keep faith with the land and annex to my own estate a very great territory to which none has surer title." "Ownership" is derived not from discovery or possession, but from living with the land, summer and winter, and waiting "its occasions."[17]

Austin was drawn to landscapes where the land "not the law . . . sets the limits" because it was there that she came closest to discovering the spiritual and aesthetic resources she needed to establish herself as an independent and creative woman. From

the desert-dwelling Shoshones and Paiutes she learned that one could come closest to experiencing *wakonda,* the divine creative energy that courses through natural and human life, in landscapes that had "the least concern for man" (*LLR,* 46). Observing the land on its own terms meant literally moving at the level of animals and insects in order to "see" as they do. In this way she came to understand the interrelationships among landforms, flowers, animals, and humans. "Let me loose in the desert with the necessity for discovering truth about any creative process of the human mind," she wrote to a friend, "and I can pick up the thread from the movement of a quail . . . from anything of beauty that comes my way."18

In the mountains of California and New Mexico, Austin discovered "holiness," the "state [of] being whole with the experienceable universe" (*LJE,* 390). It revealed to her "pattern-hungry mind" the larger order that put humans in their proper place in the web of life. Austin's eye was always uncovering the unified design in the variety of nature, such as "the suffusion of light over the Sierra highlands" which "the sage, the rounded back of sheep, the clicking needles of the pines give back in luminous particles infinitely divided." Or the spring winds that blow up along the coast of California and whip the chamisa's "fretted surface to a froth of panicled white bloom that, stirring a little as the wind shifts, full of bee-murmer, touches the imagination with the continual reminder of the sea. Higher up the thick lacy chaparral flecks and ripples . . . and tosses up great fountain sprays of ceanothus, sea-blue and lilac-scented."19

Austin also learned from her observations of the remarkable adaptations of plants and animals in semi-arid and arid regions, where flowers bloom and recede with the rainfall and foliage turns from the sun or exudes gum to catch water: "The desert floras shame us with their cheerful adaptations to the seasonal limitations. . . . One hopes the land may breed like qualities in her human offspring" (*LLR,* 5). The Papagos of southern Arizona are just such offspring. They migrate with the seasons and their names for months describe them—"Inner Bone Month" and "Month of the Cold Touching Mildly." Unlike those who seek to master their environments, the Papagos believe they are made of the earth that sustains them. Thus they do not have the sense that they are at "the apex of the scheme of things" (*LJE,* 157).

The very grudgingness of the land and climate, its indifference to human presumption and ability to take back its own, challenged Austin to tackle it on its own terms, which taught her how she could grow through her own inner resources. As a woman who had little emotional support from her mother and husband, she discovered how to sustain and nourish herself by observing the flora and fauna that throve under difficult topographical and climatic conditions. Everything in the desert looked burned, dried, squeezed—and yet it was full of life.20

The fir tree Austin writes about in *The Land of Little Rain* is a perfect symbol for her self-sufficient growth. This tree, which takes "fifty years to its first fruiting," "will repay acquaintance," because it has learned "to spend itself secretly on the inner finishings of its burnished, shapely cones. Broken open in mid-season, the petal-shaped scales reveal a crimson satin surface, perfect as a rose" (*LLR,* 135). Seyavi, the basketmaker, is the human exemplar of the strength and ability bred in those who adapt to the land. Forced to the hills with her son after her tribe is wiped out, she is reduced to "the bare core of

things" and the "sufficiency of mother wit." She weaves her beautiful baskets for both "use and desire," reflecting the symbiosis with nature perfected by Indian artists. Wise of counsel and esteemed by her people, she now sits and waits for death, "nourishing her spirit against the time of the spirit's need . . . though she has none but the certainty that having borne herself courageously to this end she will not be reborn a coyote" (*LLR*, 103–11).

In Austin's land of *Lost Borders* (1909), where her "outliers" live, women are liberated from the restrictive norms of femininity by the vast and undominated scale of the land. In this book she also creates her most original re-vision of the metaphor of land as woman:

> If the desert were a woman, I know well what like she would be: deep-breasted, broad in the hips, tawny, with tawny hair . . . eyes sane and steady as the polished jewel of her skies, such a countenance as should make men serve without desiring her . . . passionate, but not necessitous, patient—and you could not move her, no, not if you had all the earth to give, so much as one tawny hair's-breadth beyond her own desires.[21]

The heroines in *Lost Borders* are marked by this "spirit of the land" even when they take lovers. A Shoshone woman "wrestled with the wilderness" for the love of an Anglo prospector. After bringing him back to health from a serious illness, she offers herself to him. But he is driven to return to civilization and stake his mining claim. Frightened by the power he senses in her while she is within her own territory, the desert, he takes her only when he gets to the border of his territory, the "Ploughed Lands," where he finally feels he is "his own man again." Soon afterward, he abandons her.

"The Woman at the Eighteen Mile" had the "lean, wasted, burned tawny" look that the desert bestowed on women who were "warmed from within." She became the trusted guide of an eastern businessman come west to settle a mining claim; their partnership was blessed by the desert's ability to breed equality (*LB*, 94–110). Most like Austin is the "Walking Woman," who went "unarmed and unoffended" among the haunts of men. She taught Austin that, if a woman had three things, she could forego everything else. They were "to work and to love and to bear children." She had done all three with a shepherd whose flock she had helped save and whose child she had borne. Then she had gone on her way, walking off "all sense of society-made values" (*LB*, 195–208).

Austin sometimes gloried in epic stories of the West about men who struggled for possession of the earth, but these tendencies were held in check by her belief that Nature would always triumph. Or so she thought when, in *California,* she said that the power of the Sierra Madre was "immanent and inescapable. Shall not the mother of the land do what she will with it? . . . Mighty as man is in transforming the face of the earth, he is nothing without the Rains" (*C,* 40, 44).[22] In 1924, the year she moved to Santa Fe and published *The Land of Journey's Ending,* Austin switched her allegiance. California, that fertile "lady of comparatively easy virtue," had proved too seductive to developers, so she turned to the "austere virginity" of New Mexico's and Arizona's still untouched wildernesses (*LJE,* 4). Secure once more in a region where the female land reigns

supreme, she promises us her enduring voice as its spokeswoman. One hundred years later, when tourists visit Inscription Rock in Arizona and see the "silken wings of the argemone burst without the wind," it will be Mary Austin, "making known in such fashion as I may the land's undying quality" (*LJE*, 231).[23]

Henderson, Luhan, and Austin opposed the belief that the American West had shaped only an individualistic, self-reliant, and aggressive personality—the white, male, Protestant profile that was often used to delineate the national character. In its place, they held up the folkways of nonwhite, community-oriented peoples whose guardianship of the past and integration of land, work, play, worship, and art could teach modern Anglo-Americans how to overcome the psychological fragmentation and alienating isolation of their modern, industrial society.

These writers' notions of where women fit into this reformed human community were often based on the roles that women played in pre-industrial societies, where they contributed to household and community economies through their work within well-defined separate spheres. Their concept of domesticity included spiritual and aesthetic expression, which they felt was central to life for both men and women. The women they portrayed are nurturers and artists, socializers and tale-tellers.

Henderson's interest in Hispanic and Indian folkways and folk arts had much to do with the fact that their religious and aesthetic expressions were directly related to what she felt were the most important aspects of human life—loving, preparing food, rejoicing in the harvest, caring for the young and the sick, respecting the old.

In *Red Earth,* Henderson portrays Death as "a distinguished visitor, / Making even old flesh important" at the time when neighbors come to pay their last respects (*RE*, 42). In her interpretation of an Indian song that she entitles "Parting," Henderson conveys the simple and moving solace of a husband to the wife with whom he is bonded to the land: "Earth is our mother . . . / Though I go from you to die, / We shall both lie down / At the foot of the hill, and sleep." Her "Corn-Grinding Song" reflects the correspondences in the Pueblo world view between the colors of the corn, geographical directions, and their stanzaic patterns. "Green Corn Dance" celebrates the symbolism carried out in costume, gesture, and music that awakens the onlooker to the presence of a once-unified "archetypal world" (*RE*, 25–30).[24]

In a different vein, "Una Anciana Mexicana" relishes the pleasures of old age because of her freedom from domestic chores. Done with her duty to husband and children, she has earned the right to sit up and dream the night away. Henderson enters her thoughts to tell us:

> *It's good at the last to know your own mind,*
> *And travel the paths that you traveled blind,*
> *It's good to smoke and none to say*
> *What's to be done on the coming day,*
> *No mouths to feed or coat to mend,*
>
> *. . . . . . . . . . . . . .*
>
> *Though one have sons and friends of one's own,*
> *It's better at last to live alone.* (RE, 44–45)

Mabel Luhan's induction into Pueblo ways of life and thought through her relationship with Tony Luhan (a Tiwa Pueblo) was the primary factor in reshaping her vision of American culture. Over six hundred years old, Pueblo culture was one of stable communitarian values at the opposite pole from the "competition, self-assertion, and the feeling of personal influence" that defined the Anglo world from which she had come (*ETD*, 274). She was also attracted by the Pueblos' celebration of a life force that transcended the sexual passions she felt had often trapped her in a limited and dependent sensuality.

Throughout her life, Luhan had been seeking what Jungians call the "reconciling symbol" that would allow her to fulfill her desires both to act and shape life and to nurture and shelter it. To her, the Pueblos were the best exemplars of that search. Mother Earth and Father Sun were cosmic dualities equally necessary to the continuation and health of human and natural life—as were their human counterparts. The fact that Luhan rarely distinguished between male and female when she wrote of the Pueblos is partly due to the essentially androgynous psychology she associated with them, in spite of their clearly differentiated social roles.

In *Edge of Taos Desert,* Tony Luhan's love serves as a paradigm for a re-vision of male-female relationships. Unlike her previous lovers, he does not try to tap her creative energies for his own use, nor does he enshrine her as an idealized "other." He is, instead, devoted to helping her integrate her feeling, thinking, and acting selves. In this role, he is as much parent as lover, as much female as male. His home is "impregnated with a fullness of life" that comes to fruition in the nine months of "gentle organic growth" during which he sees her "into being." Unlike the Anglo male modes of knowing she had always imitated—prying, penetrating, analyzing—he teaches by suggestion and example and relies on an intuitive sense of his surroundings.[25]

The joint building of their adobe home is Luhan's revised creation myth. The shelter grows literally out of the land and figuratively out of their love. Tony designs the structure and Mabel the interior, but so intimately do outside and inside partake of one another that no firm boundary separates their work. "To take the living earth from under their feet, undifferentiated and unformed, and shape it into a house . . . all of it is a sacred matter, for the wonder of creation is in it, the wonder of transformation which always seems of greatest significance to Indians" (*ETD*, 292).

Luhan saw her relationship with Tony as "a bridge between cultures." His organic consciousness merged with her more cerebral one so that she could articulate the wisdom of the Pueblos in terms that would effectively convince modern Anglo men and women of its value.[26] Her most persuasive testament is *Winter in Taos*, a utopian domestic novel that reflects both Pueblo and Anglo cultural traditions. The metaphor of "inside/outside" binds the book, which is also organized by the cyclical rhythms of Pueblo time. Luhan centers herself in the season the Tiwa call "The Time of Staying Still," the interregnum between Mother Earth's death and her rebirth, when no nails or wagon wheels are allowed in the pueblo to interfere with her rest before gestation.

Tony is the "medium" who sets the tone of daily living and teaches Mabel how to discipline herself in accordance with the dictates of each season. Hers is the "painterly eye" that composes the seasonal cycles out of her rich "harvest of memories." Her store

of memories is connected to the harvesting of wheat by the Indians. They "bloom from the grain" they consume; partaking of the "season's life," the grain becoming "flesh of their flesh" as it passes through their hands from sowing to reaping to eating (*WT,* 30). Luhan celebrates the kind of domesticity in which men and women work and live off the land in a cooperative effort whose goals are the integration of physical, emotional, and spiritual nourishment.

Their sense of shared life with one another and with the rest of creation was the essence, Luhan believed, of the redemption the Pueblos offered Anglo-Americans. During planting and harvest times, she recalls how the young Pueblo men help to restore the balance of nature by running in relays that give "back to earth and sun what they have received. In due time they will harvest it again, in wheat and corn, and fruit. The everlasting exchange goes on—between man and the earth, one and inseparable, but infinitely divided" (*WT,* 125). When she watches the tall twisters of yellow dust that move across the land, she thinks of the column that led the Israelites "toward the Promised Land." After a spring storm, the earth is redolent with the odors of paradise as God's rainbow covenant "embraces" his chosen people. At the end of *Edge of Taos Desert,* Tony tells Mabel that he will give her "a new life, a new world—a true one, I think!" (ETD, 331). In *Winter in Taos,* Luhan gives her Anglo readers the chance to enter imaginatively into a new Eden which has been regained by the interracial partnership of a restored Adam and Eve.[27]

Mary Austin was equally attracted by the human and natural interdependence she discovered in the Indian settlements and Mexican villages she frequented. She ends *The Land of Little Rain* with a chapter on "The Little Town of the Grape Vines," an Hispanic community that displayed most of the qualities she drew upon in the development of a theory of native village socialism which she offered during the 1920s as an alternative to European Communism. Here people live with little wealth, in peace, celebrating the Independence Days of all the ethnic groups in their vicinity—American, Mexican, Cuban, and French. Their lives involve cooperative effort in work, food production, tending children, and making music, unlike Anglos who "breed asphalt pavements," and whose creeds "restrict other peoples' ways of life." "Come away," she invites us at the book's conclusion, "you who are obsessed with your own importance in the scheme of things, and have got nothing you didn't sweat for, come away by the brown valleys and full-bosomed hills to the even-breathing days, to the kindliness, earthiness, ease of El Pueblo de Las Uvas" (*LLR,* 163–71).

Central to the binding of such communities is the *acequia madre* (mother ditch) which symbolizes the cooperation made possible when the land necessitates sharing precious water resources. "Rain falls on radical and conservative alike," Austin tells us in *The Land of Journey's Ending,* "but the mother ditch makes communists of them all" (*LJE,* 89). Austin associated this kind of social and economic communalism with female-centered cultures. "Peace and stability," she writes in *Taos Pueblo* (1929), "these are the first fruits of Mother-rule."[28]

The pre-industrial domesticity of which Austin approved included that of her own Anglo ancestors. In researching her grandmother's westward journey to the Illinois frontier in the 1820s, she discovered that it was "the hearth—not the battlefield" that

had determined the course of American democracy. Pioneer women had been responsible for creating a society and culture "out of their own wit and the work of their hands, out of what they could carry with them in the wilderness" (*EH,* 15). To my knowledge, Austin is the first feminist critic to have argued for the importance of what she called the "homecentric novel." It was "stupid and inexcusable," she told a primarily male audience of critics, to ignore the centrality of women's domestic fiction to an understanding of the development of American civilization.[29]

Henderson, Luhan, and Austin opposed the judgment of the New England literary and educational establishment that European literature and art and Puritan history and symbology were the determinants of American culture. They argued that Americans could build a national culture only if it were grounded in indigenous myths and symbols, the best of which were to be found in the still vital ethnic cultures of the Southwest. In spite of their tendency to romanticize and at times racially typecast these cultures, they were among the first generation of Anglo-Americans to promote attitudes toward the Indians and Hispanics that were neither racist nor assimilationist.[30]

All three women collected, preserved, and encouraged Hispanic and Indian folk arts, some of which had fallen into decline for a variety of reasons, including the transformation from a subsistence to a cash economy, the commercialization of traditional handicrafts for mass consumption, and attempts by government and religious agencies to destroy the Indians' traditional cultures. Their decision to root their own writing in the common experiences of the folk was integral to their belief in a democratic ideal that would destroy the distinctions between so-called "high" and popular culture. Folk art, they insisted, was by its nature nonelitist and accessible to large numbers of Americans in ways that the modernist works promoted by the Eastern critical establishment were not.

Henderson was an advocate of folk culture from her early days as associate director of *Poetry* magazine, when she urged American poets fleeing to Europe in search of a muse to "build on Whitman, as the Greeks upon Homer." In a 1917 issue, she urged young black poets to rely on their own folk traditions. She suggested that, rather than be caught in the dilemma of standard English versus dialect, they create a new idiom based on the "characteristic speech" of their people. In the same year, she worked on an issue of the magazine devoted to "aboriginal poetry," out of which came one of the first major anthologies of Indian verse in translation, *The Path on the Rainbow* (1918).[31]

In a 1920 editorial, Henderson cast aspersion on the Pilgrim Fathers' "stern and rockbound coast" for its inferiority as a source of myth. The British conquest, she averred, was a "prosaic affair" next to Coronado's: "they did not encounter useless and waterless wastes, temple-haunted gorges a mile deep, and plains running like a river with huge horned beasts to the horizon." She was fond of reminding her fellow Americans that they did not need to travel thousands of miles to ancient Egypt and Greece to see the dead relics of ancient rites—they could come to the Southwest, where ancient rites, still vital and alive, "grow as naturally out of the desert as the crimson cactus flower."[32]

The writers Henderson brought to New Mexico shared her desire to make poetry a

central experience in the lives of their fellow Americans, as Indian song and ritual were for Native Americans, and Spanish ballads and oral folk traditions were for Hispanics. She made her home a mecca for committed regionalists, including Carl Sandburg, Witter Bynner, Harriet Monroe, and Vachel Lindsay. She also carried out her interest in communal ideals by establishing what is now called a poetry collective: fellow poets met once a month to read their work and get much-needed response. Out of this effort grew her 1928 anthology, *The Turquoise Trail.* "The covers of this book," her inscription reads, "now take the place of the low-roofed adobe houses within whose walls most of these poems have . . . been shared in manuscript form." Among the thirty-seven contributors to this volume, which she claims was shaped by "the distinct poetic . . . atmosphere and a world entirely different from that of any other part of the country," are D. H. Lawrence, Marsden Hartley, Paul Horgan, Willa Cather, Mary Austin, and Mabel Luhan.[33]

Henderson's work with Anglo poets was accompanied by life-long activism on behalf of the Pueblo and Hispanic populations of New Mexico. She formed a "Poet's Round-Up" to raise money for the New Mexico Association of Indian Affairs, which fought for Pueblo land rights and religious freedom, and she served as curator for the Museum of Navajo Ceremonial Arts. She collected Hispanic religious songs and wrote a much-respected book on the controversial Catholic sect of Penitentes, in which she offered a moving vision of how the landscape nurtured their religious practices: "the stark parable of the Crucifixion is close to the country's soul. It eats into the heart, this terror; and it is not difficult to imagine how the early Franciscans felt, as they gazed upon this terrible afternoon light . . . and felt the thorns of this eternal loneliness pressing into their souls. Actual mortification of the flesh is perhaps less poignant." In her chapter on literature for the Federal Writers' Project Guide to New Mexico, she acknowledged the importance of Indian myths and legends and Hispanic histories and literature along with the works of Anglo explorers and writers.[34]

Like Henderson, Mabel Luhan spent much of her time in New Mexico promoting the aesthetic and communal benefits of Pueblo life in regional and national media. Convinced that Taos was "the beating heart of the universe," she worked actively to make her estate the center for "a new world plan," where disciples in all fields would gather to begin the process of reeducating Anglo society. Among others, she brought to Taos Georgia O'Keeffe and Ansel Adams to immortalize its beauty, Leopold Stowkoski to capture the rhythms of native American music, D. H. Lawrence and Mary Austin to celebrate the power of the land and its people in prose and poetry, and John Collier to protect the Pueblos' land rights and culture.[35]

Luhan also invested time, energy, and money to aid the Pueblos with the specific matters of health care and schooling as well as to bring their culture to national attention. She put together exhibits of Indian paintings for prestigious New York galleries, collected Indian and Mexican folk tales, and wrote publicity materials for the battles that her activist friends were waging alongside the Pueblos against the federal bureaucracy. During the first of these campaigns, in which she worked with Alice Henderson and Mary Austin, she wrote Austin a letter that expressed their shared ideology: "We want *interest* and *appreciation* of the indian life and culture to become

part of our conscious racial mind. We want as a *nation* to value the indian as we value ourselves. We want to *consciously* love the wholeness and harmony of indian life, and to *consciously* protect it. . . . Keep the indian *in* the public eye and he will be an integral part of the public welfare."[36]

No one argued harder or longer than Mary Austin that an authentic American culture must be rooted in the land where artists lived and must build upon the available indigenous expressions. As Henry Nash Smith pointed out in a 1930 essay, Austin not only increased the scale of nature writing "to the measure of the continent," but she also tried "to do for the American race what myths did for the Greeks and other European people." In this endeavor, she wrote for children as well as for adults. *The Trail Book* (1918) is a retelling of Indian folk tales that she dedicated to her niece, "In the hope that she may find through the trails of her own country the road to Wonderland."[37]

Austin organized the Indian Arts Fund to promote Indian arts and handicrafts and left a major portion of her estate to the fund. She also helped organize the Spanish Colonial Arts Society to preserve and support the work of Hispanic artisans. She lectured throughout her life on folk poetry, art, and theater, worked on pilot programs for bilingual and multi-cultural education, and brought to the American public a democratic concept that cultural expression was necessary to the well-being of modern as well as ancient civilizations.[38]

Austin argued that at one time everyone was "folk," until elites appropriated written culture as the only valid one. In her introduction to *Path on The Rainbow,* she established the significance of poetry in the lives of aboriginal peoples, for whom song, dance, and ritual were *effective* rather than *affective;* that is, intended to induce change— in the weather, health, or the hunt—and to bring the listener into "harmony with the essential essence of things." In *American Rhythm* (1923), she developed her theory of the influence of the "landscape line": "all vital poetry, which speaks to how life is actually lived by people and effectively coordinates their psychic life, is shaped by the topography, climate, work, and social patterns of the land where they live."[39]

Much of *Land of Journey's Ending* is devoted to bringing different aspects of Indian and Hispanic cultures to Austin's Anglo readers. She hymns the Southwest with Indian creation myths to show that they are the most adequate expressions of a region where grass and trees run with the wind in patterns that would be whole empires in Europe. We learn of Zuni, Pueblo, and Navajo rituals, as well as of Hispanic festivals, folk narratives, religious and funeral rites, and crafts. Austin provides her own powerful examples of making myth from the land:

> As you come up out of the river gorge into the valley of Taos, you see Pueblo Mountain standing toward the north, with thin storms of rain enfilading among the cañons of Star Water and Pueblo Creek, and the dance of the Rainbow Boys in and out of the storm's blueness. . . . Or suppose the rainbow comes forth, arching from foot to foot of Pueblo Mountain, moving as you move, while the Katchinas of the Middle Heaven water the pueblo fields, then you see how myths are made out of the stroke on stroke of beauty. (LJE, 382)

The Southwest was the last place on the western continent, Austin argued, "in which culture exists as an expression of the whole, unaffected by schisms of class and caste,

incapable of being rated in terms of power or property" (*LJE*, 263). Here, indeed, was the "journey's end" of the American experience, the only place where long-lived cultures have produced "adequate symbols in art and social forms." Since there can be no great national culture without "a widely accepted set of releasing symbols" generic to the land, the Southwest was clearly the setting "for the *next* great and fructifying world culture" (*LJE*, 441–42).

Austin's prediction was, of course, wrong. She shared with her fellow prophets, Henderson and Luhan, the failure to see that much of what they hoped to teach the Anglo world was too rooted in Native American and Hispanic cultures to be "borrowed" by an increasingly urban, industrial civilization that shared little of the ethos of either group. Equally important was their failure to understand the problems associated with their own borrowing from and sponsorship of these groups (although in their time these were issues of which few Anglos were aware). On the negative side, the "revival" that Austin, Luhan, and Henderson helped to inspire involved a "classically patronizing formula—the appropriation of control over an ethnic resource primarily by members of a superordinate society." Thus, it was often the Anglo artists/patrons who determined what was "authentic" and "traditional," while their belief in a timeless and unchanging folk art was based more upon their own need for roots and enduring symbols than on historical fact. The serious political, social, and ethical issues raised by their patronage cannot be overlooked.[40]

Nevertheless, their ability to publish in the national press and their political networks enabled them to wage, alongside the Pueblos, one of the few successful battles to protect Indian rights in the 1920s, and to help lay the groundwork for John Collier's "Indian New Deal" legislation in the 1930s. Their stimulation of new markets for Hispanic and Indian crafts and arts was beneficial both to individual artists and, in the cases of Indian potters and Hispanic woodcarvers, to the economies of their communities. Henderson, Luhan, and Austin also helped create a national audience for indigenous folk arts that had been neglected or ignored, particularly by museums and galleries.[41]

Nevertheless, Henderson's, Luhan's, and Austin's ideal of achieving a national culture that draws upon the traditions, images, symbols, and forms of non-Anglo ethnic groups within American society is a healthy one. New Mexican artists more, perhaps, than those in other areas of the country, have seen themselves as culture "brokers." As Ronald Grimes notes in his study of public ritual and drama in Santa Fe in the 1970s: "Typically, [the artist] considers none of the three cultures off-limits and feels relatively free to draw on their symbolic resources. The artist is likely to view his own use of symbols as less ideological, hence less exploitative, than the uses of the civil servant, the businessman, or the priest, because he views art as a universal language which is not a means but is its own end."[42]

Equally important in an evaluation of their contributions to the re-naming of America are the ways Henderson, Luhan, and Austin speak to contemporary feminist and regionalist concerns. Certainly their traditional conception of female space as "home" space "threatens to reify precisely those stereotypes of the feminine that contemporary women have fought so hard to overturn." Yet, as Annette Kolodny has suggested, it may well be "our *own* conceptions of home that are regressive." What constitutes home

for these three women writers is not a sentimental domesticity but rather "a complex figure of adaption and interdependence between the human and natural." To mythologize the entire natural world as home is to radically revise both terms.[43]

While all three women promoted a pre-industrial "myth" of communal and ecological harmony that is increasingly irrelevant to our post-industrial civilization, their understanding of the necessity for communal and regional solutions to social and economic problems is even more urgently needed today. Austin, in particular, saw the necessity for adaptation to the environment and the use of appropriate technologies. She believed in the "indivisible utility" of natural resources that crossed state boundaries, and called for them to be used and shared in a framework of space and time very different from what was traditional for Americans. Her ideas have much in common with contemporary bioregionalist thinking. She may have been wrong in her assumption that Westerners were more regionally conscious than Easterners, but her vision of regional planning is one that an increasing number of Americans share today:

> *The farmer in the Southwest cannot think produce without thinking dams and reservoirs, cannot think dams and reservoirs without thinking power, cannot think of power without thinking of its points of application in mines and factories, cannot therefore think of his own eighty acres without thinking of the whole geographical range of which it is an item. Finally, he cannot think constructively of his regional habitat without eventually stretching his thought to include the watershed, the mountain slopes and forests which compose it . . . [and] several states distant from his home. . . . The outstanding . . . [and] saving item of south-western culture is the necessity imposed upon the community . . . of the extension of environmental consciousness.*[44]

For the best of their work, Henderson, Luhan, and Austin deserve to be counted among those Anglo foremothers who "see and name" from the woman-centered, multi-ethnic, and multi-regional perspectives that are necessary to our health and survival as a nation.

# Desert, Rock, Shelter, Legend

## WILLA CATHER'S NOVELS OF THE SOUTHWEST

*In the beginning was the prairie: wheat country of southern Wisconsin, and a farmhouse that looked out upon a yard and six hundred acres of farmland extending on all sides toward what later . . . [she] would find again in the Southwest—wind and emptiness. Now, the thing about emptiness is that one can fill it: an empty landscape, an empty paper. One can make one's own mark. And in a wide, flat, empty landscape, one is centered wherever one is.—Eleanor Munro,* Originals: American Women Artists

In the beginning was the prairie, for Georgia O'Keeffe, whom these words describe,[1] and for Willa Cather; both would later find something of that childhood landscape in the American Southwest. This place seems to have offered O'Keeffe "a glimpse of that 'something' that seems alive . . . [and] she would go out to meet it as inevitably as some forms of life seek light."[2] Sometimes, wandering in the desert, she would pick up a piece of bone—like the pelvic bones in her paintings—and hold it up in the sun against the sky "as one is apt to do when one seems to have more sky than earth in one's world. . . . They were most wonderful against the Blue—that Blue that will always be there as it is now after all man's destruction is finished."[3] The image of the artist containing a piece of the sky in a circle of bone held up against that blue vastness suggests not just what O'Keeffe sees, but how she sees—or rather, how she experiences.

A Hopi guide says to an Anglo anthropologist: "Close your eyes and tell me what you see from Hopi House at the Grand Canyon." She describes landscape she has seen—the brilliantly colored walls of the canyon, the trail that winds over the edge of it, reappearing and crossing a lower mesa—and the Hopi responds, "I know what you mean . . . but your words are wrong." For him the trail does not cross; it does not

disappear: it is only that part of the mesa that has been changed by human feet. He says, "The trail is still there even when you do not see it, because *I can see all of it*. My feet have walked on the trail all the way down."[4] He refers to a way of knowing based on a set of cultural assumptions and a relationship with the land different from those of his visitor. The Hopi experiences space with his entire body, with his senses of touch, smell, and hearing; he knows how long the trail is because he has felt it under his feet.[5] For him, space is also a matter of memory, personal and cultural: the trail goes all the way to the Grand Canyon; it is the part of the mesa that feet have worn away. With reference to the natural formations, one can make a track in a space that is vast: one envisions the whole in order to understand the trail; or, by envisioning the trail, one understands the whole.

A circle of bone containing a piece of the sky, a trail cutting through a space that is vast—both are physical and spiritual experiences of *felicitous space;*[6] both perceptions rely upon body and memory to understand or create form.

Visual perception limits understanding to background/foreground and perspective;[7] reliance on other senses frees the mind and the body from the geometric fixedness of visual structures and makes possible the perception of a world in flux, of connectedness. For Jean-Marie Latour, a French missionary priest in Willa Cather's *Death Comes for the Archbishop,* this freedom comes from the very air of the New Mexican Desert. There is in its "dry and aromatic odour" something "soft and wild and free, something that . . . softly, softly picked the lock, slid the bolts, and released the prisoned spirit of man into the wind, into the blue and gold, into the morning, into the morning!"[8] There is something unique to this place—a spatial freedom—that makes possible a sensuous perception so acute that a sound or a smell transports mind and body vast distances in time and space. When Father Latour awakens one morning to the ringing of an old bell, installed as a surprise by his friend Father Joseph Vaillant, he is carried back and further back—literally out of his body, as faraway places of the imagination merge, through sound and smell, with landscapes experienced in his young manhood and recalled from childhood:

> He recovered consciousness slowly, unwilling to let go of a pleasing delusion that he was in Rome. . . . Full, clear, with something bland and suave, each note floated through the air like a globe of silver. Before the nine strokes were done Rome faded, and behind it he sensed something Eastern, with palm trees,—Jerusalem, perhaps, though he had never been there. Keeping his eyes closed, he cherished for a moment this sudden, pervasive sense of the East. Once before he had been carried out of the body thus to a place far away. It had happened in a street in New Orleans. He had turned a corner and come upon an old woman with a basket of yellow flowers; sprays of yellow sending out a honey-sweet perfume. Mimosa—but before he could think of the name he was overcome by a feeling of place, was dropped, cassock and all, into a garden in the south of France where he had been sent one winter in his childhood to recover from an illness. And now this silvery bell note had carried him farther and faster than sound could travel. (42–43)

Father Latour experiences this same sense of connectedness when he and an Indian guide take refuge from a storm in a sacred Navajo serpent cave. After carefully filling up a hole in the cavern wall, Jacinto spends the night on his feet, his body stretched against

the rock, "his ear over that patch of fresh mud, listening; listening with supersensual ear" for the disturbed spirit within. Father Latour, heedless of the cold, lies with his ear to a crack in the stone floor, listening to "one of the oldest voices of the earth . . . the sound of a great underground river, flowing through a resounding cavern . . . a flood moving in utter blackness under ribs of antediluvian rock" (134, 132).

Like Georgia O'Keeffe's holding a circle of bone against the sky, like the Hopi's focusing on a trail dividing and connecting a space he knows with a space he cannot see, in Latour's letting the sound of a bell bring together the pieces of his geographical memory, and in his listening to the sound of the great river beneath the earth, there is a focus on detail that gives form to space, to understanding, to desire. Increasingly, this is Cather's experience as well: she concentrates, especially in her novels of the Southwest—*The Song of the Lark, The Professor's House, Death Comes for the Archbishop*—on her inner vision, paring down language so that words exist as objects—physical things implying spiritual connectedness—as she searches for a form simple and pure enough to express her desire, to contain it exactly. Surely this is the meaning, in *The Song of the Lark,* of Thea Kronborg's discovery in the Arizona cliff dwellings, when she stands naked in the stream, holding in her hand a fragment of ancient pottery, and suddenly realizes: "The stream and the broken pottery: what was any art but an effort to make a sheath, a mould in which to imprison for a moment the shining, elusive element which is life itself . . . ?"[9]

Desire, in works of art, must be concentrated within form. Form is the envelope, the sheath, of the precious element itself—the ancient pottery, for Indian women, in which life-giving water is carried from the stream; the vessel, for Thea Kronborg, that can be made of one's throat and nostrils and held on one's breath; the creation, for Willa Cather, whose own interlude in the Southwest informs Thea's, of four walls to contain one passion.[10]

*"In a wide, flat, empty landscape, one is centered wherever one is."* In the wide, flat, empty landscape it is possible to reexperience, to reenter another space, another time; the wind and the light-hearted mornings of the desert recreate in the imagination the remembered landscape of childhood freedom.[11] In the beginning was the prairie—the "moisture of plowed land, the heaviness of labour and growth and grain-bearing," Cather writes, but first there was lightness found "only at the bright edges of the world, on the great grass plains or the sage-brush desert" (*Archbishop,* 276).

Center implies circumference, a place in space. To find the center of one's boundless desire, to give it form, is to begin in a space that is felicitous, one that frees the imagination. For Cather, the American Southwest was such a liberating space, one to which she returned, as to a touchstone. As the fictional space in these three novels and as the writer's own spiritual center, Cather's Southwest is a place that can be both sensed and touched, one that concentrates being within limits that protect.

In "The Ancient People" section of *The Song of the Lark,* the Southwest is literally a sacred space, a retreat from the profane space of the surrounding world. High in a canyon in the San Francisco mountains above Flagstaff, Arizona, Thea Kronborg, the novel's artist-heroine, takes for her own one of the sun-baked, wind-swept rock rooms

that smell of the tough little cedars that twist themselves into the very doorways. She spends whole days hiberating in her sunny blanket-lined cave, out of the stream of meaningless activity and undirected effort, "undistracted, holding pleasant and in-complete conceptions in her mind—almost in her hands. They were scarcely clear enough to be called ideas. They had something to do with fragrance and color and sound, but almost nothing to do with words" (297–99). Yet physical acuteness and a sense of human connection have never been more vivid for Thea: she can dislodge flakes of carbon from the rock room of her cliff dwelling and smell the smoke of the Ancient People; when she walks their paths she discovers "a feeling in her feet and knees and loins that she had never known before—which must have come up to her out of the accustomed dust of that rocky trail." When she holds a fragment of pottery in her hands, looking from the broad band of white cliff houses painted on a black ground to the real cliff houses that appear exactly the same to her, she feels time slide away, as if, in the place of the Ancient People, their perceptions have become her own.

Although Thea's days in the cliff dwellings seem to be without form, in fact the ritual of each day is in miniature the ritual of creativity: the intense in-dwelling, the ceremony of purification, the desire for action. Thea rediscovers a place in which "everything was simple and definite, as things had been in childhood . . . [where] the things that were really hers separated themselves from the rest." She bathes with "ceremonial gravity" in the stream that was once the life-giving force for the Ancient People and is now the only thing left of "so much . . . desire"; she begins to feel "a livelier movement in her thoughts . . . a freshening of sensation . . . a persistent affirmation" (304, 306–07).

The dwelling itself is a form: the cliff dwellings of the Southwest are for Thea houses of secret rooms, abodes of an unforgettable past, with nooks and corners that invite curling up.[12] Protected by the overhanging cliff, Thea's rock room encloses infinite space, like the sky viewed through O'Keeffe's circle of bone.

For Thea, the relationship between the intimacy of the cliff dwellings and the vast-ness of the Arizona desert is analogous to the dialectical relationship between inhabit-ing and emerging: for the artistic imagination, the more concentrated the repose, the greater the expansion of the emerging being.[13] This primal experience in the Arizona cliff dwellings is, for Thea, an imaginative return to her little attic room in Moonstone, Colorado, and for Willa Cather to her lost room in Red Cloud, Nebraska—"not plastered, but . . . snugly lined with soft pine," with a low ceiling sloping down on either side and one double window reaching from ceiling to floor. The acquisition of this room is the beginning of a new era in Thea's life:

> *It was one of the most important things that ever happened to her. Hitherto . . . she had lived in constant turmoil. . . . The clamor about her drowned the voice within her-self. . . . [Here] her mind worked better. She thought things out more clearly. Pleasant plans and ideas occurred to her which had never come before. She had certain thoughts which were like companions, ideas which were like older and wiser friends. . . . From the time when she moved up into the wing, Thea began to live a double life. During the day, when the hours were full of tasks, she was one of the Kronborg children, but at night she was always a different person. (56–58)*

Thea returns to this little room after studying music in Chicago, and she finds it the same and not same: when she went away, she could just touch the ceiling with the tips of her fingers; now she can touch it with the palm of her hand. The room is "snug and tight, like the cabin of a little boat . . . [and] so little that it was like a sunny cave, with roses running all over the roof." It offers the same quality of protection—from her bed she can watch through the window people going by on the farther side of the street—and yet she senses a hostility in the house and the town that the room cannot shut out. When she realizes that her time in this room is over, Thea weeps at the sense of being pulled out too soon, of leaving "something that she could never recover; memories of pleasant excitement, of happy adventures in her mind; of warm sleep on howling winter nights, and joyous awakenings on summer mornings. There were certain dreams that might refuse to come to her at all except in a little morning cave, facing the sun—where they came to her so powerfully, where they beat a triumph in her!" (222, 238–39).

Primal images like the cliff dwellings, then, are invitations to begin again to imagine. They recreate, for Thea in *The Song of the Lark* and for Willa Cather, "areas of being, houses in which the human being's certainty of being is concentrated." To live in images that are as stabilizing as these are, is to "*start musing on primitiveness*" and to find the life "that would belong to us in our very depths."[14]

When Thea goes to the Southwest, she is tired and dissatisfied with herself; the faces around her seem stupid and the city spent and impotent. Taking little with her, she journeys to a place where she has never been but returns "to the earliest sources of gladness"—the brilliant solitudes of sand and sun—where her very personality seems to let go of her: "The high, sparkling air drank it up like blotting-paper. . . . The old, fretted lines which marked one off, which defined her, . . . were all erased," and at night darkness has "once again the sweet wonder that it had in childhood" (296). In the cliff dwellings of Panther Canyon—a dead city built into caves naturally carved out of a stratum of rock hollowed out by the action of time until it was like a deep groove running along the sides of the canyon—Thea finds a little room that she takes for her own:

> *This was her old idea: a nest in a high cliff, full of sun. . . . Before her door ran the narrow, winding path that had been the street of the Ancient People. . . . Thea went down to the stream by the Indian water trail. She had found a bathing-pool with a sand bottom, where the creek was dammed by fallen trees. The climb back was long and steep, and when she reached her little house in the cliff she always felt fresh delight in its comfort and inaccessibility. . . . She could lie there hour after hour in the sun and listen to the strident whir of the big locusts, and to the light, ironical laughter of the quaking asps. All her life she had been hurrying and spluttering, as if she had been born behind time and had been trying to catch up. Now . . . it was as if she were waiting for something to catch up with her. . . . Her power to think seemed converted into a power of sustained sensation. She could become a mere receptacle for heat, or become a color, like the bright lizards that darted about on the hot stones outside her door; or she could become a continuous repetition of sound, like the cicadas. (298–300)*

Thea's time in the cave is a period of incubation, during which she begins to be aware

of a "persistent affirmation . . . going on in her, like the tapping of the woodpecker in one tall pine tree across the chasm." Now musical phrases drive each other rapidly through her mind, the song of the cicada is too long and too sharp, and everything seems suddenly to take form, to demand action. By the time Thea is "waking up every morning with the feeling that your life is your own . . . that you're all there, and there's no sag in you," she is ready to leave Panther Canyon (307, 317).

The bird imagery—the singing of the lark in the title, the tapping for attention of the woodpecker—suggests that Thea's concentrated repose is a prelude to a great soaring. In Panther Canyon, swallows build their nests far above the hollow groove that houses Thea's rock chamber:

*They seldom ventured above the rim of the canyon, to the flat, wind-swept tableland. Their world was the blue air-river between the canyon walls. In that blue gulf the arrow-shaped birds swam all day long, with only an occasional movement of the wings. The only sad thing about them was their timidity; the way in which they lived their lives between the echoing cliffs and never dared to rise out of the shadow of the canyon walls. As they swam past her door, Thea often felt how easy it would be to dream one's life out in some cleft of the world. (301)*

Thinking of nothing at all, her mind and body full of warmth and lassitude, Thea's imagination is suddenly fired by the appearance of an eagle, "tawny and of great size, [which] sailed over the cleft in which she lay, across the arch of sky." She follows his rhythm as he drops for a moment into the gulf between the walls, then wheels and mounts:

*His plumage was so steeped in light that he looked like a golden bird. He swept on, following the course of the canyon a little way and then disappearing beyond the rim. Thea sprang to her feet as if she had been thrown up from the rock by volcanic action. She stood rigid on the edge of the stone shelf, straining her eyes after that strong, tawny flight. O eagle of eagles! Endeavor, achievement, desire, glorious striving of human art! From a cleft in the heart of the world she saluted it. . . . It had come all the way; when men lived in caves, it was there. A vanished race; but along the trails, in the stream, under the spreading cactus, there still glittered in the sun the bits of their frail clay vessels, fragments of their desire. (321)*

Thea's salute to the eagle is a moment of epiphany; her linking of its flight with the vessels that hold the life-giving water is a moment of pattern-making, a spiritual, intellectual, physical understanding of a form to contain her desire. Like the eagle, Thea has journeyed back to a time and place of origins. Like the journey in the desert or the sea change, this change in space has also been a rediscovery of that space felicitous for creativity.

This counterpoint of the sky full of motion and change and the desert monotonous and still, of the soaring flight of the eagle and the permanence of the silent and austere cliff dwellings, though it occurs elsewhere in Cather's fiction, is a view of the world that seems especially central to her novels of the Southwest, where the land itself is at the center. It seems as if Willa Cather must have discovered this great truth just as Thea

Kronborg did—lying on a shelf of rock, motionless, watching the soaring flight of the eagle. Something about this counterpoint of silence and sound, of stillness and motion, seems to come from the Southwest itself, for in Georgia O'Keeffe's works, Eleanor Munro writes, "there exists motion (in the case of her person: a life of action, self-determination, will; in the case of the world: changing lights, shadows, wind, forms in mutation, music and the breath of life) and . . . there exists a permanent ground (in the case of her person: ritualistic, timeless costume, silence, the austerity of her isolation and manner of life; in the case of the world: stars, earth and bones)."[15] Munro suggests that many women artists, isolated from sources of power in their formative years, take for touchstones not traditional style markers, "but primitive archaeological monuments that, in early days, engaged human beings in ritual behavior or afforded them elemental shelter," identifying with primal modes that "continue to align all their later work . . . [with] the 'rhythm of nature.'"[16]

This linking of O'Keeffe's person with her world, and both with her art, and the observation of the importance for women artists of the imaginative return to primal sources, suggests another dimension to Thea Kronborg's—and Willa Cather's—experience in the Southwest. I have focused on the imaginative return "to the earliest sources of gladness," but equally important is the way Thea physically becomes one with the earth at Panther Canyon—the way in which she fits her body to the shape of the cave, soaking up the warmth of the sun; the feeling of the rock ledge; the sense of the trail of the Ancient People under her feet and in her loins and even, in her imagination, the feel of a baby on her back and a jug in her arms as she ascends the trail from the stream; the play of the water on her naked body when she bathes in the stream. Even her identification with the eagle is physical: she springs "to her feet as if she had been thrown up from the rock by volcanic action"; when she herself perches on the edge of the cliff, "between sky and the gulf, with that great wash of air and the morning light about her," she radiates a sense of "muscular energy and audacity,—a kind of brilliancy of motion,—of a personality that carried across big spaces and expanded among big things" (320–21).

This physical place is what Ellen Moers called "the most thoroughly elaborated female landscape in literature":[17]

> *Panther Canyon was . . . one of those abrupt fissures with which the earth in the Southwest is riddled. . . . It was accessible only at its head. The canyon walls, for the first two hundred feet below the surface, were perpendicular cliffs, striped with even-running strata of rock. From there on to the bottom the sides were less abrupt, were shelving, and lightly fringed with* piñons *and dwarf cedars. The effect was that of a gentler canyon within a wilder one. The dead city lay at the point where the perpendicular outer wall ceased and the V-shaped inner gorge began. There a stratum of rock, softer than those above, had been hollowed out by the action of time until it was like a deep groove running along the sides of the canyon. In this hollow (like a great fold in the rock) the Ancient People had built their houses. (297)*

This land is a textured map of the female body, wild and gentle, rocky and fringed and smooth, seemingly inaccessible, yet sheltering life deep within its hollow center. Fol-

lowing the deep groove that runs from the sheltering fold in the rock, one would come to the life-giving source itself: water. All of the ceremonies of the Ancient People, and their religion itself, go back to water, Thea learns: the men provided the food, but water was the responsibility of the women. They molded forms from the earth to contain the life-giving source of the earth.

> *Their pottery was their most direct appeal to water, the envelope and sheath of the precious element itself. The strongest Indian need was expressed in those graceful jars, fashioned slowly by hand, without the aid of a wheel. . . . This care, expended upon vessels that could not hold food or water any better for the additional labor put upon them, made her heart go out to those ancient potters. They had not only expressed their desire, but they had expressed it as beautifully as they could. Food, fire, water, and something else—even here, in this crack in the world, so far back in the night of the past! Down here at the beginning that painful thing was already stirring; the seed of sorrow, and of so much delight. (303–05)*

What Thea understands as she stands in the stream with a piece of pottery in her hands, as she lies on the rock shelf in the sun, as her own body tenses in affirmation as the eagle soars overhead, is the connection between matter and spirit, between form and desire. Her emergence as an artist comes quite literally from the earth: in contact with the earth she learns once again to delight in her body. To give form to her artistic desire, which is only possible, she says, when there is no "sag" in her physical self, is literally to make of her body—of her throat and nostrils—a vessel in which to hold the life-giving element itself—breath.[18]

In *The Song of the Lark,* the enclosed felicitous space makes possible the in-gathering of the creative person; but in Cather's later novel, *The Professor's House,* where a section set in the Southwest functions again as a kind of sacred space, the union of matter and spirit, of body and memory, no longer seems possible. Although she called this novel "experimental," Cather made clear that this work is structured as a deliberate refor-mulation of classical experience, a tripartite sonata-like composition (A-B-A), the Pro-fessor's experience at beginning and end framing the central "Tom Outland's Story." "I wished to try two experiments in form," she wrote:

> *The first is the device often used by the early French and Spanish novelists; that of inserting the* Nouvelle *into the* Roman. . . . *But the experiment which interested me was something a little more vague, and was very much akin to the arrangement followed in sonatas in which the . . . form was handled somewhat freely. Just before I began the book I had seen, in Paris, an exhibition of old and modern Dutch paintings. In many of them the scene presented was a living-room warmly furnished, or a kitchen full of food and coppers. But in most of the interiors . . . there was a square window, open, through which one saw the masts of ships, or a stretch of grey sea. The feeling of the sea that one got through those square windows was remarkable, and gave me a sense of the fleets of Dutch ships that ply quietly on all the waters of the globe. . . .*
>
> *In my book I tried to make Professor St. Peter's house rather overcrowded and stuffy with new things; American proprieties, clothes, furs, petty ambitions, quivering jeal-*

*ousies—until one got rather stifled. Then I wanted to open the square window and let in the fresh air that blew off the Blue Mesa, and the fine disregard of trivialities which was in Tom Outland's face and in his behavior.*[19]

If we compare the felicitous space of Thea Kronborg's southwestern cliff dwelling, "The Ancient People" section of *The Song of the Lark,* with "Tom Outland's Story" in *The Professor's House,* we see that in the latter novel the enclosed form has a precarious vulnerability. Thea has "a superstitious feeling about the potsherds, and she liked better to leave them in the dwellings where she found them" (305). Tom Outland, on the other hand, systematically removes the pottery, mummies, and other remains from the caves, including "Mother Eve," who seems to him to be the forerunner of the race; he studies, labels, and catalogs these artifacts, which later, while he is in Washington trying to interest government bureaucrats in his find, are sold off to a foreign collector.[20] Thea's experience in the cliff dwellings is fundamental to her emergence as an artist. Tom becomes a scientist, whose great discovery, a bulkhead vacuum used in aircraft, is directly related to the materialistic decadence that Professor St. Peter finds so disheartening. To name, then, specific forms from the past, modes that embody particular ways of ordering experience, is to underline a need for clarity about forms in this novel; it is to express a wish to preserve old structures and to reestablish rational ways of perceiving and responding to the world, while at the same time securing the structures that make possible the saving grace of make-believe.

The war in which Tom Outland died left in its wake an especially pronounced need to return to forms of the past. For Cather, "The world broke in two in 1922 or thereabouts, and the persons and prejudices recalled in these sketches [*Not Under Forty*] slid back into yesterday's seven thousand years."[21] But Cather's profound alienation was personal as well as cultural: the marriage of her close friend Isabelle McClung meant, among other things, the loss of the little attic room in the McClung's house where Cather had done so much of her imagining. Like Professor St. Peter, Cather found herself unable to write in the splendid new study the Hambourgs furnished for her in their new house, the Ville-d'Avray.[22] In *The Professor's House* and the novels that follow, characters increasingly turn inward, moving toward an extreme rejection of the world.[23] St. Peter lives in what we might call the negative aspect of time: only in childhood, it seems to him, had he been truly free. It is that freedom he sees, or thinks he sees, in the Lake Michigan landscape framed by his square window.

Cather's letter on *The Professor's House* describes "old and modern" Dutch paintings. By "old" she must mean preclassical representations of people and events implicated and involved in the natural world—like the sixteenth-century paintings of Pieter Brueghel, which, packed with incident and event, "tell a story." In these paintings, place and event are "utterly integrated so that we see peasants and villagers skating or cutting wheat *in* this setting which is the context for their activities."[24] In the seventeenth century, however, *landscape*—the very word was new—came to mean something to be looked at, arranged, and admired for its formal qualities.[25] Paintings explicitly called "landscapes" become impersonal and precise representations of the land as "scene." This is the vision of landscape in *The Professor's House:* contained and

separated from the viewer by a square window, both this midwestern scene and other, remembered visions are like paintings by the seventeenth-century Dutch painter Johannes Vermeer, in which fragments of landscape, isolated for their pictorial qualities, are artistic representations of a prospect seen from a specific standpoint.[26]

The idea of landscape as something separate from life, something to be looked upon and painted, to be admired, modified, explained or interpreted, was part of the new, *rational* way of looking at the world in the seventeenth century, which in philosophy is represented by Rene Descartes' *Discourse on Method,* written in Amsterdam while Vermeer was painting his landscapes.[27] Descartes's famous proposition, "I think, therefore I am," led him to maintain that although "I could *pretend that I had no body* and that there was no world or place that I was in . . . I could not, for all that, pretend that I did not exist." The mind that reasons is certain, Descartes argued; it is distinct from and superior to the body, world, and matter because they do not think. Mind is an indivisible unity, but matter, or nature, is divisible into parts and functions according to the certainties of mathematical laws.[28]

This "rational" division between mind and body, the assertion of human reason over nature, symbolized by the vision of landscape framed, contained and separated from the viewer, has a correlative in the reconstruction of actual landscapes: mid-seventeenth-century gardens literally become *spectacles;* the framed midwestern landscape Professor St. Peter sees from his attic window has its correlative in his meticulously composed French garden below. With this reconstruction of landscape as a celebration of intellectual and visual perception, "I think, therefore I am" supersedes "I make, therefore I am."[29] The former entails a separation, the latter a unity of matter and spirit, of body and memory—in making by hand the beautifully formed and decorated pots to hold the life-giving water, as the Indian cliff-dwelling women do; in making music by combining idea (mind) with passion (body), as Thea Kronborg does; in making stories, as the immigrants in Cather's fiction do, out of their experiences, out of the earth, out of their bodies. But Professor St. Peter is the Cartesian man who cultivates a dual existence, dividing mind and body and celebrating in this division the supremacy of the rational.

Napoleon Godfrey St. Peter has two houses, two studies, two places of retreat, two lives that he divides with precision:

> *Two evenings of the week he spent with his wife and daughters, and one evening he and his wife went out to dinner, or to the theatre or a concert. That left him only four. He had Saturdays and Sundays . . . and on those two days he worked like a miner under a landslide. . . . All the while that he was working so fiercely by night, he was earning his living during the day; carrying full university work and feeding himself out to hundreds of students in lectures and consultations. But that was another life.* [30]

Yet all is not as neat as he would wish. The problem that he is faced with, as the novel opens on the day of moving from one house to another, is that of displacement or disharmony, both in his world and in his own nature. A product of his time and place— America in the early 1920s—he is, like his contemporaries, expatriated intellectuals and imagined characters who people an increasingly alienating wasteland, out of touch with

both. A man who perceives the world of matter as polluted, he withdraws into the world of his own imagining. Unlike Thea Kronborg, whose retreat into a felicitous space of physical and spiritual repose is a preparation for emergence, the Professor prefers to remain in the remembered and created space of his imagined world, increasingly oblivious to what goes on beneath and around him. Limiting his existence to a framed and isolated visionary world, his withdrawal becomes a preparation for a final retreat into death.

St. Peter does not exactly deny his body. He enjoys a long, solitary swim, sporting a brightly colored visor to mark his progress through the water; he relishes an exquisitely prepared solitary lunch with a glass of special sherry; when the family is away, he walks to the market to pick out his own fruits and salads and cooks "a fine leg of lamb, *saignant,* well rubbed with garlic," served with "a dish of steaming asparagus, swathed in a napkin to keep it hot, and a bottle of sparkling Asti." St. Peter has a rather nice body, in fact: he looks good in pajamas, and "the fewer clothes he had on, the better. Anything that clung to his body showed it to be built upon extremely good bones, with the slender hips and springy shoulders of a tireless swimmer." Tellingly, however, his artist daughter finds the best thing about Papa to be "the modelling of his head between the top of his ear and his crown," a moulding "so far from casual, that it was more like a statue's head than a man's." And though his wife admires his body, the St. Peters, once "very much in love," now occupy separate—"more dignified"—bedrooms (176, 12, 13, 31, 34). The body for St. Peter has become a thing to enjoy abstractly or in solitude—like the dressmakers' dummies stored in his old attic study, abstract forms that express only the sexuality and roles hung upon their frames. One of these dummies has been named "the bust" by Augusta, the sewing woman: it is a "headless, armless female torso, covered with strong black cotton . . . richly developed in the part for which it was named," seemingly ample and billowy "(as if you might lay your head upon its deepbreathing softness and rest safe forever), [but] if you touched it you suffered a severe shock. . . . It presented the most unsympathetic surface imaginable. . . . It was a dead, opaque, lumpy solidity, like chunks of putty, or tightly packed sawdust—very disappointing to the tactile sense." The other dummy is a "full-length female figure in a smart wire skirt with a trim metal waist line. It had no legs, as one could see all too well, no viscera behind its glistening ribs, and its bosom resembled a strong wire bird-cage." Up there in the little attic study, St. Peter, isolated with his dummy bodies and insulated from "the engaging drama of daily life," has had only a vague sense of what went on below. He lives in a fantasy world, imagining scenes like a shipwreck with no one "but himself, and a weather-dried little sea captain from the Hautes-Pyrénées, half a dozen spry seamen, and a line of gleaming snow peaks, agonizingly high and sharp, along the southern coast of Spain"; musing, abstractly, on the erotic passages from the "Song of Songs";[31] dwelling on the memory of Tom Outland's hand, holding a pair of turquoise lumps "the colour of robin's eggs, or of the sea on halcyon days of summer," the hand that held them muscular, the palm many-lined, "the long, strong fingers with soft ends, the straight little finger, the flexible, beautifully shaped thumb that curved back from the rest of the hand as if it were its own master" (17–18, 26, 95, 120–21).

St. Peter's attic retreat in his midwestern house—like Thea Kronborg's room in

Black Hawk, Colorado, and Willa Cather's room in Red Cloud, Nebraska—is the spiritual equivalent of the cliff dweller's cave in the Southwest: a space barely furnished, with a low ceiling sloping down on three sides and a single window affording the only opening for light and air. But if Thea is an eagle, soaring from her canyon nest to the vastness of unlimited space, Professor St. Peter, dreaming his life out in some cleft of the world, is the swallow that lives "between the echoing cliffs and never dared to rise out of the shadow of the canyon walls." He admits to himself that his "desk was a shelter one could hide behind . . . a hole one could creep into"; he muses upon the withdrawal of Euripides, at the end of his life, into a seaside cave, all houses having become insupportable to him; and so deep does his solitude become that he experiences "a falling out of all domestic and social relations, out of his place in the human family, indeed" (161, 156, 275).

During the fifteen years St. Peter has spent in that little attic study writing his multivolume *Spanish Adventures in North America,* the square window in this room has provided his view of the world. Even his travels to Spain to study records, and to Mexico and the southwestern United States with Tom Outland on the trail of his adventurers, become memories seen again through that square window. The notes and the records and the ideas "always came back to this room. It was here that they were digested and sorted, and woven into their proper place in his history." When he looks up from his desk, he can see the framed landscape, "far away, just on the horizon, a long, blue, hazy smear—Lake Michigan, the inland sea of his childhood," a landscape that St. Peter equates with remembered or re-imagined freedom, one that encourages daydreaming and fosters creativity. This scene is for him the great fact in life: "the always possible escape from dullness, was the lake. The sun rose out of it, the day began there; it was like an open door that nobody could shut. The land and all its dreariness could never close in on you. You had only to look at the lake, and you knew you would soon be free." And as he contemplates this landscape, his inland sea expands, imaginatively, to include the Mediterranean, where once he lay in a boat upon purple waters, envisioning the peaks of the Sierra Nevadas as "the design of his book unfolded in the air above him, just as definitely as the mountain ranges themselves" (25, 29, 30, 106).

St. Peter's other retreat is different in kind, but it shares with the attic study the sense of enclosure and the idea of landscape as vision, as composition. If the inland sea, the landscape of St. Peter's childhood, evokes images of vastness and freedom, the contained French garden recalls "the happiest years of his youth in a house in Versailles." It is his "rational" self, St. Peter believes, who in a midwestern university town has created a walled-in garden that is the comfort of his life—and the one thing his neighbors hold against him. He tended the garden for twenty years, until he "had got the upper hand of it." There is not a blade of grass: "it was a tidy half-acre of glistening gravel and glistening shrubs and bright flowers. There were trees, of course; a spreading horsechestnut, a row of slender Lombardy poplars at the back, along the white wall, and in the middle two symmetrical, round-topped linden-trees. Masses of green-brier grew in the corners, the prickly stems interwoven and clipped until they were great bushes." Like his other sensuous pleasures, St. Peter prefers his garden alone—with one exception. When his family traveled, "he brought down his books and papers and

worked in a deck chair under the linden-trees; breakfasted and lunched and had his tea in the garden. And it was there he and Tom Outland used to sit and talk half through the warm, soft nights" (14–15).

The spirit of Tom Outland pervades both attic and garden retreat. Tom has not only been the one student worth the Professor's trouble; his firsthand knowledge of the Southwest has proved indispensable to St. Peter's great project. "Tom Outland's Story," finally, is the vision seen through the window of the Professor's rather stuffy and overfurnished house; it is the unfurnished room—four walls and one passion— that is the true center of the novel. It challenges by contrast the cramped and awkward old house, the decadent materialism of the new house, and the ostentatious oddity of "Outland," the Norwegian manor house designed by a French architect and furnished with the treasures of ransacked European mansions, built by the Professor's elder daughter, Tom's fiancée, as a tribute to Outland's memory.

"Tom Outland's Story," contained by house and novel, is "true" both in its form and in its essence; the Blue Mesa (Mesa Verde), with its spectacularly preserved cliff dwellings, was actually discovered by a cowpuncher named Richard Wetherill just as Tom recounts to Professor St. Peter:[32]

> *Far up above me, a thousand feet or so, set in a great cavern in the face of the cliff, I saw a little city of stone, asleep. It was as still as sculpture—and something like that. It all hung together, seemed to have a kind of composition: pale little houses of stone nestling close to one another, perched on top of each other, with flat roofs, narrow windows, straight walls, and in the middle of the group, a round tower. . . . A fringe of cedars grew along the edge of the cavern, like a garden. They were the only living things. Such silence and stillness and repose—immortal repose. That village sat looking down into the canyon with the calmness of eternity. . . . It was more like sculpture than anything else. I knew at once that I had come upon the city of some extinct civilization, hidden away in this inaccessible mesa for centuries, preserved in the dry air and almost perpetual sunlight like a fly in amber, guarded by the cliffs and the river and the desert. (199, 201–02)*

"Tom Outland's Story" is now Professor St. Peter's world—re-created in his multi-volume book, imagined through the window of his attic study, the subject of his meditations as he sits alone in his garden. It is a world preserved, like a fly in amber: the vastness of the mesa and the silence of the cliff dwellings suggest "immortal repose." His life's work in the old house is complete, yet he returns to the old space as to a nest.[33] In his silent solitude, spaces and times are compressed: he dreams of the windswept cliff dwellings carved out of bare rock, "fringed with . . . groves of quaking asps and piñons and a few dark cedars, perched upon the air like the hanging gardens of Babylon," beyond which is "a kind of back court-yard, running from end to end of the cavern; a long, low, twilit space that had got gradually lower toward the back until the rim rock met the floor of the cavern, exactly like the sloping room of an attic" (192, 208–09).

Sitting in the garden of his old house or in his old attic study, holding Tom Outland's diary, which he intends to edit for publication, St. Peter lets the spirit of the mesa, Tom's spirit, possess him. "I lay down on a solitary rock that was like an island in the bottom of the valley, and looked up," he reads in Tom's diary.

*The grey sage-brush and the blue-grey rock around me were already in shadow, but high above me the canyon walls were dyed flame-colour with the sunset, and the Cliff City lay in a gold haze against its dark cavern. In a few minutes it, too, was grey, and only the rim rock at the top held the red light. When that was gone, I could still see the copper glow in the piñons along the edge of the top ledges. The arc of sky over the canyon was silvery blue, with its pale yellow moon, and presently stars shivered into it, like crystals dropped into perfectly clear water.*

*I remember these things, because, in a sense, that was the first night I was ever really on the mesa at all—the first night that all of me was there. This was the first time I ever saw it as a whole. It all came together in my understanding, as a series of experiments do when you begin to see where they are leading. Something had happened in me that made it possible for me to co-ordinate and simplify, and that process, going on in my mind, brought with it great happiness. It was possession. The excitement of my first discovery was a very pale feeling compared to this one. For me the mesa was no longer an adventure, but a religious emotion. (250–51)* [34]

So deeply does the Professor enter into this imaginative experience that what has been a retreat, a place for study and contemplation and spiritual rejuvenation, now lures him into permanent withdrawal. The rock of the Blue Mesa—St. Peter's correlative, as his name suggests—is no longer a source of action and creation, as it was for Tom Outland, and as it once was for the Professor. Sitting in his garden, musing on the past, he invites, or becomes again, the boy of his youth, "the original, unmodified Godfrey St. Peter," a primitive like the remembered Tom Outland (263). Returning to his attic, he invites death—a retreat that carries him literally out of his body—then experiences the resurrection of a man in his grave.

Death links Professor St. Peter to the cliff dwellers in "Tom Outland's Story," E. K. Brown suggests: between the life of the midwestern college town and that of the cliff dwellers' village, "the common quality is simply that they both end in death." Understanding this, we know how to measure the ugly and insensitive structures of the present against "the beauty of pure and noble design, unspoiled by clutter or ornament." [35] But the real link is the one St. Peter makes in a lecture when he says that "art and religion (they are the same thing, in the end, of course) have given man the only happiness he has ever had," meaning that the contemplation of pure form in its aesthetic and spiritual sense—what St. Peter calls "the calmness of eternity"—is an end in itself (69, 201). The ancient civilization that is at the core of *The Professor's House*, framed by and shaping St. Peter's vision, is not only a rite of passage in its exploration "of essential feeling about final issues"; [36] it is, unlike Thea Kronborg's fusion of form and desire, an isolation and containment of desire within exact and perfect form, a structure from the past preserved against the fragmentation of the modern world.

"Felicitous space" is not only the space that concentrates being within limits that protect; felicitous also is the space that is *vast*, that "brings calm and unity . . . [and] teaches us to breathe with the air that rests on the horizon." [37] New space actively imagined is vast space, intimate immensity. Through a change in space—crossing the

water, wandering in the desert—transformation becomes possible. Only in leaving the space of one's usual sensibilities and entering "a space that is psychically innovating"—a change of concrete space that is no mere mental operation, like Professor St. Peter's, but a fundamental change in one's nature, like Thea's—is one able to say, "I am the space where I am."[38]

For Willa Cather, the southwestern Four Corners area with its vast deserts and distant mountain ranges—the landscape Professor St. Peter envisioned from his attic window—was both this new space actively imagined and the old space, the landscape of remembered childhood freedom, re-created as touchstone. After her first long stay in New Mexico and Arizona in 1912, Cather went back during the next twelve years as often as she could and, although she was working on other material, the Southwest continued to haunt her imagination. She recalls how finding a book printed on a country press—*The Life of the Right Reverend Joseph P. Machebeuf* by Father William Joseph Howlett, the biography and letters of the first French missionary priests in New Mexico, Father Machebeuf and Father Jean Baptiste Lamy—gave her "the tone" from which she could write her story of these "valiant men whose life and work had given me so many hours of pleasant reflection in faraway places"—Joseph Vaillant and Jean-Marie Latour in her novel. Then the writing went very quickly "because the book had all been lived many times before it was written, and the happy mood in which I began it never paled." In *Death Comes for the Archbishop* Cather followed the life story of the two men presented in Howlett's book, but also used many of her own experiences; writing it, she said, "was like a happy vacation from life, a return to childhood, to early memories."

Readers found her book "hard to classify." "Then why bother?" she asked. "Myself, I prefer to call it a narrative," whose title "was simply taken from Holbein's *Dance of Death*."[39]

*Death Comes for the Archbishop* is a "narrative" of a special kind, and the matter is "simple" in a particular way. *The Dance of Death* is a series of woodcuts from the end of the sixteenth century attributed to Hans Holbein the Younger.[40] Based in theme on an early fifteenth century mural painted on the cemetery wall of a church in Paris,[41] in form the woodcuts go back to the earliest modes of pictorial expression, the woodcarving and the line drawing. Their message, meant for people who could not read, was that death comes to all alike, emperor and peasant, judge and moneylender, physician and lover, new bride and new baby, old woman and worthy bishop. We see Cather, then, journeying back to the oldest forms of representation, where the hand is in direct contact with the material of artistic expression; we see, too, that death is the supreme measure of experience. "As a writer I had the satisfaction of working in a special genre which I had long wished to try," Cather wrote.

*I had all my life wanted to do something in the style of legend, which is absolutely the reverse of dramatic treatment. Since I first saw the Puvis de Chavannes frescoes of the life of Saint Geneviève in my student days, I have wished that I could try something a little like that in prose; something without accent, with none of the artificial elements of composition. In the Golden Legend the martyrdoms of the saints are no more dwelt upon*

*than are the trivial incidents of their lives; it is as though all human experiences, measured against one supreme spiritual experience, were of about the same importance. The essence of such writing is not to hold the note, not to use an incident for all there is in it—but to touch and pass on. I felt that such writing would be a kind of discipline in these days when the "situation" is made to count for so much. . . . In this kind of writing the mood is the thing—all the little figures and stories are mere improvisations that come out of it.*[42]

This is as complete a statement of artistic intention as Cather ever made: the essential elements are the stories, which remain fixed in the mind like a series of primitive woodcuts; the process of invention; the tone or mood created in language. "What I got from Father Machebeuf's letters was the mood," she said, "the spirit in which they accepted the accidents and hardships of a desert country, the joyful energy that kept them going. To attempt to convey this hardihood of spirit one must use language a little stiff, a little formal, one must not be afraid of the old trite phraseology of the frontier. Some of those time-worn phrases I used as the note from the piano by which the violinist tunes his instrument."[43]

Language is only for tuning: the impression Cather wished to create was not one of words. The longer she stayed in the Southwest, she wrote, the more she felt drawn to the old mission churches with their "hand-carved beams and joists, the utterly unconventional frescoes, the countless fanciful figures of the saints, no two of them alike," which struck her as "a direct expression of some very real and lively human feeling . . . fresh, individual, first hand. Almost every one of those many remote little adobe churches," she found, had something of its own. "In lonely, sombre villages in the mountains the church decorations were sombre, the martyrdoms bloodier, the grief of the Virgin more agonized, the figure of Death more terrifying. In warm, gentle valleys everything about the churches was milder." No written account of these churches exists, Cather says, "but I soon felt that no record of them could be as real as they are themselves. They are their own story, and it is a foolish convention that we must have everything interpreted for us in written language. There are other ways of telling what one feels, and the people who built and decorated those . . . little churches found their way and left their message."[44]

*Death Comes for the Archbishop* works upon the reader as a series of sensations—of color, of light, of the large become small, as in the monotonous red sandhills that come to seem like so many haycocks to the solitary horseman riding through them, and the small become large, like the cruciform tree that occupies all the space between earth and sky. Light strikes the senses as brilliant and explosive, raw and blinding, full of motion and change, unlike the light of the Old World, where objects take on a soft metallic quality in light that is both intense and soft, with a ruddiness of much-multiplied candlelight and splendid finish, light that sends spiral patterns quivering over damask and plate and crystal, over the rectangular caps protecting the heads of churchmen from the sun, over their long black coats and violet vests.

Light hidden strikes the senses, on those endless journeys across this vast and strange diocese, as shape and texture, felt as the undercurrent of the great fact of the land itself,

in all of its height and depth. The two bishops, having ridden through wind and sandstorms, now in the Truchas mountains on their way to Mora ride through rain and sleet, conditions which make it nearly impossible for them to see at all.

*The heavy, lead-coloured drops were driven slantingly through the air by an icy wind from the peak. These raindrops, Father Latour kept thinking, were the shape of tadpoles, and they broke against his nose and cheeks, exploding with a splash, as if they were hollow and full of air. The priests were riding across high mountain meadows, which in a few weeks would be green, though just now they were slate-coloured. On every side lay ridges covered with blue-green fir trees; above them rose the horny backbones of mountains. The sky was very low; purplish lead-coloured clouds let down curtains of mist into the valleys between the pine ridges. There was not a glimmer of white light in the dark vapours working overhead—rather, they took on the cold green of the evergreens. Even the white mules, their coats wet and matted into tufts, had turned a slaty hue, and the faces of the two priests were purple and spotted in that singular light. (64–65)*

In the vast space of this southwestern corner of the New World, where no one can even measure the extent of the new diocese, where life is to be "a succession of mountain ranges, pathless deserts, yawning canyons and swollen rivers," where the priests would carry the Cross into territories yet unknown and unnamed, wearing down mules and horses and scouts and stage drivers—

*The sky was as full of motion and change as the desert beneath it was monotonous and still,—and there was so much sky, more than at sea, more than anywhere else in the world. The plain was there, under one's feet, but what one saw when one looked about was that brilliant blue world of stinging air and moving cloud. Even the mountains were made ant-hills under it. Elsewhere the sky is the roof of the world; but here the earth was the floor of the sky. The landscape one longed for when one was far away, the thing about one, the world one actually lived in, was the sky, the sky. (41, 234–35)*

The land at first seems to Father Latour a kind of geometrical nightmare—every conical hill spotted with smaller cones of juniper, a uniform yellowish green, as the hills were a uniform red, the hills thrust out of the ground so thickly that they seemed to be pushing each other aside, tipping each other over—and he closes his eyes against this intrusive omnipresence. But when he opens his eyes once again, a kind of miracle takes place: he sees one juniper, different in shape from the others, not thick-growing, but a naked, twisted trunk, perhaps ten feet high, which at the top "parted into two lateral, flat-lying branches, with a little crest of green in the centre, just above the cleavage. Living vegetation could not present more faithfully the form of the Cross" (15–16).[45] The tree, anonymous in its objectivity, when invested with the imagination of Latour's inner space, expands until tree and dreamer achieve a kind of oneness, a miracle, like the green thread of verdure and running stream—greener than anything Latour had ever seen in his own greenest corner of the Old World—in the midst of that ocean of sand.

The image of Bishop Latour kneeling before the cruciform tree remains in the mind like one of Holbein's woodcuts: words dissolve; the picture invites meditation. All around Latour, in the background of the novel, political and military events of mid-

nineteenth-century America hover: Mexican-American border disputes, attacks by dis-
possessed Indians on caravans moving west, which end only when the United States
government forces the Navajos out of their sacred places and onto reservations, the
discovery of gold in Colorado, the unmentioned American Civil War—these events are
not even the note by which the novel is tuned; they barely matter. The growing city of
Santa Fe, seat of the diocese, is scarcely a context.[46] The two great realities are the
journey—the endless trek on mule and horseback through "the alkali deserts [where]
the water holes were poisonous, and the vegetation offered nothing to a starving man.
Everything was dry, prickly, sharp; Spanish bayonet, juniper, greasewood, cactus; the
lizard, the rattlesnake"—and the sense of place. Place is not background, as in the
Holbein woodcuts, but the *subject* of meditation. If "the old countries were worn to the
shape of human life, made into an investiture, a sort of second body, for man . . .
[where] the wild herbs and the wild fruits and the forest fungi were edible . . . the
streams were sweet water, the trees afforded shade and shelter," the New World was a
hard place "calculated to try the endurance of giants." Missionaries thirsted in its
deserts, starved among its rocks, climbed up and down its terrible canyons, broke long
fasts with unclean and repugnant food, enduring "*Hunger, Thirst, Cold, Nakedness,* of a
kind beyond any conception St. Paul and his brethren could have had . . . in that safe
little Mediterranean world, amid the old manners, the old landmarks" (279–80).

These things are real: desert, rocks, shelter, legend.

The desert is a place to cross; it can be made to bloom: at the bottom of the world
between the towering sandstone walls of the Canyon de Chelly, crops flourish, sheep
graze under magnificent cottonwoods and drink at streams of sweet water; it is "like an
Indian Garden of Eden." A few miles above Santa Fe, at Tesuque, the bishop has a
garden: "He grew such fruit as was hardly to be found even in the old orchards of
California; cherries and apricots, apples and quinces, and the peerless pears of France—
even the most delicate varieties." He urges his priests to plant fruit trees wherever they
go and to encourage the Mexicans to add fruit to their starchy diet. Wherever there was
a French priest, he said, "there should be a garden of fruit trees and vegetables and
flowers," quoting to his students the passage from their countryman Pascal, "Man was
lost and saved in a garden" (301, 267–68).

Rocks are sanctuaries. The Pueblos, farming Indians, find sanctuary from the
nomadic Navajos and Apaches atop the rock of Acoma: "It was very different from a
mountain fastness; more lonely, more stark and grim, more appealing to the imagina-
tion. The rock," Father Latour reflects, "was the utmost expression of human need;
even mere feeling yearned for it; it was the highest comparison of loyalty in love and
friendship. Christ Himself had used that comparison for the disciple to whom He gave
the keys of His Church. And the Hebrews of the Old Testament, always being carried
captive into foreign lands,—their rock was an idea of God, the only thing their con-
querors could not take from them." North of the Canyon de Chelly is the Shiprock, "a
slender crag rising to a dizzy height, all alone out on a flat desert. Seen at a distance of
fifty miles or so, that crag presents the figure of a one-masted fishing-boat under full
sail, and the white man named it accordingly. But the Indian has another name; he

believes that rock was once a ship of the air." Ages ago, according to legend, "that crag had moved through the air, bearing upon its summit the parents of the Navajo race from the place in the far north where all peoples were made,—and wherever it sank to earth was to be their land. It sank in a desert country, where it was hard for men to live. But they had found the Canyon de Chelly, where there was shelter and unfailing water. That canyon and the Shiprock were like kind parents . . . [to the Navajos], places more sacred to them than churches, more sacred than any place is to the white man" (98, 298–99).

Shelters are frail in this place; inside and outside are one. Mexicans use the earth for their adobe structures, mixing earth with water, shaping and packing it with their hands. Navajos also build earth houses, with tree branches for roofs, like this one Father Latour finds conducive to reflection:

> The hogan was isolated like a ship's cabin on the ocean, with the murmuring of great winds about it. There was no opening except the door, always open, and the air without had the turbid yellow light of sand-storms. All day long the sand came in through the cracks in the walls and formed little ridges on the earth floor. It rattled like sleet upon the dead leaves of the tree-branch roof. This house was so frail a shelter that one seemed to be sitting in the heart of a world made of dusty earth and moving air. (232)

These shelters reflect the Indian manner of vanishing into the landscape rather than standing out against it, as does Father Baltazar, for example, whose hillside garden oasis has been planted with imported fruits and flowers and nurtured by Indian women forced to carry water from their own scarce supply up the steep cliff to satisfy the epicurean tastes of the foreign priest—who is finally flung over the cliff by the Indian men. Navajos, who lavish exhaustless patience upon their blankets, belts and ceremonial robes, have no wish to decorate or master nature in the European tradition, to arrange and re-create. Instead, they accommodate themselves to the place where they are, not so much from indolence, Father Latour understands, as from inherited caution and respect:

> When they left the rock or tree or sand dune that had sheltered them for the night, the Navajo was careful to obliterate every trace of their temporary occupation. He buried the embers of the fire and the remnants of food, unpiled any stones he had piled together, filled up the holes he had scooped in the sand. . . . Just as it was the white man's way to assert himself in any landscape, to change it, make it over a little (at least to leave some mark or memorial of his sojourn), it was the Indian's way to pass through a country without disturbing anything; to pass and leave no trace, like fish through the water, or birds through the air. . . . It was as if the great country were asleep, and they wished to carry on their lives without awakening it; or as if the spirits of earth and air and water were things not to antagonize and arouse. (235–37)

Legends are based on real stories: the legend of Kit Carson, Indian scout; the legend of Acoma Pueblo, the sanctuary built on a rock with its holy picture of St. Joseph that miraculously produces rain; the legend of Doña Olivares, who refused to tell her age; the legend of the mutinous Mexican priests, the gluttonous Padre Martínez and the

miserly Padre Lucero, who died with over twenty thousand dollars in coin buried beneath the floor of his house;[47] the passion of Christ. All are invitations to reverie.

Father Latour, a legend himself, makes no division between body and memory, between matter and spirit. He savors a glass of fine wine, the taste of a peach; he enjoys the fragrance and coolness of his garden with the same physical intensity that characterizes his difficult journeys across this vast diocese, journeys also spiritual in nature. The walled garden, as foreign to the New Mexico landscape as the priest who created it, is at the same time a place of sensuous delight, a cloister of contemplation and a spiritual symbol. Like the garden, the great cathedral Father Latour envisions is a place not so much seen as experienced totally. This Midi Romanesque structure that is to be built out of the earth itself, made of New Mexican sandstone, is for him a re-creation of the kind of structure that marked the landscape of his childhood.[48] Riding one day through a ridge covered with cone-shaped, rocky hills all of a curious shade of green, something between sea-green and olive, he has a vision that recalls his experience years earlier with the cruciform tree. He sees one hill, quite high and alone, which is not green like the surrounding hills, but yellow, a strong golden ochre, very much like the gold of the sunlight beating about it. He picks up a chip of the yellow rock, holds it in his palm with his very special way of handling objects sacred and beautiful, and looks up at the rugged wall, gleaming gold above him. "That hill," he says, "is my Cathedral" (242).

In building his Cathedral upon the Rock, in planting his garden with the purple verbena that mats the hills of New Mexico "like a great violet velvet mantle thrown down in the sun; of all the shades that the dyers and weavers of Italy and France strove for through centuries, the violet that is full of rose colour and is yet not lavender; the blue that becomes almost pink and then retreats again into sea-dark purple—the true Episcopal colour and countless variations of it" (268), Father Latour has achieved a kind of synthesis between the vastness of the landscape and the intimacy of inner space that is for him felicitous. Well might he say, "Space, vast space, is the friend of being," or "I am the space where I am." In the vast space of the southwestern desert, "every object invested with intimate space becomes the center of all space. For each object, distance is the present, the horizon exists as much as the center."[49]

Here in the vast desert spaces of the Southwest, journey and place meet to become legend. The journey for Willa Cather has been away from the "style markers" of the past; after her first experience in this felicitous space, and with each return, her task has been to simplify, to purify, to get back to the elemental form, the unfurnished space of "the novel démeublé."[50] The bare rock room at the center of the deep gorge in the southwestern cliff—like the abstract form of Georgia O'Keeffe's desert flowers—is reached by two paths: one tactile, physical, erotic; one spiritual, meditative, mystical.

# Walking on the Desert in the Sky

## NANCY NEWHALL, WORDS AND IMAGES

After her mother's death in 1964, Nancy Newhall wrote to the Massachusetts Society of Mayflower descendants, which had asked her to become a member.

> *She would, I know, like me to become a member in her stead, but though I have celebrated the Pilgrims and the Puritans in their own words in* Time in New England, *the book I did with photographer Paul Strand, and in* This Is the American Earth *with Ansel Adams, I seem to have inherited so strong a strain of idealism that I pour all of my energies into the present and I hope the future.*[1]

The two books Nancy Newhall mentions in this letter are her most eloquent publications. Both were uncommon books that set a high standard for future generations. *Time in New England,* published in 1950, was the first major book in which her innovative ideas as a designer, editor, and collaborator coalesced. *This Is the American Earth* (1960) gathered the work of thirty-two photographers in the first large-format photo book published by the Sierra Club. In both books Nancy Newhall struggled to create a new relationship between word and image. The text was not a description of the photographs, and the photographs were not mere illustrations of the text; rather, they were the best examples of the art of photography. Newhall called this relationship synergistic, and it was closely related to Alfred Stieglitz's idea of equivalence.

Born in New England, Newhall found her voice and strength in the Southwest. Like Mary Austin and Willa Cather a generation earlier, Nancy Newhall was an outsider whose experiences in the Southwest led her to appreciate and celebrate its indigenous peoples and to champion the unique landscape of the region. Here her own photography matured and she developed an environmental outlook that informs her best

47

work. In particular, she came to share Mary Austin's concern that the arid lands of the Southwest called for a new attitude toward nature, one different from her own inherited eastern values. Newhall was convinced that everyone could learn to live lightly on the land. More than either Austin or Cather she yearned to create a broad "public" image of America for its citizens: an image so complex and compelling that it would move everyone to participate in conservationism and concern for the environment, a movement that gained momentum through her efforts in the 1960s.

Although she was committed to creating an art form that would reach the widest possible audience, Newhall was not interested in presenting herself to the public as an individual artist. Unlike Austin and Cather, who fought to establish reputations in artistic circles, Nancy Newhall was drawn to collaborative and "backstage" creative endeavors. As a result, she is remembered primarily as the wife of the preeminent photohistorian Beaumont Newhall, as the biographer of Ansel Adams, and as the editor of *The Daybooks of Edward Weston I & II*. She used her talents as curator, critic, editor, and perceptive historian to design and structure projects; her role in these projects was really more akin to that of a movie director than that of an editor or curator. She orchestrated behind the scenes to create over eighty articles, books, and catalogs, fifteen major exhibitions, and one movie. Yet she shunned public notoriety and refused all invitations to lecture or teach. She held only one traditional job—as acting curator of photography at the Museum of Modern Art in New York, while Beaumont served overseas in World War II. And, even when she was clearly the creator, she did not make her contribution evident; for example, her name followed that of Ansel Adams on the dust jacket of *This Is the American Earth*. Nancy Newhall never willingly stepped forward into the public arena, often to the dismay of those near to her who were awed by her formidable creative abilities and her strong advocacy of the art of photography and the cause of conservation.

When Newhall's first book, *Time in New England,* was published, an editor at Little, Brown offered her a contract for a book of her own photographs and writing. She responded, "My husband was even more pleased with your letter than I was. He is the leader of a small but determined faction who insist that I should stop editing and exhibiting and biographing other people."[2] Ansel Adams, her most frequent collaborator, was perhaps the most prominent and relentless member of Nancy's fan club:[3]

> *When she writes it is beautiful, when she photographs, ditto. She should spend more time on herself than on us "biographical material." I mentioned this letter to her, but I think she has the feeling her niche is along evaluations, criticisms, etc. . . . That picture of me on the book [jacket] (fig. 3.2) is really superb photographically. . . . What could she do with the world at large?*[4]

It is ironic that Nancy is remembered today for her concentration on a small number of photographers whom she knew very well. She undeniably created powerful books based on the lives and work of Edward Weston and Ansel Adams, but her focus was not really directed on the individuals but on their creative processes. This woman who worked in a small and intimate circle of friends did a great deal to advance the cause of conservation and the young art of photography.

Although Nancy was artistically inclined from childhood, she was never encouraged to create, only to appreciate art. The only child of stern New England parents, her private school education was supplemented by tours to Europe. Precocious and anxious to enter art school at the age of sixteen, she wrote that her parents compelled her to enroll at Smith College. After her graduation from Smith in 1930, Nancy studied at the Art Students League in New York, exhibited her paintings in group shows, and had a one-person show in Boston, where she was invited by the Treasury Project to execute a mural in 1936. But she never painted the mural; instead, she married Beaumont Newhall, and spent their honeymoon in Europe gathering photographs for his exhibition, "Photography 1839–1937," at the Museum of Modern Art. On her resume Nancy pinpoints 1937 as the year she "gave up painting; took up photography; decided to put energies behind artists and causes I believed in."[5]

True to her enthusiasm for photography and ready for a crusade, Nancy and Beaumont collaborated on their first article, published in 1937. "Against Iconoclasm" is a passionate entreaty to preserve the artistic treasures of Europe, for, as the text noted, the world stood "on the verge of a terrible war." Beaumont had been a contributor to *The Magazine of Art* for a number of years and this joint contribution surprised and delighted the editor. Nancy submitted a complete layout. She had sequenced, sized, and captioned all of the photographs. (This was as unusual then as it is now.) She began with a photograph of a peaceful New England church and built a powerful effect by juxtaposing undisturbed monuments with those ravaged by previous wars. The visual tension culminates in an image of religious statues heaped in the streets, ablaze. Nancy's caption reads: "Saints in Agony, Spain, 1936, Destroys Its Heritage in Civil War."[6]

Nancy's intensity, her desire to use her talents for the good of humanity, and her gift for creating a potent statement are evident in this article. Also notable is her conception of the article as a whole. Throughout her life she approached each project as unique; the result had to be an integrated whole. As she matured, the concept of wholeness stretched to include the subject's place in history, in geologic time, on the planet, and in the galaxy. The idea of wholeness is a demanding one, and Nancy Newhall sweated, toiled, and wept over her projects. Always behind deadline, Nancy had just begun at the point where others would have been satisfied. She wrote, "good jobs are real growths, they are slow, like a seed or a child; they mature in the tempo of the earth. . . . I don't want to sound obstructionist—I just want to make the tremendous thing that is the idea and the material live and endure and extend its power. . . . I work in the grain of whatever is under my hand."[7]

"Horatio Greenough, Herald of Functionalism" was the Newhalls' next collaborative article. The 1920s and 1930s were a period of belief in America, and the New England heritage of both young Newhalls was rich with champions of America, such as Emerson and Whitman. In an attempt to give the "form follows function" mandate of the Bauhaus an American context, the Newhalls revived nineteenth-century sculptor and philosopher Horatio Greenough. Nancy certainly found in Greenough an echo of her own desire to create new forms that would grow out of the challenges of the American experiment. "In the America of the 1840s and 50s, the native tradition in building evolved through scarcity of labor, was already passing architecture and crafts

into new fields, finding new forms for necessities and powers."8 Nancy Newhall carried the concern for the development of an inspirational America through the majority of her work.

Anxious to continue and expand her work and to reach the broadest possible audience, Nancy wrote to Gilbert Seldes, the director of television programming for CBS in 1939. The network was planning a series entitled "Americans at Work." In a published article, "Television and the Arts," and in a number of unpublished scripts Nancy shows an astute understanding of the potential of the new medium, which she optimistically termed "televisionary." It suited her desire to talk to the full spectrum of the American public:

> *I should very much like to be of use. The growth of an American tradition and psychology in using and shaping forms, methods and inventions . . . is a field in which I have done considerable research. . . . This very morning I was discussing with my husband my desire not to make a scholarly history but a short dramatic movie or radio script.*9

The first chapter of an unrealized television script written at this time, *America Makes the Americans,* is titled "The Savage Continent." The wilderness is seen as a challenge, a provocateur for human invention. Such a perspective on the frontier emphasizes the heroic efforts of the pioneer and the settler. It continues the thread of "functionalism" and reflects identification with the American Renaissance of the 1920s. Virgin territory provided a site for a city, farm, or factory. Nancy's emphasis is indicative of the fact that up to this time she knew only the tame and cultivated countrysides of New England and Europe.

Within a year Nancy glimpsed an utterly new environment that changed her perspective on landscape and human tenancy of the land, and she began her real apprenticeship in the art of photography. Nancy's fascination with television as a means for presenting Americans with a inspirational image of themselves was set aside. For over a decade, until she created *This Is The American Earth,* her single-minded focus was on her collaborations with individual creative photographers, most of whom worked in the West. Her period of initiation into photography as art and into the landscapes of the West and Southwest was both arduous and rewarding.

In 1940, the Newhalls boarded a train bound for California. It was their first trip West, and it was prompted by the devastation and upheaval in Europe: "France had just fallen, the last of the continent; England was under heavy bombing; there was no Europe to go to anymore. . . . Refugees . . . to listen was to scream inside. . . . In the West we would at least be exploring different country."10 Ansel Adams and his wife, Virginia, took charge of the Newhalls' visit, introducing them to a wide circle of San Francisco artists, the California coastline, and the dramatic splendors of Yosemite Valley.

Up to this point Nancy had seen and handled thousands of photographs. Both she and Beaumont usually carried small hand-held cameras; however, Nancy had not been in the company of creative photographers who worked with large-format cameras. These California photographers lugged their monstrous black boxes up mountainsides

to spend hours looking into the large ground glass, with their heads beneath a white cloth lined with black velvet:

*Before coming West I had never beheld the engulfing ground glass of an 8×10″ camera. Now here were images from the world by Ansel and Edward [Weston], moving, sparkling. . . . I had only a Rolliflex—I began to see what Ansel meant when he called it "navel photography" and I resigned [myself] to photographing through the back of the station wagon.*[11]

At first Nancy was intimidated by the intensity of both Adams and Weston, and her timidity was surely compounded by the overwhelming proportions of the landscape. Her vista had been expanded; it was virtually miles wide. Her sense of being adrift and disoriented is conveyed in a photograph made at Point Lobos, on the coast near Carmel (fig. 3.3). The image has a completely ambiguous scale. Although the pool of water is probably tiny, the craggy rocks feel both monumental and ominous. Like many of her best images, the Point Lobos photograph engages the kinaesthetic sensibility; the center reflection of the blazing sun evokes a strong physical sensation. Nancy printed this photograph repeatedly during her lifetime.

A seasoned European traveler, Nancy was genuinely surprised to be so deeply affected by the western landscape. The dramatic mountains and vast expanses were suitable arenas for the exuberant company of Ansel and his circle. Edward Weston's sparsely furnished cabin on Wildcat Hill was an environment where making art was clearly the priority. All of it was fundamentally different from the decorum of Nancy's upbringing and she was startled at how directly the land spoke to her innermost person:

*Seldom, even in Europe, had Beaumont and I suffered the exaltation of so much beauty. Nor, though we had experienced . . . architecture, painting and all the other arts had we ever truly entered the vision haunted life of the truly creative photographer. When, finally, we climbed on the train back to New York, the world had changed for us.*[12]

Nancy the creative artist was undoubtedly responding to the camaraderie of thoroughly dedicated artists. Ansel, the main protagonist and native son of this unsettled terrain, exuded an intensity that matched Nancy's own and on which she thrived: "If you work with Ansel Adams, you get up before dawn. . . . if the unrisen day calls forth herculean amounts of work, you may get two breakfasts before noon, or far from towns, and too busy to bother. . . . exist on laughter until sundown."[13]

On their California sojourn, the Newhalls told Ansel of their hope to establish the first museum department of photography at the Museum of Modern Art. In the fall of 1940, Ansel was brought to New York with the financial support of museum trustee David McAlpin to assist the Newhalls in founding the department. Beaumont and Ansel had known Alfred Stieglitz for a number of years. Nancy says of her introduction to the great photographer: "I had tiptoed in and out of the place [gallery] for years. . . . Between them, they dragged me, much like a reluctant puppy. . . . I was to go back almost every day for two years. . . . It was one of the most illuminating experiences of my life. I learned about art and its creators as I doubt any university can ever teach."[14]

She recorded all of her conversations with Stieglitz. In her unpublished "Notes for a Biography on Stieglitz", she describes her first contact with his concept of equivalence. In 1922 Stieglitz made his first "Equivalents," a series of photographs of clouds called *Music: A Sequence of Ten Cloud Photographs*. Stieglitz had been accused of producing magnificent portraits either because he photographed extraordinary personalities or because he hypnotized his sitters with his own powerful personality. *Music* was intended to "show that my photographs were not due to subject matter."[15] The title of the series stressed musical sound to suggest that nonverbal communication was desired. The linkage between music and photography served as a model for Nancy. Working with Paul Strand on *Time in New England*, she wrote to him, "The book begins to sing in my head: I can see it."[16]

Equivalence is a concept that inspired many photographers, most notably Ansel Adams and Minor White. Nancy was the first to take hold of it as an ideal for combining words and images. From her first collaborative articles with Beaumont, Nancy sought to respond to each project without a formula or recipe and to let the photographs speak on an emotional level. Clearly Stieglitz's idea of equivalence confirmed her own tendencies.

Equivalence as a concept has defied definition by numerous articulate writers. Even Nancy, who was both precise and poetic, could only recount her experience of viewing Stieglitz's "Equivalents":

> *Frankly, I thought it was mostly humbug, and Stieglitz at his romantic worst.*
>
> *Then one afternoon, he turned me loose, alone, among the several boxes of Equivalents. . . . A couple of hours later I came out in tears . . . the sun itself could not compare to this blinding brilliance within. . . . There must be some way to lead those who don't understand into those things. Dramatic anecdotes don't do it—at least not for me.*
>
> *He said, "You will have to make your own Equivalents."*
>
> Make your own Equivalent. *That still rings in me. It has been the guiding principle of almost all the books and shows I have done.*
>
> *It is an extraordinary experience to observe how a different text or sequence or general context can change what people see and feel in the same photograph.*
>
> *Behind us all stands Stieglitz: without Equivalents and the sequence concept, both of which are beyond journalism, we might never have done what we have done—perhaps we would have had to invent it ourselves.*[17]

As World War II escalated, Nancy Newhall could no longer visit Stieglitz daily in his tiny gallery; she was needed at the Museum of Modern Art. Beaumont was called to active duty and served as a photo intelligence officer with the U.S. Army Air Force in Egypt, North Africa, and Italy. Nancy worked as acting curator of the fledgling department of photography.

It was a time of great stress for her—the separation from Beaumont was wrenching and she was under pressure from the museum administration to make the photography department financially independent. The plan was to open a center for photography that would attract the support of the photo industry and the membership of thousands

of amateur photographers in camera clubs. Nancy threw herself into the work; she began curating exhibitions. Although the center only existed for a short time, Nancy organized shows of the work of Helen Levitt, Eliot Porter, W. Eugene Smith, Lisette Model, and two group shows: "Mexico" and "Action Photography." She responded wholeheartedly to working with contemporary photographers. The center was meant to be lively, and Nancy's sensibilities as an artist led her to the most current work. Beaumont, the historian, was not at her side. Despite the difficulties, Nancy worked with independence and creativity.

Ansel, an irrepressible correspondent, fed her romantic, independent spirit with invitations to the open expanses of the West:

> *Your world seems more related to the Saraband and some fresh air, and some space under the sky, than to the esthetic chess games . . . or the Witches Cauldron of the Museum Menage.*
>
> *Come out west soon—come take a real simple trip in the Sierra; I can show you a place near at hand that would make you feel like the shipmates of Ulysses.*[18]

By the summer of 1944, Nancy, exhausted and unhappy, left New York for Los Angeles. Ansel and Virginia Adams picked her up at the train station and they drove up the Owens Valley to Yosemite:

> *How to describe the first trip up the Owens Valley? Even today, more than twenty years later, moments from the journey suddenly come back down the alien corridors of existence. Virginia must have divined that this might result in more than just a jaunt for a weary museum worker, for when, after the first stop, I started to climb in the back seat, according to customary rotation, she halted me. "No—you stay in front." Her face became radiant. "It's your duty to see."*[19]

Virginia Adams was determined that Nancy witness the devastation of the once fertile and verdant agricultural valley. Water from the Owens Valley had been drained to fill reservoirs for the expansion of Los Angeles. Virginia Adams was raised in Yosemite. She was the daughter of Harry Best, the owner of Best's Studio, a concession in the park. Both Ansel and Virginia were ardent conservationists and Yosemite was home to their family. Although Ansel took a more active public role in the cause of conservation, Virginia was no less fervent.

Nancy was introduced to the writing of Mary Austin on this excursion. Austin was an early champion of Ansel Adams. She encouraged the young, still unknown photographer by writing the text for *Taos Pueblo* (1930), his first art book. An activist and the author of many books, Mary Austin had led the unsuccessful fight against the parching of the Owens Valley.

Nancy's photograph of a dead tree is an image not of the romantic splendor of the West but of devastation in the name of progress (fig. 3.4). Her own fatigue and loneliness is also amply conveyed in this image. On this trip her education as an advocate of the environment began in earnest. The landscape of the Southwest now had an added dimension. On her first trip Nancy had been exalted by untrammeled beauty; on this second visit she saw that it needed protection. Her familiarity with the

strong, sensitive voice of Mary Austin enabled her eventually to write an empathetic article on Austin.

In the company of the Adamses, both native Californians with few ties to the cultural traditions of Europe, Nancy rethought previously held perceptions and experiences not only of the landscape but of photography and art:

> *Hitherto, I had inclined to the notion that natural beauty was too easy: mere copying, that the penetration of the commonplace and its transformation into the new and significant form were the true test of the true artist. Edward [Weston]'s work clearly related to Picasso and Brancusi. Ansel's did not. "Nature" and "beauty" were scorned as reactionary. What was the source of Adams's power? Now, I discovered that the metamorphosis of the ordinary was only the first step; without those basic abilities one could not tackle the infinitely more difficult problem of translating a beautiful object of experience into a beautiful image, and further conveying the mood and magic of the original. . . . I could see at last through the banalities of a century of postcards.*[20]

Nancy was not only working out her attitude toward Adams's vast panoramas, she was struggling with the dissolution of hope brought on by the war. Ansel Adams had been accused of being frivolous and unpatriotic in his persistent concentration on nature's grandeur in his photographs. But Nancy could not deny how deeply she was touched by the sound of a mountain stream, the glow of a sunset, the dew on a wildflower. She was groping toward the idea expressed to Ansel upon publication of *This Is the American Earth:*

> *It is terrifying to be living in what may be the last days of the world. . . . Instant and complete destruction is enough to mourn for the end of man and beauty, and all love and promise. . . . I think our job is to prepare a way for a new faith and a new world. I don't think we do it by fighting bits and pieces of the old negativity . . . I think we do it by powerful words and images. Man still has the capacity for faith and action; it is up to us to rouse it, to concert it.*[21]

Upon returning to New York, Nancy Newhall was surprised by her new sense of bravado and confidence, an unexpected legacy from her sojourn in the West and Southwest. She noticed this fundamental change while visiting a frail and ailing Stieglitz:

> *During a terrific thunderstorm, I opened the window and stuck my head out in the rain, the thunder, the darkness and the lightning. For the first time in my life I looked down a skyscraper without cringing. "Why," I thought, "with all those hand holds and toe holds it would be much easier to rapel down those seventeen stories than any practice precipice in Yosemite."*[22]

Nancy needed all the mettle she could muster in her struggle to realize the Paul Strand and Edward Weston retrospective exhibitions and catalogs at the Museum of Modern Art. Her position had always been considered temporary; her salary was set at half pay. Nancy wrote Ansel about the Edward Weston show, "I'd like people to come

out of [the] show with a feeling as of hearing a great horn-note among the mountain tops." Her letter also emphasizes her desire to respond anew to each project:

> *I don't think there can be a formula about artists and their work. The important thing is to show their great and individual and inimitable achievements. How that is done is dictated by the artist's own work. Perhaps that's one reason I love what I'm doing—with each [artist] there is a grain, an unexpected potential, a feeling of material to work with.*[23]

Upon Beaumont's return in 1945, there was suddenly no place for the Newhalls at the Museum of Modern Art. The winds of favor had shifted to Edward Steichen, who promised a hundred thousand dollars from ten photographic manufacturers for his appointment as director of the department of photography. Beaumont resigned in frustration in 1946. Despite the success of Nancy's shows and monographs, she never again worked in an institution or trusted a bureaucracy. Her catalogs of the Weston and Strand exhibitions were, however, benchmark publications, her most important accomplishments from these years. The Newhalls turned their hopes westward. Ansel Adams proposed that together they found an institute in California to publish a journal and books, teach workshops, and organize exhibitions.

Nancy's difficult solo apprenticeship at the Museum of Modern Art not only forced her into an uncomfortable public role but also led her to develop highly individual ideas of what made a photograph art. In her "Four Photographs," published in the *Magazine of Art,* she named three qualities:

> *1. It must be photographic; it must achieve results impossible in other mediums. If a photograph suggests a painting or etching, its maker is unequal to seeing with the swift exactitude and power of the photographer.*
>
> *2. It should bear the imprint of the photographer's* individuality *so unmistakably that to anyone who knows his work his signature is superfluous.*
>
> *3. It must have* inner life *which is not exhausted by years of looking. This the acid test of a photograph; thousands are made everyday which cannot survive a second glance.*[24]

Both Nancy and Beaumont were determined to live as freelancers and she began collaborating with Strand on *Time in New England.* As with all her projects, the portrait of New England had deep roots in Nancy's sensual nature, the nonverbal, nonrational, nonlogical ground on which she stood. "The first photographs by Paul Strand I ever saw were images of forest, raindrops and rock made on the Maine coast in 1927 and 1928. They struck me with the force of revelation. Here was what I had felt as a child close to the same earth and never expressed in any medium."

Originally thought of as a three-month project, *Time in New England* absorbed Nancy for five years. In the foreword she cites two compelling challenges that kept her "embedded" in it. First, she wanted to "examine firsthand the enigma of New England, unobscured." This enthusiasm for first-hand, direct experience in virgin territory, whether in the arena of photography, the new medium of television, or the wilderness of the Southwest, motivated all of Nancy's work.

*Further, here was the challenge of a new form: could the words of the eyewitness—not captions or pseudo-verse, but actual letters, poems, journals . . . be joined to these images so each would expand and clarify the other?*

*The sound of that lost time was essential . . . the great music of seventeenth century prose . . . the brisk, bright marching tunes of the Revolution.*[25]

Nancy's correspondence with Ansel from the period reveals that both were working with Stieglitz's idea of equivalence. "Ansel at one end of the continent, high up in the Sierras, and Paul Strand and I at the other, in sweltering New York. . . . using the subtle connotations between words and photographs, [discovering that] you can create a third effect—synergistic if you like—which is emotional and visual all at once and more powerful than either."[26]

In May, 1947, the Newhalls accompanied Ansel Adams on a photo excursion to truly remote and untouched patches of the Southwest—Death Valley, Bryce, and Zion National Parks (Fig. 3.5). It was on this trip that Nancy and Ansel became a trusting and productive team that eventually turned out a plethora of joint projects. Nancy was no longer a timid observer of either the landscape or other photographers. Jokingly, she now called herself the "Anselographer." Actually, Nancy's powerful public presentations of Ansel Adams the artist were in large part responsible for bringing him to be America's most prominent photographer.

Alongside Ansel, both Nancy and Beaumont photographed magnificent spectacles in the West. Nancy was clearly in her element and oblivious to the discomforts of camping with the relentless Ansel. Beaumont, however, was ready for the amenities of a hotel. Beaumont wrote in his journal: "I was tired, and spontaneously burst forth, to the amazement and amusement of all . . . 'What, nature again? I've never seen so much Nature: we sleep on it, we look at it in the morning and in the afternoon and by moonlight and by sunrise and sunset!' "[27]

Inspired by complete immersion in photography, Nancy accompanied Beaumont to Black Mountain College, North Carolina. While Beaumont taught, Nancy concentrated on making photographs. With insight and apparent ease she made exquisite and penetrating portraits of Annie Albers, Buckminster Fuller, and others. But it was the landscape that challenged her. "A difficult branch of the art," she wrote. "In only one of the two kodachromes and maybe two black and whites have I succeeded in making them convey something of what they make you feel. Of course, the Blue Ridge isn't the Sierra or the Tetons, but they do sweep and swoop until you feel like a small bubble on a very large wave."[28] "Black Mountain Landscape," an image of hills reflected in the lake, is one of Nancy's finest photographs (Fig. 3.6). As with most of her favorite images, she reprinted it in many variations through the years. Above all it is an image that conveys feeling, both haptic and emotional. It is appropriate that Nancy first satisfied her criteria for a successful landscape in North Carolina, where she was more on her own and where the mountains were not so staggering as the Sierra Nevada. In the Black Mountain image Nancy intends to embrace the viewer in an experience of scale, an approach very unlike the heroic monumentalism of Ansel Adams' photographs, which often render the individual insignificant.

3.1 Beaumont Newhall, *Portrait of Nancy Newhall*, gelatin silver print, n.d. Collection of Beaumont Newhall.

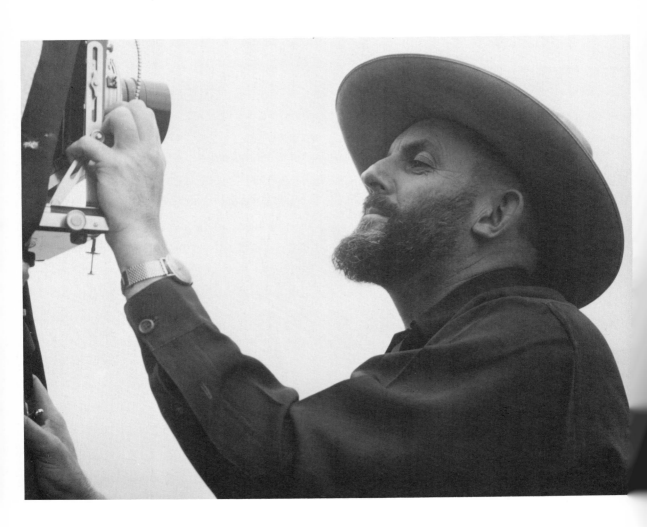

3.2 Nancy Newhall, *Portrait of Ansel Adams,* gelatin silver print, 1950. Collection of Beaumont Newhall.

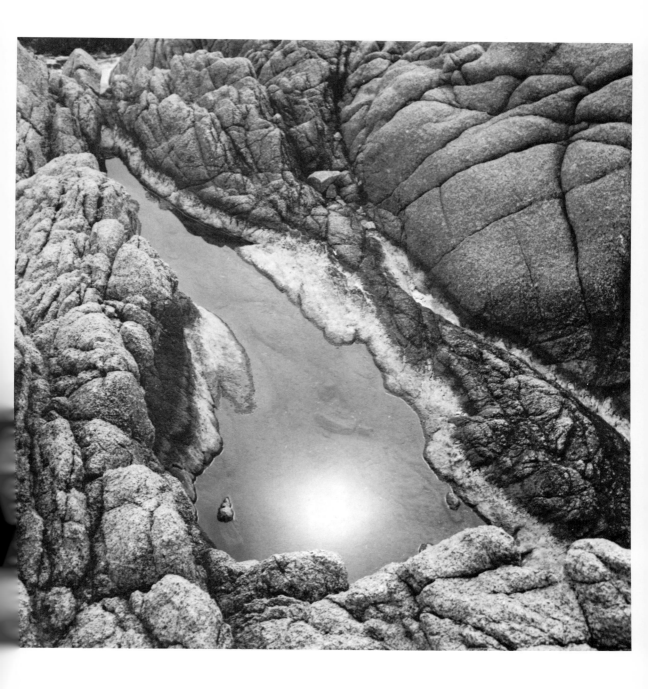

3.3 Nancy Newhall, *Untitled*, gelatin silver print, 1940. Collection of Beaumont Newhall.

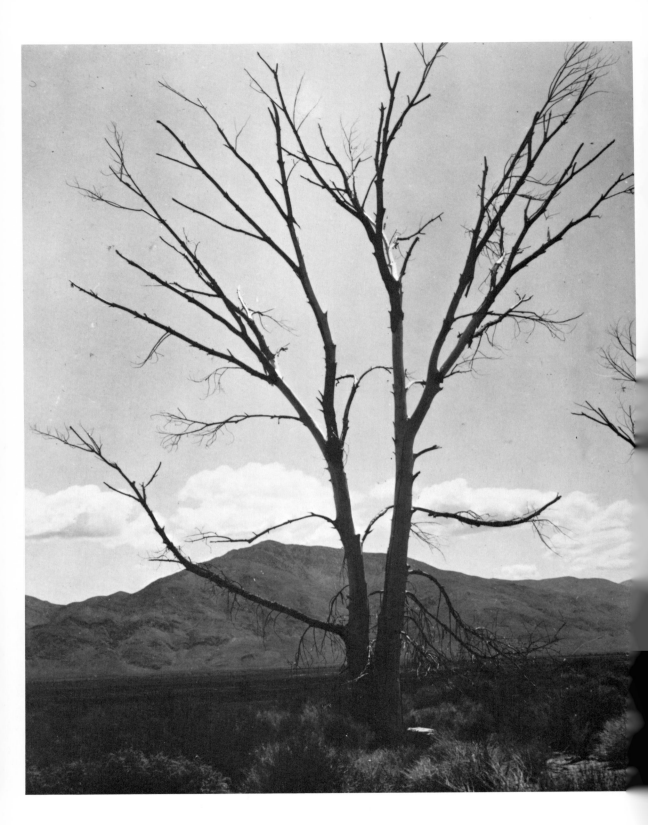

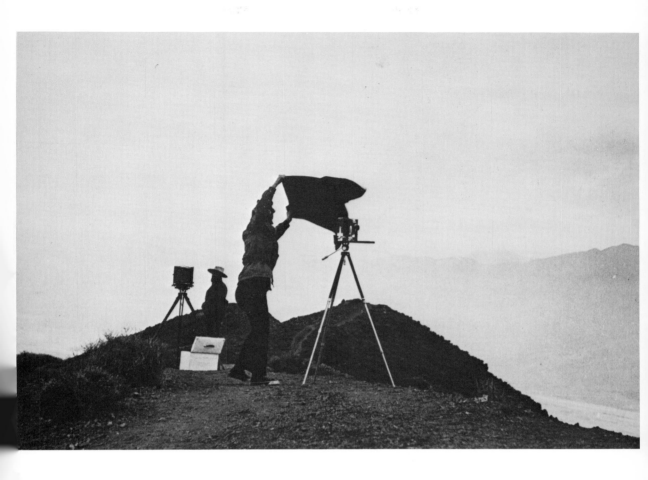

3.4 Nancy Newhall, *Dead Tree, Owens Valley*, gelatin silver print, 1944. Collection of Beaumont Newhall.

3.5 Beaumont Newhall, *Nancy Newhall and Ansel Adams, Dante's View, Death Valley*, gelatin silver print, 1947. Collection of Beaumont Newhall.

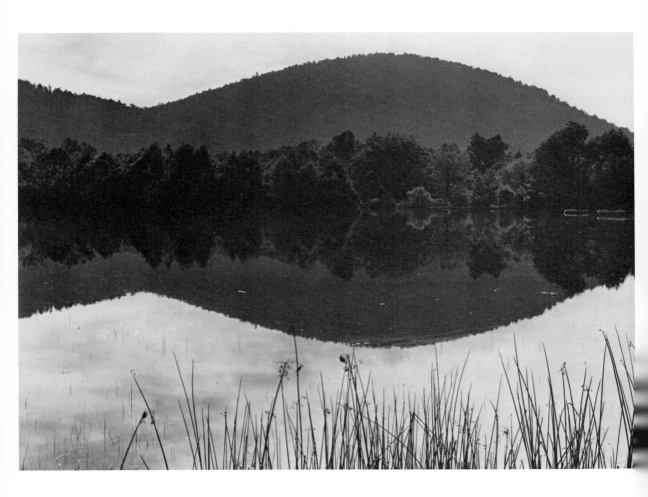

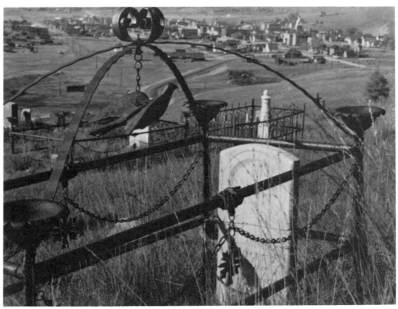

3.6 Nancy Newhall, *Black Mountain Landscape,* North Carolina, gelatin silver print, 1947. Collection of Beaumont Newhall.

3.7 Nancy Newhall, *Grave, Silverton, Colorado,* gelatin silver print, 1951. Collection of Beaumont Newhall.

The Newhalls set aside their dream of moving to the West and went to Rochester, New York, where Beaumont had a position as curator at the George Eastman House. When Nancy was not assisting Beaumont in setting up the collection and mounting exhibitions, she was increasingly absorbed in projects directing her toward the West and Southwest. Like Mary Austin, she drew deeply from the region as a source of her creativity. Nancy could easily have been describing herself in this passage about Austin's tenure in an eastern city after having found her true home: "never from the bastions of metropolis, never from the idioms of talk that swirled above the pavements, did there come the power and understanding she felt when the naked earth was under her feet and space encompassed her."[29]

On a solo journey back to the West in 1950, Nancy found that she had missed something else. Three hours late and trying to gain time, the transcontinental train deposited Nancy on the platform in Sacramento without her baggage. Too late for the connecting train to Merced to meet the Adamses, Nancy boarded a local bus. The result was "one of the most important journeys of my life."

> *I had never seen anything like that bus, Mexicans, Chinese, Japanese, Indians, Negroes. . . . The temperature inside the bus rose, to what in spite of open windows must have been 120°. . . . The distressing stops . . . patient people waiting, waiting, waiting — to me it was a revelation, at once sordid and marvelous. Something happened to me during this journey, something distinctly echoing . . . Dorothea Lange in the wartime shipyards. . . . Where I had been involved I was now committed.*[30]

Up to this time Nancy had always wanted to speak to the whole of America, but she had remained sheltered in an intimate society of artists and intellectuals, small and populated with the educated, the comfortable, the witty, and the powerful.

In 1951 the Newhalls joined Ansel for a second intensive photographic expedition. Together they looked through their viewfinders at Santa Fe, Taos, Chimayo, and many pueblos and mountain villages of northern New Mexico. The journey culminated at a photo symposium in Aspen, Colorado. Nancy made many of her best images of the Southwest on this trip. Her camera vision was confident and mature. One of the strongest photographs is taken from a graveyard atop a foothill, using the string of houses in the background as the horizon line (Fig. 3.7). It is in many ways a modest image that refers quietly to the cycle of life in a small frontier town. She has framed a certain sweetness in the wrought-iron grave marker, a reminder that human tenderness is not dwarfed by the vast expanses of the Southwest.

A contract for a series of articles written by Nancy with photographs by Ansel finally brought Nancy to the Southwest for extended visits. Beginning in March, 1952, they traveled on assignment for *Arizona Highways* to Death Valley, Mission San Xavier del Bac south of Tucson, and Organ Pipe National Monument on the Arizona-Mexico border. In many ways *Arizona Highways,* a magazine promoting tourism, an attitude despised by both Nancy and Ansel, was an unlikely vehicle for the two artists. A chatty editorial introducing the series claimed that Ansel Adams would "interpret and wrap up" the country and Nancy Newhall would write "interpretive" texts. Of course, Nancy had nothing of the kind in mind; her intent was visual communication to the world.

Had the *Arizona Highways* editor read her article "The Caption: The Mutual Relation of Words and Photographs," he would have realized that the articles submitted by Nancy Newhall would be unlike any he had ever published. Nancy wanted to hasten the time when "the old literacy of words is dying and a new literacy of images is being born." The new "photograph-writing" was intended to speak as directly to people as did music. In addition to the three types of traditional captions (*enigmatic,* as found "in full classic purity in *Time*"; *miniature essay,* as found in *Life*'s "picture of the Week"; and *narrative,* the common or familiar form, a "bridge between text and photograph"), Nancy introduced a fourth kind of caption, which she called *additive*:

> *[It is] the newest form to answer a new need . . . and adds a new dimension. A fine early example occurs in* La Revolution Surrealiste; *the photograph shows three men bending to look down an open manhole and the caption reads: "The Other Room." . . .*
>      *In* Land of the Free *[by Archibald MacLeish], the poem . . . becomes a "sound track." It employs the additive principle so that the reader seems to hear the thoughts of the people in the portraits.*[31]

The MacLeish example comes closest to Nancy's own intentions for "photograph-writing." Ansel's startling photographs fed the eye and her words provided rhythm.

*Arizona Highways* eventually published six articles by the Newhall-Adams team. From these emerged Nancy's strong voice as a writer and her vision as an editor and designer. Her emphasis on the primacy of the image led her to open each article with a dramatic full-page photograph, without a caption and before the text. Nancy's "additive" prose sang passionately alongside Adams's austere, uninhabited images. She wrote of the past, the people, the light, and the sound.

Two places in particular magnetized Nancy in her travels for the magazine: Death Valley and San Xavier del Bac. She wrote so much on each that her essays and Ansel's photographs were eventually published as large-format paperback books. These two environments epitomize the characteristics that drew her most strongly to the Southwest: the wilderness and the indigenous peoples. Wilderness to Nancy meant experiences that made her shed her accepted concepts of reality.

> *Facts unfamiliar to the East and Europe must be taken into account, and the basic fact is* wilderness. *In the West there are immense distances where any track of man is either invisible or ridiculous. The oldest civilizations on the continent are there, in the Indian pueblos and the Spanish foundations; so are some of the most advanced manifestations of the newest civilization. . . . The proper study of man in the West is the powers of the functions of the earth, and how he may live with them during his brief tenancy. . . . In man as in nature, the same forces are at work.*[32]

In researching Death Valley, Nancy kept widening her scholarship. She buried herself for months in treatises on geology, wagon trains, and mining. The opening of the article clearly demonstrates how thoroughly she was jolted to a new perspective, an expanded sense of time and space: "Unearthly and immense, Death Valley so seizes the imagination that during the century the white men have known it, it is a history of illusion."[33] As in *Time in New England,* Nancy selected quotes revealing the vanity and

insanity and heroism and desperation of fortune-seekers and frontier families. However, along with words of eyewitnesses from a lost time in whose "cadences was the sound . . . and in [whose] thought [was] the germ of a nation," Nancy has added her own words for the wonders she discovered.[34]

Finally, at the article's conclusion, Nancy claims that "if you stay to explore, you will begin to understand why the Indians are still here." She asserts that they remain in touch with the vast, unaltered wilderness and its strange beauty. "Phenomona that anywhere else would be objects of pilgrimage are lost in the immensities. . . . Up at the Race Track after a rain, huge boulders weighing up to a quarter ton move in the wind leaving tracks like snails on the clay."[35] Death Valley, removed and isolated, was a place where every nuance, however fleeting and transitory, could resound in the willing and open participant.

Mission San Xavier del Bac offered another kind of release from New England respectability: "High mass at San Xavier has nothing to do with the pale and well-gloved decorum of churchgoing in the North and East. Here the mission is crowded with a barbarian dusk and shot with startling splendor."[36] While Ansel waited to photograph the interior of the beautiful baroque church at dawn or midnight, when he would not be interrupted by the faithful, Nancy reveled in the Papago, Pima, and Sabaipuri congregation. She thrived in the "confusion of emotions" and saw "magic and mystery" in the relaxed atmosphere of women, children, and dogs attending mass amidst ease and laughter.

It was at Organ Pipe Cactus National Monument, however, that Nancy experienced a profound personal transformation. Like Death Valley, Organ Pipe seems desolate and stark, tough and unforgiving—a home for cacti, lizards, a litter of bleached bones. In this article Nancy does not speak through others; she does not quote geological or historical sources. Her prose is incantatory, the reader is included in a universal and intimate use of the word *you*. All is sensation; the land is a body:

*You are shut in by distances of light. You walk in the focus of the sun's rays. You are clothed in sun; sun glows in your blood, until even your bones feel incandescent.*

*You feel in your body why the desert wears grey, and why it blooms with such vital brilliance.*

*Night clings, paling to your body, until once more day is limitless, and you are walking on the desert in the sky."*[37]

Henceforth Nancy spoke with a new tone, mystical and religious and distinctly out of place in a cynical, fashionable world. She became a woman of undeniable faith, a convert with a new humility. Her writings about the Southwest are the epiphany of an enthusiast, a communion declaring the unity of creation. Like Mary Austin, whom Nancy quoted for her article on Austin:

> *Man is not himself only . . .*
> *He is all that he sees*
> *all that flows to him*
> *from a thousand sources*

*Arizona Highways* did not publish the Newhall-Adams piece on Mary Austin until 1968. Comparisons of the articles from the 1950s and the Austin article are very instructive. Nancy was not involved in the selection, sizing, sequencing, and layout of the piece, and the result is pedestrian. Ansel's pictures look like all the others, pretty, banal, and common. But the text remains exhilarating and comes the closest of any of Nancy's writings to autobiography. She knew the difficulties of a Mary Austin.

> *WHO WAS MARY AUSTIN?*
> *A strange woman, who had the courage to walk alone. A writer, a searcher, a fighter. . . .*
>
> *Her country was the West. Even today, long after she is dead, her impress lies across the whole Southwest. Whosoever travels there will find her moving before him—will see a hill move suddenly into the shape of the words she gave it.*[38]

*This Is the American Earth,* Nancy's most triumphant creation, like Austin's words, forever alters for the reader the image of America's various landscapes. Originally begun as a two-week volunteer project coordinating a modest conservation exhibit at the small Le Conte Lodge in Yosemite, it was eventually built into a huge exhibit, circulated throughout the United States by the Smithsonian and throughout the world by the United States Information Service. Nancy selected the images of thirty-two photographers, relying most heavily on the vast inventory of Ansel Adams. She wrote the "soundtrack," which Ansel called "a sublime poem, paeonic and evocative."

*This Is the American Earth* set a standard that has rarely been attained since in any book of "photograph-writing." In accord with Nancy's convictions, the images are given first importance, and the overall structure refers to music. The oversized book opens with four monumental panoramas on two-page spreads. This is called the Overture. Underneath, Nancy beings her invocation:

> *This, as citizens, we all inherit. This is ours*
> *to love and live upon,*
> *and use wisely down all generations.*[39]

The Overture asks such questions as "What is the price of exaltation?" next to an image of a raging waterfall.

One way to assess Nancy's accomplishment is to ask if the book meets her own criteria for photographic art. Is the book "photographic"—does it achieve results impossible in other mediums? Beginning with the Overture, she has exploited one of the most important qualities of the camera—its ability to telescope scale. The question "What is the value of solitude . . . ?" is woven in an image of a glassy mountain lake and a close-up of raindrops on feathery ferns. The small is placed next to the vast, the Spiral Nebula next to a rock pool, destroying what Ansel Adams called a false emphasis on anthropocentric concepts of size.

Does this book bear the imprint of Nancy Newhall's individuality? Into it she poured her hardwon experience, her keen perception, her convictions about wilderness, photography, wholeness, America, humanity, and God. *This Is the American Earth* is

unmistakably hers in its scholarship, rhythmic prose, and hope for the future. No one else could have gathered such a broad scope of photographs and ideas—"selecting, compressing, arranging, restating, at last achieving a stirring counterpoint of images, on film and in word, that can reveal in the whole what only the parts could suggest."[40] The six Movements—Brief Tenant, New World, The Machine and a New Ethics, The Mathematics of Survival, Dynamics, and The Crucial Resource—are the fruits of this New Englander grown humble in the Southwest. She quotes poets, historians, philosophers, scientists, the Bible, Thoreau, John Muir, and many others concerned with the individual's relationship with the natural world. Unlike Ansel, who sent his environmentalist pleas via political routes, Nancy directed her message to the heart.

Inner life is the third criterion Nancy Newhall demanded of a photographic work of art. Before *This Is the American Earth* went out of print over ninety-nine thousand copies were sold, and the exhibit was enjoyed by a worldwide audience of thousands. It is not, however, in these numbers that we recognize inner life. When you sit with the book in your hands, let go of your personal identity, that part of you bound up to time and culture, and become a part of the many others hopeful of the future "when you shall need the tongues of angels to tell what you have seen," then you experience most vibrantly the continuing strength and importance of Nancy Newhall's accomplishment.[41]

# Laura Gilpin and the Tradition of American Landscape Photography

"What I consider really fine landscapes are very few and far between," Laura Gilpin wrote to a friend in 1956. "I consider this field one of the greatest challenges and it is the principal reason I live in the west. I . . . am willing to drive many miles, expose a lot of film, wait untold hours, camp out to be somewhere at sunrise, make many return trips to get what I am after."[1]

Gilpin spoke with authority about the challenge of landscape photography. Her first published picture, a view of the Grand Canyon, appeared in a photography magazine in 1916, and since then she had hiked, driven, and flown tens of thousands of miles across the Southwest. Just weeks before her death in 1979 at the age of 88, she leaned out the window of a small plane flying low over the Rio Grande valley to make her last photographs.[2]

No other woman in the history of American photography so devoted herself to chronicling the landscape. Others photographed the land, but none can be regarded as a landscape photographer with a sustained body of work documenting the physical terrain. Anne Brigman (1869–1950) often photographed in the woodlands and along the coast near her California home, but the land was generally a setting for her artfully placed nudes, and her pictures were less landscapes than elaborately staged allegories. Dorothea Lange (1895–1965), along with Gilpin the only woman included in a recent Museum of Modern Art survey of American landscape photography, photographed west Texas and California for her project "Dorothea Lange Looks at the American Country Woman" (1967).[3] But her landscapes were always conceived of as counterparts to her portraits of rural women. Other women in the West and Southwest photographed landscapes even more incidentally. When the eastern pictorial photogra-

phers Louise Deshong Woodbridge (1848–1925) and Clara Sipprell (1880–1975) passed through the Southwest on vacation trips early in this century, they made skillful views. But these pictures were not part of a sustained commitment to landscape work. Barbara Morgan (b. 1900) began to photograph the southwestern landscape on a trip through Arizona and New Mexico around 1930, but shortly thereafter her sons were born and she abandoned landscape photography for work that would allow her to stay closer to home.[4] Only in the last decade or two have younger women in the region begun to pursue landscape photography seriously.

Gilpin thus claims her own niche in the photographic world. For even as her interest in landscape work distinguishes her from other women photographers, her approach to landscape photography sets her apart from the men who documented the same subject. Gilpin was interested in the land as an environment that shaped human activity, an approach that distinguished her from such nineteenth-century photographer-explorers as William Henry Jackson or Timothy O'Sullivan, and from her contemporary, Ansel Adams, who photographed the West as a place of inviolate, pristine beauty. For Gilpin the southwestern landscape was neither an empty vista awaiting human settlement nor a jewel-like scene resisting human intrusion. It was a peopled landscape with a rich history and tradition of its own, an environment that shaped and molded the lives of its inhabitants. Gilpin developed her point of view on her own. As Ansel Adams said after her death, she had "a highly individualistic eye. I don't have the sense that she was influenced except by the land itself."[5]

It is difficult to draw conclusions about a "feminine" way of seeing from the work of one woman who persevered in a field traditionally dominated by men. But Gilpin's approach to landscape photography has analogies in the work of women writers who, far more than their male counterparts, have traditionally described the southwestern landscape in terms of its potential to sustain domestic life. Her pictures also suggest new ways to look at the limited body of landscape work done by contemporary women photographers.

Western American landscape photography grew out of a male tradition, pioneered by the photographers attached to the government survey teams that went west in the 1860s and 1870s. It was intensely physical work—photographers had to haul hundreds of pounds of equipment, chemicals, fresh water, and fragile glass plates up steep mountains and across dry deserts. It was also lonely work that required them to spend long periods of time away from their families. A veteran of two decades of exploration photography, Carleton Watkins complained to his wife in 1882, "I have never had the time seem so long to me on any trip I ever made from home, and I am not half done with my work. . . . It drags along awful slow, between the smoke and the rain and the wind, and as if the elements were not enough to worry me, a spark from an engine set fire to my [dark]tent last week and burned it half up."[6]

Survey photographers like Jackson or Watkins photographed the West that their government employers wanted to see: an exotic and majestic land shaped by awesome natural forces, unpopulated and ready for American settlement. Photographers employed by the railroad companies who went west after the Civil War also brought back views of an empty landscape ripe for commercial exploitation. These photographers

made pictures of great beauty incidentally; their chief purpose was to document the land in the interests of science and commerce.

Gilpin had strong connections to this heroic strain of explorer-photographers. Born in 1891 just outside of Colorado Springs, she was distantly related to both William Gilpin, the visionary expansionist and explorer who became Colorado's first territorial governor, and to the photographer William Henry Jackson. As a girl, she knew Dr. William A. Bell, who had photographed along the thirty-second parallel for the Kansas Pacific Railroad in 1867, and she was a friend of General William Jackson Palmer, the founder of the town and of the Denver and Rio Grande Railroad. The elderly general took her horseback-riding and "as we rode," she recalled, "he would point to plants, trees and wild life, citing their names. He taught me to know the outdoors, and especially to love it." To General Palmer she attributed her life-long fascination with physical geography.[7]

Laura Gilpin's father, Frank, was also a western adventurer. A would-be cowboy from a proper Baltimore family, he moved to Colorado to seek his fortune in 1880. The West seemed full of possibilities that eluded him. He tried his hand at ranching, mining, and investing before settling down to a career as a craftsman of fine furniture in the late 1920s. Laura's mother, Emma Miller Gilpin, did not share her husband's enthusiasm about the possibilities of western life. Raised in a refined St. Louis family, she attempted to bring culture into the family's rustic homes. She encouraged Laura's musical studies and saw to it that she was educated at eastern boarding schools. But Laura felt out of place at the eastern schools she attended from 1905 until 1909; at parties she asserted her identity by wearing a cowboy outfit.

Unlike her mother, Gilpin felt at home in the great outdoor spaces of the West from childhood. This is a key to her interest in and success at landscape photography. William Henry Jackson and his eastern-born colleagues had photographed the West as an alien land where great mountains and featureless deserts dwarfed humans to insignificance. But for Laura Gilpin the Southwest—particularly the areas around northern New Mexico and southern Colorado where she grew up—was home. Her pictures of the region suggest a kind of quiet intimacy, an easy familiarity that only a native daughter could have. Gilpin's mentor, Gertrude Käsebier (1852–1934), a native Coloradan who by the 1910s had established herself in New York as the country's leading woman photographer, recognized this intimate quality in Gilpin's work and wrote to her in 1924 that her landscapes were "doubly precious to me because of the years of my childhood which were spent amidst such surroundings."[8]

If Gilpin's upbringing connected her to the explorer-photographer tradition, her formal training linked her to a different school of landscape photography. In 1916, after experimenting with photography for more than a decade, Gilpin moved to New York to study at the Clarence H. White School, a bastion of photographic pictorialism. Pictorialism, a style popular in America around the turn of the century, emphasized mood at the expense of description. Eager to prove that their images were more than mere mechanical reproductions, pictorial photographers favored soft-focus lenses that rendered a hazy view of the world, and they often manipulated their negatives and prints to assert artistic control. Pictorial landscapes, as made by White and others,

frequently became metaphorical images, revealing more about the photographer's feelings toward the land than about the land itself. They were very different from the straightforward, meticulously detailed pictures made by the earlier survey photographers.

Gilpin was deeply influenced by White's pictorial style: his preference for soft-focus lenses, his interest in design and the flat, decorative forms of Japanese prints, and his taste for platinum printing papers that yielded a broad tonal scale of grays. Most important, she embraced his idea of photography as a personally expressive art. Years after she left New York and abandoned the soft-focus style, Gilpin wrote, "Many enter the field of photography with the impulse to record a scene. They often fail to realize that what they wish to do is to record the emotion felt upon viewing that scene. . . a mere record photograph in no way reflects that emotion."[9] For this reason, Gilpin preferred black and white: color seemed too literal a rendering of the scene she observed.

After returning to Colorado Springs in 1917, Gilpin opened a commercial studio specializing in portraiture and architectural work and began making expressive pictures of the nearby mountains and prairies of eastern Colorado. Her 8 × 10-inch platinum prints have a personal, intimate quality that suggests Gilpin's romantic fascination with the terrain. In *The Prairie* (1917), a tiny windswept figure stands at the left of a broad, featureless plain, her arms outstretched as if beckoning the light and wind, perhaps a suggestion of Gilpin's own unquestioning embrace of the landscape (fig. 4.1). Despite its intimacy and small size, this picture still conveys the enormous scale of the prairie. *The Spirit of the Prairie* (1921), a similar image also made in eastern Colorado, won great praise from the New York critics who reviewed Gilpin's one-person show in 1924, precisely because it gave "most successfully the sense of the vastness of the plains."[10]

Gilpin's intuitive affection for the southwestern landscape matured during the 1920s as she became increasingly interested in the region's history. Ironically, her interest had been piqued on a trip to Europe in 1922 when she studied French and English culture through art and architecture. "The romance of the old West vanished so fast and so few ever did anything with it," she wrote in her journal. "Does it make you realize the importance of Art and how the main knowledge of history is through Art alone."[11] On an old globe in the Bodleian Library she noted that Santa Fe was the only spot marked in the terra incognita of the American West: it suggested that her area of the country had an important history of its own to be documented.

Thus Gilpin was prepared to be impressed by an aura of history when she made her first trip to Mesa Verde in 1924. She framed and composed her photographs to suggest the precarious nature of the cliff-dwellers' lives and the bare-boned simplicity of their culture, and she made atmospheric, soft-focus prints to evoke the seeming romance of the ruins (fig. 4.2). She strove to capture a spirit of place. The photographer Paul Strand, whom she admired, worked at Mesa Verde in 1926, but his pictures were formally composed close-ups of rocks and tree stumps that revealed nothing about the site's special history.

Gilpin's broad, emotional response to Mesa Verde (she returned in 1925) was much like that of Willa Cather, whose story about the discovery of the ruins, *The Professor's*

*House,* came out in 1925. Cather's hero, Tom Outland, lamented the fact that "we had only a small Kodak, and these pictures didn't make much show,—looked, indeed, like scrubby little 'dobe ruins such as one can find almost anywhere. They gave no idea of the beauty and vastness of the setting." Gilpin thought her pictures of the majestic, sculptural ruins compensated for Outland's shortcomings. Some of Cather's writings even seemed to describe her own photographs. "Far above me," Cather had written, "a thousand feet or so, set in a great cavern in the face of the cliff, I saw a little city of stone, asleep. It was still as sculpture—and something like that. It all hung together, seemed to have a kind of composition." Gilpin hoped to interest Cather in collaborating on an illustrated edition of *The Professor's House*; unfortunately, her efforts to contact the author failed.[12]

Gilpin eventually used her Mesa Verde photographs in her own book, *The Mesa Verde National Park: Reproductions from a Series of Photographs by Laura Gilpin,* which she published herself in 1927. This small photographic booklet and its companion, *The Pikes Peak Region: Reproductions from a Series of Photographs by Laura Gilpin* (1926), introduced the theme that would recur throughout her subsequent books: the Southwest has a particular history, physical geography, and almost inexplicable spirit of place that has profoundly influenced the course of cultural development.[13] Any careful observer could sense this. At Mesa Verde, for example, "the atmosphere which emanates from these age-old ruins takes possession of all who behold them."[14]

The two publications established Gilpin's interest in using her pictures for purposes that were at once remunerative and instructive. In 1930, after attending a poorly illustrated lecture on Mexican archaeological sites, Gilpin resolved to produce a superior set of lantern slides illustrating the archaeological sites of the American Southwest. She planned three sorts of pictures: sweeping landscapes to show the settings of the sites, images of the sites themselves, and pictures of contemporary Indian life that would suggest the connections between America's past and present. Her landscape views were quite different from those being made around the same time by the photographer Edward Weston and others in the influential California-based Group f/64. Weston and his colleagues favored revealing, sharply focused close-ups. A single pebble might represent an entire rocky coastline. Gilpin preferred wide, all-encompassing vistas that better suggested the sweep of human history and the impact of the environment on patterns of human settlement. She had a keen sense of design and composition, but her interest in the cultural significance of the landscape was always as strong as her formal concerns.

Gilpin's slide sets were critically praised (although they were a financial failure) and the images from the sets were eventually incorporated into her first major book, *The Pueblos: A Camera Chronicle* (1941). The pictures in the book moved from images of prehistoric sites through photographs of the contemporary Rio Grande pueblos, emphasizing the links between past and present. In her text Gilpin, like so many other writers and artists of the period, made it clear that the ancient history of the Southwest, a history "old as Egypt," was what gave the region its particular allure. Though the Gilpins were relative newcomers to the Southwest, Laura claimed the legacy of the ancient Pueblo people as her own. "There is something infinitely appealing in this land

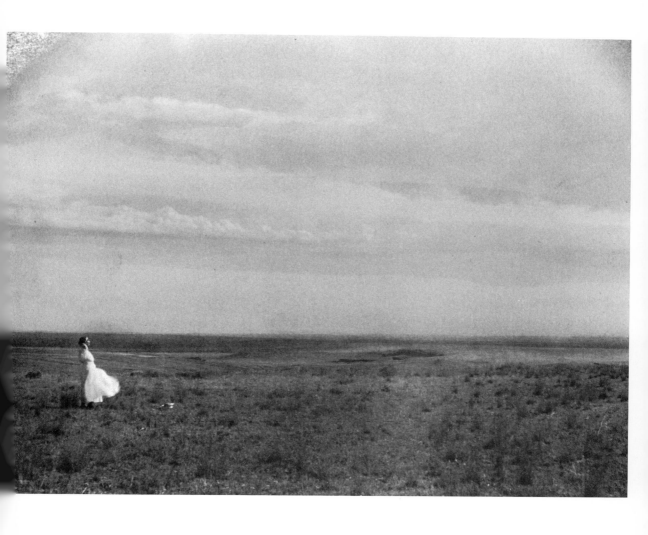

4.1 Laura Gilpin, *The Prairie*, platinum print, 1917. Laura Gilpin Collection, Amon Carter Museum, Fort Worth, Texas.

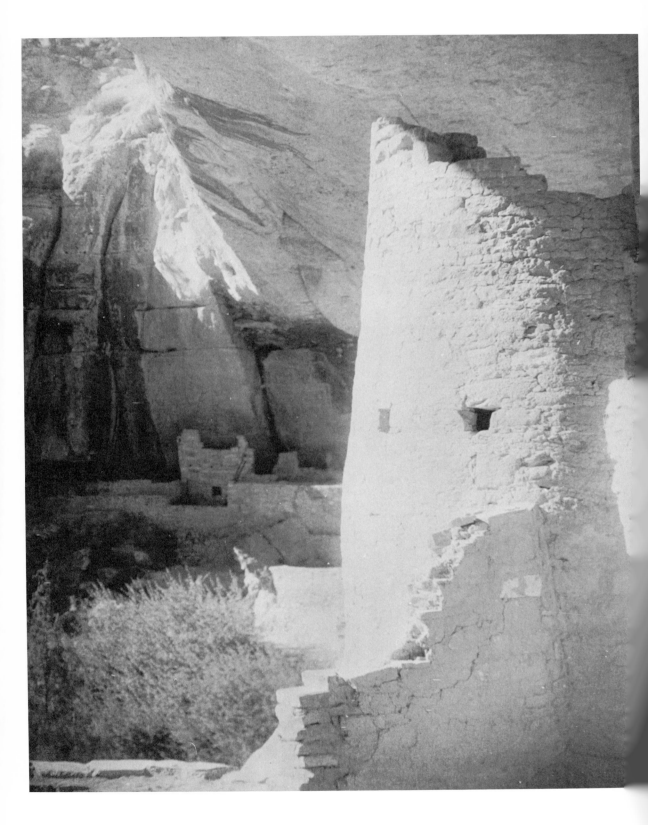

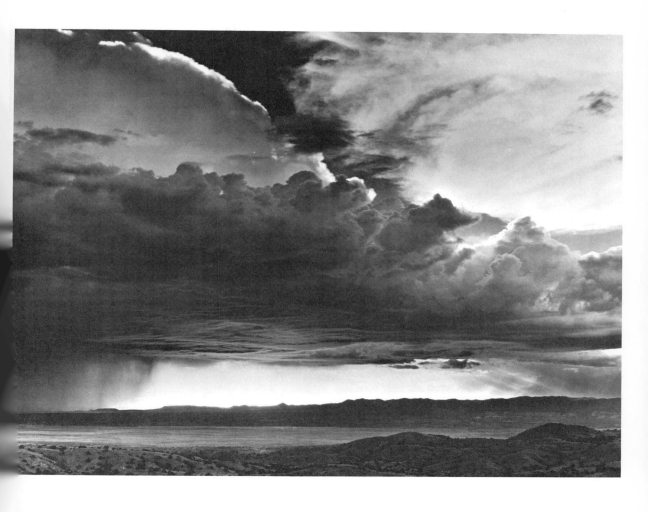

4.2 Laura Gilpin, *Round Tower, Cliff Palace, Mesa Verde, Colorado*, hand-coated platinum print, 1925.
Laura Gilpin Collection, Amon Carter Museum, Fort Worth, Texas.

4.3 Laura Gilpin, *Storm from La Bajada*, gelatin silver print, 1946.
Laura Gilpin Collection, Amon Carter Museum, Fort Worth, Texas.

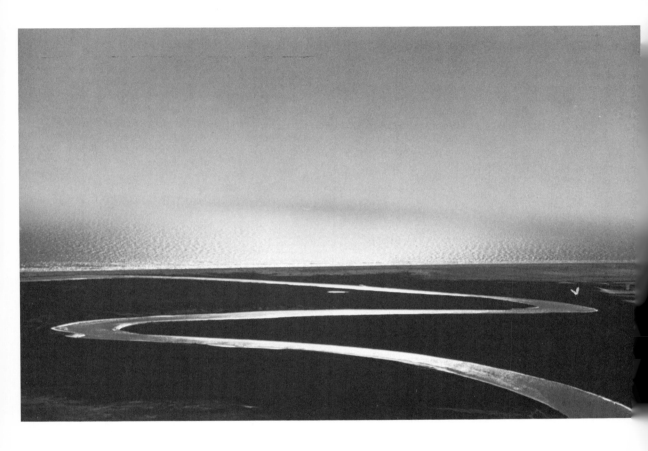

4.4 Laura Gilpin, *Rio Grande Yields Its Surplus to the Sea*, gelatin silver print, 1947.
Laura Gilpin Collection, Amon Carter Museum, Fort Worth, Texas.

4.5 Laura Gilpin, *A Chance Meeting in the Desert*, gelatin silver print, 1950.
Laura Gilpin Collection, Amon Carter Museum, Fort Worth, Texas.

4.6 Laura Gilpin, *Shepherds of the Desert,* gelatin silver print, 1934.
Laura Gilpin Collection, Amon Carter Museum, Fort Worth, Texas.

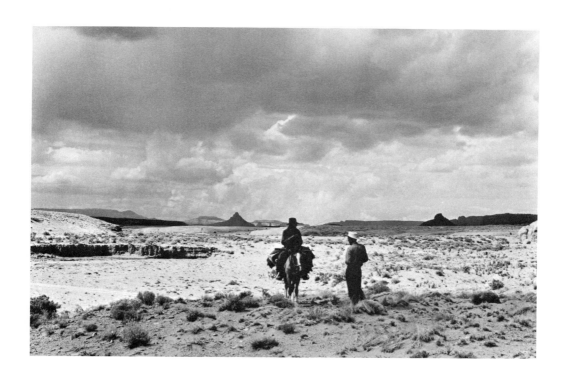

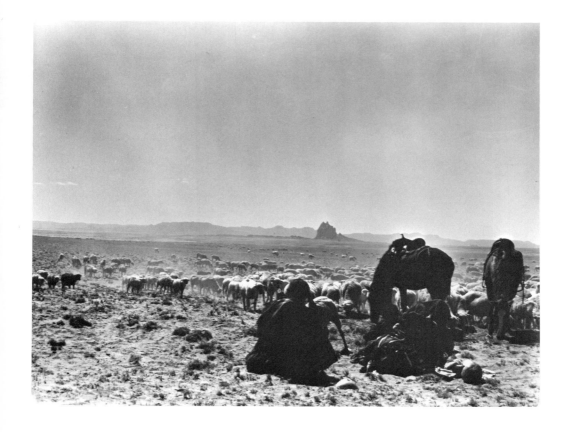

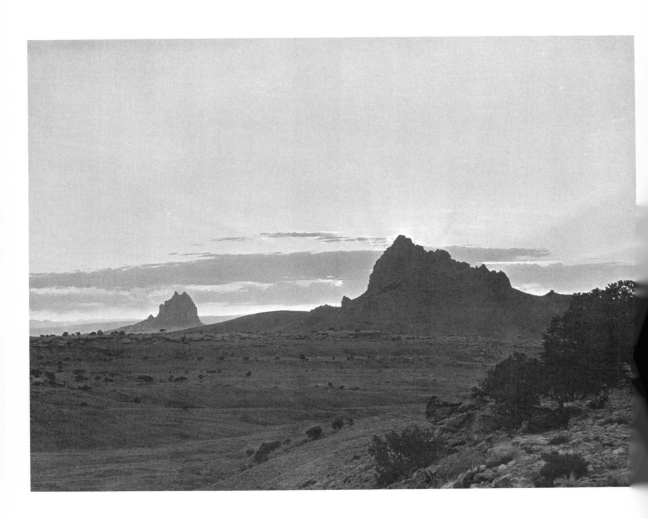

4.7 Laura Gilpin, *Big and Little Shiprock, New Mexico,* gelatin silver print, 1951.
Laura Gilpin Collection, Amon Carter Museum, Fort Worth, Texas.

4.8 Linda Connor, *Spanish Entering Canyon de Chelly, Arizona,* gelatin silver print on printing-out paper, gold toned, 1982.
Collection of the artist.

4.9 Marilyn Bridges, *Fort Mohave Twins, Fort Mohave Reservation, Arizona/California,* gelatin silver print, 1983.
Collection of the artist. Etherton Gallery, Tucson, Arizona.

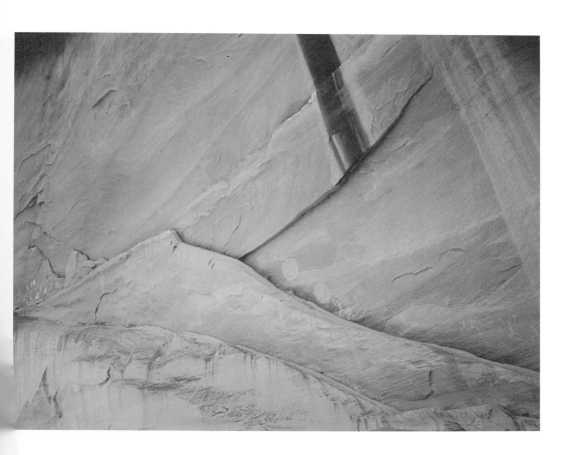

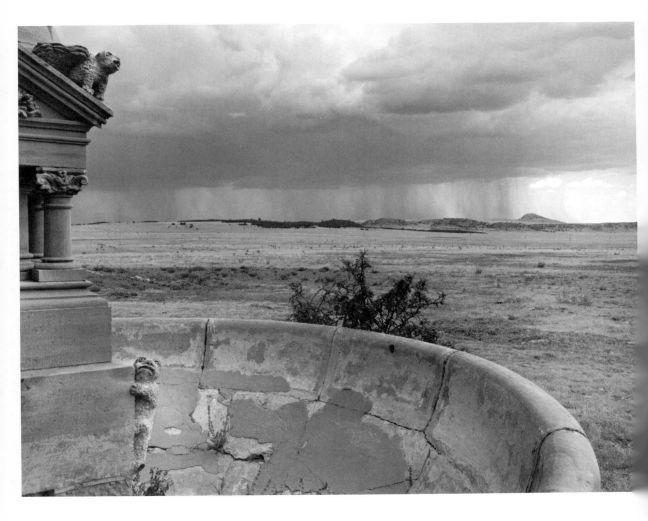

4.10 Joan Myers, *Dorsey Mansion, New Mexico*, platinum print, 1983. Collection of the artist.

4.11 Mary Peck, *Near Lesley, Texas*, gelatin silver print, 1984. Collection of the artist.

which contains our oldest history," she wrote, "something which once known will linger in one's memory with a haunting tenacity."[15] With her deep sense of herself as a rightful inheritor of a rich Indian tradition, Gilpin echoed the words of Cather's hero Tom Outland, who remarked that the relics of Mesa Verde "belonged to all the people. They belonged to boys like you and me that have no other ancestors to inherit from."[16]

The alluring legacy of the Pueblos was for Gilpin (as for many other writers working between the wars) a legacy of peace. Willa Cather wrote in 1925 that the cliff dwellers of Mesa Verde "developed considerably the arts of peace." Likewise, Gilpin found at Mesa Verde an enduring and "lasting sense of peace." At Taos, where Mary Austin sensed a deep "peace and stability," Gilpin too felt "the peace which seems so instilled in the atmosphere."[17]

Considering it impossible to depict the Pueblo people without their land, Gilpin stressed the intimate connections between the people and their environment with photographs of cliff-dwellings sheltered by natural rock outcroppings, deeply slashed canyons that afforded protection, unusual stone structures built to protect scarce water sources. In the text accompanying her landscapes she speculates about the ancient people who lived there and describes the role of particular geologic features in Pueblo mythology. "In this great southwest," she concludes, "the vast landscape plays an all-important part in the lives of its people. Their architecture resembles the giant erosions of nature's carving. It is a land of contrasts, of gentleness and warmth, and fierce and raging storms; of timbered mountains and verdant valleys, and wide, arid desert; of gayety and song, and cruel strife."[18]

*The Rio Grande: River of Destiny* (1949), her next book, included a more mature and carefully detailed explication of the ideas developed in the Pueblo book, and it established Gilpin as a cultural geographer.[19] John Brinkerhoff Jackson, himself a student of the American landscape, reviewed the book as a "human-geographical study," noting that Gilpin "has seen the river from its source to its end and permits us to see it through her eyes, not merely as a photogenic natural phenomenon, but as a force that has created a whole pattern of living, that has created farms and villages and towns and that continues to foster their growth. . . . Miss Gilpin is undoubtedly the first photographer to introduce us to the pueblos, the Spanish-American communities, the whole countryside of farms, as something more than picturesque."[20]

Gilpin began work on the Rio Grande book in 1945, just after leaving a wartime job with the Boeing Company, and during the next four years she traveled more than twenty-seven thousand miles to make photographs for the project. Because gasoline and film were in short supply, she traveled on borrowed gas ration coupons and was forced to limit herself to one exposure of each scene. She packed in on horseback to photograph the river's source in Colorado, and she chartered a small plane to fly her over the river's confluence with the Gulf of Mexico. Her plan for the book dictated the content of her pictures: "The people—the Spanish Americans, the Mexicans and the Anglos are important but are subservient to the river. The people come and go—the river flows on forever."[21] Thus she made few portraits, focusing instead on landscapes and pictures that showed the people in the context of their environment. She organized the book geographically, following the river down through the Colorado mountains

and the fertile San Luis Valley, into the Indian and Hispanic regions of northern New Mexico, and out through the ranching areas of west Texas and the Mexican border-lands.

The photographs in the book are more forceful than the romantic, evocative pictures in the Pueblo book, and they reflect Gilpin's increasing self-confidence as a photographer and her growing preference for a more sharply focused style. Her text, however, reveals that she had not abandoned her interest in the cultural context of the landscape. Though her Rio Grande landscapes may appear to be unpeopled, pristine bits of wilderness, they are still, as in the Pueblo book, part of a broader cultural environment. Consistently describing the Rio Grande in terms of its significance to human culture, Gilpin identifies the river as a source of irrigation water, a shaper of immigration and settlement patterns, a repository of mineral wealth, a source of food for livestock, and a provider of natural town sites. Gilpin's favorite picture in the book was *Storm from La Bajada* (1946), a dramatic image of a huge, flat-bottomed storm cloud hovering over the Jemez Mountains of north-central New Mexico (fig. 4.3). Good fortune, intuition, and skill had allowed her to capture the image. In her book, she provides an explicit context for this landscape which, like many others in the book, contains no visible sign of human presence. Violent storms, she notes, can wash away precious topsoil and flood arroyos with dangerous rushing water that can sweep away "many a vehicle, horsedrawn as well as automotive. . . . It is thrilling, sometimes terrifying, to watch such a magnificent storm sweep over the land." There is a similar emphasis on the power of the natural landscape to shape human culture in most of the captions. The text accompanying her photograph of Taos Mountain speaks of the mystic symbolism of the mountain in Taos Pueblo religious thought; the text beneath an image of the mountains near Las Cruces, New Mexico, stresses their value as a nineteenth-century military outpost.[22]

The anthropologist and photographer John Collier, Jr., found the essence of Laura Gilpin's westernness in this continuing interest in the interplay between human culture and nature. "The easterner's milieu is so often man against man," he wrote in 1950, "in contrast to the westerner's vision of man against the mountains, man finding his way across the vast plain, the personal challenge against wilderness, time, and space."[23] Thus he correctly identified the central concern of Gilpin's work as the interconnection between people and the natural environment. But Collier misplaced his emphasis. Gilpin's interest was never so much in the personal challenge against the wilderness as in the challenge to accommodate to it.

In *Rio Grande Yields Its Surplus to the Sea* (1947), the final photograph in *The Rio Grande,* the sunlit river snakes across a dark delta toward the Gulf of Mexico, its waters' eighteen-hundred-mile journey at an end (fig. 4.4). The image provides a visual coda for the book as well as an opportunity for Gilpin to make her concluding comments about the precarious relationship between people and the natural world, a relationship easily upset by human greed:

*Since the earliest-known existence of human life in the Western world, all manner of men have trod the river's banks. With his progressing knowledge and experience, man has*

*turned these life-giving waters upon the soil, magically evoking an increasing bounty from the arid land. But through misuse of its vast drainage area—the denuding of forest lands and the destruction of soil-binding grasses—the volume of the river has been diminished, as once generous tributaries have become parched arroyos. Will present and future generations have the vision and wisdom to correct these abuses, protect this heritage, and permit a mighty river to fulfill its highest destiny?*[24]

Almost immediately upon finishing the Rio Grande book, Gilpin decided to do a book on the Navajo, a tribe she had photographed extensively during the early 1930s when her life-long companion, Elizabeth Forster, was working as a field nurse in the small Navajo community of Red Rock, Arizona. In this book, Gilpin intended to shift her primary emphasis from the landscape to the people, who lived in seeming harmony with the natural world. The Navajo were the Dinéh, the People of the Earth, "moving about in loneliness, though never lonely, in dignity and happiness, with song in their heart and on their lips, in harmony with the great forces of nature." The two salient qualities of the people were their dignity and their happiness. "Both spring from their vital traditional faith, faith in nature, faith in themselves as a part of nature, faith in their place in the universe, deep-rooted faith born of their Oriental origin, moulded and strengthened by the land in which they live."[25]

Shortly after she began her project in 1950, Gilpin was disturbed to learn that the Harvard anthropologist Clyde Kluckhohn was also preparing a text on the Navajo with photographs by the *Life* magazine photographer Leonard McCombe. But when *Navaho Means People* came out in 1951, she was relieved to find that the book was nothing like the one she planned. "The Navaho are a characteristically happy people and people to whom the land in which they live means everything," she wrote to her editor. "In that book not one landscape! But my observation is that LIFE photographers never see landscape, nor its effect on the people, nor its importance. I don't want to sound too critical of that book, but I see it all so differently."[26]

Gilpin's book, *The Enduring Navaho* (1968), opens with an explicit statement about the relationship between the Dinéh and their land: "Within the boundaries of their 25,000-square-mile reservation, more than 100,000 Navaho People, the largest tribe of Indians in North America, are striving for existence on a land not productive enough to sustain their increasing population." Before she speaks about the people themselves, she recounts their creation myth and describes the physical terrain of their reservation as seen from the air, focusing on how that terrain influenced historic settlement and migration patterns. Reflecting on her flight afterward, she notes, "It seemed incredible that in the course of a few hours, I could have seen so closely and so clearly practically the entire 25,000 square miles of Navaho domain, and looked down on areas where so much history had taken place. It gave me new insight and understanding of the Navaho and their land."[27] The sequencing of the pictures underscores her text. Aerial views of the Navajo's four sacred mountains, conveying a sense of the larger physical world in which the people live, precede any portraits of the people themselves.

Concern for the physical context of Navajo life pervades the book. In the section on habitation, a distant shot of a lone hogan at the foot of an empty mesa is followed by

detailed pictures of hogan exteriors, and finally by views made inside the hogans themselves. The section on tribal government opens with distant views of outdoor chapter meetings, continues with indoor shots of council meetings, and concludes with formal portraits of tribal leaders. Indeed, everything about traditional Navajo culture seemed to Gilpin to be dictated by the physical landscape—the symbols of Navajo religion, the domestic architecture, the sheep-based economy, the simple diet.

With pictures and words Gilpin conveys an overwhelming impression of the vastness of the landscape and the small scale of the people who have adapted to life there with seeming ease. In *A Chance Meeting in the Desert* (1950), a figure on horseback and a man on foot converse in the middle of a sweeping, empty stretch of desert. Dark storm clouds hover over the buttes and mesas on the horizon; sunlight pours through the clouds illuminating the scrubby land behind the two figures (fig. 4.5). Gilpin notes that she was so intent upon watching a young shepherd in one direction "that we did not see a young man approaching on foot from another. Then up out of a wash appeared a lone horseman who stopped to talk with the young man on foot. After a while each went his separate way as we watched them all disappear." The picture she chose for the dust-jacket of her book is similar, reiterating her fascination with the graceful accommodation of the people to their land. A young Navajo woman holding a cradleboard sits on a burro. Her young son sits behind her and an older boy stands shyly behind the burro. Gilpin notes that she encountered the family by chance as she approached "a slight rise in the undulating desert. . . . They seemed miles from any habitation, yet in the gentle rise and fall of the desert it is remarkable how a hogan can be hidden from view."[28]

The theme of Gilpin's book is revealed in her use of the word *enduring*. Gilpin found no evidence that the tribe Edward Curtis once referred to as "the vanishing race" would soon disappear. The Navajo she depicted could accommodate to change as easily as they could adapt to their desert environment. Most important, they could do so without losing the essential values of their culture. Her book includes a photograph of a young man proudly posing in the uniform of the National Park Service, his long hair tied back in traditional Navajo style. A modern-day medicine man poses with his two traditionally dressed daughters, while his son wears the ubiquitous denim jeans and jacket uniform of the modern West. A woman in traditional dress covers her head with a shawl and laughs beside a carefully arranged collection of soft-drink bottles.[29] Gilpin lamented the passing of the colorful covered-wagon days, but she accepted the inevitability of change and had an unshakeable faith in the ability of the Navajo people to adapt to new ways. Concluding her book with a section on Navajo tradition and ceremonialism, she writes, "Many who know the Navaho will think that the great days of ceremonialism are lost. Possibly this is true, but I cannot believe the old ways will really be lost. . . . We can but hope that those essential qualities of the Dinéh will never be lost. Song and singing are the very essence of Navaho being, and as long as the Navaho keep singing, their tradition will endure" (fig. 4.6).[30]

As she worked on her Navajo project, Gilpin came increasingly to identify with her subjects' deep affection for their land. After attending a Nightway ceremonial she wrote, "feeling the assembled reverence as the Prayer to Dawn is sung in the chill, clear Southwestern air, makes one realize the strength and beauty to be derived from

closeness to the elements. Here is something vital, something real."[31] Indeed, she began to identify with many of the attributes she ascribed to the Navajo people: the material poverty of their traditional ways, their interest in creating functional art of great beauty, their profound sense of history and tradition, their respect for the land in which they lived. She never thought of herself as a Navajo and never presumed to understand the intricacies of Navajo religion and ceremonialism. Yet Gilpin did not feel presumptuous at all in claiming with pride that *The Enduring Navaho* was done "from *their* point of view. That's the whole point. They see the difference. . . . They like it and I don't care about any other part of it."[32]

Gilpin's book on the Rio Grande had explored her own connections to the Southwest. The Navajo book allowed her to ally herself with one of the region's ethnic groups. In her next project, on the Canyon de Chelly, begun in 1972 when she was eighty-one years old, she sought an even more intimate connection with the native peoples of the Southwest as she documented the lives of the handful of Navajo families that lived and farmed in the canyon. When one of these families put on a picnic in her honor, in thanks for the gift of a photograph of a deceased family member, Gilpin called it, "a Navajo gift. That was a day I'll never forget because it just summed it all up. . . . It was just that I was accepted by them, I think, as much as anything else—as somebody that understood them."[33]

Photography had become her way of getting close to a people whose history and traditions seemed deeper than her own; photographs had become her means of appropriating some of that tradition for herself and experiencing the land as those with the strongest claim to it experienced it. This deep sense that she, too, was somehow a part of the landscape and tradition she photographed is what distinguishes Gilpin from the other great photographers of the American Southwest (fig. 4.7). Nineteenth-century explorer-photographers like John K. Hillers, Timothy O'Sullivan, and William Henry Jackson were always outsiders, cataloging the natural wonders of the terrain for their employers. Gilpin's contemporaries, Ansel Adams and Eliot Porter, worked as she did out of a compulsion to photograph what interested them, but their concern was never with people's place in the wilderness. Often working with conservationist groups, both photographers wanted to create a record of what the landscape looked like untouched by humans. Their preferred role was that of a respectful outsider peering in with awe at the fragile natural world.

Gilpin, by contrast, created a record of the Southwest as a historical landscape; a landscape with a past measured not just in geological or evolutionary time but in human time, as evidenced by architectural ruins, ancient trails, and living settlements. It was a landscape with intrinsic beauty, but one whose greatest meaning derived from its potential to change and be changed by humankind. Gilpin did not dislike the idea of a wilderness, but for her there was no true wilderness in the Southwest, no area that had remained untouched by more than a thousand years of human settlement. With her imagination, she peopled the empty vistas she photographed, speculating what life might have been like (or might in the future be like) for those who settled there. She generally avoided extreme close-ups of her natural subjects (which were made by many of her male contemporaries) because emblematic details could never suggest the intri-

cacies of the interrelationship between people and nature that made the landscape a compelling subject for her. Gilpin knew that the Southwest sometimes provided a nurturing landscape, sometimes a hostile one. She knew that the landscape could be modified by human action, but believed that it would and should remain the dominant force shaping and molding human culture.

The Navajo people, living in "harmony with the great forces of nature," accepted the immutable fact of their landscape and provided, for Gilpin, an exemplary model of human adaptation to the environment. There was "nothing superfluous about the Navaho;" no bit of waste or extravagance in the way that they lived.[34] They lived with respect for their land, taking only what they needed, and adapting their homes, their economy, and their way of life to the rugged high-desert terrain.

Gilpin's photographic record of a historical landscape—a landscape that changes people and in turn is changed by them—suggests a useful frame of reference for a study of the pictures currently being made by the small group of young women making photographs of the southwestern landscape. Linda Connor (b. 1944), for example, documents the region's petroglyphs, addressing quite literally the issue of how people have made their mark upon the landscape (fig. 4.8). With a similar interest in human markings, Marilyn Bridges (b. 1948) makes aerial photographs of Native American earth-art and architecture (fig. 4.9). Her large prints are well suited to the grand, public scale of her subjects, while Connor's quiet 8 × 10-inch images are similarly faithful to the more intimate quality of the smaller rock carvings. Both women document a landscape with a particular historical past. Indeed, their pictures document the very stuff from which history is written, the tracings left by a people who had no written language with which to record their own lives.[35] Meridel Rubenstein (b. 1948), work-ing in a very different style, has also made the historical past an explicit concern of her landscape work. She notes that she often makes sequential exposures of sites because "the lives of these remarkable places, from my limited vantage point, seemed to exist at once in the past, present, and future."[36] Her photographic collages combining por-traits of people with images of their homes and homesites underscore this interest in the landscape as an evolving environment with a particular history.

Among women currently working in the Southwest, Santa Feans Joan Myers (b. 1944) and Mary Peck (b. 1952) have been most devoted to documenting the regional landscape. The fact that this interest continues to set them apart (as it did Gilpin) from most of their female contemporaries suggests that landscape photography remains—nearly 150 years after the invention of the daguerreotype—a field dominated and largely defined by men. Yet the work of both Myers and Peck supports the idea that the few women who have tackled landscape photography have developed a new tradition for the genre, one focusing on the human elements of the physical environment.

In 1982, Myers began photographing the Santa Fe Trail, the old wagon trail extend-ing from Missouri southwestward to Santa Fe. She writes, "It was my challenge to photograph a feeling, an idea, a dream from the past using the landmarks of the trail and the tangible imagery of the present."[37] Her landscape views reveal the traces left behind by the nineteenth-century traders and immigrants who traveled down the trail or their later descendants who settled along the length of the route. Myers depicts the graves of

two early pioneers; the names carved deep into the stone at Inscription Rock, Oklahoma; the barbed wire stretched taut across the prairie at Round Rock, New Mexico; the ruins of a grandiose mansion along a desolate stretch of trail; the sprawl of modern Santa Fe at the end of the route, stretching out beyond the seventeenth-century plaza at its core (fig. 4.10). More recently, she has been photographing the remains of ten western relocation camps used to house Japanese-Americans during the Second World War. She writes, "What remains in these barren windswept places and what I choose to photograph is the imprint left from thousands of lives, hopes, and dreams."[38] Her pictures record names drawn in concrete and the remains of small gardens planted to soften the harsh, impersonal environment of the camps.

Mary Peck has worked extensively in the open plains of eastern New Mexico and west Texas, seemingly empty, desolate stretches of land that have attracted few visual chroniclers (fig. 4.11). Ever since travelers began recording comments on this region, she notes, "most reactions have been unfavorable. This land has none of the things to offer that most people associate with a beautiful or grand landscape. There is no place for the eye to rest, no seeming point of interest."[39] But Peck finds it an interesting landscape, marked by its inhabitants' efforts to make it a useful or more hospitable space. People rarely appear in her pictures. Instead, one sees mere traces of their presence: old dirt roads, cattle crossings, abandoned windmills, broken-down cotton trailers, and stunted orchards. The spare austerity of Peck's work matches the austerity of the life these artifacts represent. The horizon stretches in a taut line across the middle of her 6 × 15-inch prints, accentuating a sense of limitless space and distance. Wide, empty skies proclaim the preeminence of the land and the futility of human gestures to change this world. Like Laura Gilpin (for whom she worked as a darkroom assistant), Mary Peck seems drawn to scenes that suggest people's efforts to accommodate themselves to the immutable fact of this physical environment.

Gilpin never thought of herself as a "female" photographer and eschewed any discussion of gender as it related to her work. While critics of the 1960s and 1970s speculated about the existence of a uniquely feminine artistic sensibility, she maintained little interest in the possible existence of a particular "woman's eye."[40] Her pictures, she rightly thought, should be judged on their own merits, apart from any consideration of their maker. Thus it is ironic that Gilpin's photographic evocation of a historical landscape should prove so suggestive of a different, if not a distinctive, women's approach to landscape photography; one emphasizing empathy with the human import and human past of the natural world. This approach is an alternative both to the heroic tradition of nineteenth-century landscape work, carried on in this century by Ansel Adams and his followers, and the romantic, allegorical style promulgated by Gilpin's pictorial mentors. Yet Gilpin's landscape pictures and those being made by contemporary women photographers, are not overtly feminist or political. Rather, they represent a new humanistic strain in landscape photography that regards people and the physical landscape as an integral whole, an approach offering great possibilities to all artists, men and women alike.

# Crazy-Quilt Lives

## FRONTIER SOURCES FOR
## SOUTHWESTERN WOMEN'S LITERATURE

Historians of Anglo women's experience on the trail West are revising the old stereotypes of the sunbonneted helpmate and Calamity Jane cowgirl. Analyzing class, life cycle, and role expectations, they suggest a much deeper reading of women's lives on the frontier. The bulk of such research centers around women's experiences prior to the turn of the century, focusing on the trail and early settlements. Of primary interest are the expectations women brought with them on their journey West and how those beliefs affected their response to the frontier. Julie Roy Jeffrey argues, "Frontier women gave many indications of their desire to hold on to the conventions of female culture no matter how unfavorable the circumstances seemed. . . . Women planted flowers and trees from seeds they had brought with them and generally tried to maintain the standards of domesticity . . . with which they had been familiar before emigration."[1] The only new attributes they valued were the "strength and ingenuity" required to make such a home in the wilderness. To date only Annette Kolodny has argued that women valued the frontier environment itself. Kolodny demonstrates women's attachment to the prairies and finds women more ambivalent than men to the development of these natural landscapes.[2]

While these sources are useful for defining some of the beliefs frontier women brought to the Southwest, they do not speak to the ideology of the settlers and their daughters and granddaughters. What aspects of their values did pioneer women pass on to succeeding generations? What constitutes the usable past, the traditional lore, of the second, third, and fourth generations of frontier women? Joan Didion, three generations removed from the frontier experience, carefully preserves a quilt made by her great-great-grandmother on her wagon journey West, during which the woman experienced many travails common to the times: birth and death of children, illness, and

punishing work. Describing what it means to be a "California Woman," Didion once explained that she is heir to a specific narrative about the meaning of life, also noting that this multi-generational story of her ancestors' lives can be read as either a boon or an affliction to women of her generation.[3] Didion's essays and fiction include parts of the narrative meaningful to her life now. Nor is she singular in using stories from the pioneer period to structure her fiction. From the turn of the century, women writers have found stories of migration and settlement crucial to their understanding of women's lives in their own time.

With these contemporary writers in mind, I went back to their sources—the diaries, journals, and reminiscences left by frontier travelers and settlers—to discover whether any thread ran from the early writings to the later. I found a continuous tradition. This review of women's writings of the trail and settlement in the Southwest modifies the standard image of pioneer women. In their readings, Jeffrey and others argue that the new frontierswoman incorporated "strength and ingenuity" into her domestic life mainly for the purpose of making a garden in the wilderness. They planted petunias in a hostile landscape in an attempt to overcome scarcity, to make the landscape more fertile in the hope for return to sheltered, domestic life. While this ideology is a part of the accounts considered here, I find that these women also acknowledged the resistance of the environment to their efforts, and many came to some celebration of that resistance.[4] Twentieth-century writers for whom the pioneer experience constitutes a usable past continue that story of women's struggle with the conflicting values of domesticity and respect for the natural environment. Beginning with the early materials, I trace a narrative of women's life in the Southwest developed over three generations. It is based on stories handed down from travelers to settlers, and finally to their children and grandchildren.

The Southwest has a long history as a region of contradictions—embodying both fabulous riches and life-threatening desert.[5] Susan Parrish's reminiscences of her family's move to Tucson, Arizona, in 1850 include both visions. She remembers that the region "was a kind of pot of gold at the end of the rainbow that we set out to find. . . . It took the form of a California gold mine or a cattle ranch extending over miles of New Mexico, or again, it was a fruit ranch on the Gulf of Mexico. It was never definite, but it lay always with alluring promise somewhere in the great West."[6] At the same time, her reminiscences of the childhood journey to Tucson describe a terrain of death, fear, disruption of family, and constant danger. Much of the danger stems from the natural landscape which, when they run out of food between Santa Cruz and Tucson, offers little in the way of nourishment. Parrish's tales of famine relate the deaths of both American Indians and captured whites; even the Indians had difficulty surviving in this landscape. Her father promises to settle "in the first place where water [is] to be had in abundance" (12). Yet, the trip also offers young female heroines like Susan herself, who saves oxen from starvation, leads the trail through the sand dunes when her parents are ill, and makes friends of the Mexican population through her healing skills (6).[7]

Eveline Throop Martin's diary of her travels as an army wife in the Southwest in 1866–67 evokes a similar ambivalence about the harsh landscape and its people. She is

an acute observer of nature, at one point regretting that she did not bring her "botany" so that she could classify the new plants she finds in New Mexico. She carefully describes the difficulties faced by Navajos in obtaining firewood. Although she understands the requirements of survival in the landscape, she remains ambivalent toward the actions required for such survival. Like Susan Parrish, who is "soft-hearted" toward her starving oxen, Eveline Martin regrets the death of a fawn but adapts gracefully to her own changing role in this place. Her writings contain little bitterness or sense of undue suffering, and even a little humor: "I begin to realize I have [come] into the land of the redskins, where the squaw has various duties to perform. Yesterday I was superintending the disjointure of a calf, and today have performed the same offices by a fawn."[8]

Harriet Bunyard, who traveled from Texas to California with her family in 1868, is surprised by her enjoyment of the journey. She, too, shows a lively interest in the landscape; almost every diary entry refers to the natural or built environment. The arid environment remains a problem, but she seems to suffer more from a lack of "culture." She often assesses the degree to which a village or settlement is properly situated, built to her "standards," or tenanted by "nice" people. Although interested in how the Indians and Mexicans live, she most often finds their dwellings lacking something: "They do not care as to houses—just so they have shade." She is always pleased to find Anglo habitations.[9] Diaries like Bunyard's remind us that the Southwest had already been settled before the arrival of the Anglos and was only being rediscovered by this new set of settlers. Bunyard, like other diarists, separates her aesthetic appreciation for the landscape from her assessment of its settlement potential. She finds value in desolate landscapes even when they seem useless as habitations or even life-threatening: "Passed through the Castle Mountains. They are the prettiest mountains I ever saw— not a bush can be seen—nothing but scatter grass" (101).

Maria Hargrave Shrode's diary of her own journey as a forty-year-old married woman from Texas to California in 1870 is also full of contradictory visions of harsh terrain. Shrode is well aware of the conflicting messages the landscape holds: "the grandest scenery, that I ever saw in my life and if it had not been for the bones of dead cattle strewed in every direction I could have enjoyed the romantic scenery."[10] Her diary offers much advice on finding water in the desert, as well as a wealth of information on making "dry camps." Although she longs for the journey to end, she also explores the terrain and takes advantage of her freedom of movement during the trip. At one point she ruefully notes the children playing in the grass during the full moon and comments, "If we all could enjoy the trip as the children do, how happy the time would pass away" (17).

Shrode, like the others, learns to cope not only with contradictory feelings toward the natural landscape but also with the indigenous cultures which will be a part of her new life. At first she regards the Indian and Mexican settlers as a tourist might, with a passing curiosity about how they live, but her final journal entry directly confronts the adjustments she will have to make to settled life in a landscape already tenanted by them. She notes that, upon reaching their destination, "our mules were stolen by the Mexicans and they refused to give them up" (37).

Some southwestern diaries and journals document lives of people who might be called natives, in that they had settled in the West previously and were now migrating to another area there. Such was the case with Bunyard, Shrode, and Mrs. Robert Orion. Mrs. Orion lived in Colorado and kept a diary of her journey in 1877 to Arizona. Unlike many of the overland travelers, western women were already somewhat familiar with the terrain they encountered and were neither easily fooled by its beauties nor over-whelmed by its harshness. Mrs. Orion and another woman drove one of the teams during the entire journey as well as handling all the usual domestic chores. She records no bitterness at doing such double duty, nor does she renounce other, more feminine pastimes. Her status as a "native" of the region is clear when she compares Arizona's flowers to Colorado's: "Irma gathered a very pretty bouquet this morning. Some of the flowers are very handsome—especially the bloom of the cactus—it was a bright crimson and tulip shaped. The cactus was [a] different shape from any I have ever seen. The Chandelier cactus are quite tall and branching resembles a small tree in size. We found some here which do not grow in Colorado, and some are as familiar as faces of old friends."[11]

These accounts indicate that women experienced the landscape through which they passed from a variety of perspectives. They do evince characteristics associated with the middle class and the genteel role, such as a soft-hearted concern for the death of animals, a feeling for the beauty in small flowers, and a focus on how people make homes in such terrains. Some of these women's "genteel" skills provided them with a special apprecia-tion of the natural landscape. They used their considerable knowledge of plants to learn about and appreciate the scenery. They were in tune with the daily experience, aware of their surroundings, and constantly assessing the merits of the landscape through which they traveled.[12]

Their judgments about landscape reflect their status as relatively educated women of the late-nineteenth century. Like eastern readers of *Scribners* and *The Century,* they expected to find "grand scenery" and "romantic" vistas in the West.[13] Such expecta-tions probably account for their delight in certain landscapes—such as the moun-tains—over others, and for their appreciation of sublime and picturesque terrains holding no promise for settlements.

Such knowledge and appreciation did not help them understand the built environ-ment. Because they had not yet lived in the region, they did not comprehend some of the adjustments of those who had. They failed to appreciate the agricultural and architectural practices of Mexican and American Indian populations, and their judg-ments reveal a bias toward their own culture's way of doing things.

But is is clear that on the journey women were interested in more than domestic concerns. They did not assess the landscape one-dimensionally as a future home; they also saw it as an opportunity to expand their knowledge of nature and raise their spirits. Its most difficult aspect was not nature, but the built environment of the indigenous peoples. Their experiences with the Mexican and Indian populations warned them that settling in the Southwest, rather than simply journeying through, would require radical adjustments of their cultural baggage. In settlement literature these conflicts do not disappear as women build homes and communities. Rather, they continued to

stress the goal of a cultured, civilized life in a controlled landscape. And the writers, as time goes on, make more and more definitive statements about the value of the landscape.

In Edith Nicholl's *Observations of a Ranchwoman in New Mexico* (1898), the effects of Victorian domesticity and European aesthetic traditions are clearly delineated. Nicholl, an Englishwoman who came to the Mesilla Valley as a "health seeker" and stayed (with a female companion) to run a small ranch, seeds her *Observations* with self-conscious references to the differences between art and life. Educated in the landscape aesthetic of the period, she sees a familiar beauty in the region: "There had been welcome thunder showers, and the air held a dewy softness not common in the Arid Belt. But for the glorious mountain range—over whose bright face the clouds trailed giant shadows— the varying greens from emerald to sombre olive, the swift play of light and shade across golden wheat-field and verdant pasture, were almost English in their unaspiring love-liness."[14] In a study of the changing meanings of landscape from the sixteenth to the twentieth century, Edward Relph notes that "for most artists and certainly for the general population in the late-nineteenth century, landscape was nice scenery that made a gentle or fashionable impression on their senses."[15] When Nicholl looked at the "landscape" as an object for leisurely appreciation, that "nice scenery" was what she first found attractive in the Southwest.

But Nicholl always balances these artist's notions by reminding us of what actual life in this land requires: "from the artist's point of view, the effect was perfect. But the eye of the rancher looks deeper. With that eye we noted the scanty crop in a fertile land—its scantiness in part the result of a long drought and the river's treachery" (72). Nicholl is not only recording the traveler's impression on the way to a different destination; she is looking at the Mesilla Valley as a home. Seeing with the "eye of the rancher," she notes its resistance to human tenancy. Although she arrived in New Mexico expecting a natural (and maybe a built) landscape similar to that she left in England, she quickly adjusted those expectations to the exigencies of the arid climate.

Nicholl's choice of a home reveals the importance to her of both the older landscape of England and this newer, more "treacherous" landscape of New Mexico. On her ranch she had the best of both worlds. Explaining why she chose the place, she lists: "An attractive carriage-drive bordered with young trees, a few rose-bushes before the door, a magnificent cottonwood spreading wide, sheltering arms over a well-built adobe dwelling. And was this all? No—for bounding the horizon, a perpetual vision of beauty, rose the grand heights of the Organ Mountains" (18–19). The choice of an adobe is important, for here too Nicholl was of two minds. On the one hand she often describes the cultural wasteland she has entered, disparaging American Indians, Mex-icans, and lower-class Anglos. In this vein she projects the middle-class Anglo woman settler's wish for a landscape built like the one she left. But neither did Nicholl find the brick and wood buildings of Las Cruces at all suitable to this new environment. She realized that the native inhabitants knew how to build in keeping with the climate.

Finally, Nicholl appreciated just those aspects of the terrain—the heat, aridity, and desolation—that force these adjustments in her expectations. Her observations end not with a practical ranchera's ideas of how to live in the "Arid Belt" but with a nature

lover's celebration of a place inimical to human habitation. She ends in praise of the desert conceived as woman: "Undisturbed by our coming, indifferent to our going, Sphinx-like still she broods and watches from her pyramids and towers. But her spirit, the Spirit of the Great Desert, has entered in. It is ours for all time" (270–71). Not only did she learn how to make a living in this land, she came to appreciate the moral force contained in scenery radically different from any she loved in the past.

Nicholl apparently brought to New Mexico a Romantic belief in the value of natural landscape as a door to universal values.[16] In her initial search for the kind of landscape she had experienced elsewhere, Nicholl did not at first love the desert Southwest. The combination of living in that land with her belief in the moral value of all nature brought her to a new appreciation of landscapes resistant to human occupation. The desert teaches one about divinity and humility: "All that is mortal is behind us, a mere jangle of voices submerged in this tremendous calm. Even the thunder of wheels— bearing, as the ship across the ocean, all that nineteenth-century civilization demands on its voyage from port to port—is lost in the low breathing of the desert wind" (268– 69).

Nicholl's text is interesting in that it is written by an apparently well-educated woman aware of the major intellectual trends of her generation. But settlement documents of women whose background, education, and class provided them with less access to elite culture also reveal the adaptability of their perceptions of the land—particularly their interest in the values of the southwestern environment of scarcity.

In *My Desert Memories,* Sadie Martin recounts her life in Arizona from 1888 to 1920. Enduring the lack of a permanent home, the death of her first-born child, and her husband's ill health and unfitness for farming, she often echoes the comments of early travelers about the difficulties of life on the frontier. And yet, given the opportunity to live in the safety and relative urban comfort of Los Angeles, she chose to take her child and move out to a rough mining camp to be with her husband. She was pleased to note that her daughters, though educated in Los Angeles, returned to the desert to live.

While she chronicles her own successful efforts at "making do" with the celebrated strength and ingenuity of pioneer women, it is not these qualities of her life she values most. Her memoirs continually stress the experience of impermanence—in the desert nothing lasts except the physical environment. Describing a return visit to her old homestead, she notes first that any signs of her family's tenancy on the land have been obliterated, then goes on to meditate on the lesson such a loss provides: nature, in this case the nearby river and the seasonal sandstorms, does not tolerate human changes on the land.[17] Although her feelings are rather more rueful than Edith Nicholl's celebration of the desert "spirit," she too values the humility learned in a landscape resistant to her sort of habitation. Martin does not hate the desert; she simply recognizes that lack of permanence is the price one pays for its beauty.

Permanence is an elusive concept for Mary Hudson Brothers' family as well. *A Pecos Pioneer,* her account of her father's life as a cowboy and then a rancher in late-nineteenth-century New Mexico, is a chronicle of a family on the move. Mary Hudson, the eldest child, shares domesticity with her mother but also rides the range with her father. Part of the circle of women in a quilting bee, she understands the frontier aesthetic that

appreciates the sight of an entire family dressed in the same dimity cloth.[18] With no sense of contradiction, she just as easily understands why she is expected to help her father protect his horses from a gang of thieves by guarding the barn alone in the night (125). She realizes that living in a difficult and sparsely populated landscape requires flexibility, and she considers the contradictions in her life to be intrinsically good.

Hudson defends her life as a Westerner by opposing the values of an older eastern civilization to the ethics bred in the Southwest. After a trip to "cosmopolitan" Magdalena, New Mexico, she locates not only "Prince Charming," but God, in the desert Southwest:

> *I met many of Dad's friends, and could tell at a glance whether they were my kind, bred of the desert and far places, or aliens, reared in crowded towns and looking at us Westerners with a pitying, tolerant air. I felt that my dream Prince Charming would come to me far out in the West, on a lonely horizon. . . . The true and the faithful, like the desert, are held in the hollow of God's mighty hand, and can be identified by their quiet majesty and infinite grace—the indelible stamp of true worth. (144)*

Mary Rak, an easterner who settled late in the West, found just such a man in her rancher husband. In Rak's 1934 account of her life as *A Cowman's Wife,* she connects herself to earlier pioneer women both in her frustrated domesticity and in her appreciation for life in a beautiful but demanding land. Her ranch life makes her feel somewhat out-of-date. While churning butter, she reads in a woman's magazine that " 'the days of bread-making, churning, and standing over the washboard are long past.' The churn dasher thumped an echo to my sentiments. 'Oh yeah? Oh yeah?' "[19] Strength and ingenuity are daily requirements, but she exercised them with little thought to ultimately establishing an easy life.

Rak understood well the extent to which nineteenth-century visions of women's desires and needs affected her life. Her husband often encouraged her to go to town for a few days to share in the company of other women. She avoids going with a standard excuse—she has nothing to wear—but confesses that part of her reluctance stems from the fact that the rough road often leads to car breakdowns in the middle of nowhere. Again we are reminded of the land's resistance to human intervention, and again see a woman somewhat perversely enjoying this resistance—for, in fact, Mary Rak tells us she does not care to go to town at all.

Rak's account ends not with pride in the changes she and her husband have made on the land, in what they have built or will build; instead, she concludes with a lesson in waiting. The last few chapters concern how she and her husband held on during a drought. With the arrival at last of a great rain, the built landscape and the natural landscape are contrasted. Nature, not human works, provides meaning to her life and that of the ranch: "Down at the edge of the river, where the fence had been swept away by the flood, I saw myriad tracks. Cloven hoofs of cattle, all pointed toward the mountains, had left their imprint there since the rain. Obeying the instinct of their kind, they had forsaken the pasture, the corrals, the feed provided by the foresight of men, and at the falling of the rain they were returning to their hills" (292). Rak's account ends with this long-awaited rain—the gift given, not won, in the arid place they call home.

Two threads connect these first-hand stories of settlement. Women are concerned with maintaining a traditional life under difficult circumstances, but this concern is balanced by a growing appreciation for the indigenous landscapes (natural and built) of the region. The natural landscape, particularly, comes to have meaning beyond its potential to support their domestic lives. In fact, the land's resistance to settlement has moral and spiritual value. These writers define themselves as frontier, or pioneer, or western women in part through values taught by appreciation of the natural landscape of the arid Southwest.

While much has been written of men's changing self-definition brought about by their experiences in the frontier West, change in women's definition of self has hardly been addressed.[20] There are, however, hints in these accounts of role changes quite different from men's as women adapt to the new landscape. Most studies of the frontiersman assume or assert that the conquering urge, the struggle to make his mark on the land or fight his way through the wilderness, is most important to the definition of western (and American) manhood.[21] In the works studied here, women, by contrast, define themselves as Westerners to the extent that they are subsumed by the environment, in tune with the rhythms of nature, not engaged in appropriation. The greatest tension in their settlement accounts arises when the tenets of domesticity (which imply control over the land) conflict with their impulses to merge with the environment. This tension seems to have carried through to the next generation, as frontier grandmothers and mothers passed on their memories and definitions of southwestern womanhood to their children.

By the 1930s and 1940s another type of southwestern trail and settlement memoir appears. In these, granddaughters of pioneer women recount stories told them by mothers and grandmothers. Often these books are offered more as imagined fiction than family history or memoir, but they continue to reflect the conflicts between domesticity and naturism expressed in the diaries and journals of the earlier pioneer women. Two such novels offer examples.

May Merrill Miller's novel *First the Blade,* based on her grandparents' life, is the story of a young Missouri woman who moves to southern California and participates in the development of the San Joaquin Valley during the late nineteenth century. The story takes the classic pattern of a husband always on the move, desiring to be part of change, and a wife who seems to prefer a more settled life. The title refers to the irrigation of the valley and the settlers' celebration of the first green blade of corn—harbinger of the fertile and populous place they will create. These novels, which span much more time than some of the original settlement documents, also capture the rapid transformation of the Southwest into an urban region. Emilie's husband, first seen as a farmer in the Santa Clara Valley, ends up as a real estate agent in the new town—Nueva Esperanza— he has helped to build. She understands that here, in this urban environment, he has found a challenge to build comparable to the old one of bringing water into the valley.[22]

Mabel Hobson Draper's fictional re-creation of her mother's and grandmother's lives, *Though Long the Trail,* offers a similar vision of the diversity of life in the Midwest and Southwest in the late nineteenth century. Her grandfather was a freighter along

the overland trails, and her mother's childhood was spent in constant motion—one year living in the relative luxury of Oakland, California, the next on a farm in the Midwest, at last settling in Joplin, Missouri, during a mining boom. Her mother seems destined to repeat this pattern as she and her husband move around in the Midwest and Southwest during the first five years of their marriage. As in Miller's account, it is the woman who longs for a more settled, urban place in which to raise her daughters.[23]

Both accounts are filled with confusion about the appropriate place for women in the regions. Draper's story celebrates the freedom and grittiness her mother developed as a result of her life on the trail, while acknowledging the sacrifices she had to make. Probably the most reflective comment in the book is on New Mexico, where the family moved after failing as farmers in Kansas. Magdalena has beautiful scenery but seems dangerously full of wild animals and wild society. Her mother remembers that she loved the scenery of New Mexico as much as her husband did but remarks, "you can't raise a family on scenery" (86). Draper's account seems finally to insist on the priority of a settled, cosmopolitan life over one lived in a landscape of scarce natural and cultural resources.

Miller describes the same tension but ends with the opposite conclusion. Although Emilie resists the move to the San Joaquin, she very quickly reconciles herself to the landscape, in part because she finds she can help her husband as an equal there. At their nadir, when it appears the San Joaquin will beat them, she helps him grow a corn crop by waiting out the drought. But, once the irrigation system is developed, settlement rapidly increases and she finds herself an urbanite with no equal role to play. Then she looks back with longing to the days of struggle in the resisting land. In the book's dedication, Miller sets the tone for this ambivalence: "To the memory of my grand-mother . . . and my grandfather . . . and those other pioneer men and women of my youth who taught me there was a two-edged truth in that first green blade, harvest of water from the Sierras." Most important, Emilie's solace comes directly from the landscape. The family is reunited spiritually by a camping trip to the Sierras. Living as she did as a settler, Emilie recovers the landscape that has been plowed under:

> The great dome of the stars curved above her as she lay awake. She had not seen so many stars since the days of the pine cabin before the ditch had brought the water and the many trees. She reached out with her hand to touch the dried grasses. Suddenly a sharp scent smote her nostrils, one she had not known for a long time. Camphor weed. It does not grow on plowed ground. With her arms outstretched and the earth beneath, came back the night on the plains. (624)

Much new history of women's lives on the frontier reacts to older stereotypes of pioneer women. One of the basic criticisms of these stereotypes is that their sources are unreliable as history, primarily because early western historians went to men's fiction for descriptions of women's lives.[24] Many scholars now working on women's history in the West have turned to women's diaries and journals as more reliable documents. In their eagerness to insist upon validity of the experiences described there, scholars sometimes fail to acknowledge that diaries and memoirs are acts of the imagination,

revealing dreams and desires as well as reality. They often form a continuum with women's fictional representations of frontier experiences, one that has not been sufficiently explored. In *The Female Imagination,* Patricia Spacks describes the similarities (and differences) in the forms:

> *The ordering of experience in memoir or diary, the implicit assertion that this life makes sense, seems . . . a way for the author to remind herself of the value of her own experience. . . . The issue of freedom looms large in women's fiction as well as more direct forms of autobiography. No more securely than diaries or memoirs do novels reveal how to do it— how a woman is to find freedom for work and for love and to use it effectively—but they multiply the clues.*[25]

To date, Annette Kolodny's is the most sophisticated analysis of the connections between women's fantasies of frontier life and their experiences. She reveals how American women from 1630 to 1860 ordered their experience in diary, memoir, and fiction to provide themselves and their readers with imaginative models of womanhood in order to help women accept and value the forests and prairies they encountered. My method is modeled on Kolodny's, but I found a rather different fantasy developing among women as they encountered the southwestern landscape.

Kolodny finds that women on America's first frontiers in the East and Midwest were able over time to convert imaginatively the lands they settled from desolate wildernesses into domesticated gardens. This conversion process was aided in part by the specific terrain they found in the prairies—a natural landscape of gently rolling hills interspersed with park-like stands of trees. In the prairies, women envisioned themselves in a "ready-made" garden.[26] Thus fantasy and reality interacted to support women's visions of themselves as domesticators. But in the Southwest, as I have shown, the landscape was not so easily converted into a garden; in fact, women in the Southwest tended to place as much value on the surrounding desert as on the ranch and farm oases eked out of the land. In attempting to discover how appreciation for gardens became appreciation for desert, I find Patricia Spacks's observations of how women's imagination works helpful.

Spacks defines *imagination* as "a slippery term, designating a power that penetrates the inner meaning of reality but also a power that creates substitutes for reality."[27] In *The Female Imagination,* she considers women writers from the Duchess of Newcastle to Sylvia Plath, looking at fiction, autobiography, journals, and diaries for evidence of a female imagination, and finding in them "patterns of self-depiction that survive the vagaries of change." One of these patterns is in the way women perceive freedom. Spacks's reading of early to mid-twentieth-century writers such as Stein, Nin, Lessing, and Hellman indicates that these women felt their intellectual power was achieved at the expense of the traditional female power of physical attraction. The trade-off caused deep ambivalence toward their achievements: "Their 'freedom' unnervingly resembles resignation." Spacks posits that "as women approach freedom, they find it receding; as they approach limitation, it comes to look strangely like its opposite."[28]

Spacks's model for how women deal with pressures to move out of traditional roles works well as an explanation of southwestern pioneer women's ambivalence to the

requirements of life in an undeveloped landscape. Required to abandon the power inherent to their separate sphere, unsure of the new freedoms that might be gained out of the pioneer experience, they see the frontier not as a place of opportunity but as a place filled with limitation. The Southwest, with its obvious physical resistance to the typical settlement patterns of the East, exemplifies these limits. What the early women of the region come to celebrate are the humbling freedoms of an arid terrain. Thus, for Nicholl the desert is the most important place to understand because it teaches resigned humility, and with that humility comes freedom.

Southwestern women's writing, then, often seems to have different concerns than those expressed by the women Kolodny considers. These concerns are best described in Annis Pratt's analysis of women writers' use of nature in modern fiction. Pratt suggests that nature as a setting for arrival into full selfhood is as important to women's fiction as to men's, but that each sex has a different relationship to nature. Men come to full sexuality (and full adulthood) through an identification of woman with nature and dominance of both; women, on the other hand, are often faced with the choice between the love of nature and the love of men. The works Pratt considers are filled with the same ambivalence toward freedom that Spacks finds in women writers. Women seek nature not because it offers freedom, but because it offers solace for the freedom women lack in the social world: "Communion with the authentic self, first achieved by the heroine in early naturistic epiphanies, becomes a touchstone by which she holds herself together in the face of destructive roles proffered to her by society. . . . Desiring only to be human, woman is expected to conduct herself in a less than human fashion, and thus she turns to nature, which seems less unnatural, for solace."[29]

In Mary Rak's appreciation of the resistance of the desert to her automobile, in Sadie Martin's understanding acceptance of the desert's reclaiming of the land she once homesteaded, in Emilie's celebration of the smell of camphor weed are glimpses of women turning to nature for relief from the restrictions of gentility. Admittedly, such appreciation for the natural landscape is not the primary theme of any of these writers, or of pioneer women's writing in general, but it offers what Patricia Spacks calls "clues" to the freedom more settled generations may express. The most important aspect of those clues is the growing tendency to turn away from the garden, to look beyond the confines of domestic homes, and celebrate the potential return of a natural world that is not green and not supportive of domestication.

In the four works considered next these changing attitudes toward nature are multiplied. The writers emphasize that pioneer women brought with them not only domestic expectations, but cultural values about how to live in nature and their own way of defining themselves through the natural world. These values helped them adjust to, rather than let themselves be defeated by, the vagaries of life on the difficult frontiers of the Western Plains and the arid Southwest. How the very different values of domesticity and naturism interact in fiction is the subject of the rest of this essay. Both Spacks and Pratt indicate that we should expect to find deep ambivalence as women work their way into new roles despite their nostalgia for the old. They also provide a defense for the use of literature as a way of understanding how the daughters of pioneer women met the future. In the following novels, I look at imaginative literature that moves us

outside comfortable assertions and into new insights. These works refuse to affirm what the audience already believes; in so doing they offer clues to freedom.[30]

Margaret Collier Graham's *Stories of the Foothills,* published in 1895, suggests that after the first burst of settlement women developed a different vision of their roles, although they still looked back to their mothers' notions of women's proper response to the frontier as a resource. Three stories in particular offer heroines who appear in some ways stereotypical young frontierswomen, yet who ultimately reject the ideology that would develop the landscape into a more "fitting" place for women.

In "The Withrow Water Right," Melissa, the youngest daughter of a pioneer mother, is an unlettered but self-reliant country girl who falls in love with an engineer from the city. She displays all the weaknesses for finery and flattery commonly attributed to women but lacks the veneer of gentility required of a truly suitable mate for a nineteenth-century middle-class man. In "Idy," the heroine is the only daughter of a newly settled mother (who is "one o' your chronics") and father. While displaying certain "masculine" characteristics of strength and resourcefulness, Idy is also rather vain about her finery. Committed to her father's temperance stance, she helps him remove wine grapes from his property and refuses to marry a man who cannot give up drink. In "E.M.," another only daughter not only pines over a potential lover in true nineteenth-century Romantic fashion but sacrifices this love to save an ailing brother. She makes this sacrifice by violating codes of gentility, working in the raisin grape fields with a group of men. Each of these women embodies the blend of gentle domestic roles and more masculine characteristics that frontier ideology required of "gentle tamers."

Though she sets up her heroines in standard fashion, Margaret Collier Graham undercuts their domesticity in two ways. First, she makes their domestic virtues seem out of place and somewhat overdone. When Melissa, trying to woo her engineer, changes from calico into more womanly finery, she is described "in all her pink and rigid glory" as "a garish spot of discordant color in the landscape."[31] Idy's mother's illness, initially suggesting gentility under stress, is described as "hysterical egoism" (175). And Em's selflessness, a quality supposedly highly regarded in women, is presented as a forced veneer: "Even a caress wore its little mask of duty with Em" (228).

Second, each heroine experiences a close relationship with the native landscape. Melissa is most strikingly a part of her environment. This fit between person and place draws the engineer to her briefly. The story ends with him now middle-aged, remembering Melissa. He remembers the landscape her presence embodied: "There came over him . . . a memory of sycamores and running water, and the smell of sage and blooming buckthorn and chaparral" (113). Even though Idy is engaged in a classic battle with the community over the development of wine grapes or raisin grapes, she also values the natural, preexisting landscape. At one point her would-be fiance tries to shoot an ibis, beautifully described by Graham, in order to give Idy some feathers for her hat. He earns from her "a look of radiant contempt" (172). Em finds solace and companionship in the environment as she picks raisin grapes: "The girl worked on without faltering, looking down the valley now and then through a blur that was not haze, and seeing always something there that dulled the pain of her loneliness" (224). Women are at their best when they respond directly to the preexisting, undeveloped natural environment

and at their worst when they deny that environment in favor of some preconceived, ideological vision of women's role.

Graham does not romanticize the lives these women lead, for she is writing about scarcity—about make-do, limited lives. Although the stories contain beautiful descriptions of landscapes, Graham is careful to warn her readers away from supposing the southern California frontier to be a garden. Living in cultural scarcity may tie the women more closely to the natural environment and engender in them an appreciation of its beauties, but the lack of opportunity for social interaction also limits them and, from a social standpoint, can coarsen them. In "The Withrow Water Right," the engineer makes a romantic object of Melissa, seeing her as "a fitting central figure in the soft blur of the Millet-like etching of which she formed a part" (98), but Graham is careful to balance this artist's vision with reminders of the girl's limitations. In "E.M.," the environment of scarcity pointedly matches the limited opportunity available to settlers' girls: "The mountains which hemmed in the little valley were a deep, velvety blue in the morning light. Em looked at them with a new throb in her heart. . . . The valley was wide enough for Em's world—a girl's world, which is hemmed in by mountains always, and always narrow" (218).

Such description challenges traditional assumptions about women's responses to the frontier landscape. Generally they are seen bringing a rich culture to a bleak frontier, opening that environment to cultivation and civilization. But Em's cultural resources match the natural environment and make a landscape of scarcity an appropriate place for living out her life. Graham's stories subtly criticize the ideology informing women's lives while valuing the "uncivilized" landscape.

Dorothy Scarborough's *The Wind,* published in 1925, a generation after Graham's work, provides a much more open critique of the ideology as a southern belle is literally suffocated by the demands of the west Texas landscape of the late nineteenth century. On first reading, the novel seems to refute the image of western women as steady, fearless, undaunted helpmates to their competent pioneer spouses. The "heroic women of the west" form the historical backdrop for the heroine's slow slide into insanity. They are the measure against which she fails. Until orphaned and sent West, Letty had dwelled among those "living tranquil lives, waited on by servants, keeping an exquisite daintiness of body and mind, in spacious, leisured ease and comfort. . . . How should she ever fit into this difficult scheme of things wherein a woman was expected to be a pioneer."[32] Forced into a loveless marriage, isolated in a one-room shack, stressed by drought, she at first attempts to turn the landscape into one fit for civilization—papering the walls with newspapers and covering the tables with old clothes. When such efforts to transform the landscape fail, she retreats into fantasies of her southern home.

One reading of the text would see the rigors of the landscape as the primary agent in Letty's decline. She believes the wind wants her, destroys her chance at living in west Texas, and will ultimately overwhelm her. The wind is seen as a destructive, malevolent, and masculine force that had to be tamed so women could live in Texas. A prologue introduces the story, placing it in the past: "In the old days, the winds were the enemies of women. Did they hate them because they saw in them the symbols of that civilization

which might gradually lessen their own power? Because it was for women that men would build houses as once they made dugouts?" The question then becomes, "How could a frail, sensitive woman fight the wind?" (3). Thus the book sets out to tell the by now classic tale of female civilization intruding into the masculine wilderness.

What destroys Letty is not the land itself but her rigid resistance to it. She looks at the drought-wrecked place and sees only what it lacks, only the ways in which it is not the South. This interminable longing for that other place is a symptom of her unwillingness to give up her old life of gentility and domesticity. The natural landscape must be able to support the sort of built landscape from whence she came; only then can Letty live. Thus the lack she experiences is not as much in the land as in herself. Rather than bringing a richness of cultural resources to make the desert bloom, Letty brings "frail sensitivity" and no skills. The resources she requires are not only strength and ingenuity but an acceptance of the natural and built landscape of the west Texas plains.

Cora, the Westerner who married Letty's cousin, embodies all the resources Letty lacks. Cora in fact seems to derive her strength and beauty from the landscape: "It was as if the boundless energy of the plains, the stored-up vigor of the long centuries that had waited for human life to inhabit these prairies, had expressed themselves in her" (77–78). Cora's roots are all in the West, she looks to no other landscape for sustenance. She describes her love for her husband, Bev, in terms of the environment: "Bev's the whole world to me. I love him like a cyclone. And I love him, too, the way the prairie feels when it's still and calm at night, when the wind don't blow an' the spring flowers are in bloom and the stars shine soft" (125).

Just as Graham was careful to point out the problems in women's lives built on such a wilderness landscape, so Scarborough notes the limitations the landscape engenders in Cora. Cora may be strong, ingenious, and beautiful, but she is also selfish, harsh, and hemmed in by her limited surroundings. Letty asks: "was she like nature herself, contemptuous of weaklings, impatient and disregardful of others less capable than herself?" (78).

Cora is different from Letty in the ways settlers are different from travelers. Both carry visions of the landscape in their heads. Under the stress of a new or difficult environment, both look to those other landscapes for sustenance. Letty's other landscape is the place she left; Cora's is west Texas in its benign seasons. Cora has lived in the place long enough to know both the beauty and terror of the land. Although she suffers with the rest during the drought, she knows the lushness that the rain can bring and holds that other landscape in her memory. It is a natural landscape evoked beautifully throughout the book by several characters, especially by Lige, Letty's husband. He tries to help Letty see the plains as they will be when the drought breaks: "It makes you feel you own the universe to be on a horse on these prairies when the spring flowers are blooming and the Sonora doves are talkin' soft and sympathetic to each other, and the little desert wrens are flyin' round, and the field-larks are sailin' high into the sky, droppin' music down like a shower o' melody" (55–56). Just as Margaret Collier Graham balances the romance of the western landscape with the life of scarcity it often implies, so Scarborough crafts a work balanced between beauty and harshness. Letty can never quite reconcile the horrors of the wind with the magnificent sunrises and sunsets of the

west Texas plains. She is destroyed because she never understands how the whole environment works. Cora achieves such reconciliation and wins a victory in, not over, the place.

Scarborough does not simply create a tension between the pampered southern belle and the heroic western pioneer. Cora is no more heroic, in the traditional womanly sense of selflessness, than Letty: Cora exemplifies the difference between strength defined as a passive endurance and resistance and strength defined as active acceptance and appreciation. Letty hopes to be able to endure the plains until she can return "home" or turn them into a model of home; her attitude mirrors much of the documented experience of the initial settlers. Cora is a new force. From settled stock, she defines the West as home and loves the landscape on its own terms. Contrary to earlier proscriptive stereotypes of women's roles in the West, Cora does not want to build the region into model gardens or towns. She is not even concerned with building a traditional family.[33] Such attitudes do not, however, make her a retrograde slut, wasted farmer's wife, or masculinized woman, but the sort of woman the West engenders, who expects to live and knows the next generation will live in a world of scarce resources, accepting and loving that southwestern landscape.

Scarborough's focus on Letty, the woman who cannot survive in a natural environment of extreme deprivation, criticizes the limitations, the scarcity of resources if you will, allotted to women by the cult of true womanhood. *The Wind* is similar in striking ways to Charlotte Perkins Gilman's *The Yellow Wall-Paper*. Gilman, however, offers no victorious women in her highly civilized, suffocatingly cultured society. Scarborough's Cora blazes forth in *The Wind*, promising a way out for women, an escape from debilitating restrictions in the very landscape that makes them so apparent.

In Frances Gillmor's *Fruit Out of Rock*, written in 1940 and two generations removed from the initial settlement experience, the heroine becomes that western woman and the "frail, sensitive" creature who cannot remain sane in the desert landscape all but disappears. Although the novel is set in the late 1930s, the settlement period of the 1880s and 1890s is the measure against which the characters live.

Initial glimpses of the heroine, Amanda, recall the girls Margaret Collier Graham created fifty years earlier. The only daughter of a dying father and a city-crazed brother, it is her duty to stay with the ranch while the brother goes off to seek his fortune. Although she has neighbors, there are no young men to ease her social isolation. Amanda is strong and resourceful, capable of handling her restricted life. Only when she sees a romance developing between her brother and a neighboring girl does her limited environment seem oppressive. She turns to the natural landscape for solace in a fashion Graham and Scarborough suggest can happen: "A big blue heron rose in front of her, slowly, heavily, as if the lethargy of summer were in his wings. . . . She walked faster, crossing the stream knee-deep in cold water, feeling the drag of it cool and strong around her legs. She went on, thinking of the heron. Around the next bend the blue wings would lift again heavily. Her mind centered on the heron—blue and slow."[34] She strips and swims in the river that flows through the canyon: "When she started back down the canyon, the taut weariness had slipped from her. Loose and effortless, she felt her arms and body swing to her stride. . . . She was neither happy nor unhap-

py; she was hardly thinking; she was walking and alive" (28). Like Melissa in "The Withrow Water Right," Amanda seeks self-forgetfulness in the natural environment. She gains this distance by merging with the place, matching her rhythms to those of the canyon.

Gillmor's description of the Arizona canyon strikes a balance between the lushness and fertility of the canyon bottom and the desert which surrounds that cool, garden world. Amanda, through her tutelage by the original settler of the canyon, Abel Bane, knows that her small fruit farm can easily return to desert. *Fruit Out of Rock*'s story is of Amanda's choice between preservation or destruction of this environment.

The potential destruction comes in the guise of a lover, a goat herder from the top of the canyon. Stephen appears in Amanda's life at a time when sexual frustrations peak; he also arrives at a critical period for the natural landscape—a drought has dried up water above the canyon, the grasslands are dying, and the goat ranchers are without feed. Stephen sees the lush green of the canyon as a place of refuge for his goats; Amanda realizes the animals are destroying its fragile ecology (206). Finally, she is caught by the restrictions of a woman's life. She asks Stephen to give up his goats and become a fruit farmer; when he will not (partly out of masculine pride, partly because he is as tied to his way of life in the landscape as she is to hers), she succumbs.

Her choice is complicated by remnants of the nineteenth-century vision of woman's role, woman's sphere. She is seconded in her battle with Stephen by her mother and Abel Bane. Resisting him is thus a matter not only of ecology but also of allegiance to family. She reconciles the conflict in a memory of her mother's own choice to break away from her family, make "her way west with her husband to the unknown [and bear] her children in a mountain canyon" (230). Thus she sees herself reliving the initial settlement experience as she agrees to move with Stephen and the herd if the drought does not break; if necessary, she will live with him in a cave and raise children in the wilderness. She even begins to envision a frontier sort of domesticity, planning to take "one of the bright quilts which her mother had made up to the painted cave. She would have some potted plants there to make it gay" (231).

When Stephen begins cutting trees to feed his goats, she knows that the canyon settlement will not survive even when the rains finally do come, for Stephen has cut back Abel Bane's carefully planted flood break. While Stephen, the migratory herder, plans for their future, Amanda the settler knows that they really do not have one (237). In the end the floods kill Abel Bane and Stephen as they try to save the ranches.

Gillmor draws no clear distinction of right and wrong in this novel. Rather, she points the reader toward an awareness of how one must live in the desert—never forgetting that it is a land of scarcity. Abel Bane was as much deluded in his attempt to create a permanent oasis as Stephen was in his refusal to abandon his herd. Victories of civilization over nature in this land are temporary and cyclic. This is the lesson of its history—a history of lost civilizations and boom-or-bust mines:

> *The day was gone when the Spaniards had brought their horses and cattle, and, while the Apaches watched them from the high cliffs, marched through the canyon, leaving the boast—"There is no knowledge that anyone else has passed through here"; when the*

*Mormons had passed the mouth of the canyon . . . establishing their towns in the places to which they had been called; when the American soldiers had built the fort which now was washing back to earth with every rain.* (66)

Settlement in such a landscape of temporary civilizations is a chancy matter. Amanda understands this at last when she tells her mother that both Abel and Stephen were right—the land simply did not support them. In another year, another generation, the coexistence of goats and canyon life might have worked.

Gillmor also refuses to blame the land itself. The desert is not evil or malevolent, as the wind comes to be for Scarborough's Letty. As the older Texas settlers continually comment in *The Wind*, in this landscape "all signs fail"; the environment refuses to be objectified—either into a beautiful garden or a hellish place. Appreciating that resistance to human designs, understanding the limitations it places on the lives of settlers, Amanda chooses to remain on the flooded ranch and rebuild. Twice she is offered the choice to move into town and become a teacher, but she refuses that civilizing occupation. Instead, she sees her future in her mother's past: she will cultivate the ranch again (with the help of her mother and the child Amanda carries). The conclusion of the book expresses this willingness to continue the ways of the earlier settlers, to salvage what she can from the destruction and nurture the land again: "We can cut back the leveled peach trees . . . and set them out again here" (269). The point is not that Amanda retreats to the garden, but that she resists a lifestyle that would deny what she has come to see as the natural rhythms of growth and decay in the land she inhabits. Amanda loves and respects the whole environment, not just what is amenable to domesticating intentions.

Patricia Spacks's comment that women's writings convey resignation certainly applies to these three works. Each provides a lesson in humble freedoms. None of the heroines wins and keeps the man of her dreams or achieves many domestic luxuries, but each is left free to pursue a valued life in the natural world. Until the 1930s, Amanda's choice of small-scale farming over city life was realistic. The 1930s and 1940s, however, were a watershed period in the region. After World War II the Southwest changed so radically that lives like Amanda's were the stuff of grandmothers' nostalgia, not real possibilities for twentieth-century heroines. The Southwest of the last forty years is composed of agribusiness, urban oases, and federal lands.[35]

Joan Didion writes eloquently of the difficulties great-great-grandchildren have finding their pioneer roots in this new Southwest. Of her own connection to California, she says, "It is hard to *find* California now, unsettling to wonder how much of it was merely imagined or improvised; melancholy to realize how much of anyone's memory is no true memory at all but only the traces of someone else's memory, stories handed down on the family network."[36] Maria, Didion's heroine in *Play It as It Lays,* was born in the 1930s, the time when Gillmor's Amanda commits herself to farming. *Play It as It Lays* is another celebration of desolate landscapes and the domestic arts of "making-do" in such territory. Maria relates what she has learned to keep herself from committing suicide in the urban landscape of 1970s America: "I used to ask questions, and got the answer: nothing. The answer is 'nothing.' Now that I have the answer, my

plans for the future are these: (1) get Kate [her young daughter], (2) live with Kate alone, (3) do some canning, Damson plums, apricot preserves. Sweet India relish and pickled peaches. Apple Chutney. Summer squash succotash."[37] The route to this seemingly contradictory statement is through the surviving remnants of the natural landscape of the desert Southwest and the accrued memories of women's lives in that region.

Although Maria lives the ultimate urban life—she is a resident of Hollywood and drives the freeways with skill and courage—her modern Southwest contains the same tension it always has. She lives in a fabulous land of wealth and power, but always in peril, threatened by destruction. Didion offers visions of wealthy men and women, health spas, fast cars, and expensive lifestyles. The culmination of this vision is not Los Angeles or Las Vegas (both of which figure in the novel), but Hoover Dam. Visiting the dam, Maria is overwhelmed by the man-made miracle of so much water-powered electricity in the desert (170). The wonder of Hoover Dam harks back to Susan Parrish's comment that the Southwest was the end of the rainbow—the source of gold (and power). By the mid-twentieth century, Didion realizes, the Southwest had fulfilled the dreams that brought the first pioneers across the plains.

The region also suggests impermanence, temporary human occupation, and age-old perils. The novel begins with an image of one of the most common dangers of the Southwest (and one of women's mythic fears), "a pygmy rattler in the artichoke garden" (1). Maria is haunted by classic fears of pioneer women—especially the peril to children of the "rattlesnake in the playpen" (99). Desert dwellers fight entropy as well. At one point Maria becomes friends with a woman who lives the new settler's life and continues the battle for permanence: "The house was on the edge of the town, a trailer set on a concrete foundation. In place of a lawn there was a neat expanse of concrete, bordered by a split-rail fence, and beyond the fence lay a hundred miles of drifting sand" (197). The woman spends her time sweeping sand back outside her fence. Silver Wells, the desert town in which Maria grew up, has disappeared. An actress and the wife of a film director, Maria spends much of her life in motels—those ultimate landscapes of cultural scarcity.

Commenting on life in Los Angeles, Didion notes the importance of understanding environmental determinism: "Los Angeles weather is the weather of catastrophe, of apocalypse, and, just as the reliably long and bitter winters of New England determine the way life is lived there, so the violence and unpredictability of the Santa Ana affect the entire quality of life in Los Angeles, accentuate its impermanence, its unreliability. The wind shows how close to the edge we are."[38] Such determinism forms much of the point of *Play It as It Lays*. Just as other writers recognize the preexisting landscape as a first priority, so too does Didion. Even in fantastically rich southern California the denial of human occupation remains important. Out in the desert, on location with her ex-husband, Maria comes to an understanding of the importance of the natural landscape. While the others film themselves, she notices that "the light had changed on the dry wash. Tomorrow she would borrow a camera, and station it on the dry wash for twenty-four hours" (201).

Against this desolation, Didion plays out the traditional roles assigned men and

women, and they remain similar in striking ways to those of the late nineteenth century. Men make the money and define the culture, including the parameters of women's culture. Women's culture is separate, centered on a leisurely gentility reflecting their husbands' success. Reminiscent of the nineteenth century's separation of spheres, we learn about women who plan "restorative weeks at Palm Springs and La Costa," women "with the silk Pucci shirts and the periodically tightened eye lines and the husbands on perpetual location" (43–44). Maria reluctantly acknowledges the objectification women's roles entail in this wealthy, "cultured" world.

Gradually, Maria moves away from the fabulous society of contemporary Los Angeles and lives more and more in the past she inherited from her mother and father—a past always in sight of the dry river beds of the Southwest. Recounting her youth, she notes that they were in a constant state of motion and failure: "We had a lot of things and places that came and went, a cattle ranch with no cattle and a ski resort picked up on somebody's second mortgage and a motel that would have been advantageously situated at a freeway exit had a freeway been built" (3). At first rejecting the crazed optimism with which her parents lived their lives—the boom-or-bust mentality stereotypical of frontier families—she finally finds meaning not in the "boom" aspects of the dream, but in the skills her parents (particularly her mother) had for surviving the bust.

Searching for the strength to get through an illegal abortion, Maria returns to the world of her pioneer forebears. Seeing newspapers on the floor of the room in which she is to have the abortion, she remembers they are antiseptic: "to deliver a baby in a farmhouse you covered the floor with newspapers." She also recalls that newspapers can be sewn to a blanket to make a warm quilt. Suddenly she realizes that, thanks to her mother, she can survive any disaster. The memory of her mother's belief in an educated approach to the threatening landscape ("splints, shock, rattlesnake bite, rattlesnake bite was why her mother made her read [The Red Cross Handbook]," 80) releases her somewhat from the guilt of the abortion. What she remembers then is her mother's strength and ingenuity, not whether she succeeded in changing the landscape.

In fact, Maria's mother symbolizes the ultimate defeat of culture by the desert. She dies alone in an automobile wreck outside Tonopah, Nevada. No one knows why she was in Tonopah or where she was going, only that "the coyotes tore her up before anybody found her" (6). Thus the region continues to challenge women with visions of personal peril, isolation, and obliteration.

Only one other character in the novel—B.Z., a film producer—understands the futility of creating a sophisticated culture in this place. B.Z. kills himself; Maria survives. She survives by returning to a female culture (albeit one that exists more as memory than as reality) based on making do with the least resources in a landscape in which "all signs fail": "I concentrate on the way light would strike filled Mason jars on a kitchen windowsill. I lie here in the sunlight, watch the hummingbird. This morning I threw the coins in the swimming pool, and they gleamed and turned in the water in such a way that I was almost moved to read them. I refrained" (213). Refraining from reading the coins, Maria counters her father's faith in the search for gold at the end of the rainbow with her mother's faith in traditional female culture. Attractive as her

father's gambling mentality remains, Maria's reason for continuing to live in the Southwest comes out of female culture, not male. More important, it comes from female culture adapted to the limitations and perils of the given landscape, not out of the contemporary cities built by those pioneer forebears. That Maria offers this resolution and discusses her future while confined to an insane asylum continues the questions raised by earlier writers about the price of "freedom."

In concluding *The Land before Her,* Kolodny indicates what adjustments may be made to women's stories of Edenic gardens as they move further West, cross the "Great American Desert," and have more opportunity to farm and ranch on their own: "the postbellum Eve of California and Oregon, the Dakotas and the high plains, soon spoke in the voice of *both* adventurer *and* domesticator, asserting a garden wholly her own. Indeed, just as Eve had once been edited out of the wilderness, so now Adam would become superfluous to the homesteaded Eden."[39] In the conclusion of *Play It as It Lays,* the men have all disappeared. B.Z. is dead, Maria's husband, Carter, is gone, and she cares only about the future with her daughter. At the conclusion to *Fruit Out of Rock* the men are also gone: Amanda's father, lover, and teacher are all dead; her brother has moved to the city. She and her mother inherit the natural environment. Cora in *The Wind* knows more about how to live in the west Texas landscape than does her southern-bred husband Bev, who came West for his health. His strength and ability to survive the rigors of the place are continually in doubt, leaving Cora ultimately responsible for the family's ranch. Each girl in Margaret Collier Graham's stories is deprived of a strong, capable, pioneer father: Melissa's father had abandoned the family and is killed in the course of the story; Idy's father suffers from consumption and may die at any time; Em's father is long dead. In effect, each is left without the primary resource of pioneering women—the men who supposedly chose this adventure of life in the wilderness.

In denying her characters men, each author tests the tradition at the heart of the western experience by fantasizing a different place in it for women. Such an imaginative warping of experience provides both limitations and freedoms. Forced to fend for themselves, these women become devoted to the process of creating life in a landscape of scarcity. Although their characters occasionally lapse into attitudes of gentility, these authors do not value domesticity as a goal. They value the process of survival; part of that process is coping with the stress that frontier life places on efforts to lead a genteel, sheltered life. Thus the "freedom" in which Letty had lived her life in the South comes to look horribly restricted as she compares herself to Cora, who wrenches a certain beauty out of life in a drought-stricken, isolated landscape. Perhaps the best image of this process is Didion's own description of her goal in writing *Play It as It Lays:* "to write a novel so elliptical and fast that it would be over before you noticed it, a novel so fast that it would scarcely exist on the page at all. . . . Empty space."[40] Here is an ultimate statement of freedom garnered out of the silences, restrictions, and subterfuges of women's culture and determined by the light and space of the southwestern landscape.

Spacks's comment offers a fitting refrain: "as women approach freedom, they find it

receding; as they approach limitation, it comes to look strangely like its opposite." We experience as much ambivalence toward lives like Maria's and Cora's or fictional forms like Didion's as we do reading frontier diaries or looking at quilts. On one hand we value the hard-earned beauty achieved, on the other we are dismayed at the price.[41] Didion herself reminds us that women keep quilts and other family mementos not only out of deep regard for the strength and ingenuity of their makers but also as exemplars of the limitations such artifacts signify. In a speech describing the pioneer women of her family as pragmatists, she notes their willingness to move away from relations, friends, and home, but also comments on their tendency to eccentricity and even insanity when confronted later with time for meditation on the meanings of such dislocations.[42] Even in the late twentieth century, the freedom we want to see in pioneer women's mobility, in their ability to take the scraps of their lives and turn them into a crazy-quilt, is mixed with deep doubt about the stabilizing social role that was lost in the process.

Perhaps such ambivalence stems from the fact that, in the Southwest, women not only have to "edit" men out of their fantasies, they also have to edit out received traditions of the domestic garden. They have confronted the darker aspects of the Edenic tale—"the pygmy rattler in the artichoke garden"—and adjusted their fantasies to include wilderness as well as cultivated land. Gradually, women of the Southwest come to question male fantasies of dominance, not because they see the landscape as an already-tamed paradise, but because they recognize its resistance to such manipulation. Linking the domestication of wilderness to their own domestication, they find freedom in the harsh, demanding terrain they encounter. Here, men are superfluous not only because women are fully capable of exploring and settling a new frontier, but also because the basic meanings of exploration and settlement, coming from masculine concepts of discovery and dominance, are changed. Thus, the Anglo Eve in the Southwest spends her time on the border between the wilderness and the garden, celebrating the paradoxical freedom the former offers her while confronting its threats to the security of the latter.

Finally, the works considered here help us around an issue currently the subject of intense debate among feminist scholars. While some, like Patricia Spacks, celebrate the victories within limitations that creative women have achieved, others are worried lest scholars encourage such limited voices by "misguided" appreciation. Elaine Showalter and Carolyn Heilbrun have both expressed such concern.[43] In a statement particularly pertinent to this study, Heilbrun argues that we must be careful not to find too much value in the restrictions placed on women's lives. "Men, taking unto themselves all adventure, leaving women each other, the children, and the laundry, will further enslave women if women identify all adventure as 'male' and not for them. . . . If women forfeit the culture men have dubbed 'male' when it is, in fact, human, they will have deprived themselves of too much."[44] My reading of women's responses to the Southwest suggests that we may not need to engage in such either/or debates. These women have, over time, come to their own appropriation of a very human adventure—the encounter with a challenging natural environment—through (rather than in spite of) many of the restrictions in their lives. That their adventures deny aspects of both "feminine" domesticity and "masculine" dominance renders the lessons learned from

their accounts all the more valuable. Too often in historical and literary scholarship, Anglo women have been frozen in an attitude of resistance to challenging natural landscapes. They are used as the motive behind male manipulation and destruction of the natural world.[45] In order to move beyond these stereotypes we do not necessarily need to find female Daniel Boones playing out a male adventure. What we do need to find, and what I found in the literature of the Southwest, is women appreciating, protecting, and preserving the natural environment, using it as a place in which to mature and to find the resources to cope with the limitations of their culture, which experience constitutes one of the most laudable *human* adventures we have yet discovered.

# Tradition and Mythology

## SIGNATURES OF LANDSCAPE
## IN CHICANA LITERATURE

*The Hispano has almost vanished from the land and most of the chapels are nonexistent, but the names of hills, rivers, arroyos, canyons and defunct plazas linger as monuments to a people who pioneered into the land of the buffalo and the Comanche. These names have undergone many changes, but are still known and repeated. Very likely many of those who pronounce them daily are unaware that they are of Spanish origin. —Fabiola Cabeza de Baca,* We Fed Them Cactus

These are the words of Fabiola Cabeza de Baca, writing in the 1950s about New Mexico. She centers her feeling about the land and the landscape both on a sense of loss and on the enduring, underlying Hispanic stamp upon that landscape, seen here as Spanish place names and plazas.[1] So too have Hispanic/Chicana women writers survived and endured. The signatures of their landscapes, both interior and exterior, are a monument to their survival, sense of self, and identity. They use the power of their perceptions of the landscape to transmit this sense of identity: one that is female, Chicana, and deeply connected to land, myth, and self. In their writings they have discovered the ability, the magic of words to capture their heritage and transform it through images.

In the literature written by early Hispanic women writers about the Southwest, the land is called *la santa tierra* (holy or blessed land). Many popular Anglo writers of the nineteenth and early twentieth centuries saw the land as virgin territory without traditions and roots, a land representing primal freedom, a land to be imagined and created by their own hands. Hispanic writers had a different sense of the southwestern landscape; for them it meant a long tradition of families not only tied to the land but

96

nourished by it. Historical referents did not come from the American East, with its large cities and materialistic concepts of progress, but from the land lying south of the border and a past in which the American Southwest belonged to Mexico. The land exemplified a heritage and a tradition in conflict with dominant Anglo values. Early writers identified the landscape with loss: of culture, of traditions, of language. Recent writers have looked to the rich and varied heritage of the past to find a regenerative and transforming sense of identity in the present and for the future.

The writers discussed in this chapter fall into two generations. Hispanics of New Mexico writing in the first half of the twentieth century and oral histories of Hispanic women of Arizona living in the same period are contrasted with the generation of writers publishing after the Chicano Renaissance in the 1960s.[2] Between the two generations value systems changed: working- and middle-class women began to write where before mostly educated upper-class women were writing; in the first generation the emphasis was only on Spanish culture, but in the second a pride in the combined Indian and Spanish heritage became much more dominant. The first generation of women writers still generally perceived themselves as Spanish; the second generation saw themselves as Chicana. There is a vast ideological and political gulf between these two terms,[3] but the new generation continues to feel links and connections to its past, its values and traditions. The first generation foreshadows what is to come. Both link their culture, values, and history to the landscape.

The term *signature* means a "personal unique mark that connotes a specific pattern of human expression by its author." A signature in landscape, therefore, is its unique distinguishing feature or features as an individual or a group modifies the landscape. These features are significant within the group or individual creation. They are a "comment in space," and studying them gives us better insight into the nature of their creators. Signatures, or unique features in a landscape, can range from "predominantly visual features, such as settlement patterns, house types, gardens or clothing, to more subtle manifestations, such as types of entertainment and cuisine. All of them share a common bond: they serve as cultural or individual hallmarks."[4] Culturally diverse patterns can be identified and examined through these features. As distinctive signatures in the landscape of Hispanic/Chicana writers, I particularly want to examine the perceptions of the desert and its plants, domesticated flowers and gardens, the cactus, and the figure of the *curandera* (healer) as the mediator between nature and human beings. These signatures are common to many Hispanic and Chicana women writers of the Southwest, and they provide a thread linking the different generations as well as a signal of changes that have taken place in the intervening years.

Until the Chicano Renaissance of the 1960s, Mexican-American women writers were marginalized.[5] Theirs has been called a heritage of silence. Little information is available about early Hispanic women writers, but in the 1930s, 1940s, and 1950s several books were published by New Mexican Hispanic women writers dealing with local customs, foods, history, and folklore. These books take the guise of first-person accounts incorporating stories or tales of older relatives or acquaintances, thus extending the "personal" narrative further into the past. The Federal Writers Project, active in New Mexico in the 1930s, awakened in these women a sense of the value of Hispanic

folk histories and culture. The three writers considered here, Fabiola Cabeza de Baca, Cleofas Jaramillo, and Nina Otero Warren, came from old, landed, upper-class New Mexican families, and their stories reflect these class origins. They generally extol the Spanish (not the Mestizo or Indian) heritage, and see the past as a utopia in the pastoral tradition where human beings were integrated with nature. Their perspective was not unique; it was also the prevailing attitude among male writers of the time.[6]

Otero Warren concentrates on quaint folkloric vignettes praising the lost Spanish heritage. Her book *Old Spain in Our Southwest* (1936) evokes days of gay caballeros, fiestas, and señoritas. The past is greatly romanticized and stylized, yet she also feels change and loss as she describes the people and the region near Santa Fe: "This southwestern country, explored and settled nearly four hundred years ago by a people who loved nature, worshiped God and feared no evil, is still a region of struggles."[7] She envisions the Indian as well as the Hispanic shepherd as integrated with nature both in religious belief and in understanding of the land. But she is on the fringe, longing for the sense of integration denied her, in part because she is a woman, but also because she represents a culture and class in a state of transition. Her desire for a utopic integration is expressed when, inside her small adobe house on the top of a hill, she watches a storm's effect on landscape and people:

> In the only room of my house, a melancholy candle was flickering as if gasping for breath. . . . I had a feeling of vastness, of solitude, but never of loneliness. . . . The night was alive with sounds of creatures less fearful than humans, speaking a language I couldn't understand, but could feel with every sense.
>
> In the night the storm broke, wild and dismal. The wind hissed like a rattler, and as it struck the branches of the trees, it made a weird sound like a musical instrument out of tune.
>
> At dawn, the clouds parted as if a curtain were raised, revealing the outline of the mountains. The hush following the storm was tremendous. . . . As the shepherd was extinguishing the camp fire, there appeared on the top of the hill a form with arms stretched to heaven as though offering himself to the sun. The shepherd from his camp and I from my window watched this half-clad figure that seemed to have come from the earth to greet the light. A chant, a hymn—the Indian was offering his prayer to the rising sun. The shepherd, accustomed to his Indian neighbors, went his way slowly, guiding his sheep out of the canyon. The Indian finished his offering of prayer. I, alone, seemed not in complete tune with the instruments of God. I felt a sense of loss that they were closer to nature than I, more understanding of the storm.[8]

Otero Warren begins her book with admiration for these "simple" people who have more understanding of nature than she does, thus communicating her own sense of separation from the landscape, illustrating her feelings of alienation and isolation in a time of transition.

Her work and that of other New Mexican writers has made some contemporary Chicano critics, interested in more political social commentary, shudder. Raymond Paredes, in a generally perceptive study, condemns these early accounts, claiming that

the writers had a "hacienda" mentality, ignored social concerns, and lacked interest because they were too sappy and genteel:

> *The Mexican American literature in English that emerged from New Mexico during the 1930s evokes a past that, while largely imaginary, is presented with rigid conviction. . . . The writers described a culture seemingly locked in time and barricaded against outside forces. Here the New Mexico Hispanos pass their lives in dignity and civility, confronting the harsh environment with a religiosity and resolve reminscent of the conquistadores themselves. . . . There is something profoundly disturbing about this body of work. It seems a literature created out of fear and intimidation, a defensive response to racial prejudice, particularly the anglo distaste for miscegenation and ethnocentrism.[9]*

Paredes is one of the few male Chicano critics to deal seriously with early women writers. But he is very harsh toward them, overlooking perceptions that contrast with the "romantic" view. Moreover, he views these writers with the social sensibility of the 1960s, criticizing them for internalizing the class, sexual, and racial attitudes of their culture. Most Hispanic women had no education and even those who did had little leisure to write. Nor were they encouraged to write; they were confined to fairly rigid gender roles, carefully watched and cared for. It is a wonder they wrote at all.

If in Otero Warren's book most things of value are presented as Spanish in origin, one must look at her work as an early attempt to preserve in literary images a vanishing way of life. All the narratives written by these women are valuable in their preservation not only of accounts of folk life but more particularly of the customs women thought important to record, for accounts of the lives and duties of women were not usually included in male writing. These texts were among the first attempts to make such records against the overwhelming dominance of Anglo culture and language and against patriarchal norms. This is even more true of *We Fed Them Cactus* by Fabiola Cabeza de Baca and *Romance of a Little Village Girl* by Cleofas Jaramillo. A careful reading of these two texts reveals a concern with the economic and social fortunes of all Hispanic New Mexicans living through the change from Hispanic to Anglo New Mexico. The transformation from the stable society in which they had been born is recalled in their memories and shadowed by their perspective on the landscape. Both Cabeza de Baca and Jaramillo use landscape to reflect changing cultural values.

The title *We Fed Them Cactus* is itself symbolic. The cactus appears as a central symbol not only for Cabeza de Baca but also for many women writers of today. The cactus holds water in reserve over times of drought and protects itself with thorns. The plant itself can be eaten and its fruit (*la tuna*) is delicious. *We Fed Them Cactus* refers, on one level, to the fact that, in the drought of 1918, Hispanic farmers fed cactus to their cattle to help them survive. On another level, it refers to the Hispanos themselves as survivors able to weather misfortunes. The book, then, is an account "of the struggle of New Mexico Hispanos for existence on the Llano, the Staked Plains."[10]

Fabiola Cabeza de Baca contrasts past tradition and present reality in New Mexico. Her book covers the arrival of the Spaniards in New Mexico in colonial days, buffalo hunts and the Comancheros, her family's establishment on the land upon receiving a

land grant near Las Vegas, New Mexico, the loss of the country to the Anglos in 1848, her childhood, the arrival of homesteaders, the destruction of the land through plowing and overgrazing, the loss of the land by the Hispanos, and the loss of a traditional way of life. At the beginning of the book she describes the New Mexico landscape as a rich, nourishing, fruitful Garden of Eden, a varied topography with hills, wooded lands and sweet springs gushing from secluded places even though rain is scant. It is a land to be appreciated and valued solely by those who possess it spiritually:

> *From Cañon del Agua Hill to Luciano Mesa, the vegetation includes juniper, piñon, yucca, mesquite, sagebrush, grama and buffalo grasses, as well as lemita, prickly pear, and pitahaya. There are wild flowers in abundance, and when the spring comes rainy, the earth abounds in all colors imaginable. The fields of oregano and cactus, when in full bloom, can compete with the loveliest of gardens.*
>
> *It is a lonely land because of its immensity, but it lacks nothing for those who enjoy Nature in her full grandeur. The colors of the skies, of the hills, the rocks, the birds and the flowers are soothing to the most troubled heart. It is loneliness without despair The whole world seems to be there full of promise and gladness. (1–3)*

This paradise not only has a plenitude of sweet water, but the plains are seen as "fields" of herbs and cactus, domesticated and accessible. The land thus functions as a place of nourishment and cultivated beauty. Surely the cactus would not have presented the same image to someone not raised in the Southwest. Cabeza de Baca's attitude also reveals adaptation to the flora and fauna of the region. In the not too distant past, the area had been savage wilderness. In "the days of the buffalo and the Comanche, the Llano was uninhabited and dangerous" (3–4).

The houses of the early Spanish settlers in north central New Mexico were built as fortresses to protect both people and animals. In 1821, when Mexico gained its independence from Spain, protection from the Indians was no longer available, and the lands around the settlements became depleted from overgrazing. The ranchers then moved eastward with their sheep and cattle to the Llano and Ceja country (near Las Vegas) and found the "promised land":

> *There, where the mountains end and the plains begin, they found grama and buffalo grass growing as tall as the cattle. The best pastures were on the Ceja, the Cap Rock areas at the top of the Staked Plains. . . . To one living on the American plains of the Middle West, so level and flat, the land on the bluffs of the Staked Plains, with its rocky hills, juniper, mesquite, and piñon may not seem a Llano, but to New Mexicans, because of the drop of two or three thousand feet from the peaks, it is not the Sierras, and they have called it the Llano—the wide open spaces. (5)*

Cabeza de Baca is careful to contrast the Anglo perception of "plains" with the Hispanic perception. She describes in detail the houses, the ranching, the relationships among the people. Throughout her narrative it is clear that her family, once settled, depends upon the land and that the relationship to the land, weather, and landscape is all-important:

*Money in our lives was not important; rain was important. We never counted our money; we counted the weeks and months between rains. I could always tell anyone exactly to the day and hour since the last rain, and I knew how many snowfalls we had in winter and how many rains in spring. We would remember an unusually wet year for a lifetime; we enjoyed recalling it during dry spells.*

   *Rain for us made history. It brought to our minds days of plenty, of happiness and security, and in recalling past events, if they fell on rainy years, we never failed to stress that fact. The droughts were as impressed on our souls as the rains. When we spoke of the Armistice of World War I, we always said, "The drought of 1918 when the Armistice was signed." (11–12)*

Storms were welcomed by people and animals alike: the thunder, lightning, and particularly the rain are envisioned as a symphonic rapture: "A storm on the Llano is beautiful. The lightning comes down like arrows of fire and buries itself on the ground. At the pealing of thunder, the bellowing of cattle fills the heart of the listeners with music. A feeling of gladness comes over one as the heavens open in downpour to bathe Mother Earth" (14–15).

Cabeza de Baca then describes what is left of a vanishing people as she traces the arrival of the American homesteaders who plow and ruin the land and the loss of land grants. Bitterness over lost land and nostalgia over lost culture are implicit in her description of a barren wasteland in what had once been paradise:

*The land, between the years 1932–1935, became a dust bowl. The droughts, erosion of the land, the unprotected soil and overgrazing of pastures had no power over the winds. . . . Gradually the grass and other vegetation disappeared and the stock began to perish. There was not a day of respite from the wind. The houses were not protection against it. In the mornings upon rising from bed, one's body was imprinted on the sheets which were covered with sand. . . . One forgot how it felt to touch a smooth surface or a clean dish; how food without grit tasted, and how clear water may have appeared. The whole world around us was a thick cloud of dust. The sun was invisible and one would scarcely venture into the outdoors for fear of breathing the foul grit. The winds blew all day and they blew all night, until every plant which had survived was covered by hills of sand. (177)*

The tragedy of the New Mexico Hispanos is reflected in the interrelationship between the land and Cabeza de Baca's father. The loss of his land parallels the losses of all Hispanos. The land is gone to Hispanos forever, passed into the hands of Anglos:

*The land which he loved had sucked the last bit of strength which so long kept him enduring failures and sometime successes but never of one tenor. Life so cruel and at times so sweet is a continuous struggle for existence—yet one so uncertain of what is beyond fights and fights for survival.*

   *He is gone, but the land which he loved is there. It has come back. The grass is growing again and those living on his land are wiser. They are following practices of soil and water conservation which were not available to papa. But each generation must profit by the trials and errors of those before them; otherwise everything would perish. (178)*

*We Fed Them Cactus* is an extraordinary account by a woman who expressed the evolution and change suffered by her people through landscape and their connection to the land. A sense of place and belonging can also be connoted by such mundane activities as regional food traditions. Cabeza de Baca also published a cookbook of New Mexican recipes called *The Good Life*.[11] Recipes are integrated with accounts of folk life, as if the female sense of rootedness and place is passed down through the distinctive foods nature offers. The cookbook, like her narrative writings, preserves these traditions.

Another New Mexican woman, Cleofas M. Jaramillo, also wrote a cookbook: *The Genuine New Mexico Tasty Recipes: Old and Quaint Formulas for the Preparation of Seventy-Five Delicious Spanish Dishes* (1939). The preface claims, "In this collection of Spanish recipes only those used in New Mexico for centuries are given, excepting one or two Old Mexico recipes."[12] Jaramillo, born in 1877, also wrote *Cuentos del Hogar* (1939), which is a collection of folktales mainly told to her by her mother, *Shadows of the Past* (1941), and her autobiography, *Romance of a Little Village Girl*.

The autobiography is based on the Spanish ballad tradition, a *romance,* which tells a story. Stanzas of poetry frame the narrative sections. Her story begins with a nostalgic, romanticized description of a wilderness gradually controlled by the brave Spaniards. She wrote the book, she states, because "writing and art are contagious in this old town (Santa Fe). We have caught the fever from our famous 'cinco pintores' and author Mary Austin, and some of us have the courage to try. It is only by trying that we learn what we can do."[13] Writing in English, at the beginning of the story she expresses her feeling of being a foreigner in her own land:

> *Under the apparent deadness of our New Mexico villages there runs a romantic current invisible to the stranger and understood only by their inhabitants. This quiet romance I will try to describe in the following pages of my autobiography, although I feel an appalling shortage of words, not being a writer, and writing in a language almost foreign to me. May I offer an apology for my want of continued expression in some parts of my story. (vii)*

Early in her tale, like Cabeza de Baca, she describes the effect of the change from Mexican to American government on the inhabitants of her region. For Jaramillo, change meant that the New Mexican families (especially the women) retreated behind their walls and enclosed placitas. Women and girls were not encouraged to go outside the walls. On a rare day as a child out in the country, she writes, "I can still see myself, like a wild bird set free of a cage, running from one berry bush to another, filling my little play basket, my heart beating with delight at the sights of beautiful mariposa lilies, blue bells, yellow daisies, feathery ferns" (10). The boys of the family, however, roam freely and are allowed to hunt.

In Jaramillo's nostalgic view, the land held abundance for all and a religious, spiritual significance:

> *Everyone was happy in those days. How could people be otherwise, living according to God's laws and close to the good earth and the natural beauties of nature? Beauties were there*

*that not even the most gifted artist can copy. The real tints of a glowing sunset, when the sky seems on fire or is suffused in delicate rose and gold. Those autumn colors on trees and shrubs covering mountains, and on wooded rivers. The crystal-like sheen in the river water, and the murmur as it splashes on its way. What sweeter music is there to sooth tired minds and nerves of hard-working people? (14)*

The desert is seen not as a waste of wilderness but as a landscape where people are integrated with nature. The landscape is pure and clean, no social disorders jar the sensibilities—the rivers are crystal-clear and fresh, nature is tranquil and soothing. Early in the book, describing her return home from boarding school, Jaramillo says:

*I climbed up on the seat by my father and rode along inhaling the fresh fragrance of the newly-awakened sage and wild flowers. The desert plain seemed turned into a fairy-land. Icy winter had given place to warm summer, melting snow and filling rivers and causing ditches to overflow. Here and there we dropped into a verdant little valley, the sparkling river fringed with new green plants and drooping willows. From the edge of the highest ridge we looked down into the Arroyo Hondo sunken valley, which in its rich verdure seemed to lie asleep, the deep silence enveloping the valley broken only by the rattling of our carriage wheels or the distant barking of the dog. Happy in letting my tongue loose in my fond Spanish, I had chatted all the way. (41–42)*

Jaramillo lives a protected, sheltered life and marries under protest, stating that she would have preferred another year with her mother or even "a year at one of those fine colleges I saw advertised in my *Home Journal* magazine." But her suitor comes from an old New Mexico landed family and is wealthy and good-looking, so she marries in 1898. She experiences wrenching homesickness when she first moves to live with her husband some miles away, and she is delighted when she can return home to visit: "A hymn of gladness sang in my heart as we came in sight of the villages nestling in their natural setting at the foot of the high ridges of hills that shelter the green bowl of the valley. It appeared like an oasis in a desert after the ride across the plain" (87). Later she and her husband lead the active life of the wealthy, traveling and visiting the East. However, when her first baby dies, she turns to nature and a comfortable sense of place for revitalization:

*That summer I busied myself in my garden with my flowers to drown my sorrow. There is a romance in gardening. The mere word makes me think of bright sunshine, of flower-scented air. To bury a dry seed in the ground and see it burst through the earth as a green sprout, watch it grow, spread its branches and be covered with exquisite flowers is a magic wand. (109)*

The garden's fertility is a positive counterpoint to her own inability to engender a living child. Her autobiography continues as her second baby dies, her third child is born, her husband is elected to the state legislature and later dies. She discovers that their grand life has been led at a great cost; their property is heavily mortgaged. She moves to Santa Fe and becomes a businesswoman to support her family. But there savage civilization takes over and her daughter, Angelina, is brutally murdered. She writes,

"some weeks after, when I took courage to go out for a walk, the sun seemed to have lost its bright rays and the whole world to be in an eclipse" (164).

The book is a lament for life and times lost, a desire to return to a better and simpler world where humanity and nature are in harmony. Jaramillo describes the sadness of a trip back to the home that is home no more:

> After dinner, my nephew took me in his car for a visit to my old house at Arroyo Hondo. In fifteen minutes I found myself gliding down the once steep hill, now almost level and I was surprized to see before me the little sunken green valley. What a different aspect it now presented! High pitched roofs, a new modern looking schoolhouse with nothing left but memories of our once lively-happy home, now in melting ruins . . .with a sigh, I turned away from this sad sight. (187)

Each section of Jaramillo's autobiography is framed by a ballad stanza detailing the rise and fall of the Spanish people: a history mirrored in her life. The romance is pieced together as the ballad form mirrors the content of the autobiography, both, in turn, reflecting the sense of nostalgia and cultural loss.

> The first white speck on the
>       Western sea was made by a Spanish
>       sail,
> And the first lonely grave on the
>       plains
>       was dug by a Spanish trail.
>
> They left their loved abodes
> To tempt new seas and stretched
>       their sails
> Full-blown before the driving gale—
> Theirs to be submissive to fate
> Self-sentenced, yet elate,
> Fearless o'er trackless waste to fly
> To lands unsettled to habitate. (1)
>
> Let the old houses their secrets keep
> Leave them alone in their quiet sleep;
> They are like old folks who nod by the fire,
> Glad with their dreams of youth and desire. (118)
>
> Life has its Spring—
> The rosy years of youth,
> Its summer of achievement;
> Then autumn with its piece
>       of work well done,
> Brings rest and understanding
>       of the whole.

*Then winter's long night sets in,*
*When autumn's sunset colors fade away*
*Like embers of the hearthstone*
   *burning low;*
*The soul must rest,*
*Her weary eyelids close. (127)*

*For all through the darkness*
*Of mist or of wrong,*
*I have found solace in prayer,*
*In faith and in love. (200)*

Landscape here contains metaphors of change, a tragic sense of loss of place, loss of culture, and loss of language. Jaramillo's native tongue, like that of Otero Warren and Cabeza de Baca, is Spanish. Nevertheless, to communicate with the dominant culture they write in English. Jaramillo is always conscious of the "foreignness" of communicating in a language that is not hers, of being unable to "chat" in her "fond" Spanish.

Within the narrative histories and folk accounts of these writers appears a singular "folkloric" figure: that of the "herb woman" or the "medicine woman," the curandera. Active in both Hispanic and Indian communal lives, she was a woman of wisdom and knowledge of the natural world. In Hispanic folklore the curandera has always had more freedom of movement than other women. Cabeza de Baca saw the herb woman as not only freer but clearly outside the confines of society. Although she could not write, she stored her knowledge in her incredible memory: "The medicine woman seemed so old and wrinkled to Doña Paula and she wondered how old she was. No one remembered when she was born. She had been a slave in the García family for two generations and that was all anyone knew. She had not wanted her freedom, yet she had always been free. She had never married, but she had several sons and daughters."[14]

This curandera is the keeper of secrets: some that women need to know and that men inadvertently destroy. Thus men are the destroyers of landscape, women the preservers. This is evident as Doña Paula says to the medicine woman in *The Good Life*: "But there are still more herbs you have not told me about in that neat pile there. And the curandera replies, "These are getting so scarce that I only brought you a few leaves: the men pull them up as weeds."[15] The curandera has been an important social and cultural force in Hispanic tradition since the colonial period and continues to play a strong role in daily life as well as in folklore and myth.

Within Cabeza de Baca's and Jaramillo's accounts, one finds social commentary, concern for the poor, and discussions of life and customs. Although in many ways their books are wrapped in romantic, idealized notions of a fantasy life, their writings also reveal that they suffered great losses and leave us detailed accounts of their lives. A feeling for the land is central to their vision of paradise found and paradise lost.[16]

Thus, though these writers are seen to be elite, not in touch with the common people, they foresaw the loss of their culture. Oral histories of common women and men coming out of the same tradition reflect a similar sense of loss and set the stage for the

radically changed landscape of the period after World War II. This perspective of loss can be seen in such recent oral histories as *Del Rancho al Barrio* from the Mexican Heritage project in Tucson, Arizona, and in *Images and Conversations: Mexican Americans Recall a Southwestern Past*.[17] Patricia Preciado Martin, for example, evokes the image of a fig tree to symbolize the vanishing cultural landscape:

> *In 1858 José M. Sosa built a small residence for his family on Main Street—Tucson's old Camino Real. . . . In 1878 the property was sold to Leopoldo Carrillo. . . . In time he dug a well, built corrals and chicken houses, planted herbs and flowers—and a fig tree. The fig tree, nourished by the sweet water drawn from the well, flourished in that desert garden. Through the years it grew, its spreading branches finally embracing the garden walls. On warm summer nights, the family would gather outdoors to enjoy the cool evening breeze. Undisturbed by the noise or concerns of modern urbanites, they would count the stars and fall asleep beneath the protective canopy of the sky and the fig tree.*
>
> *Through the years the fig tree continued to grow and give fruit to succeeding generations. In the twentieth century a bustling Mexican neighborhood grew up around the house of the fig tree. It was a community of vitality and culture and tradition, built with the love and labor of those who dwelled there. But the laughter and songs of the descendants of those early Mexican pioneers would in time be silenced by the bulldozers of progress and urban renewal. Only the Sosa-Carrillo house would be spared, standing alone in a wilderness of asphalt, brick, and glass—mute evidence of the past. And miraculously that same fig tree still branched and flowered in stubborn affirmation of those families who gave it root, greening forth in solitude—a symbol of history and nostalgia in a modern wasteland of concrete, an inheritance which still gives sustenance to those of us who pass this way.*[18]

After the early books were published in the 1930s, 1940s and 1950s, the Hispanic women writers of the Southwest lapsed into a Sleeping Beauty silence. They continued to write, but little was published and even less distributed. It was not until after the Chicano civil rights movement and the accompanying literary renaissance of the late 1960s that Hispanic (now Chicana) women writers once again found their voices. In the intervening period many things had changed in Hispanic/Chicano culture. Recognition of the value of the intermixture of races, pride in the Indian as well as the Spanish past, desire to retain culture in the form of language, recognition of the richness of bilingualism and biculturalism, and pride in the legacy of history left to the Mexican-American resulted in a literary outpouring. Women after 1968 wrote of social and political issues and struggled with who they were. They searched for meaning in the past and took as role models revolutionary heroines such as La Adelita. They resuscitated Aztec goddesses who represented power and authority, found old myths, created new ones, and reinterpreted the ones they did not like, such as the one of La Malinche.[19] They discussed relationships with men, women, and families. In this literary movement toward definition they talked about their daily lives and their environment. Landscape and their perceptions of the world around them were a focus of their evaluation. An early poem, "The Knowing Earth" by Gina Valdés, illustrates the Chicana writer's continued connection with the land:

*In this, my own land, I stand an alien*
*Mistreated, oppressed, unwanted, at best ignored*
*But this knowing earth recognizes me*
*Like a mother recognizes her child*
*This earth welcomes me, it opens to me*
*I caressed this earth with songs, whispers, and sighs*
*I broke and turned this earth with my dancing feet*
*I moistened this earth with hard rainfalls of tears*
*I nourished this earth with my rich, warm, faithful blood*
*I fertilized this earth with my salty sweat*
*I cursed this earth with miseries, pain, and fears*
*Maddened, I spit poetry over it.*
*They scorn me, turn me away from this, my land*
*But this knowing earth recognizes me*
*Like a dog recognizes its master*
*This earth welcomes me, it kisses my feet.*[20]

Contemporary Chicana writings have centered on two distinct perceptions of land-scape: the urban situation and the urge to return to the middle landscape that integrates human beings and nature. As we have seen in "The House of the Fig Tree," as Chicanos lost political and economic power they also lost social stability. Their neighborhoods declined until today the word *barrio* (neighborhood) to some signifies a slum. In the Southwest as well as in California and Texas, the continuous waves of new immigrants from Mexico often crowded Spanish-speaking neighborhoods. The immigrants maintained their connections with Mexico and reinforced bonds with its language and culture, but at the same time they strained the social and economic fabric of the neighborhoods. In many barrios life became an increasing struggle, and the city evolved into a labyrinth of social ills and alienation. Chaos reigned. The Chicanos had become a minority in what they considered their own land, rejected because of their language and race, exploited and unrepresented in the midst of the myth of democracy: such is the signature of urban environments that the Chicana writer sees and reflects in her choice of landscape.

The Chicanos' struggle to make order out of chaos continues. The move to the city in some senses breaks down regional ties and many of the responses to this landscape are the same whether the writers live in Albuquerque or in Los Angeles. Angela de Hoyos' poems of the late 1960s, for instance "Hermano" and "La gran ciudad," established the bilingual, bicultural feeling by writing interlingually in Spanish, English, and Caló (Chicano slang). These poems are about two cities; one San Antonio, Texas, the other abstract—representing any large city. The cities are signatures for cultural perceptions of rejection and alienation. In "Hermano," de Hoyos chooses the American seizure of the Alamo and of San Antonio as a metaphor of loss:

*Blind-folded they led you*
*to a marriage of means*

*while your Spanish blood*
*Smouldered within you!*

The sky, the land, the Spanish missions now belong "to a pilgrim who arrived only yesterday / whose racist tongue says to me. I hate / Meskins. You're a Meskin. *Why* don't you / go back to where you came from?" The poet points out that they are all pilgrims, and says:

*I was born too late*
*or perhaps I was born too soon;*
*It is not yet my time;*
*this is not yet my home.*
*I must wait for the conquering barbarian*
*to learn the Spanish word for love:*
                      HERMANO[21]

"La gran ciudad" details the struggle of a single mother who has arrived in the city looking for a job; racial prejudice and lack of opportunity threaten her survival. The poet reveals contradictions between racist behaviors, including stereotyping of "Mexican's" linguistic abilities, and the promise of an urban paradise, and ends with an ironic comment on the democratic ideal:

*No one told me.*
*So how was I to know*
*that in the paradise*
        *of crisp white cities*
*snakes still walk*
            *upright?*
. . . . . .

*when I couldn't pay the rent*
*the landlord came to see me.*

. . . . . . .

    *Ain't you Meskin?*
    *How come you speak*
    *such good English?*
*Y yo le contesto*
    *Because I'm Spanglo, that's why.*

. . . . . . . . .

*So where is the Paradise?*
*In the land of the mighty*
*where is the shining*
    —THE EQUAL—opportunity?[22]

The ambivalent attitude evoked by the city is also echoed by Xelina, another Chicana writer of this period:

> *tia juana u glisten by night*
> *sequined by dazzling city lights*
> *by day we are shrouded with misery*
> *groping for a bite to eat.*[23]

The glittering, shining white paradise, the land of opportunity promised by the city, means despair and hunger for Chicanos. Cities originally settled by the Spanish take on in the eyes of the prejudiced Anglos attributes of the Chicanos who live there. In "San Antonio" by Carmen Tafolla, this anthropomorphic stereotyping is clearly evident. San Antonio is portrayed as a woman toiling, yet always seen as indolent.

> *San Antonio*
> *They called you lazy.*
> *They saw your silent, subtle, screaming eyes,*
> *And called you lazy.*
> *They saw your lean bronzed workmaid's arms,*
> *And called you lazy.*
> *They saw your centuries-secret sweet-night song,*
> *And called you lazy.*
> *San Antonio*
> *They saw your skybirth and sunaltar,*
> *Your corn-dirt soul and mute bell-toll,*
> *Your river-ripple heart, soft with life,*
> *Your ancient shawl of sigh on strife,*
> *And didn't see.*
>
> *San Antonio*
> *They called you lazy.*[24]

Clearly, for Tafolla, San Antonio holds more complex meaning than that read into it by Anglos—while on the one hand life there is difficult and degrading for many contemporary Chicanos, San Antonio also contains a valuable past offering much positive meaning.

Rina García Rocha, in "North Avenue/1600 North," also images the city as a woman. In contrast to Tafolla, García Rocha's city is ragged, indifferent, and wicked. But even this city connotes belonging in spite of the poet's desire to reject it: "North Avenue, why do you wrap your arms / so thick around my neck / and refuse to let me go." In García Rocha's "The Truth in My Eyes," the city becomes a savage place of corruption and filth:

> *Taking a walk down 26th street*
> *passing "La Luz del Norte";*
> *the strip joint*
> *Veracruz Barber Shop*
> *Doña Lupita's Supermercado,*

*and the currency exchange with the sign*
  *"Se Habla Español"*
*Ah, Latino Barrio*
*Is this the ghetto?*
.    .    .    .    .    .
*Two boys down the block been shooting rats with*

*their B-B guns behind a capitalist back door restaurant*
*Wild game available and plenty*

*Came up close enough to a dead body of one of the rats*

*Came up close enough to see how the shiny little bodies of*
*the flies nested*
*filth—*
*Disgust*
*As I smash the maggots on the cobble stone alley. . . .*[25]

The truth is, of course, that these "savage civilizations" are the result of oppression and lack of opportunity which allows rats and maggots to breed. Such disintegration of the landscape affects the social and economic situation of the Chicano/Spanish-speaking minority who live in the barrios. The mental oppression in the barrio is directly addressed by Irene Blea in "spaces like the barrio":

*it's safe there in the barrio*
  *you can handle it*
    *no one expects anything*
      *all you have to do is stay alive*
        *and keep out of trouble*

*spaces are the things you know exist*
  *the talents that go unrecognized*
    *because the fear of failing*
      *while grasping opportunity*
        *that exists elsewhere*
          *is much too overwhelming*[26]

These Chicana writers, like the early Hispanic writers, express mixed emotions about their city environment: both a sense of alienation and one of fond memories. The early writers tended to look to the past when life was more secure and stable; the more modern writers see *today's* reality, with or without a sense of nostalgia. Beverly Silva, in her urban *The Second St. Poems,* echoes many of the feelings of alienation and despair already discussed, but also chronicles her struggles with some sense of humor culminating in ultimate survival. In "The roaches came from everywhere," the wild beasts threatening a sense of security and protection in the wilderness of the city are the cucarachas. Like early pioneers, woman is on the frontier; her weapon now becomes a spray can!

*under*
*over*
*above*
*behind*
*between*
*around*
*below*
*it was a lesson in prepositions to ponder them.*
*Big ones*
*small ones*
*medium sized ones*
*families & communities of them invaded our apartment.*
. . . . . . . . . . . . . . . . . . .

*At night they crawled from all the cracks*
*to cover our walls like some grotesque canvas*
*painted by a madman.*

*To move wasn't possible,*
*we had to fight.*
. . . . . .

*The roaches became my nemesis.*
*Sharing these vermin bound me forever to my neighbors.*
*The temporariness of our situations became enhanced*
*by rejections of our mutual suffering,*
*pretense of waiting lists for better apartments,*
*or savings for deposit money.*
*Easier to live with roaches when:*

*We're going to move from here any time now.*[27]

The ultimate threat on the edge of chaos is fear of complete extermination: that too is chronicled by Silva in "Always close to death on Second St." where annihilation is as close as a pane of glass:

*there's no way to escape knowledge of mortality*
*living on Second St.*
*with only a pane of glass separating you from the prostitutes,*
*dance hall music entering all your windows,*
*& a mortuary across the street.*
*Downtown violence is a thing you live with:*
*all night sirens,*
*barroom knifings,*
*once a month eruptions from people on dope or booze*
*wrecking their apartments.*
*Poverty and frustration speak out.*
*Every few months there's a murder,*

> *an unidentified body*
> *the police always link to dope or passion or prostitution.*[28]

Yet not all is grim in the Chicana portrayal of the urban landscape. For Evangelina Vigil, the city of her childhood holds fond memories:

> *barefoot is how I always used to be*
> *running barefoot*
> *like on that hot summer*
> *in the San Juan Projects*
> *they spray-painted all the buildings*
> *pastel pink, blue, green, pale yellow, gray*
>
> . . . . . . . . . . . . .
>
> *no sooner than had the building wall/canvasses been painted clean*
> *did barrio kids take to carving new inspirations*
> *and chuco hieroglyphics*
> *and new figure drawings of naked women*
> *and their parts*
> *and messages for all*
> *"la Diana es puta"*
> *"el Lalo es joto"*
> *y que "la Chelo se deja"*
> *decorated by hearts and crosses*
> *and war communication*
> *among rivaling gangs*
> *El Circle*
> *La India*
> *pretty soon kids took to just plain peeling plastic pastel paint*
> *to unveil historical murals*
> *of immediate past well-remembered:*
> *más monas encueradas*
> *and "Lupe loves Tony"*
> *"always and forever"*
> *"Con Safos"*
> *y "Sin Safos"*
> *y que "El Chuy es relaje"*
> *and other innocent desmadres de la juventud*
> *secret fear in every child*
> *que su nombre apareciera allí*[29]

Surely this writing of names in Pachuco hieroglyphics on urban buildings is a literal signature of the Chicano landscape which is then preserved with the poem. Such writing evidences ownership and control of a landscape otherwise threatening and overpowering.

Thus, as seen by the contemporary Chicana writer, the city is not the land of hope and

opportunity. To survive and to grow, these writers search for a new connection, a sense of home, place, and belonging. Lorna Dee Cervantes' poem "Beneath the Shadow of the Freeway" signals the need for connectedness to family heritage (particularly through the female family members) and tradition: by respect for your self and for who you are. Through the contrasting discourse of her mother and grandmother in the poem, the lyric speaker finds her own voice and identity. She learns to survive in the city by trusting in human relations (which her mother warned her against) and by trusting in herself (which her grandmother advocated). It is significant also that she learns her direction *below* the freeway:

*Across the street—the freeway,*
*blind worm, wrapping the valley up*
*from Los Altos to Sal Si Puedes.*
*I watched it from my porch*
*unwinding. Every day at dusk*
*as Grandma watered geraniums*
*the shadow of the freeway lengthened.*

*We were a woman family:*
*Grandma, our innocent Queen;*
*Mama, the Swift Knight, Fearless Warrior.*
*Mama wanted to be princess instead.*

. . . . . . . . . . . .

*Myself: I could never decide.*
*So I turned to books, those staunch, upright men.*
*I became Scribe: Translator of Foreign Mail,*
*interpreting letters from the government, notices*
*of dissolved marriages and Welfare stipulations.*
*I paid the bills, did light man-work, fixed faucets,*
*insured everything*
*against all leaks.*

*(Grandma)*
*likes the ways of birds,*
*respects how they show themselves*
*for toast and a whistle.*

*She believes in myths and birds.*
*She trusts only what she builds*
*with her own hands.*

. . . . . . . .

. . .*The freeway is across the street.*
*It's summer now. Every night I sleep with a gentle man*
*to the hymn of mockingbirds,*

*and in time, I plant geraniums.*

*I tie up my hair into loose braids,*
*and trust only what I have built*
*with my own hands.*[30]

The discourse in this long poem contrasts the "old" traditions (her grandmother's potted plants) and the "new" traditions (her mother and the freeway). The poet creates, by means of her writing (translations, meaning the going back and forth between two cultures), a bridge between the two landscapes, thus forging her own individual identity or signature: "I trust only what I have built with my own hands." Significantly, she does not have to return to agrarian landscapes of the past to make this reconciliation, but can find a meaningful life "Beneath the Shadow of the Freeway" with only minimal reminders of the older natural world.

This link with old traditions and a sense of survival in landscape is also revealed in a short story by Patricia Preciado Martin, "The Journey." The story is structured on the glaring contrast between old and new Tucson; the disappearance of the old barrio stands as the central metaphor. The elderly aunt, "tía", lives in the "Martin Luther King Jr. Apartments, Low Cost Housing for the Elderly," an ironic comment on the success of the black civil rights movement and the relative lack of advancement for the Chicanos, since almost all those who live there are Hispanic *viejitos*. The young Chicana in the story takes her aunt shopping and their route is always the same, past the landmarks and signatures of old Hispanic Tucson. Each building, each house, is peopled by memories of those who lived there. Each signature is also sharply connected to an ironic voice of the present:

> *On Ochoa Street we turn west again and walk toward the gleaming white towers of the Cathedral. San Augustín. The Dove of the Desert. The pigeons flutter over our heads when the noon bells chime. Sr. Enríquez, the old bell chimer, died long ago. He climbed the rickety stairs to the bell towers three times a day for more years than anyone could remember. One day he climbed up and played the Noon Angelus and never climbed down again. They found him with the bell rope still in his hands. Now the angelus is a recorded announcement.*[31]

The Freeway cutting through the center of the Spanish-speaking barrio is a symbol of the destruction wrought by modern civilization, particularly by those planners who looked upon the barrios as slums and, therefore, appropriate places to build freeways or urban renewal projects. Preciado Martin says: "The Freeway has cut the river from the people. The Freeway blocks the sunshine. The drone of the traffic buzzes like a giant unsleeping bee. A new music in the barrio."[32] The aunt's journey always leads to the same place: the house of her parents, the house where she was born.

> *The pace of tía quickens now. I follow her, carrying the straw bag laden with groceries. We walk past the Concert Hall to the vast parking lot of the Community Center Complex. A bill-board reads: CONCERT TONIGHT. ALICE COOPER. SOLD OUT. We stop in the middle of the parking lot. The winter sun is warm. The heat rises from the black asphalt. The roar of the Freeway is even more distinct. It is the end of the journey. I know what tía will say.*

*"Aquí estaba mi casita. It was my father's house. And his father's house before that. They built it with their own hands with adobes made from the mud of the river. All their children were born here. I was born here. It was a good house, a strong house. When it rained, the adobes smelled like the good clean earth. . . . See here! I had a fig tree growing. In the summer I gave figs to the neighbors and birds. . . . I had a bougainvillea: it was so beautiful! Brilliant red. And I had roses and a little garden. Right here where I am standing my comadres and I would sit and visit in the evenings."[33]*

As they turn to go, the niece/narrator (who has become the recipient of the cultural heritage) for the first time sees something new.

*"Tía. Tía." I call. "Ven." She turns and comes toward me.*
*"Look!" I say excitedly. "There is a flower that has pushed its way through the asphalt! It is blooming!"*
*"Ah, mihijita," she says at last. Her eyes are shining. "You have found out the secret of our journeys."*
*"What secret, Tía?"*
*"Que las flores siempre ganan. The flowers always win."*

And the story ends with a refrain: "ABUELITA, ABUELITA / ABUELITA. NO LLORES. / TE TRAIGO. TE TRAIGO. TE TRAIGO. / UNA RAMITA DE FLORES."[34]

The first ambivalent response of Chicana writers to the urban environment with its social, economic, and cultural problems is thus contrasted to the sense of hope and regeneration exemplified by the flower breaking through the asphalt as seen in this second, more positive, response of contemporary Chicana writers. They return to a sense of integration with the land, with nature, with the cosmos seen in their landscape. The desire for integration is strongly present in contemporary southwestern Chicana poetry and is in some ways a direct link to the earlier traditions exemplified by Otero Warren, Jaramillo, and Cabeza de Baca. Rather than rejecting the city and relying on memories of a rural past for images of integration, however, the contemporary writers feel connected with the humble, ephemeral aspects of the natural world still surviving in the cities. The geranium on the windowsill carries as much landscape meaning for Cervantes as the Llano carries for Cabeza de Baca.

Furthermore, where the older writers turn to Spanish traditions to help maintain a connection with the changing landscape, many of the new authors look to Mexican and pre-Columbian culture. Estela Portillo Trambley, a poet and playwright, was among the first writers after the Chicano Renaissance to formulate a cosmic system integrating Aztec and Mayan mythology, a sense of the land, and female forces. In *Rain of Scorpions and Other Writings,* Portillo Trambley's characters search for a paradise lost but instead find destruction. In her mythic structures, struggle "paradoxically" achieves wholeness. Following the Nahuatl myth cycle of destruction/regeneration, Portillo Trambley creates a successful social order based on a vital balance, not on static harmony.[35] She differs from male Chicano writers in that she also uses these myths in an attempt to integrate the power of women into an equal social structure in an even more vital

balance. Portillo Trambley provides a link between the early and contemporary writers, because she incorporates both Christian and Nahuatl myths into her work. She is also among the first to portray strong women in a vital and equal balance with men, and to do so through the metaphor of landscape.

Although Portillo Trambley's work on Aztec myth and women is exceptional, other contemporary writers, such as Pat Mora, use Aztec and Mayan mythology in even more complex ways to point to new directions. Poets like Mora, Rebecca González of Texas, and Denise Chávez of New Mexico use the link with nature and the desert landscape to define self. Distinctive signatures in the landscape of these Chicana writers are their perceptions of the desert and its plants (particularly the cactus), domesticated flowers and gardens (wherever they may appear), and, as mediator between nature and human beings, the figure of the curandera.

In "South Texas Summer Rain" by Rebecca González, the desert landscape contains three strongly integrated images: the rock as a symbol of strength and endurance, the cactus as an image of woman, and the rain as the instrument of change. The enigmatic cactus is a wicked woman who blossoms long enough to enjoy the pain of her metaphoric "sin":

> *Dust cools easily*
> *with the lightest summer rain.*
> *Not rocks.*
> *In the midst of dry brush,*
> *they hold the sun like matchheads,*
> *a threat against the water*
> *that would wear them out.*
>
> *Dust becomes clay,*
> *cups rain like an innocent offering.*
> *Not rocks.*
> *They round their backs to the rain,*
> *channel it down the street where children play,*
> *feeling the rocks they walk on,*
> *sharp as ever under the water,*
> *streaming away.*
>
> *If rocks hold water at all,*
> *it's only long enough*
> *for a cactus to grow gaudy flowers*
> *hoard a cheap drink*
> *flash it like a sin*
> *worth the pain.*[36]

This connection between female sexuality and the desert landscape was perhaps latent in Cleofas Jaramillo's discovery of solace in the fertility of her garden when she herself seemed infertile. The contemporary writers, however, seem more interested in the sensuality and sexuality of the female forces in the desert than in its fertility. Pat Mora illustrates how the desert unveils her sensuality:

> *The desert is no lady.*
> *She screams at the spring sky,*
> *dances with her skirts high,*
> *kicks sand, flings tumbleweed,*
> *digs her nails into all flesh.*
> *Her unveiled lust fascinates the sun.*[37]

The relationship between sexuality and the land is explicitly detailed in another poem by González, titled "Obsession," in which the woman/land becomes the taker/possessor, distracting man away from the sky and toward an intuitive integration with the earth. Here sexuality *is* closely tied to fertility by use of the polyvalent *"YIELD."* The landscape is a field cultivated in order to nourish:

> *I would be the land*
> *and words would be no good.*
> *My softness would be*
> *the loose dirt under your feet.*
> *You would stand over me silently*
> *and I would hold your shadow.*
>
> *You would work me*
> *and I would yield season after season*
> *of nights when you would think nothing*
> *of the starlight you would lose at daybreak,*
> *only of the dark fields waiting for you.*
>
> *You would work me*
> *until you would lose yourself in me,*
> *feeding hunger,*
> *face down in the ground,*
> *your back to the untouched sky.*[38]

In an essay on her play, "Mario and the Room Maria," Denise Chávez comments on the power of one's natural universe. She says: "the characters have a land inside and outside that is still unchartered, unpredictable and disquieting. . . . Each character becomes as an object in nature, as outwardly different as a rock or a tree."[39] It is the objectification of personality, the abstraction of vitality that gives Chávez's poetry the distance that the reader feels. One of the more striking features of her poetry is that nature seen, the objects personified, are often female. Her landscape is vibrant with eroticism engendered through images of the land as sensual woman. A description of a cloud skyscape illustrates this:

> *Cloud: crablike*
> *drags her swollen moonless thighs*
> *across the sky*
>
> *Her secret tendrils engulf mystery*
> *the light full moon puffed cotton*

*Jagged breasts of air, not flesh*
*writhe elongated stars in space*

*The colloidal blue grease*
*is beaded, broken*

.   .   .   .   .   .

*The clouds open*
*crablike*
*the moon rises.*[40]

In "Progression from Water to the Absence," the landscape is again seen as female.

> *VIII*
> *Purple red*
> *secret*
> *labial skies*
> > *IX*
> *Stone breasts of horizon*
> *dear and moving*
> > *X*
> *Tufted with a brown down*
> *razored hair of earth*
> *clodded and fibrous*[41]

New Mexico, the Southwest, the desert and its rivers have seeped into Chávez's images: the landscape is clearly personified as a woman's body. The sexuality of the landscape seen as female, the female body, female response stand as a central metaphor for union, integration of woman, land, and man. The landscape becomes for Chávez an all-surrounding female force. The desert, its heat, and the scarce water that flows through it are anthropomorphized into a living person with arteries and pores. But most of all, the landscape has the accrued memories and sensibilities that signal a sense of place and of belonging:

> *Artery of land*
> *the water flecks quench*
> *certain*
> *desert thirsts*
>
> *Your pore-red valleys*
> *wander sun-paths*
> *along the vision line*
> *of that New Mexico heat*
>
> *Small children remembering*
> *afternoons pricking them*
>
> *Feigning sleep*
> *In airless rooms*

> *They recall*
> *tiny beads of sweat:*
> *Home.*[42]

In the poetry of Pat Mora, the mythology of integration reaches its most complete expression. A woman is usually present and the landscape is always portrayed as female, often as a wise woman with knowledge to impart to the narrator/lyric speaker. The figure in the landscape is sometimes old, full of intuitive knowledge she has received from nature. In "Puesta del Sol" we see and feel the intense pleasure the old woman has in viewing the beauty of a sunset. The larger view of nature is then encapsulated in the more specific cultivation of her "garden" of plants growing in tin cans (paralleling Cervantes' image of the freeway versus the geraniums):

> *The gray-haired woman wiped her hands on her apron,*
> *lightly touched the worn wood counters of her kitchen*
> *as cars sped on the dirt road outside her window,*
> *cars of young men hot for Saturday night,*
> *beer and laughter.*
>
> *The woman pushed open her front screen door,*
> *leisurely looked at the pink summer clouds,*
> *slowly watered the plants growing in large tin cans,*
> *said to her small granddaughter, "Mi 'jita,*
> *such a sweet time of day, bird songs, wind songs."*
>
> *The abuelita smiled when in the last tin can*
> *she found a geranium in bloom, wine bloom,*
> *her wine on a Saturday night.*[43]

"Curandera" by Mora is a poem clearly showing the kinship between the landscape, the mediator who gathers wild plants and herbs for healing use, and the powers of magic. Once again the Chicana writer picks up the myths and folkloric figures of the early Hispanic writers, but they are transformed to include much more complex roles. A gatherer and an imparter of nature's secrets, the curandera represents both intuition and rational knowledge. She can harness nature's secrets and is in harmony with both order and disorder. She is the alchemist who transforms simple, ordinary things into the knowledge of life and death—the mysteries. In her especially rests the knowledge of female tradition. If witches are a force for total chaos and are closely associated with other wild forces or manifestations of chaos such as dark nights, wild animals, wild bush country (such as the desert), mountains, and stormy weather, then the curandera is both a witch and not a witch. She has the power to control those forces but she has chosen to heal rather than choosing the negative way of a *bruja* (witch). Thus she is both at the center and on the edge.

In Mora's poem, the curandera is associated with both the owl and the coyote. She eats chopped cactus and brushes the sand from her bed, both reminiscent of Cabeza de Baca's cactus and sandstorm. Like Cabeza de Baca's "Herb Woman," this curandera has

intuitive as well as learned knowledge; she is free to come and go and is feared as well as respected by the townspeople. Desert inhabitants learn to value water and to fear sandstorms. Mora's curandera has learned how to live with both the desert's harshness and its bounty:

> They think she lives alone
> on the edge of town in a two-room house
> where she moved when her husband died
> at thirty-five of a gunshot wound
> in the bed of another woman. The curandera
> and house have aged together to the rhythm
> of the desert.
>
> She wakes early, lights candles before
> her sacred statues, brews tea of yerbabuena.
> She moves down her porch steps, rubs
> cool morning sand into her hands, into her arms.
> Like a large black bird, she feeds on
> the desert, gathering herbs for her basket.
>
> Her days are slow, days of grinding
> dried snake into powder, of crushing
> wild bees to mix with white wine.
> And the townspeople come, hoping
> to be touched by her ointments,
> her hands, her prayers, her eyes.
> She listens to their stories, and she listens
> to the desert, always, to the desert.
>
> By sunset she is tired. The wind
> strokes the strands of long, gray, hair,
> the smell of drying plants drifts
> into her blood, the sun seeps
> into her bones. She dozes
> on her back porch. Rocking, rocking.
>
> At night she cooks chopped cactus
> and brews more tea. She brushes a layer
> of sand from her bed, sand which covers
> the table, stove, floor. She blows
> the statues clean, the candles out.
> Before sleeping, she listens to the message
> of the owl and the coyote. She closes her eyes
> and breathes with the mice and snakes
> and wind.[44]

This healer listens: to the desert, to people, to animals. The wilderness is not threatening in this mythical world.

The curandera is not a figure of the past for contemporary Chicanos because today curanderas still thrive. Yet she is in some senses the repository of past learning, of history. She is also an integral part of the utopic pastoral tradition so strongly evident in early Hispanic literature. Mora plays upon nostalgia for the archetypal, integrated world and on the nourishment and enrichment that magic, utopia, and fantasy offer. This unity of magic and myth is illustrated in "Leyenda" with its use of oral history and legend and images of fertility linked to landscape. The Toltecs who inhabited Tula in Mexico were known among the Nahuatl speaking peoples as the great artisans, the great creators:

> They say there was magic at Tula.
> Seeds burst overnight.
> Plants danced out of the ground.
> By dawn, green leaves swayed.
>
> At Tula the Toltecs
> picked giant ears of corn.
> Mounds of soft cornsilk
> became mattresses and pillows
> for small, sleepy heads.
>
> They say at Tula the Toltecs
> picked green cotton, red cotton.
> In fields that were ribbons of color,
> Indians harvested rainbows.
>
> They built palaces of jade, turquoise,
> gold. They made a castle
> of gleaming quetzal plumage,
> and when the wind blew
> small green and red feathers
> landed on Indian heads.[45]

This knowledge of stories and myth is deposited into the hands of the inheritors of culture, those who remain in contact with nature and tradition. For Mora, as for Chávez, the natural landscape becomes personified, and she transforms the desert into the mother/teacher and the narrator into the mediator:

> I say feed me.
> She serves red prickly pear on a spiked cactus
>
> .   .   .   .   .   .   .   .   .   .   .   .   .   .
>
> I say sing to me.
> She chants lonely women's songs of femaleness.
>
> .   .   .   .   .   .   .   .   .   .   .   .   .   .
>
> I say teach me.
> She endures: glaring heat
>                     numbing cold
>                     frightening dryness.

*She: the desert*
*She: strong mother.*[46]

The magic passes from the hands of the curandera into those of the narrator/poet. The narrator then passes the knowledge on to the reader, through the act of writing. The power to write comes from the landscape, nature integrated, magic and myth together. This is even more directly stated in "Offering":

*Silent morning coolness, silence*
*ended by the scratching of rough*
*fingertips digging in the desert,*
*turquoise threads buried by the Indian*
*woman, buried to bribe the Earth.*

*Come, Mother. Guide my hands*
*to weave singing birds, flowers*
*rocking in the wind, to trap them*
*on my cloth with a web of thin threads.*

*Secretly I scratch a hole in the desert*
*by my home. I bury a ballpoint pen*
*and lined yellow paper. Like the Indian*
*I ask the Earth to smile on me, to croon*
*softly, to help me catch her music with words.*[47]

The landscape myth for Pat Mora, as for Portillo Trambley, is intimately related to Aztec, Nahuatl, and Mayan mythology, and she uses rituals, folk customs, and nature to interpret modern life. Contemporary women are reflected in age-old customs. Mora uses these myths and rituals to emphasize connections between past and present, but also, unlike Portillo Trambley, to criticize the hold these old traditions have on contemporary women's lives. The life of a young Aztec woman was closely circumscribed, illustrated by the speeches of the elders to female babies when they were born:

*You must be in the house like the heart in the body. You must not leave the house. . . .*
*You must be like the ashes and the hearth. . . . Now you have come into the world where*
*your parents live amidst cares of toil, where glowing heat, cold and winds prevail, where*
*there is neither real joy nor satisfaction for it is a place of work, cares and wants. . . . You*
*must not sigh, nor weep to have come. Your arrival has been longed for. Yet there will be*
*work and toil for you, because this is the wish of our master and his decision that we shall*
*obtain all that is needed for life only through sweat, only through work.*[48]

In "Aztec Princess," Mora explores the socialization process in Aztec society (which continues in contemporary Chicano society) that limited a girl's life—exemplified by the ritual of burying the girl's umbilical cord inside the house. For Mora such traditions need readjustment so that they free, rather than cage, her heroines:

*Her mother would say, "Look in*
*the home for happiness. Why do you stare out*
*often with such longing?" One day*

*almost in desperation, her mother said,*
*"Here. See here. We buried your umbilical*
*cord here, in the house, a sign that you,*
*our girl-child, would nest inside."*

*That night the young woman quietly dug*
*for some trace of the shriveled woman-to-woman*
*skin, but all she found was earth, rich earth,*
*which she carefully scooped into an earthen jar*
*and carried outside to the moonlight*
*whispering, "Breathe."*[49]

Nature and the land thus become allies of the woman hero. Keeping her in touch with her self, they are a kind of talisman that enables her to make her way through the alienations of male society, and also of the received female traditions of a limited society, whether represented by the history of Spain or Mexico.

Chicana writers are discovering the magic of words that transform heritage into images and the power of the landscape to transmit a sense of identity. The relationship to the land continues tradition as well as introduces change. The early writers saw the desert as a powerful element but also as a bountiful garden with wild plants to be harvested and used for nourishment or for healing. The gatherer and distributor of this power was woman. The contemporary writer follows this tradition while incorporating a new consciousness of her heritage, an acknowledgement of the importance of the Indian past. The sense of female tradition and female connectedness is also of primary importance to contemporary writers, since that indefinable heritage too often lost in history books and literature must be recollected, organized and captured in words. These writers also use the landscape to reject the aspects of that past that attempted to limit female freedom. They have achieved an integrated world in discovering the secret of writing their voice; in their specific and integrated discourse they have come into full selfhood.

In general, Chicana literature is optimistic. The power to make changes comes from the ability to speak out, and these women are finding their voices. Rooted or rootless, they are surviving, and they are surviving in a way that is creative and strong. They are also, finally, able to put their message into words. This voice, lost to them for many years, is a strong collective discourse. They are the curanderas, the healers: the women with intuitive powers who listen and transform. They are the creators and the weavers. The image of the cactus—enduring, strong with inner reserves and resources, yet able to bloom given proper nourishment—is a recurrent one in Chicana literature. The cactus is the Chicana herself. Beverly Silva's urban poem, "The Cactus," perhaps best connects the natural world and the city, the early writers and the contemporary writers. The landscape may be small, it may grow in a pot on a windowsill, but nevertheless it is a signature of endurance, survival, and fruition:

*November sunshine floods my kitchen window.*
*The plants thrive.*
*The lemon tree bursts with ripe fruit.*

*i measure the cactus.*
*Five inches of new growth*
*since that cold January afternoon*
*i found it.*
*Lone spindly thing like all the life here*
*on Second St.*
*uprooted and cast off in a corner of the alley*
*between Taconazo and my apartments.*
*i brought it home*
*laid wet paper towels on its roots*
*not knowing then*
*that almost nothing can kill a cactus.*
*i planted this dried up spike in a plastic pot*
*with dirt from the parking lot of this next door dance hall.*
*Taconazo dirt.*

*The cactus grows.*
*i eat nopalitos every morning with my breakfast.*[50]

Mora echoes this image of nourishment and survival in "Desert Women," where the fruit and leaves of the cactus symbolically nourish the writer, and goes beyond mere survival to illustrate also the joy, celebration, and beauty that is stored within:

*Desert women know*
*about survival. Fierce heat*
*and cold have burned our skin.*
*Like cactus, we've learned*
*to pull in tender leaves,*
*to shoot spines*
*from soft areoles, to hide*
*pain and loss by silence,*
*no branches wail or whisper*
*our sad songs. Our secrets*
*stay inside, only dried scars show*
            *if you get close*
            *if you dare push*
            *against our thorns*
*But when we flower, we stun.*
*Like cactus, we've learned*
*to gulp and hoard.*[51]

7 · MARIANNE L. STOLLER

# *Peregrinas with Many Visions*

## HISPANIC WOMEN ARTISTS OF NEW MEXICO, SOUTHERN COLORADO, AND TEXAS

*I perceive man and woman as wanderers or pilgrims* (peregrinos) *passing through this world on their way to immortality. I feel that art is a proclamation of their spirit and their struggle, along with nature, to attain this immortality by dying and rising again.*

*Having grown up in the barren desert, I witnessed the desert become a symbol to this great mystery of resurrection. Through its seasons, the power of life over death is celebrated. The luminosity of the morning and evening sky is reminiscent of a person's spirit or soul and the river is the eternal flow of life. The mountains are reminders of our return to earth. I attempt to project this awesome mystery into my art.*

Thus wrote Ysela Provenicio O'Malley, a watercolorist living in El Paso, Texas, about her aspirations for her art.[1] Her *peregrinos*—shrouded, blanketed, almost faceless figures in white—wander across the desert, encountering the mystery of the changing seasons, seeking fate in the celebration of life and death, by their pilgrimage making the earth sacrosanct (fig. 7.1).

*Mud is the flesh of the earth, and stones are the bones. The* enjarradoras *of northern New Mexico are those women who have finished, embellished, and maintained the native architecture of the Rio Grande Pueblo area since pre-Columbian times. Passed orally from woman to woman, the technology of wall-finishing and fireplace building represents the accumulated experience of centuries of adobe builders. The sister arts of earth-building, ceramics and sculpture are combined in my works.[2]*

With these words, Anita Rodríguez, a native of Taos, New Mexico, and an *enjar-radora*, expresses the Indo-Hispanic tradition of the area, which combines the architec-

125

tural materials and styles of the Pueblo Indians and their ancestors with Spanish Colonial introductions of mold-made adobe bricks, wooden doors, and indoor fireplaces.

> *What I try to communicate through my art work are my experiences as a Chicana woman and as an American, and my views on social, political, and economic inequities. One of the strongest things I oppose is U.S. involvement in Third World countries. I make social comments with my work. I am not interested in being an artist for art's sake. I want my work to remind people of the injustices and sufferings minority peoples are enduring.*[3]

So stated young Carmen Rodríguez, born in Brownsville and living in Austin, Texas. Her pencil drawings and silkscreen posters are of women and children and men suffering the violent effects of discrimination, persecution, and exploitation (fig. 7.2). They reach for the moral consciousness of the viewer.

Each of these three contemporary Hispanic women provides in her art a unique and distinctive expression of her relationship to the landscape in which she lives. Ysela O'Malley, from El Paso and the Mesilla Valley, portrays her beloved desert and the perennial human quest for affirmation and salvation. Anita Rodríguez in northern New Mexico demonstrates the beauty and usefulness of age-old styles and techniques employing materials from the earth. Carmen Rodríguez in south central Texas draws attention to the alienation of the most recent Hispanic peregrinos in the Southwest.

Hispanic women's different artistic expressions and life experiences define three subcultural and subregional variations in the modern Hispanic Southwest. Their creativity demonstrates the strength and resiliency of this New World heritage as it has been lived by their ancestors and is being lived by themselves in a difficult but beautiful land with a complex human history. In turn, the land of the Southwest and the history of Hispanic people's interaction with it helps to explain their expressions.

The areas of the Southwest selected for this study are those of the oldest sustained Hispanic settlement and colonization: New Mexico, with a northern extension to the headwaters of the Rio Grande in southern Colorado; the southern extension of the Rio in the Mesilla Valley of New Mexico, terminating in El Paso; and south central Texas, the San Antonio or Béxar area. These three units comprise the eastern half of the region identified by Richard Nostrand as the Hispanic-American Borderland, a region he defined on the basis of the density of population of Spanish-surnamed people over time.[4]

Although the areas of study have been selected on the basis of history, I began the study in the present by surveying Hispanic women artists in those areas. I interviewed and viewed the works of about forty artists, collecting information on their personal backgrounds, artistic training, motivations and intentions in their art, and their feelings about the places they lived. Information on about one hundred women artists was collected from other sources, yet there are many more women in these areas who are or have been active artists within the past two decades, but who are not included in my study. I also interviewed the directors of arts organizations, including public arts programs, museum curators, and gallery owners, in order to discern the milieu in which

contemporary women artists worked. This information has been augmented by previous research on the history and development of Hispanic arts in the Southwest,[5] which, however, has paid little attention to women artists and none at all to the questions of gender and landscape.

In my studies I discovered a considerably larger number of women artists than anticipated, and I realized that with very few exceptions only the most cursory attention has been paid to Hispanic women artists.[6] But my most significant discovery was the vitality and diversity of art being created today. This variety is most striking in forms of expression, styles, and preferred media, which range from what have usually been called crafts, popular arts, or folk arts, typical of New Mexico, to the high, fine, or academic art of easel painting, drawing, and sculpture found in Texas. While this variety exists in all three subregions, each region proves to favor different dominant art forms. The three artists whose statements and works introduce this essay are examples of these subregional differences.

Not only do the art forms differ among the three areas, but so do the cultural and social circumstances and backgrounds of the artists themselves. Thus, to approach an understanding of Hispanic women artists, to explore their visions of landscape, we must describe how their lives, histories, and works incorporate the "intimate intermingling of physical, biological, and cultural features" that D. W. Meinig designates for the concept of landscape.[7]

Such a broad concept requires the identification of specific components. Tentatively, therefore, I set up a structural model to guide the characterization and analysis of these women and their art. Such a model must take into account the women's relationships to historical traditions, to gender identification and experience, to economic class, social units, and community, to ethnicity and interethnic interactions including political participation, to education and artistic training, to personal and social value systems, to their audience, and finally to the physical landscape. All of these factors enter into the experiences and expressions of their landscapes.[8]

The model contrasts the women artists of northern New Mexico and southern Colorado and those of south central Texas. The former are closer to the world of nature and interact more directly with their physical landscape; the latter are more estranged from the natural world and are more involved with a social landscape. The women artists of El Paso occupy a mediating position, exhibiting characteristics of both opposites, and they are the artists who portray most directly the entire landscape, physical and social.

The physical landscape of the Southwest is marked by a great diversity of landforms and vegetation, although strong sun and a semi-arid to arid climate serve as unifying forces. The scarcest resource is water: wherever it is accessible is an oasis for human habitation.

The early accounts of Spanish exploring and colonizing expeditions into the Southwest contain few descriptions of the natural landscape. Unlike the centuries' later Anglo-American explorers and settlers from the United States, who encountered in the Southwest a landscape and climate radically different from what they knew, the His-

panic peoples did not perceive the area as a strange and unusual land. The settlers' visions were focused on the green oases and the need to find habitable areas where they could convert resources to human use.[9] This they did without appreciably altering the natural features of the land. Sparse vegetation, cliffs and canyons, high mountains and vast plains, too few rivers and a dry climate were not remarkable to the early Hispanic colonizers of the Southwest. As Fray Angelico Chavez has so eloquently argued in his spiritual history of New Mexico, the southwestern landscape strongly resembles that of Spain.[10] To Spain may be added the landscapes of Mexico, for the physical world does not suddenly change at the political border, and the majority of settlers in the Hispanic Borderlands were and are of Mexican origin.

On this northern frontier of New Spain, the oldest settlement by more than a century was founded in New Mexico in 1598. In 1659, the mission of Nuestra Señora de Guadalupe del Paso was established, and civilian settlers followed, colonizing the El Paso district. It was not until 1718 that civil settlement commenced in Texas, in the San Antonio area and subsequently along the southernmost section of the Rio Grande.[11]

## MUD IS THE FLESH OF THE EARTH, AND STONES ARE THE BONES

By the time settlement was started in the San Antonio region, the colonies in New Mexico were beginning to thrive, following an hiatus in occupation of thirteen years caused by the revolt of the Pueblo Indians against Spanish domination in 1680. More isolated from the administrative and cultural centers in Mexico than either San Antonio or El Paso, more restricted by a rugged terrain and a severe climate, surrounded by nomadic, often hostile Indian tribes, living amidst and on sufferance of the Pueblo Indians, the Spanish Colonial settlers in New Mexico developed a largely self-sufficient way of life dependent upon their sheep and small agricultural plots, local resources, and their own and Indian artisans. Joined by the need to defend their livestock and crops from the raids of nomadic Indians, Pueblo Indians and Españoles developed systems of economic interdependence and technological interchange. Distinctive cultural forms evolved, including a number of folk art traditions.

The majority of women artists of Hispanic background in northern New Mexico and southern Colorado today have revived the distinctive folk art traditions developed by their ancestors in the eighteenth and nineteenth centuries. Contemporary forms include woven and embroidered textiles, straw mosaic decoration, furniture, architectural finishing, metalworking in silver, gold, and tin for jewelry and household ornaments, and wood carving and painting, especially in the religious art tradition unique to the area. Most contemporary artists study museum collections of original pieces to learn of techniques and as inspiration for their own designs. How the past and the present are incorporated in their creations will be illustrated as each of the art forms is briefly discussed.

Weavings on the treadle loom in handspun wool were made for local consumption and, at least by the 1800s, for export to Mexico and California. Most consisted of weft-face plain weave done on a two- or four-harness loom. Blankets had simple

band-and-stripe designs or central diamond motifs derived from Saltillo *sarapes* woven in Mexico.[12]

Teresa Archuleta-Sagel's textile, *Centella,* uses the Saltillo diamond as a departure point for an entirely new creation (fig. 7.3). The colors—various shades of blue and yellow—are derived from traditional vegetal dyes (indigo and *canaigre*). While the traditional design motif may have been lodged in her visual memory, the artist's intent was to represent a natural phenomenon well known in northern New Mexico. "*Centella* visually recreates the violence and beauty of a New Mexican thunderstorm. At the edges of the weaving one encounters the pale indigo of our clear skies. The blues deepen into night when, suddenly, a bolt of lightning splits the darkness."

Surviving from the early to the mid-nineteenth century in New Mexico is a small collection of blankets whose designs are done using weft-ikat, a technically complex technique in which the weft threads are tie-dyed before the weaving to form the design. A few contemporary weavers have revived the process, notably Maria Vergara-Wilson of La Madera, New Mexico. Her weft-ikat textile using vegetal dyes presents a new composition of traditional motifs, but the title she gave it, *Fantasía Antigua* (ancient fantasy), commemorates her inspiration from the past (fig. 7.4).

Other traditional textile forms have also been revived. *Jerga,* a thick, coarse, twill-weave fabric used primarily as a floor covering, is made by a number of weavers, as is *sabanilla,* loosely woven yardage of natural wool that was used for clothing, mattress ticks, and so on. Contemporary weavers, however, have elevated a strictly utilitarian product to an art form. Juanita Jaramillo-Labadie of Taos has specialized in weaving sabanilla of such sensual luxury it would be inappropriate for ordinary use.

The most elaborately decorated textiles of the past were *colcha* embroideries, used for bed-coverings, altar cloths, wall-hangings and draperies. They were done in handspun yarns using the colcha stitch (a couching stitch) on a backing of sabanilla. The designs covered the entire fabric; they were predominantly floral, although geometric and heraldic motifs also appear. Revived in the 1920s and 1930s under the aegis of the Spanish Colonial Arts Society and the New Deal's Federal Arts Project, as most of the traditional folk arts were, colcha embroidery has been carried on, on a limited scale, since then. Although the stitch can be done rapidly, the process is still very time-consuming and most women have contented themselves with using isolated motifs with commercial fabrics and yarns. A few, such as Maria Vergara-Wilson, have returned to hand-woven materials, hand-spun, vegetal-dyed yarns, and all-over embroidery (fig. 7.5).

Bricks of the local clay soil, mixed with sand and/or straw, were the primary building materials for domestic, public, and religious architecture in New Mexico.[13] Stone and various kinds of *jacal* structures (chinked logs and brush, covered with adobe plaster) were also common, and in mountain villages log houses with pitched roofs were built. Otherwise, roofs of layered large and small logs covered with brush and earth were generally flat and followed Pueblo Indian construction techniques; the Spanish did not introduce roofing tiles—or their own ceramic traditions in any form—to New Mexico. Houses were plastered with an adobe slip both inside and out; different-colored earth pigments, especially white from local gypsum deposits, frequently decorated the inte-

rior rooms. The Spanish introduced indoor fireplaces with chimneys as well as the *horno* (outdoor, free-standing, beehive-shaped oven).

Traditionally, men made adobes, felled and stripped the logs for beams, and did the heavy construction work. Women (enjarradoras) did all of the finishing, the plastering, and construction of fireplaces. This was the custom of the Pueblo Indians and it became Spanish custom also. Basic house construction offered little opportunity for variety beyond size; but individual variation in fireplace styles, color and decoration of walls, and so on, was supplied through the creative efforts of women.

During the Territorial period (that is, when the area became part of the United States after the Mexican-American War of 1846–48), Anglos introduced kiln-fired bricks and other architectural styles and materials. Anglo men also increasingly dominated the construction industry except in the most remote villages and in the Indian pueblos; men learned to do interior finishing and women's work was coopted. In the twentieth century Anglos increasingly adopted the Indo-Hispanic architectural styles not only because of their beauty but also because of their utility and adaptability to the terrain and climate. Reclaiming their traditional roles, some women have revived the old skills of the enjarradoras, especially in the Taos area where they could apprentice themselves to Pueblo Indian women.

Census records from the late eighteenth century show that carpenters were working in virtually every settlement; pine and animal hides were combined to make most domestic furniture as well as ecclesiastical furnishings such as altar screens and tables.[14] After the United States' conquest, various eastern styles, materials, and tools were introduced, leading to greater elaboration of decorative elements. By 1900, however, inexpensive, factory-made, mass-produced furniture had all but replaced local production. Again under the Federal Arts Project, furniture-making, mostly in nineteenth century styles, was revived and has continued. Since the revival women as well as men have been furniture makers.

Metalworking was relatively minimal in Spanish Colonial New Mexico, apparently because local ores eluded available mining technology.[15] There was more ironworking done than any other kind of metallurgy because of the need for armor, weaponry, horse equipment and hand tools; but, since all iron and steel had to be imported from Mexico, local smiths were relatively few in number compared to weavers or carpenters. Accustomed to the extraordinary iron and steel traditions of Spain and to the abundance of gold and silver in Mexico, Hispanic New Mexicans must have felt impoverished indeed, but their ingenuity did not desert them. E. Boyd feels that the development of a unique style of straw-mosaic art in New Mexico was an effort to bring a semblance of the glitter of gold to religious forms and personal trinkets.[16] Flattened wheat or corn stalks were applied to black-painted, pine-wood crosses, picture frames, candlesticks and small boxes. Again, the art form almost became extinct before it was revived by Anglo, Indian, and then Hispanic artists in the 1930s. Several women and one man are noted for their work in this form. Although old pieces show only geometric and stylized floral designs, modern artists Paula and Eliseo Rodríguez have introduced religious scenes on their large crosses and *retablos* or flat boards (fig. 7.6).

Two art forms in metal appeared in the nineteenth century with the opening of trade

with the United States and the beginning mining activity in New Mexico. One is tinwork, used to make picture and mirror frames, candle scones, chandeliers, and reflectors, crosses, small boxes, *nichos* or small cases for displaying religious statues, and other ornaments. For some time this form largely replaced decoration with straw mosaic. Tin was cut, stamped making repoussé designs, and chiseled in geometric and floral motifs. The tradition of tinworking persisted, adapting in form to the tourist market but undiminished in attraction.

Two of the best known tinworkers today are women living in Santa Fe. While Conchita López taught herself the techniques and has invented new styles and objects, Angelina Delgado Martínez continues a craft for which her family has long been famous. Filigree jewelry of gold and silver wire became very popular in the nineteenth century, both among Hispanos and Anglo tourists. Early pieces were used to decorate religious statues, but filigree was primarily made for personal decoration, used in earrings, chains and necklaces, rings, hair ornaments, and brooches. Desultory attempts have been made to revive filigree jewelry-making and Colonial styles in silver flatware, but only one couple, Rámon and Nance López of Santa Fe, who are also furniture makers, do much with this metal art.

The best known of all Hispanic New Mexican folk arts are the religious images made by *Santeros* (saint-makers).[17] The images were primarily in two forms: carvings in the round or statues, called *bultos,* and paintings on a flat surface, called *retablos.* The images were usually painted on pine panels, the statues carved of cottonwood root; water-soluble paints, of both local and imported earth oxides and organic materials, were applied over homemade gesso. Both bultos and retablos were incorporated in a hand-hewn altar-screen (*reredos*) in churches and chapels, and no doubt every home had at least one *santo* as the centerpiece of a home altar. The sacred personage or subject to be portrayed was the sole concern of the santero: conventional attributes identified the particular saint and little attention was paid to landscape or narrative context. Some of the favorite saints in New Mexico, however, related directly to the life of the people and their environment.

The arts of the santeros flourished for almost one hundred years in New Mexico until the advent of European and American priests (many of whom held the art and the folk practices associated with the images in disdain), Anglo-Protestant attitudes, and factory-produced plaster statues and cheap religious prints. Something of the carving tradition was carried on in the village of Córdova, but the statues were unpainted and the carvers catered to tourists, who were charmed by little animals and such allegorical scenes as a Tree of Life carved of aspen and cedar. C.L. Briggs's thorough study of the Córdova carvers, now in their third and fourth generations, reveals that women have long participated in the production of these carvings, although few assigned their names to their work and only one, Gloria López Córdova has achieved much fame (fig. 7.7).[18] Not until the late 1960s did other santeros revive polychrome painting (using acrylics) and begin using museum collections as prototypes for their own creations.

The religious arts have received far more attention than any other of the traditional art forms of New Mexico. Anglo artists and writers in the Taos and Santa Fe art colonies incorporated them into their works and became collectors of the old santos.

Frank Applegate and Mary Austin are credited with bringing attention to this and other Hispanic artistic traditions. They encouraged both collection and preservation of examples from the past and the revival of the arts and training of artisans; they helped found the Spanish Colonial Arts Society, incorporated in 1929, with Mary Austin as the first chairman.[19]

Despite the fact that a considerable literature now exists on the arts of the santeros and much research has been done, none of the scholars seem to have considered that women as well as men may have been saint-makers in the past as they are today. Besides Gloria Córdova, who works in the Córdova style, several contemporary women carvers and painters have achieved recognition for their work both in the villages by their own people and in the art market of museums, galleries, and collectors. None of these women—Zoraida Ortega, Anita Romero Jones and Marie Romero Cash (the latter two are sisters), Monica Sosaya Halford, and others—seem to think they are doing anything unusual by creating religious images, nor do their neighbors. Zoraida Ortega and her husband, Eulogio, may well illustrate the kind of cooperation that existed in the past: he is a carver and carpenter and she paints his bultos and retablos and has also done two complete altar screens that he built.

Without a comparative study of contemporary male and female santeros, it is difficult to ascertain whether there are differences between the images produced by men and women. It seems to me, however, that women are introducing landscape contexts into their works, thus innovating on the traditional style. Zoraida Ortega's retablo from an altar screen, *Nuestra Señora de la Joya,* shows the church of her village (Velarde, formerly called La Joya) and the produce of its rich fields and orchards (fig. 7.8). Women carvers seem more often to elaborate on the iconic attributes of the saints to the point of providing a narrative context for them.

We do not know whether any of the traditional art forms of New Mexico were exclusively the province of one gender; none are today. Ironworking (blacksmithing) may have been done by men only, but one of the few contemporary ironworkers, Rolando De Leon, has had female apprentices. It might be expected that colcha embroidery was done only by women, but at least two Hispanic men achieved some fame for their embroidery.[20] The advent of power tools may have brought carving and furniture making within the reach of more women, but there seems good reason to speculate that they engaged in these activities traditionally, perhaps in gender-complimentary roles such as those described for house construction and finishing.

It is very common today to find couples working together; family groups of two or more generations are also common. Family and community provide the usual training grounds for contemporary artists; most learn basic techniques through either formal or informal apprenticeship or are self-taught. Although many of the women attended college or university and have academic degrees, only a few had academic training in art. Those few tend to work in more than one medium: Juanita Jaramillo-Labadie, who has a masters degree in art, is a muralist and a weaver, but her knowledge of weaving came from her family, not her academic training. Older women and those from more isolated areas often have less formal education; the late Tiva Trujillo, who spent her life in the

San Luis Valley of southern Colorado and left a ren arkable embroidered tapestry map of the area, did not finish grade school (fig. 7.9).

The women artists range in age from early twenties to eighties. Most are married, have children and sometimes grandchildren, and are thoroughly embedded in a large extended family. Family relationships are very close and important; much social life occurs within the circle of relatives. As women, they identify closely with their mothers and other female relatives, but they generally have or have had close relationships with their fathers. They are as likely to have been encouraged and taught by men as by women. Virtually all can trace their genealogies back to the eighteenth and nineteenth centuries in New Mexico and most are living in or very close to where they were born. It is rare for them to name a recent migrant from Mexico in their ancestry, but a Pueblo or Navajo Indian is not uncommon, nor is intermarriage with Anglos.

The aura and status of being landed gentry attaches to most Hispanic New Mexicans despite the fact that, by the end of the nineteenth century, most had lost their claims in Spanish and Mexican land grants as a result of legal and economic manipulations on the part of Anglos. Regardless of their economic situation, the legacy of landedness provides Hispanic New Mexicans with a class position, a very strong emotional attachment to the land as a source of identity, and an extraordinary pride in their cultural heritage. This heritage is a living reality and the women artists see themselves and their art contributing to that continuing tradition.

Art is a source of income for these women. Benefiting from the ambience of one of the major art markets in the United States, they are also aware of how they contribute to that ambience. They feel a responsibility to their heritage which, as much as monetary gains, encourages mastery of skill and attainment of excellence. A few women derive their living solely from their art; for most it is a supplementary source of family income. Their audience and patrons are both internal and external to the communities in which they live. Events such as the annual Spanish Market (staged by the Spanish Colonial Arts Society) in Santa Fe and *Feria* in Albuquerque are major markets, but various other events such as festivals provide arenas for reaching the public. Local and regional museums support these artists with special exhibits, as does the plethora of art galleries that litter Taos and Santa Fe (although only a few of the best-known Hispanic women artists are handled through galleries). The contrast with the situations of women artists in southern Colorado and south central Texas, where the Hispanic artistic and cultural heritage is not seen by the larger society as an economic resource, is striking.

Perhaps because of their economic power, but primarily because of their history and numbers, the Hispanic women of New Mexico do not, by and large, consider themselves an oppressed people or a minority. They are not intimidated by the political system; they do not feel they lack access to it, nor are they reluctant to engage in it when aroused over an issue. Rarely, however, do political issues find overt expression in their art. As women, they identify with a somewhat subordinate status, much of the same order as that of Anglo women. The "machismo" complex, so much a part of Texas women's experiences, is less significant for New Mexican women (although not totally absent). They follow traditional sex roles more closely than do Anglo women, but

tradition in this area has long been characterized by greater equality between the
sexes.[21] Enjarradora Anita Rodríguez recalled that her greatest struggle in establishing
her business was with the male-dominated Anglo construction industry and govern-
ment housing regulations; she has had little difficulty employing Pueblo Indian and
Hispano men to work under her direction.

Few of these women would deny that their greatest honors as artists come from being
recognized within their communities—by being asked to decorate local churches and
chapels or public buildings, or by exchanging their works with other artists whom they
admire. Many of them are closely involved with the religious institutions and practices
of their communities. Most are Catholic. The saints still guard their lives, offering
solace to human suffering and celebration for the earth's goodness. Zoraida Ortega and
Paula Rodríguez see the creation of their works (figs. 7.8 & 7.6) as religious acts as much
as artistic ones. Even for younger women, who are less likely to be closely tied to
organized religious institutions, religious symbols are not secularized and spiritual
values are a comfortable part of their world.

These artists' most direct association with the land is in the materials they use: local
woods for carvings, paintings, and furniture; plant materials gathered locally for straw
applique and vegetal dyes for textiles; local clays and minerals for plastering. The
detailed knowledge of the resources of the earth, how and when and where to collect
these resources and prepare them for use, is the cumulative knowledge in the Indo-
Hispanic heritage of generations of northern New Mexicans. Even the urbanites' ties to
the land are still close. Rhythms of work tend to follow the seasons, as indeed they must
for those who derive their materials from the earth.

Invariably, the women spoke of their feelings for the land, their deep appreciation of
its beauty, the inspiration they derive from it. Hispanic women artists, like Indian
artists, have heretofore felt little need to represent their physical environment in other
than abstract forms. Exactly how the physical landscape enters into their artistic cre-
ations is well expressed by Teresa Archuleta-Sagel in her discussion of her textile work
(fig. 7.3). It is apparent that these women have a spiritual attachment to their landscapes
much like that of their Pueblo and Navajo neighbors. Anita Rodríguez and the potter
Sandi Maestes both learned many of their skills from Taos Pueblo women and they
handle the earth with the same awe and respect. Maria Vergara-Wilson often wan-
ders—a peregrina—over the prehistoric Pueblo ruin called Hupobi, which is near her
home in La Madera, wondering about the people who once lived there and collecting
the wild plants that grow out of the crumbling walls and dirt fill to make dyes for her
textiles. She commemorated her idylls in the title to a woven textile with geometric
designs and colors from the plants: *Reflexiones*.

There are other peregrinas in New Mexico, women artists who do not create from the
folk art tradition or are not particularly influenced by it. Smaller in number and less
well known, their media range from easel painting and sculpture to stained glass. More
likely to be urban and art-school educated, their styles are influenced by the academic
traditions of mainstream Euro-American—including Mexican—theory and practice.
Margaret Herrera Chávez, one of two women artists (and the only one from New
Mexico) included by Jacinto Quirarte in his book on Mexican-American artists, is an

example.[22] However, the thematic material of these artists, in contrast to their styles, is largely shaped by the regional western and southwestern representational school: picturesque churches, village houses hung with strings of chile, *ancianos* (old people) sitting in the sun, mountains and mesas. It is difficult at present to discern distinctive female or Hispanic expressions in the works of these women. The move to new media, however, may well be taken up by more artists in the future, and the interest in landscape and pictorial representation may be an emerging symbol of their cultural and historical attachment to the land.

Perhaps this tendency toward more representational art is a reflection of these artists' desire to make an explicit statement about their landscape. Pictorial contexts have begun appearing more often in the works of some contemporary santeras. Women's creations in the traditional folk arts were used by relatives and friends in the familiar and intimate spaces of home and church—a world of shared scenes, understood meanings, and personal relationships. Today, New Mexican women artists find themselves between the traditions of folk art and fine art, because the majority of their works are created for aesthetic rather than utilitarian and functional purposes. While they retain an audience and patronage within their local communities and ethnic group, their art also reaches outside the region, to impersonal relationships. It has entered a national and international art market and reaches an audience that does not share their history and way of life. Perhaps these artists must become more "literal" so that their visions can be readily understood, appreciated, and enjoyed by others.

## TEXAS IS THE MISSING METAPHOR

In contrast to New Mexico, no regional traditions in the visual arts developed in eighteenth- and nineteenth-century Texas, not even in the mission churches.[23] At least, if there were arts-and-crafts traditions, they have left few artifacts and/or have been little researched.[24] Arnoldo DeLéon's study of nineteenth-century *Tejano* culture contains many references to material culture, but apparently the styles were not particularly distinctive (from those, say, of northern Mexico), or, again, few remains have been preserved or studied.[25]

Kay Turner's recent research on home altars in the barrio of east Austin points to a prevalent form of folk art in Hispanic Catholic households throughout the Southwest, one that is uniquely the creation of women. But, according to Turner, it is the assemblage of religious artifacts for the home altar that constitutes this folk art form, not the fabrication of them.[26] Terry Jordan's survey of funerary art in Mexican graveyards in Texas illustrates a similar circumstance; it is the arrangement of things on and around the grave, not the things themselves, that is distinctive.[27] Hence, there is a difference between the Texas home altars and those that would have been found in nineteenth-century New Mexico (and also today), where the religious images and other artifacts themselves, as well as their arrangement and symbolic significance, were and are created by the folk artist.

A number of factors may help explain the comparative lack of a Tejano visual or

material art tradition. Historically, these might include:[28] the relatively small Hispanic population during Colonial times; the minimal influence of the Indian tribes, which unlike the Pueblo Indians in New Mexico, were nomadic and had little material culture, visual art, or architectural tradition that could have served as models for the Hispanic settlers; the emphasis on training the Indians in the missions as artisans in Spanish techniques and styles and then their virtual demise, followed very shortly by the early, large influx of Anglo Americans, who brought their own material culture and quickly assumed political and economic power. The climate and terrain of south Texas requires less protection from the elements, hence less need for sturdy and enduring architecture or warm clothing. The development of cattle-raising and ranching by Tejanos (versus sheep-herding and farming by New Mexicans) may also be a significant factor; the distinctive material culture involved in working cattle and horses was almost exclusively the work of men and much of it was imported from the longer-established craftsmen in Mexico.

In the twentieth century, other forces mitigated against the development of a Tejano art tradition. The major migration of Mexican Americans began in the latter part of the nineteenth century and continues today. The proximity of the Mexican border to the areas of intensive Mexican-American settlement, together with the retention of familial ties across the border and the ease of transportation, combine to make Mexican arts and crafts readily available; religious items such as plaster statues, *milagros* (tiny votive offerings), and prints, and domestic utensils such as *comales* (griddles) and *molcajetes* (mortars) are examples. Most immigrants were poor and uneducated and came to the United States to improve the quality of their life, hence they may have been especially receptive to Anglo material culture; furthermore, they were frequently migratory agricultural workers, and such people can carry words but not much pottery with them.[29] Nonagricultural employment, at least in the early part of the century, often involved working with Anglo material culture. Women worked as domestic servants, laundresses, and in garment factories in El Paso, for example, while skilled Mexican craftsmen found ready employment in the construction industry.[30]

Given the low economic status of most Mexican Americans, both past and present, discrimination, and the fluctuating U.S. policies on Mexican migration, it might be expected that immigrants would rapidly adopt Anglo-American dress and material goods. Nonetheless, these goods have sometimes been given distinctive expressions in the United States: examples are the Zoot Suiters of the 1940s and the Low Riders of today. More important, however, is the Chicano art movement of the 1960s and 1970s, which was born of the protest against social and economic discrimination and the desire to retain and proclaim the unique cultural identity of Mexican Americans.

The artworks of the Mexican-American women of south central Texas are new, not old. They are a tradition in the process of creation. The artists (including men) are *primeros peregrinos*—the first pilgrims—seeking distinctive expressions for their social and cultural identity as Chicanos, Mexicans, and Americans. Their introduction to art has been primarily through American educational institutions. They thus look for inspiration not to the folk traditions of either nation, but to the elite art forms and

academic trends, the mainstream traditions of both countries. Their media are easel painting, drawing, sculpture, and print-making. Men and women rarely work together; when they do, the women are in a subordinate position: students with male teachers, organizers of exhibits in museums or galleries headed by men, workers on a public mural but not the organizers of it. These women stand in contrast to most of the social and cultural characteristics delineated for their sisters in northern New Mexico.

With few exceptions, Hispanic women artists from south central Texas are academically trained in art, usually within the University of Texas system, and many hold bachelor's or master's degrees in fine arts. As Shifra Goldman notes, the Civil Rights movement of the 1960s succeeded in opening some doors for Chicanos in higher education, and these women artists are products of that belated opportunity.[31] A few are self-taught, but study under an individual artist or anything resembling apprenticeship training is rare except insofar as it exists within the university classroom, where their teachers are usually Anglos.

There is a much smaller number of Chicana artists in south central Texas than in New Mexico. They range from the early twenties to mid-fifties in age, but the majority are between twenty-two and thirty-five years old. Most identify closely with the Chicano political movement and with the issues and problems of Third World peoples. They feel themselves part of an ethnic minority, an oppressed, alienated people excluded from the systems of power. Only one of the artists I interviewed had little inclination toward political affiliation with La Raza, and she was one of the few from a middle-class family with relatively deep roots in the area. These artists feel acutely the triple oppression of Chicanas as members of a minority ethnic group, as members of a subordinate gender within Anglo society, and as members of a subordinate gender within their own ethnic group.[32]

Virtually all of these women were born and grew up in Texas, most in small cities in the Lower Rio Grande Valley along or close to the border. One is from west Texas and a few others were born in larger cities such as El Paso and San Antonio. Quite a few are the first generation to be born in the United States; their parents were born in Mexico, usually in the northern states adjacent to the border. Others are second- and third-generation U.S. citizens. Only one traces her ancestry back to Spanish Colonial times and a family with a land grant in south Texas, and only two had families who owned land and were ranchers or farmers. Parents or grandparents are usually migrant agricultural workers or unskilled urban laborers.

The majority of these artists come from urban, economically lower-class families. Most still live at poverty level, but this is in part a function of their age, since their education makes it possible for them to obtain reasonably good jobs, often as art teachers in schools and public programs. Their economic status perhaps thus reflects more than anything else their desire to be professional artists; like many young artists in the United States, they take any job that they can subsist on so long as it leaves them time to create.

They live in the barrios, or their fringes, of San Antonio and Austin (although in Austin one of the barrios is simply the usual kind of student housing that surrounds most U.S. universities and is not ethnically specific). Both cities have strongly marked

ethnic neighborhoods—west San Antonio and east Austin—and many of these women live in such neighborhoods or in public housing projects. A few are married or have been married; several have a child. As with their economic status, the presence or absence of a spouse and children is in part a function of their ages.

Separation from their natal families is another characteristic. It may be merely a function of distance, but for most it is more than geographical. The two women who have landed, rural backgrounds appear to maintain much closer relationships with their families than the others do, even though they, too, are geographically separated. Some of the women's backgrounds are marked by broken homes and radical differences in value systems that strain relationships with their parents. Others, again because of their age, are simply asserting their independence and moving away from home as their Anglo peers do, but that in itself causes strain since they are not fitting into the traditional roles for Mexican women valued by their families. The pain of generational differences is expressed in Santa Barraza's "Mother Looks on While the Vulture Preys on Us" (fig. 7.10). Whatever the particular circumstances, in few instances are these women securely tied to a circle of relatives, and most live with friends or alone.

Together, however, they form a strong support group, including a formal organization, *Mujeres Artistas del Suroeste* (MAS), whose level of activity fluctuates according to need. Most of the women know and help each other, promote and critique each other's works, and frequently exhibit together under the aegis of various public arts organizations in Texas (and occasionally elsewhere), particularly in the barrios of their cities. Cooperation is an important and positive value to them.

In general the artists identify closely with, respect, and admire their mothers; however, they want to escape the lives their mothers had—including large families, domination by men, being economically responsible for their children, knowing little but hard work. Frequently, they spoke of their mothers' creativity—talent in sewing, in creating decorations for the home from cast-off materials, in making home altars. Only one woman, however, identified an artist or craftsperson in her family, and that was her father.

A deep spirituality is expressed in the personalities of these artists as well as in their work, but for most it does not find expression in organized, formal, or traditional religious institutions. Intrigued with myth, mythic symbols, extrasensory perception, and American Indian religions, they are estranged from the faith and religious practices of their parents. Our Lady of Guadalupe is as significant, or more significant, as a secular, political symbol as she is a religious one—a symbol of *La Raza,* the blending of Indian and Spanish to create a distinctly New World people. Neither piety nor humility mark their use of this symbol of the Virgin Mary in their art—but I sensed regret for the absence of these emotions.

Claiming descent from the Aztecs as Chicanos, few of the women have had any contact with American Indian cultures or people, although they are fascinated by them. Their identification with Indians is abstract, diffuse, and lacking in cultural content or social and personal specificity. It is a generalized kinship with Indians, whom they recognize as oppressed people like themselves, and the kinship of a house divided within itself that all Chicanos carry, being both oppressors and oppressed. For Chicanas

this has often been called the Malinche complex,[33] Malinche being another female symbol, like the Virgen de Guadalupe, of deeply felt secular power, but in this case with strong sexual overtones. Only one of the women, Mary Louise López, paints Indians; she has traveled extensively in Mexico and is familiar with the multitude of Indian cultural traditions there.

Nature, wilderness, and the earth—the physical landscape—are similarly abstract points of reference and identity. Some of the artists talked wistfully of seeing mountains, forests, or living in the country. Neither natural nor urban landscapes are usual sources of inspiration for them and rarely figure in their subject matter. Only flowers and healing herbs as symbols of health and beauty are given particular attention and have immediacy in their life. The materials they use are commercially produced and purchased from art stores.

Finally, in characterizing the social worlds of these women artists, one remarkable personal trait stands out: their extraordinary energy and dedication. They care deeply about people, children, justice, honor, human suffering—and above all about their art, which they see as a vehicle for expressing their feelings and the triumph of the human spirit. Many are not comfortable with their lives or, perhaps, even with themselves, but they do not ask for comfort; they ask for change and give their energies and talents to that goal.

In their art these Chicana women of south central Texas primarily use the media of pencil, pen and ink, watercolors, acrylics, oils (less commonly), and a variety of print techniques or a combination of these media. A few are plastic artists. Since most are art-school educated, they have been exposed to a variety of media, so their choices are deliberate. Stylistic influences come almost exclusively from the more-or-less contemporary movements and theories of mainstream, Euro-American (including Mexican) art. For example, Carolina Flores, a San Antonio painter, is firmly based in the Abstract Expressionist school, while Santa Barraza's works, especially up until the early 1980s, were strongly influenced by mainstream Mexican art from the twentieth century. The Mexican muralists and their expressions of social protest are fundamental to the Chicano art movement, and, although none of these women are muralists, the style has left its mark. Social realism is dominant among them. Most are inspired by Mexican art, especially by women artists such as the painter Frida Kahlo—but they study the academic art tradition of Mexico, not the folk art or contemporary Mexican and Mexican-Indian traditions.

The subject matter that these artists portray is overwhelmingly concerned with people; women and children are more commonly portrayed than men (fig. 7.2). The latter are not treated unsympathetically or made into sex symbols, as some Chicano artists have done to women. The human subjects are usually shown singly; a mother and child or two or three adult figures at most are represented, sometimes as complete torsos, sometimes only as busts or heads, more rarely as entire figures. Disembodied faces are shown in multiples on different planes, and the faces are depicted either in full or three-quarter view, with the eyes the dominating feature—haunting, reproachful, sorrowful, hopeful, rarely laughing. The human figures are seldom given much context. If one is present, it is usually the most human landscape, the interior of a house—as in

Santa Barraza's monoprint series of a vulture on a child's bed (fig. 7.10), or Marta Sánchez's painting of her home and her little brother. Similarly, Carolina Flores' paintings of hats, shoes, flowers, and even San Antonio rooftops and her daughter are isolated and out of context with a larger environment. The artists do not represent their surroundings, not even the home altars of their childhoods; they do paint the people from their backgrounds. All of these subjects and their treatment seem to make very direct statements of loneliness, isolation, alienation. A person is used to stand for a group of people—even of humankind—proclaiming estrangement, inequities, and suffering.

The few motifs that accompany figures are, and are meant to be, highly symbolic, really iconic: the gun, the skull, the flag, the maguey cactus—but not the nopal cactus or mesquite that exists in south Texas. Santa Barraza's *Renacimiento* (fig. 7.11) is a statement of rebirth in a new world of a new people from an old earth; the cactus is the maguey of Mexico. Despite the promise that birth brings in this drawing, symbols of death and destruction are more common there than symbols of life. These symbols not only suggest evil afoot in the world but also demonstrate the link with Mexico and its celebrations of the dead.[34]

Color is used sparingly by many of these artists, although to some extent this is a result of their preference for poster art (and the cost of color reproduction). Still, black, greys, white and brown represent a choice. When color is used it is to bold effect, as in Santa Barraza's work (fig. 7.11). The colors are strong, deeply hued, and pure.

Some of the women employ innovative and unique forms and materials. Celia Muñoz of Dallas works with paper constructs that are half books (the writing is an integral part of the object), half sculptures. Alicia Arredondo does *tejidos en nudos* (fibers in knots), a self-invented macrame technique, to create small wall-hangings that almost invariably depict a single human figure torturously entangled with symbolic elements such as an eagle, a moon, or a flag. Cat Cisneros of San Antonio, a conceptual artist, creates environmental sculptures, usually of metal and ropes, meant to be set up in a locale such as a woods or sometimes a room, so that changing air currents created by a person walking through or by them will affect their position and the light cast on them. Some women also work in stage design; there is probably more Chicano art activity in the theater, in San Antonio particularly, than in any other art form.

The audience for these women's works is primarily their own people in the barrio. They sell few of their paintings and drawings and they are only rarely included in major museum or gallery exhibits in Texas. A few have shown in invited exhibits outside Texas and in Mexico. None enjoy the economic success or prestige of several of their male counterparts. Organizations within the barrios and the larger community make considerable demands on these women to produce works (often posters), donate works, or organize exhibits, usually in support of political and social causes. At the same time their works are criticized by the (almost invariably) male heads of such organizations as being too political or too depressing and the women are told that they will never be successful artists until they change their subject matter. It is in part in response to this negativity that the three women whose works are illustrated in this chapter—Carmen

Rodríguez, Santa Barraza, and Marta Sánchez—moved out of Texas since my research period.

In sum, the Chicana artists of south central Texas have created art with a message; while the message may be symbolic and metaphorical, it is not obscure or abstract. This art is direct, much of it is "ethnobiographical," and it carries a highly charged, emotional, personal impact. It lacks a contextual landscape—Texas is the missing metaphor. It is the art of women asserting themselves as women on behalf of their *raza*—and, more important, on behalf of humankind. Their work calls out to all of us to create landscapes for human life.

## THE DESERT BECOMES A SYMBOL TO THIS GREAT MYSTERY OF RESURRECTION

To a remarkable degree, the women artists contacted in the El Paso and Mesilla Valley area share personal and social characteristics either with the south central Texas women or with the northern New Mexican women. Their subject matter is unique, however, for most are landscapists (fig. 7.1). Like the south Texas artists, their media are predominantly graphic. Most are easel painters in watercolors, acrylics, or oils; although one, Mago Orona, is primarily a muralist working with sand casts or mosaic in low relief, she also does some sculpting, as well as graphics. All are academically trained in art and two have taught art in high school and college.

Their social and economic backgrounds are middle to upper class, like the women of New Mexico. In age they range from early thirties to mid-fifties; all are or have been married and have at least one child. One is a grandmother. They have close relationships with members of their natal families and, again like the women of New Mexico, an interest in and concern with both family and area history. They were born in the area, two on the Mexican side of the border and the others on the U.S. side; of the latter, their parents or grandparents were also divided in citizenship.

Their relationship to and cultural identification with Mexico is much like that of the women of Austin and San Antonio, except that it is much more constant, direct, and intimate. Culturally, the border unites two national histories, obliterating distinctions (except economic ones), and creates its own unique milieu. The border between the two nations is a very ephemeral line; most of these artists cross it frequently since they have close ties with family or friends on both sides. Their works are exhibited on both sides. Mago Orona lives in El Paso, but she is building a studio in the hills above Juarez and does some of her work there. Juarez-born Hilda Contreras de Rosenfeld and Cuidad Chihuahua-born Marta Arat have exhibited their works in those cities and others in Mexico and are represented in both Mexican and American private collections. Ysela Provencio O'Malley is a New Mexican, born up the Valley in Anthony, where she still retains the family ranch.

Most of these women have had little connection with the Chicano political movement, but all have been involved in the artistic and cultural life of El Paso, Juarez, or the Mesilla Valley. They move with ease, comfort, and a lack of self-consciousness in the

multi-ethnic situation of the area. In this regard, they closely resemble the women of northern New Mexico, strongly and proudly possessed of their heritage in and identity with this binational region. Similar, too, is their lack of feeling of subordination to men, although each had some struggle within her own family to establish herself as an artist and to have her career and work taken seriously.

To a considerable extent, the works of the El Paso and Mesilla Valley artists represent the world in which they live, connected in medium and style to academic traditions of both Mexico and the United States. Lacking a strong folk art tradition, these artists are influenced by the Western art genre of landscape. Most show little concern with ethnobiographical, symbolic and social realism, abstract subject matters, or artistic problems. Mago Orona's work is in part an exception, since she is less interested in the physical landscape and more in abstraction and symbolic statements. Still, her murals stand in the landscape and are part of it. Her most recent mural, a mosaic wrapping around two sides of a public building in El Paso, depicts a stylized Christ-like figure complete with stigmata; the materials, however, deliberately represent natural and urban environments: local rocks, shells from the California and Mexican coasts, ceramic tiles from a local factory, and broken glass collected from the streets of Juarez and El Paso. Marta Arat's interest in the Tarahumara Indians, of whom she has painted a number of portraits, stems from her childhood interest and acquaintance with them (fig. 7.12). She regards her paintings of these Indians, who live in the deep canyons of the Sierra Madre, as both historical documents and a means to call public attention to their situation. She also paints scenes of the Mesilla Valley, its verdant fields and trees along the Rio. Hilda Contreras de Rosenfeld concentrates on flowers both native and introduced to the area (fig. 7.13).

Ysela Provencio O'Malley draws inspiration almost exclusively from the land forms of the river valley, the twin cities situated in the surrounding hills, and her own and her family's experiences with the area (fig. 7.14). A rich sense of humor balances her spiritual attachment to the mountains, hills, and desert. She has done a series of watercolors of puckish angels with fully feathered wings flying over the Franklin Mountains—figure 7.15 shows one bumping its bottom on a mesquite bush. Her peregrinos wander the desert (fig. 7.1). As her statement (which began this chapter) suggests, she reads the course of human life in the physical world, seeing the power and wonder of life as synonymous with the power and wonder of nature.

The works of the El Paso artists demonstrate a strong concern for the physical landscape of their mountainous desert environment and human experiences of it. Whether they represent its forms and features, use its natural materials in their creations, or portray its people, a spiritual inspiration drawn from the natural world infuses their art.

The diverse characteristics of Hispanic women artists' lives, artistic expressions, relationships to their landscapes, and experiences with the places and peoples of their environments are summarized in table 7.1. Clearly, three subcultural variations have emerged, along with three distinctive types of expression in the visual art forms. The chart can be read as a structural model and will be briefly interpreted from this theoretical perspective.

TABLE 7.1. *Hispanic Women's Arts and Experiences in the American Southwest*

| Northern New Mexico-Southern Colorado | El Paso-Mesilla Valley | South Central Texas |
|---|---|---|
| A primarily rural landscape | Urban and rural landscape | Urban landscape |
| Inspired by natural beauty of landscape | Inspired by natural beauty of landscape | Not oriented to the physical environment |
| Use of materials directly extracted from the land and its products | Use of synthetic, manufactured materials | Use of synthetic, manufactured materials |
| Inspired by traditional art styles | Inspired by contemporary art styles | Inspired by contemporary, mainstream art styles and theories |
| Based on Spanish Colonial artistic tradition | Based on contemporary regional artistic tradition | Based on international artistic tradition (especially post-1910 Mexican) |
| Art historically based through genealogical connection | Art historically based, but little genealogical connection | Art atemporal, no genealogical connection |
| Art forms derived from crafts (with functional purposes) | Art forms for aesthetic pleasure | Art forms for social and political purposes and aesthetic pleasure |
| Training through apprenticeship and self-taught | Academic training | Academic training |
| Lower, middle and upper social and economic classes represented; little emphasis on class | Middle and upper classes represented; some emphasis on class | Lower to middle classes represented; more class consciousness |
| Active relationships to Indians reinforce landed and ethnic identity concepts | Less interactive relationships to Indians but specific consciousness of their presence | Abstract relationships to Indians, defined by Anglos |
| Social values of church, family, small community, and land | Values of family, larger community, and land | Values of justice, friendship, responsibility to ethnic community, mobility |
| Confident and proud of ethnic identity and acceptance in larger society | Confident and proud of ethnic identity and acceptance in larger society | Proud but less confident of ethnic identity; striving for acknowledgement of ethnic heritage |
| Aura of personal serenity; possession of their world | Aura of personal serenity | Aura of restlessness and protest; insecurity with their world |
| Tendency toward equality in gender relationships | Tendency toward equality in gender relationships | Less equality in gender relationships |
| Creation for community and larger audience; acknowledgment and appreciation by both | Creation for larger audience and community; acknowledgment and appreciation by both | Creation for own community; little recognition by larger society |

The model shows the characteristics of the artists of northern New Mexico and southern Colorado and those of south central Texas in positions of binary opposition. In between are the artists of El Paso and the Mesilla Valley. They are in the position of mediation, playing the role of synthesizers in that they share characteristics of both groups. The artists of New Mexico would be equated (in classic Levi-Straussian terms)

with Nature. They are closest to the natural world, their nonrepresentational expressions use materials drawn directly from the earth, and their social values, like their art forms, are inspired by tradition. The artists of south central Texas would be equated with Culture. They are closest to the humanly conceived world, their expressions are largely confined to human subjects, their materials are mostly synthetic and manufactured; they are landless and urban, from families more recently immigrated, and their social values, like their art styles, are in a state of flux, drawing inspiration from intellectual and self-conscious theories of art and history.

Thus, the New Mexicans are *of* the physical landscape. It is so thoroughly incorporated in their being that they need not overtly express it. The artists of south central Texas, on the other hand, are *on* the landscape, as yet unrelated and unattached to it. Hence it should become obvious—in fact it is predictable from the model—why the women of El Paso, urban yet very conscious of their physical environment, in a locale that has been settled almost as long as northern New Mexico but which draws much of its population from more recent migrations, ethnically cosmopolitan yet historically conscious, would represent the landscape in their works.

This interpretation derived from the model is tentative since the data, especially on the art forms themselves, have not been analyzed deeply enough for a thorough structural presentation. But the model does make it possible to draw together, on the one hand, some of the relationships in the logic motivating these women's art and their selection of styles, materials, and thematic content with, on the other, a number of social, cultural, and historical patterns in the Hispanic experience with the Southwest. The model helps us understand the operation of the multiplicity of factors identified from the backgrounds, lives, and works of these women without placing undue emphasis on any particular factor. For example, despite the historical orientation of this study, history is not seen as a causal factor of these women's artistic expressions any more than economic class or artistic training is. Yet, by coordinating these factors, the subregional differences appear in sharp contrast.

So, too, does the dynamic state of Hispanic women's art come into sharp focus. Many factors surrounding these women's lives are changing, and the variety in their artistic expressions—especially in their relationships to the landscape—is reflecting this complexity. We may predict from the model, for example, an increasing attachment to place for the Chicana artists of south central Texas, as Arreola has recently noted in the mural art of Chicano communities in southern California.[35]

The model also provides for some intriguing questions. Is "folk" art to landed people as "fine" art is to landless? Since most contemporary northern New Mexican artists are not really folk artists, and their products, which are now created primarily for aesthetic purposes, are not really folk art in terms of usual definitions, is increasing realism and landscape representation predictable? Does the revival and elaboration of folk art traditions correlate with the loss of these artists' families' traditional lands, resulting in the need to create overt symbols to proclaim their ethnic identity and heritage? Is the south Texas women's preoccupation with the human figure linked to their subordinate status? Is their frequent representation of the head and upper body, rather than the whole human figure, a reflection of their sexual subordination to men?

While such a model may help provide some insights into the diversity of Hispanic women's artistic expressions, it obscures their similarity, expressed primarily in a concern with people rather than nature. The women of south central Texas portray people, those of El Paso blend people with the physical world, and those of northern New Mexico and southern Colorado decorate and provide comfort in the domestic and public spaces in which people live. These peregrinas seek to convert a natural landscape into a human landscape or a human landscape into a more humane one of wholeness and unity. Theirs is the pilgrimage of human existence. The Southwest is a difficult land: the wonder of these women's creativity is like the wonder of water bringing seeds to life in the desert.

7.1  Ysela Provencio O'Malley, *Peregrino,* 27″ × 8 ¼″, watercolor, 1977. Collection of the artist.

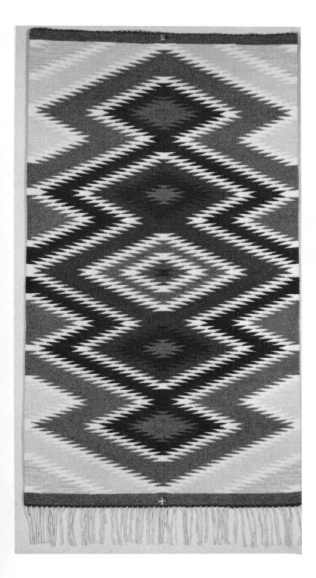

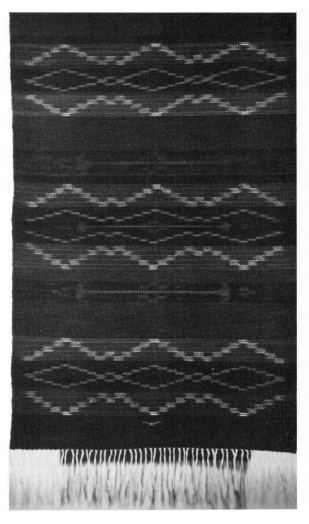

7.2 Carmen Rodríguez, *Tell the Children the Truth,* pencil and pastel, 1983. Collection of the artist.

7.3 Teresa Archuleta-Sagel, *Centella,* 57 ¾″ × 32 ½″, hand-loomed textile, wool, vegetal dyes, 1984. Collection of the artist.

7.4 Maria Vergara-Wilson, *Fantasía Antigua,* 63″ × 37″, hand-loomed textile, wool, vegetal dyes, 1985. The Taylor Museum, Colorado Springs Fine Arts Center, Colorado Springs, Colorado.

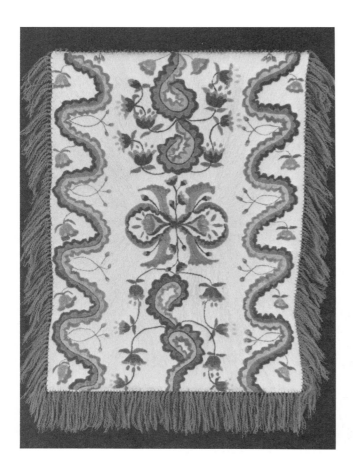

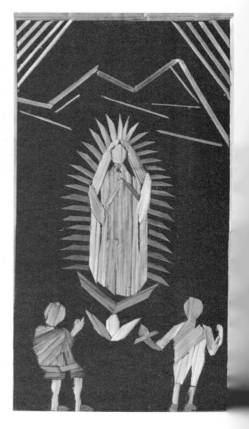

7.5 Maria Vergara-Wilson, *Colcha*, 41″ × 30″ plus frame, wool on wool embroidered textile, vegetal dyes, 1981–1984. Collection of The Albuquerque Museum, Albuquerque, New Mexico.

7.6 Paula Rodríguez, *Straw Mosaic Cross* and detail. *Straw Mosaic Cross with Scenes of the Nativity and the Saints: Nuestra Señora de Guadalupe, Santa Barbara and San Isidro*, 4′ × 2′, wheat straw on pine, 1983. Collection of the artist.

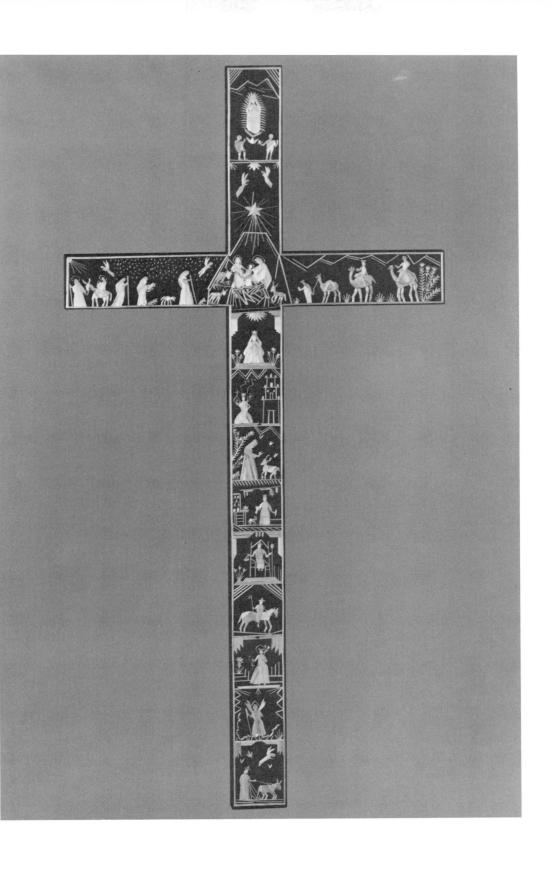

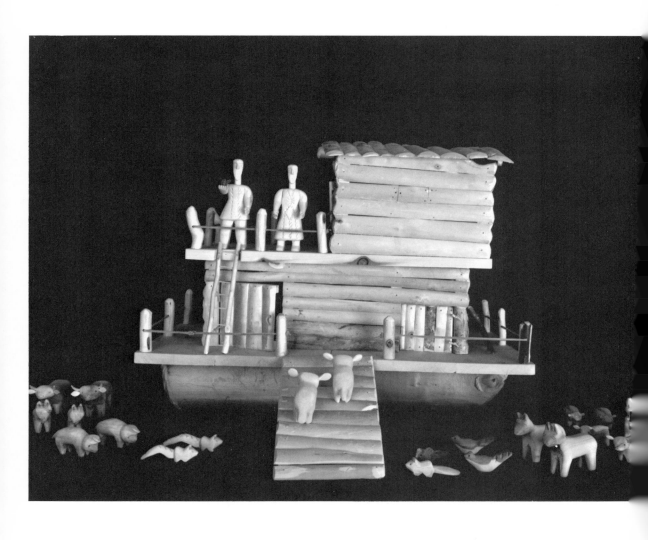

7.7 Gloria López Córdova, *Noah's Ark,* wood carving, aspen and cedar, 1984.
Collection of The Albuquerque Museum, Albuquerque, New Mexico.

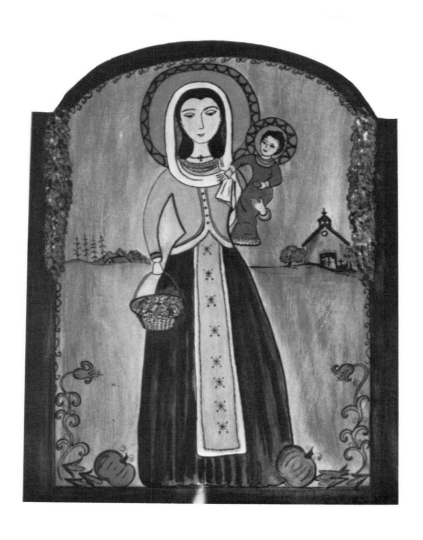

7.8 Zoraida Ortega, *Nuestra Señora de La Joya*, retablo, acrylic on pine, 1983.
Collection in a private chapel.

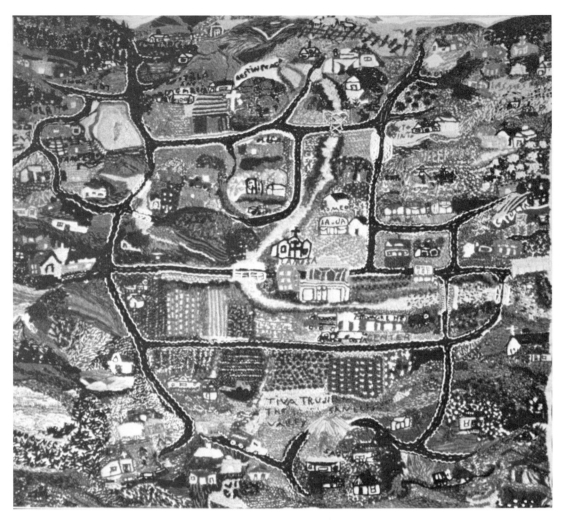

7.9 Tiva Trujillo, *Map of the San Luis Valley* and detail of map, 4′ × 4′, wool on wool embroidery, c. 1979. Collection of the Colorado Historical Society, Denver, Colorado.

7.10 Santa Barraza, *Mother Looks on While the Vulture Preys on Us, Stage II*, 14″ × 19″, lithograph, 1981. Collection of the artist.

7.11  Santa Barraza, *Renacimiento*, painting, pastels, 1981. Collection of the artist.

7.12 Marta Arat, *Tarahumara Runners*, 37″ × 28″, painting, pastels, 1978. Collection of Mr. and Mrs. Robert Salazar.

7.13 Hilda Contreras de Rosenfeld, *Desert Splendor*, 29 ½″ × 22 ½″, watercolor, 1985.
Collection of KINT-TV, El Paso, Texas.

7.14  Ysela Provencio O'Malley, *Rio Grande: El Paso and Juarez*, 36 ½″ × 22 ½″, watercolor, 1980.
Collection of Reverend Joseph Hermoso and Gilberto de la Rosa.

7.15  Ysela Provencio O'Malley, *Angel over the Franklin Mountains*, 14″ × 10 ¼″ watercolor, 1978.
Collection of the artist.

8 · NANCY J. PAREZO, KELLEY A. HAYS,
BARBARA F. SLIVAC

# The Mind's Road

## SOUTHWESTERN INDIAN WOMEN'S ART

*Many of the images used in my jewelry are drawn from my surroundings, mainly the landscapes. I try to make concrete the impressions of the land that are ingrained in my mind. Interpretations of dry, cracked riverbeds, patterns of rock formations, the horizon or shapes in clouds, become ideas for jewelry. In designing a piece, it becomes a challenge to capture the essence of these things as the beauty of this land is so subtle.* —Christine Eustance of Zuni and Cochiti Pueblos

Nampeyo, Mary Morez, Maria Antonio, Maria Martinez, Lucy Lewis and Pablita Velarde are well-known southwestern Indian female artists. Henry Shelton, Ambrose Roanhorse, Narciso Platero Abeyta, Popovi Da, Wolf Robe Hunt and Juan Gutierrez are well-known southwestern Indian male artists. These individuals belong to different cultures: Navajo, Hopi, Hopi-Tewa, and the Pueblos of San Ildefonso, Acoma, and Santa Clara. They make various forms of art—pottery, easel art, sculpture, silver and bead jewelry, textiles, basketry, and kachina dolls. Certain forms are made only by women and others only by men, but division of labor varies by culture and has changed over time. Some crafts developed as a result of Anglo-American and Spanish conquest in the Southwest, while others are offshoots of art forms that have been found in prehistoric indigenous cultures. Certain artists make forms that are designed for use only within their own cultures, while others produce fine and ethnic art only for the international market in luxury items.

The art produced by American Indians is as varied as the southwestern environment. Because of this variability, it is difficult to make any generalizations about how Indian women view their landscapes and how their perceptions affect the art they produce.

Nevertheless, the variability allows us to pose interesting questions about the role of gender and ethnic context in shaping aesthetic responses to the Southwest: How do culture and gender work together to influence perception of the landscape, which in turn influences artistic expression? How does gender enter into art? Is it a function of who produces specific art forms? How does the landscape appear in gender-specific forms of art, such as basketry and textiles? Do women in different American Indian cultures view landscape the same way? Do American Indians express femaleness in their art, and is this in any way influenced by how they perceive the landscape?

We cannot answer all these questions in this paper, but we can explore why they are important, what factors need to be considered, and how landscape and art must be viewed cross-culturally. Our goal is to gain some idea of how landscape is seen by various southwestern Indian groups and to discover ways that it is visualized in the art of American Indian women. Gender enters into the making of art and into how the landscape is used and seen by artists. Therefore we will look at femaleness in art in terms of the sexual division of labor in craft production.

These questions have not previously been asked in studies of the Southwest. We lack data on perceptions of landscape as expressed by a culture, let alone by men and women. Neither are there data on craft production and gender roles and identity. There has never been a complete survey of the sexual division of labor in southwestern craft production. We have surveyed the anthropological literature for information from which inferences could be drawn—studies of specific art forms, gender roles, the sexual division of labor, mythology and religion, and general ethnographies of each culture. We also used exhibit catalogues, gallery guides, and semipopular literature. The anthropological tradition of informant anonymity makes it difficult, if not impossible, to tell whether the anthropologist obtained information from a man or a woman or to provide quotations from identifiable artists. Because our best information is of the Puebloans and the Navajo, we will take most of our examples from these groups. Interviews with individual artists are beyond the scope of this work, though they will be valuable in future studies.

The difficulty of our study is compounded by the region's diversity—cultural variation, historical development, and the influences of Anglo Americans on each Indian culture. It is often difficult to separate patterns that are the result of indigenous development from those created by cultural borrowing and acculturative pressures, which have had a strong impact on American Indian material culture and art. American Indian artists, as members of a multi-ethnic or plural society, inhabit two worlds: that of their own culture and that of Anglo Americans. Because most American Indian artists produce for an Anglo-American audience, they must deal with two sets of values and understandings simultaneously. For example, Aloisa Juan, a Papago basketmaker from Bigfields, Arizona, earns her living by designing art for Anglos. She needs to understand and meet some of the aesthetic requirements of her purchasing group while simultaneously satisfying her own concepts of beauty. But the aesthetic values of the two cultures do not always coincide. To a Papago, an object may be beautiful because it is useful or because of the prayer that was spoken during its making, rather than because the artist has successfully used linear perspective or superior craftsmanship. The Ameri-

can Indian artist must learn which tenets of his or her aesthetic system will be cross-culturally valid if the art is to sell. In order to understand American Indian art and the role that perception of the landscape plays in its production, researchers must isolate the cultural preconceptions and concepts of the politically dominant group.

Before looking at gender in southwestern Indian art and at American Indians' concepts of art and the landscape, we must come to grips with southwestern cultural and historical diversity. We will first look at cultures within the Southwest and then at how American Indian art has changed since the coming of Europeans. Ideally, such analysis would begin at the most specific level and discuss each concept group by group, defining cultural norms and establishing their strength and the amount and kind of variation surrounding each norm to determine any variations due to gender. Because of the lack of data, however, we can make only general comparisons based on regional subgroups, all of which may perceive the landscape according to different ecological adaptations and world views.

Our use of basic cultural groupings is not meant to imply that these subgroups or cultures are homogeneous. In any group there is always internal variation based on individual characteristics.[1] People do not uncritically accept all the goals, ideas, and conventions of their societies. What they select is based on many factors, including gender. Unfortunately, southwestern anthropologists interested in intracultural variation have not discussed gender as an influencing factor.[2]

## CULTURES OF THE SOUTHWEST

The greater Southwest encompasses the states of Arizona and New Mexico and small parts of Colorado, Texas, and Utah in the United States; and Sonora, Chihuahua, and parts of Sinaloa in Mexico. Before European contact, this culture area was populated by approximately sixty-five groups of people who had adapted to the arid environment by means of hunting and gathering and horticulture.[3] Today only forty-four cultures remain (table 8.1, figs. 8.1 and 8.2). They can be placed in four major groups on the basis of language, ecological adaptation, and other similarities. Economic and cultural differences have influenced the way individuals in each culture have interacted with the landscape, the relations between men and women, and the types of art that are produced. The four groups are:[4]

*Pueblo or Village Groups.* The Puebloan groups reside in permanent, politically autonomous villages of contiguous stone and adobe houses on the Colorado Plateau in northern Arizona and New Mexico where they practice intensive agriculture (fig. 8.3). Each village is a highly structured theocracy, organized around an elaborate ceremonial life. Religion permeates all aspects of life, including interaction patterns with the landscape. Compared to other societies in the Southwest, Pueblo groups are nonindividualistic and innovations are accepted or rejected by group decision. The Pueblos are divided into two main subgroups based on location, ecological adaptation, and language. The Eastern Pueblos (Tanoan and Keresan language groups), who live on

TABLE 8.1. *American Indian Cultures of the Southwest*

| Subgroups | Cultures |
|---|---|
| **village** | |
| WESTERN PUEBLOS | Hopi (Uto-Aztecan speakers) |
| | Hopi-Tewa, Hano |
| | Zuni |
| | Acoma (Keresan) |
| | Laguna (Keresan) |
| EASTERN PUEBLOS | |
| Tanoan | |
| *Tiwa* | Taos |
| | Picuris |
| | Sandia |
| | Isleta |
| *Tewa* | San Juan |
| | San Ildefonso |
| | Pojoaque |
| | Nambe |
| | Santa Clara |
| *Towa* | Pecos |
| | Jemez |
| Keresan | Zia |
| | Santa Ana |
| | San Felipe |
| | Santo Domingo |
| | Cochiti |
| **rancheria** | |
| YUMAN | |
| River Yuman | Quechan or Yuma |
| | Cocopa |
| | Mohave |
| | Maricopa |
| Upland Yuman | Yavapai |
| | Walapai |
| | Havasupai |
| PIMAN | Gila Pima |
| | Papago |
| | Lower Pima |
| | Tepehuan |
| OPATA | Opata |
| CAHITAN | Yaqui |
| | Mayo |
| TARAHUMARAN | Tarahumara |
| | Warijio |
| | Concho |
| **band** | |
| SOUTHERN ATHABASCAN–APACHEAN | |
| Eastern Apache | Mescalero |
| | Jicarilla |
| | Chiricahua |
| | Lipan |
| Western Apache | Navajo |
| | Western Apache |
| **non-agricultural band** | |
| SERI | Seri |
| PAIUTE | Southern Paiute |
| | Ute |
| SHOSHONEAN | Chemehuevi* |

*A Southern California group that has recently been moved to the Southwest and placed on a reservation near the Mohave.

the Rio Grande and its tributaries, have a permanent water source enabling them to practice irrigation agriculture. The Western Pueblos (Hopi, Hopi-Tewa, Zuni, Acoma, Laguna), lacking a steady supply of water, rely on dry farming. The difference in water supply affects many aspects of culture, from agricultural practices to religion.

*Rancheria Groups.* At the time of Spanish contact, the agricultural rancheria groups—the Cahitans, Tarahumarans, Pimans, and Yumans—comprised the largest subgroup in the Southwest. They lived in widely spaced settlements along rivers or in well-watered mountain and desert areas in southern Arizona and northern Mexico. The extended family, rather than the village, formed the basic social unit; each family owned a house and fields scattered along the river. Nevertheless, the members of each settlement still thought of themselves as a community, moved as a unit, and symbolized their unity by placing a community house in the center of each settlement.

*Band Peoples.* The Southern Athabascans or Apacheans were newcomers to the Southwest, arriving just before European contact. Most Apacheans lived in small units based on extended families and followed a seminomadic existence, their residences temporary and seasonal. Local groups composed of several matrifocal extended families formed bands, the largest level of political organization. Most bands practiced some agriculture combined with hunting and gathering and by the early 1700s also depended on herding and raiding. Because of their economic patterns, many groups lived in protected highlands, canyons, and mountain valleys. All of the groups considered individuality a strong cultural value; yet they borrowed heavily from the Puebloans, especially in the areas of religion and material culture. The Apacheans are usually divided into the Eastern Apaches (Jicarilla, Lipan, Mescalero, and Chiricahua) and the Western Apaches (White Mountain, Cibecue, and Navajo) (fig. 8.4).

*Nonagricultural Bands.* A few isolated groups in the Southwest maintained a hunting and gathering existence, producing none of their own food and following a nomadic and seminomadic lifestyle in small bilateral bands. Moving often, they possessed small inventories of material culture. The Seri relied heavily on marine products, while the groups of Paiutes who came into the Southwest marginally followed a Great Basin pattern.[5] Some groups of Upland Yumans and the Sand or Western Papagos practiced so little agriculture that they can be numbered in this group.

These four basic cultural groups of the Southwest can be recognized in modified form today. Even after three hundred years of European contact, most groups have managed to preserve a sense of individual cultural identity and a feeling for the land that is recorded in oral traditions. Indian groups have not, however, completely retained their precontact cultures, nor have they reacted uniformly to the attempts of Hispanic, Mexican, and Anglo-American societies to assimilate them. All exist as part of either the Anglo-American or the Mexican socioeconomic system and incorporate a mixture of aboriginal customs and European traditions. Thus, while they are distinct cultures, they are no longer separate societies. They maintain their ethnic identities in various ways,

such as producing distinctive forms of art and retaining feelings about, and interaction patterns with, their environment. Zunis, for example, say that Anglo Americans and Mexican Americans have no respect for the land and abuse it rather than work with it. Southwestern Indians have retained "identity systems that have as an important element the symbol of roots in the land—supernaturally sanctioned, ancient roots, regarded as unchangeable."[6] Such a perspective provides these groups with strong mythological sanctions for their residence, their right to live in the Southwest, and their views of the land. The land is not something that can be controlled and changed; it is something of which all human beings are a part.

## Acculturation and Craft Production

Before addressing questions about the relationship between culture and gender in artistic production and perception of the landscape, we must consider culture history, diffusion, and the influence of Euro-American cultures on American Indian groups. What is produced in each culture has been affected by changes in technology, in the scale of political-economic units, in marketing units, and in interaction patterns. This is not unexpected, for cultures constantly change, even though anthropologists have tended to portray them as frozen in time and space. Furthermore, it is difficult to define exactly what is traditional or indigenous in any culture, because borrowing among American Indian cultures has been common.

Although all the groups in the Southwest have changed over time, some of the most drastic changes in arts and crafts began in the 1880s.[7] Anglo-American pressures to assimilate, coupled with the destruction of traditional subsistence strategies, pulled southwestern Indians into the nation-state's market economy. Craft objects, formerly created for home use with minor trading of surplus goods by barter, were now produced as a supplemental or major source of income. Craft production became important in the economic strategies of many families, even though there was a low hourly return for the labor involved. Often women made crafts for sale while men did outside wage work. In 1923, it was estimated that 5,500 Navajo women produced rugs for sale.[8] In general, craft production has varied inversely with economic conditions: the better the economy, the fewer women weave.[9] However, even in the best of times, craft production has given Indian men and women a way to obtain cash and to maintain economic flexibility (fig. 8.5).

The changes that resulted from direct and indirect contact with Euro-Americans can be illustrated by an extended example from Zuni—the creation of "needlepoint" silver and turquoise jewelry. Before European contact, Zuni men made intricate necklaces, earrings, pendants, and bracelets of turquoise, shell, argillite, jet, and other stones. Each stone had special symbolic meaning. Turquoise, for example, symbolized the Upper World: blue turquoise was the color of the sky and green turquoise represented the earth. Turquoise symbolized good luck and protection.[10] Beads were produced by

cutting, incising, carving, abrading, and drilling with wooden tools. Turquoise mosaic fragments were glued onto shell or basket rings with lac or placed in the eye sockets of stone fetishes.[11] To wear turquoise jewelry was a sign of respect for Mother Earth as well as an indication of the owner's good fortune.

The Zuni did not work silver until the Anglo-American period.[12] They first learned silversmithing techniques in 1872, when a Navajo, Atsidi Sani, taught a Zuni, Lanyade.[13] Lanyade in turn taught a few other Zuni men during the 1870s and 1880s, though there is no indication that any women became smiths.[14] Silver jewelry quickly came to be prized as a symbol of wealth and good fortune, and the Zuni traded turquoise and shell beads for the more abundant Navajo silver jewelry.[15] With improved tools obtained from Anglo-American traders and anthropologists and the increased availability of turquoise around 1900, Zuni smiths began placing their blue stones in silver settings. By 1910 every piece of Zuni jewelry was set with turquoise or coral.[16] Simultaneously, Anglo Americans began purchasing large quantities of Zuni jewelry. In the 1920s, retailers were influencing design to such an extent that the jewelry reflected "the Indian's idea of the trader's idea of what the white men thought was Indian design."[17] Traders encouraged whole families to produce silver, and women began to manufacture as much jewelry as men, becoming especially expert in cutting and mounting the stones.[18]

By World War II, jewelry-making had become a major source of income for the Zuni. In 1946–48, to tap into the expanding market in ethnic arts and to utilize the substance that still symbolized blessings, the Zuni developed a distinctive style, called needlepoint, in which numerous small, slender, blue turquoise stones are cut with pointed ends and set in silver mountings, with turquoise dominating each piece. Needlepoint has now become extremely popular with all the native groups and with Anglo Americans;[19] so many Navajo and Hopi smiths now reproduce it that it is often difficult to tell the origin of a piece. A contemporary needlepoint brooch created by a Zuni woman is thus a product that combines precontact traditions, intertribal borrowings, and Anglo-American values and market influences. Even throughout all the changes, Zuni feelings for an important part of their landscape are reflected in each finished piece.

The changes in cultural context after 1880 that affected craft production can be seen in five main areas. First, the types of objects produced by each society changed. Some crafts declined while others flourished. With the introduction of cheap manufactured goods—cotton clothing, china, and cast-iron cooking pots—weaving, tanning, and pottery-making declined.[20] (For example, cloth weaving disappeared in the Rio Grande Pueblos by the 1890s and at Zuni by 1920 because wage work, commercial cloth, and sewing machines had made the hand loom inefficient.)[21] In general, the manufacture of household goods and basic tools had become neither necessary nor economically feasible. Housing changed as groups were moved onto reservations. Furniture, metal tools, and modern equipment—not the least important of which was the automobile—changed the material culture and artistic repertoire of every group in the Southwest. Most art in the region before 1880 was produced in the form of functional items.

When these were replaced, many of the mechanisms for artistic expression were also eliminated. The greatest stability has been in the inventory of sacred and ceremonial paraphernalia. The great process of cultural change was essentially complete by World War II.[22]

Second, the materials used in the crafts themselves have changed since the entrance of Europeans into the Southwest. One of the best known examples is the substitution of wool for native-grown cotton in Navajo and Pueblo textiles. In addition, commercial Germantown yarns became available to Navajo and Hopi weavers; coral was added to the inventory of substances made into jewelry; metals were introduced and the art of silver jewelry-making and blacksmithing flourished in several groups; synthetic dyes were substituted for native dyes in baskets; poster paint was used to decorate masks and kachina dolls. Often new materials were combined with old production techniques and although materials and tools have changed, there has been a strong tendency to retain the use of customary media whenever practical.[23] Changes in raw materials affected weaving, painting, and jewelry making more than basketry and pottery.

Regardless of the craft, the changes in raw materials changed the nature of the landscape for Indian artists. The addition of sheep to the landscape, for example, extended the environment for some crafts. For others, the changes meant that artists relied less on the land for their raw materials, hence interacted less with the landscape. In general, because of the crafts that they practiced, women artists have retained their precontact patterns of interacting with the landscape in search of raw materials to a greater extent than have male artists.

Third, the shift in craft production greatly affected designs and quality. For example, Western Apache basketmakers began producing two types of baskets—one for sale, which was often poorly made with elaborate designs, and another for their own use, which was generally well-crafted.[24] Pueblo potters began to develop styles that were village-specific (so that their wares could be easily recognized) and began to make exotic shapes like ashtrays and pitchers. In addition, since most tourists wanted inexpensive goods irrespective of craftsmanship, many villages produced badly made and badly fired pottery.[25] The designs on silver jewelry were greatly influenced by traders, who requested that silversmiths use nontraditional designs (swastikas, bows and arrows, thunderbirds) that reflected Anglo-Americans' concept of "Indianness" and rarely had anything to do with native design elements.[26] Hence the designs on these objects often reflect little of the native artists' views of the landscape.

Fourth, many Anglo Americans were concerned about the decline in native craftsmanship resulting from commercialization in the 1880s and early 1900s. Collectors, traders, art patrons, and anthropologists tried to improve the quality of the crafts and expand markets, and in the process they turned crafts into fine art made specifically for Anglo Americans. During this transformation they affected designs and materials, and their views on the landscape may have entered into many art forms. For example, in the 1930s, Kenneth Chapman, curator of Native American art at the Laboratory of Anthropology and the Museum of New Mexico, created a set of designs adapted from traditional pottery for Santo Domingo jewelers. These designs, predominantly life

forms floated on a blank background, were adopted by silversmiths and eventually became the dominant style for that pueblo.[27]

Anglo-American art patrons also introduced western European art media and techniques, many of which have been incorporated into traditional crafts. For instance, Dorothy Dunn, a Chicago-trained art teacher at the Santa Fe Indian School, helped train American Indians in the methods of easel art and fresco in the 1930s.[28] Her goal of combining Anglo-American and American Indian aesthetic concepts demanded the development of new motifs, styles, and techniques that would harmonize with old methods and maintain tribal and individual distinctions. Dunn was successful, and one result of her work is the Institute of American Indian Arts. During the 1970s, American Indians from all over North America gravitated toward Santa Fe, forming a center for a pan-Indian artistic community that supplied a world market with both "quality traditional crafts" and more innovative work.[29]

As a result of these activities and changes, it is sometimes difficult to separate American Indian from Anglo-American aesthetic concepts. The artwork of post-1880 potters, painters, weavers, and silversmiths reflects Anglo-American tastes and preferences. Marketing decisions play an important part in determining what is produced and how the finished product should look. For example, since tourists prefer baskets with naturalistic designs (antelope, eagles, kachina faces), Hopi basketmakers use these designs rather than their traditional geometric patterns.[30] These changes are not necessarily "bad" (although they present a problem for this study)—the transformations have been responsible for the continued existence of many forms.[31] The survival of a craft has come to symbolize the survival of the people. While art has been modified to reflect Anglo-American tastes, tradition has continued to play an important part in the choices artists make about their work. Often this includes the retention of traditional uses for the object and, whenever possible, the artist's interaction with the landscape in the preparation of raw materials.

In sum, the crafts produced by American Indians are a combination of several forces: the individual creativity of the artist, the influence of traders and buyers, the tastes of influential patrons, customers and connoisseurs, and cultural tradition.[32] American Indian art is not the same as that which was being produced when Europeans first entered the Southwest. There are almost always two cultures involved in each piece of contemporary American Indian art. Tradition, however, is still an important factor, especially in areas that deal with landscape.

## GENDER IN ART PRODUCTION

Gender enters into artistic production by American Indians in the Southwest first in the form of craft specialization by sex. Differences in media and in each medium's ability to carry design complicate cross-cultural comparison of each gender's response to the landscape: it is easier to depict the landscape realistically in an oil painting than on a basket. In addition, the specificity of artistic production by gender affects another area

of creativity: while both men and women view the landscape as a source of design, they also see it as a source of raw materials for that craft. Because they utilize raw materials from different parts of the environment, men and women interact differently with the landscape.

Division of labor based on sex has long been recognized as the most basic form of specialization in a society, but the assignment of technological and artistic activities to a sex varies by culture and through time. Sex-specificity is not intrinsic to the manufacture of any craft.[33] This variation can be seen in the following comparison of gender divisions of labor in artistic production in the Rio Grande Pueblos and the Navajo. Table 8.2 summarizes our knowledge for crafts extant before 1880 and for those that became "fine art" after 1880.

Throughout the Southwest, division of labor by gender has always been associated with daily living activities and the performance of religious duties. It affects art production because people make and decorate the things they use. The distinctions, however, are not intrinsic to the manufacture of any craft and vary across cultures and through time. Comparison of the Rio Grande Pueblos with the Navajo illustrates such variations. In the Rio Grande Pueblos, women were responsible for food preparation, housework, cleaning, childrearing, gardening, producing storage containers, and some agricultural tasks, and men for agriculture, hunting, fishing, corral-building, firewood-gathering, and cattleherding.[34] Today, both engage in wage work, sheep-herding, and trade, and both have religious tasks to perform throughout the year and on special occasions. Only men weave and paint religious objects such as kiva murals, wooden headdresses, and altars. Similarly, only women produce baskets and pots.[35] Production of objects by each sex is felt to be complementary, and in some cases it is seen as a privilege that the other sex should respect. At pueblos like Zuni, Hopi, Isleta, Santa Clara, and Cochiti, men build the houses and women plaster them. According to Matilda Coxe Stevenson, women at Zuni loved to plaster and "they would feel that their rights [control over clay] were infringed upon were men to do it."[36] In other cases, however, production has always been based on immediate need; an individual can make an article for his or her own use when necessary, even if it is usually produced by the opposite sex.[37] The most rigid adherence to production rules is in the realm of religious paraphernalia.

The Navajos were, and still are, characterized by a flexible division of labor, even though a basic dichotomy exists in household tasks as defined by the Emergence Myth and by custom. Women cook, clean house, gather, herd sheep, weave, produce such storage containers as baskets and pottery, and care for children; men build and repair houses, haul water, chop wood, hunt, care for horses and cattle, cure, produce silver jewelry, and make cradleboards (fig. 8.6). Flexibility is evident in the manufacture of utilitarian items—each individual produces the tools and utensils associated with his or her daily activities. Production of these objects is, however, considered either men's or women's work, and group pressure is brought to bear on an individual artist to work with the media and the raw materials appropriate to his or her sex. One exception is the production of ceremonial objects used in rituals. This is the prerogative of men, and

TABLE 8.2. *Gender Rules for the Production of Southwestern American Indian Art*

| Culture | pre-1880 | | | | |
|---|---|---|---|---|---|
| | *pottery* | *basketry* | *weaving* | *embroidery* | *jewelry-beadwork* |
| Taos | F | F | A | F | M |
| Picuris | F | F | A | F | M |
| San Juan | F | F/M | M | M/F | M |
| Santa Clara | F | F | M | M/F | M |
| San Ildefonso | F | F | M | M/F | M |
| Nambe | F | F | M | M/F | M |
| Tesuque | F | F | M | M/F | M |
| Jemez | F | F/M | A | F | M |
| Santa Ana | F | F | M | F | M |
| Zia | F | F/M | M | F | M |
| Santo Domingo | F | F | M | F | M |
| Cochiti | F | F/M | M | F | M |
| San Felipe | F | F | M | F | M |
| Sandia | F | F | A | F | M |
| Isleta | F | F | M | F | M |
| Laguna | F | F | M | M/F | M |
| Acoma | F | F | M/F | M/F | M |
| Zuni | F | M/F | M/F | M/F | M |
| Hopi, Hopi-Tewa | F | M/F | M | M | M |
| Navajo | F | F | M/F | A | A |
| Western Apache | F | F | A | A | F |
| Mescalero Apache | A | F | A | A | F |
| Jicarilla Apache | F | F | A | A | F/M |
| Chiricahua Apache | F | F | A | A | F |
| Yuma | F | F | A | A | M/F |
| Cocopa | F | F | A | A | F/M |
| Mohave | F | F | A | A | M/F |
| Maricopa | F | F | M/F | A | M |
| Yavapai | F | F | A | A | A |
| Walapai | F | F | A | A | A |
| Havasupai | F | F | A | A | A |
| Pima | F | M/F | M | A | M |
| Papago | F | F | M | A | M |

| Culture | post-1880 | | | | |
|---|---|---|---|---|---|
| | *pottery* | *basketry* | *weaving* | *silver* | *easel art* |
| Taos | F | A | A | M | F/M |
| Picuris | F | A | A | A | M/F |
| San Juan | F/M | A | A | A | F/M |
| Santa Clara | F/M | A | A | M | F/M |
| San Ildefonso | F/M | A | A | M | M/F |
| Nambe | F | A | A | A | M |
| Tesuque | F | A | A | A | F/M |
| Jemez | F | F | M/F | M | M/F |
| Santa Ana | F | A | A | M | A |
| Zia | F | M | A | M | M/F |
| Santo Domingo | F | A | A | M/F | M/F |
| Cochiti | F/M | M/F | A | M/F | M/F |
| San Felipe | A | F | A | M | M |
| Sandia | A | A | A | M | A |
| Isleta | F | A | A | M/F | M/F |
| Laguna | F | A | A | M | M/F |

TABLE 8.2.    (*Continued*)

| Culture | pre-1880 | | | | |
|---|---|---|---|---|---|
| | *pottery* | *basketry* | *weaving* | *silver* | *easel art* |
| Acoma | F | F | M | M | F/M |
| Zuni | F | F | A | M/F | F/M |
| Hopi, Hopi-Tewa | F | F | M | M/F | M/F |
| Navajo | F | A | F | M/F | M/F |
| Western Apache | A | F | A | M/F | M/F |
| Mescalero Apache | A | A | A | F | M/F |
| Jicarilla Apache | F | F | A | M | M/F |
| Chiricahua Apache | A | A | A | F/M | M/F |
| Yuma | F | A | A | F | M/F |
| Cocopa | F | A | A | F | A |
| Mohave | A | A | A | F | A |
| Maricopa | F | A | F | A | A |
| Yavapai | A | F | A | A | A |
| Walapai | A | F | A | M | A |
| Havasupai | A | F | A | M | A |
| Pima | F | F | A | A | M |
| Papago | F | F/M | A | A | M |

*Legend:* F—usually produced by women
       M—usually produced by men
       A—no production of item or no information available
*Note:* Only selected items of material culture that were transformed into major art items are included. Omitted are musical instruments, weapons, agricultural implements, some apparel, tanning and leatherwork, architecture, and ceremonial paraphernalia.

ceremonial prohibitions restrict women producing or using them.[38] Another exception is basketry, the construction of which is assigned exclusively to women. Associated with basket construction are many religious taboos which restrict the basketmaker's behavior and predict dire consequences, including impotence, for men if they attempt to produce baskets.[39] The manufacture of baskets had become so ritualized by the turn of the century that women ceased production and only *nadleeh* (transvestites) would make them.[40] For other crafts which could be used either ceremonially or in daily life, such as pottery, production was and is gender specific, but no rules or negative religious sanctions enforce the cultural norm.

As crafts have been turned into art for Anglo Americans, the same sex that produced the craft traditionally has tended to produce it commercially—almost all contemporary Hopi, Apache, and Papago basketmakers are women, and Hopi rattle-makers and kachina doll carvers are men. Gender distinctions also continue in the production of crafts for use by the group, such as items used for religious purposes and surrounded by ritual sanctions—only Hopi men produce the weavings used in rituals throughout the Pueblo area, and only Navajo and Ute women make ceremonial baskets. Thus women and men continue to work with different types of materials.

As a commercialized art becomes economically important, gender distinctions in production have tended to blur, especially in situations where permanent wage work is lacking and agriculture declining. At Cochiti, for example, women now make jewelry of glass, turquoise, and shell beads, as well as necklaces of dyed corn and seeds.[41] Likewise,

pottery designed for everyday use is still made exclusively by women in Rio Grande Pueblos,[42] but wherever pottery has entered the fine art market, men have become independent artists or assistants to their wives, sisters, or mothers. Julian Martinez and Tony Da painted the vessels that their female kin shaped, thereby extending their traditional duties as painters of kiva murals (fig. 8.7).

The blurring of gender lines has not been without disruptive effects. Women have not been happy with this incursion of men into the domain of clay. According to W.W. Hill and Charles H. Lange, pottery production is "the principal medium through which women can achieve individual prominence"; success in pottery production gives women public recognition both inside and outside the village.[43] Of equal importance, pottery-making provides women with an independent source of income. If men make pottery, they usurp women's access to an elevated social status and their unique relationship with Mother Earth. In general, however, group pressure to maintain gender lines in craft production has decreased as the economic rewards have increased.

Women's traditional crafts have more often been commercialized than men's. Most of men's traditional products, with the exception of ritual objects, have been replaced by manufactured items and their commercial art forms have developed after European contact. Production of introduced crafts or innovations, especially those intended for external consumption, is initially assigned to men, although in several cases women gradually became producers once the new craft was shown to be successful and lucrative. The initial assignment is based on norms for the most similar traditional craft that is not governed by strict rules or religious sanctions. Thus, silver jewelry, like traditional beadwork, is made primarily by men, although several women are now expert smiths. Likewise, most contemporary easel artists are men. Occasionally, after World War II, new crafts began with equal participation by both sexes: Navajo sandpainting plaques have been made by both men and women since they began to be produced in 1962.[44]

Gender specialization in craft production forces men and women to interact with different features of the environment while collecting raw materials for their respective activities. For example, Pueblo women gathered willow and yucca for baskets, plants for dyes, and clay for pottery. Men mined turquoise and jet, traded for shells, hunted, and gathered cotton. The way each artist saw the land was affected by the raw materials sought. The same thing happens today. The child of a Navajo woman sandpainter complained that, since her mother began sandpainting, it took them too long to go anywhere; she no longer saw trees, just stopped every five minutes to look at colors of rocks and soil.[45] Patterns of interaction with the earth change as men and women begin to produce crafts for the commercial market. On the whole, women's interaction patterns have changed less with commercialization than men's, because the raw materials for women's crafts—clay, willow, devil's claw, and yucca—are still found in the immediate landscape. The raw materials for most commercialized men's arts, however—silver, turquoise stones, oil paints, and canvas—must be bought. They are not "found" materials and so are not perceived as part of the reservation landscape in the same way as sheep or juniper trees or the mesas are.

### AMERICAN INDIAN CONCEPTS OF ART AND LANDSCAPE

Members of a society share basic understandings that make the world comprehensible, but a concept that is important for one group may have little meaning for another. The words *art* and *craft* are two such concepts. American Indian cultures do not distinguish arts from crafts. To most American Indians, art is an essential part of everyday life; feelings about life cannot be separated from the act of expressing these feelings.[46] Thus, in a sense, all people are artists *because* they are human; American Indians do not consider artists to be unique individuals or cultural mavericks. As John Adair has noted, "the Navajo and Pueblo Indians do not regard art as the creation of people outside the mainstream of the community."[47] However, American Indians do recognize that some individuals have special abilities that help them to produce pleasing objects. In all groups, craftmanship is highly regarded.

American Indian thought is integrative and comprehensive. It does not separate intellectual, moral, emotional, aesthetic, economic, and other activities, motivations, and functions. The Navajo language often combines two or more of these categories, for example, *good* and *beautiful*. Clyde Kluckhohn recounts an incident which occurred at a physically unremarkable spot on the reservation: "I remember seeing a Navaho of about fifty years of age with his family in a wagon some miles off course between his hogan and the Rimrock trading store. When I asked him what he was doing there, he replied: 'This is a beautiful spot where my family used to live. Sometimes I come here just to look at it.'"[48] According to Gary Witherspoon, the Navajo concept of beauty is expressed in the suffix *-zho-*. This is usually preceded by *ni*, meaning something specific, or *ho*, conditions or things in general. A beautiful rug is *nizhoni* and a beautiful place is *hozhoni*. Both these terms connote order, good, harmony, health, and happiness.[49]

For both the Navajo and the Zuni, moral good tends to be equated with aesthetic good: that which promotes or represents human survival and human happiness tends to be experienced as "beautiful." Beauty is in the nature of things as well as in people, and it is the natural state of affairs. The landscape is beautiful by definition because the Holy People designed it to be a beautiful, harmonious, happy, and healthy place.[50] For beauty to be maintained it must be expressed in actions such as the creation of art. Thus the process of making art, as well as the art object itself, is considered beautiful. For the Navajo, "the piece is merely the vehicle whereby beauty, *hozho,* is transmitted from an artist, who is himself or herself in a state of beauty, to a recipient or audience, who will in some measure be brought into a state of beauty through viewing, wearing, or appreciating what the artist has done and made."[51] The Navajo concept of beauty is an extremely active one.

There appears to be no concept of "landscape" in American Indian languages. Navajo, for example, does not contain the word *landscape*. This does not mean that Navajos do not see trees, vistas, or mesas, but only that they do not have an abstract category for unspecified vistas such as one glimpses in the rear view mirror.[52] Instead, Navajos have two words for land—*keyah,* which refers to their land as a country or nation, and *leezh,* soil, ground, and dirt.[53] When speaking to a Navajo artist, one must refer to specific

mountains, specific trees, and specific colors of the soil rather than to the "Navajo landscape." This must be done in reference to identifiable places, not to a generalized southwestern landscape on which one draws for inspiration. The landscape *is* the land that supports life for the Navajo, and because of this it is beautiful.[54] Therefore, including in a painting specific trees, plants, or mesas which have meaning to the painter will make a painting beautiful. In addition, the raw materials used in any piece of art are beautiful because they are of the land. This view might be better described by the term *landbase,* as used by George Longfish and Joan Randall. Landbase includes "the interwoven aspects of place, history, culture, philosophy, a people and their sense of themselves and their spirituality, and how the characteristics of the place are all part of a fabric. When rituals are integrated into the setting through the use of materials and specific places and when religion includes the earth upon which one walks—that is landbase."[55]

Landscape, an active force, and the artists' feelings about the land, are in all American Indian art. Landscape for American Indians is part of a dynamic force, part of a "cosmos composed of processes and events, as opposed to things and facts," part of a living force that can be personified in supernatural beings, which are visualized in art and myth.[56]

## LANDSCAPE REFLECTED IN THE ART OF AMERICAN INDIAN WOMEN

American Indian women use the landscape in their art in at least three ways. The first involves direct, realistic renditions in media such as oil and watercolor paintings and landscape rugs, one genre of Navajo weaving. The second is via symbolic means, as seen in Pueblo pottery and Navajo sandpaintings. The third use of landscape involves interaction between artists and the land, for example, in the procurement of raw materials. In this way, almost every piece of American Indian art made by women includes an aspect of the landscape in its most active form.

### Direct Portrayals of the Landscape

Artists select design elements from their experiences and from the world around them. In nonindustrialized societies, design focuses on symbolic, religious, and social aspects of life. According to Raymond Firth, art in these cultures is highly socialized and artists reflect these aspects of life in the art forms themselves. Because of this, Firth contends that "there is [an] almost entire absence of landscape [in nonindustralized societies' art forms]. What depiction of landscape does exist appears as subsidiary material in hunting scenes and the like."[57] The art produced by women in the Southwest supports Firth's generalization. Direct renditions of isolated landscapes comparable to "landscape painting" in Western European easel art do not appear in the designs of any southwestern Indian art. The two exceptions, landscape painting in modern easel art and landscape rugs made by Navajo women, developed after Anglo-American contact.

Most Navajo women weave rugs and blankets with purely geometric designs. One

variety of rug, however, depicts trains, horses, human beings, houses, school buildings and churches, cattle, birds, plants, trees, clouds, mesas, and buttes and other landscape elements.[58] These are generally termed *pictorial* or *landscape* rugs. They are considered "Navajo folk art," paintings in wool, and they contain impressions of what Navajo women see in their landscape.[59]

Harry P. Mera believes that pictorial rugs were first made in the early 1860s but were extremely rare until the 1880s and 1890s. While such rugs have never been common, Joe Ben Wheat reports that "there have always been a few weavers who went beyond the standard geometric designs to depict something that intrigued or amused them, or to create a picture expressive of the life around them."[60] The style of this creative picture has changed over time. The earliest pictorial elements were small, isolated figures, usually birds, in the corners of the traditional banded rugs. In terms of the total composition of the rug, these landscape elements were relatively unimportant. Two styles developed in the 1890s. In the first, rows of dominant landscape elements (for example, cows, horses, human beings) were floated against a solid or banded background; in the second, small stylized motifs were scattered on borderless geometric rugs.[61] For example, one rug pictured in Mera's volume has four rows of men on horseback alternating with three rows of sheep. In landscape rugs indications of spatial relationships were usually negligible. Foreshortening and fields of vision had no importance—what was important was the inclusion of all figures found in the landscape. One of the best-known landscape rugs has two trains with box cars, several horsemen, ducks, birds, dogs, coyotes, rabbits, men, women, and children in various sizes interspersed with arrowheads, diamond shapes, scrolls, and stepped lines.[62] Animals and figures often have elongated torsos. These "floating" elements are a strikingly different depiction of the landscape than that found in English landscape paintings.

Contemporary pictorial rugs developed in the 1920s and 1930s and are extremely varied. Charlene Cerny writes, "Compositions range from the very simple, where attempts at spatial depth are limited to a simple overlapping of forms, to the complex. In the most sophisticated of these, we now find full-blown attempts at linear perspective, with a foreshortening and modelling of forms."[63] Recurring images include the homestead, trucks, cars, animals, mesas, and other features of the contemporary Navajo environment (fig. 8.8). All the motifs are made as realistically as possible, given the constraints of the right-angled elements in weaving. The rugs are extremely active: animate beings, an important Navajo category, are virtually always depicted. Domesticated animals—sheep, horses, dogs, cattle—are displayed as important parts of the landscape. Another common theme involves men and women performing various tasks in front of a hogan with a background of mesas, hills, sky, and clouds. Also portrayed, however, are exceptional events—a circus train, an Enemyway ceremony, and elements adapted from Navajo sandpaintings, such as the twelve eared corn with birds from Blessingway. There are no austere, empty landscapes.

Landscape rugs show the positive side of everyday life, as one would expect given the Navajo concepts of beauty and the land. There are no negative (that is, "ugly") elements in any landscape rug—no disasters, no dead things, no thunderstorms or cyclones, no

desolation. Colors are bright and hopeful, creating an almost idyllic effect. Landscape rugs are human interaction with the landscape at its most positive and hence, at its most beautiful.

Although American Indians traditionally produced paintings on rocks, the walls of kivas, and the bodies of ceramic vessels, they did not create art on canvas until the late nineteenth century, when Navajo and Puebloan men began to use European materials and gradually developed a distinctive southwestern Indian easel art tradition.[64] By the early 1930s, there was only one well-known woman artist, Tonita Pena of Cochiti. Since that time most easel artists have been men. While both men and women learned to paint in school, most women appear to have stopped painting upon graduation. There have been, however, women artists who have excelled in several media: Pablita Velarde, Geronima Cruz Montoya, Eva Mirabel, Linda Lomahaftewa, Tonita Lujan, Lori Tanner, Maria Chinana, Mary Gachupin, Clara Shendo, Helen Hardin, Pop-Chalee, Mary Morez, Eileen Lesarlley, Mary Ellen, Lorencita Atencio, Cipriana Romero, Betty Nilchee, Phyllis Fife, Lucille Hyeoma, and Sybil Yazzie. Unfortunately, the work of these women is rarely analyzed or even mentioned in the literature on American Indian easel art.

The subject matter and the use of landscape features in the easel art of Indian women has reflected stylistic changes in Indian art in general. The earliest male painters made drawings of public ceremonial activities in a flat style with the main figures floating in space. Tonita Pena's paintings also centered on joyful public ritual performances, but, in addition, she made paintings of pottery and of women performing daily activities. Like the work of male painters, her compositions lack foreground, background, and perspective. According to J. J. Brody, the works of such self-taught painters as Pena are characterized by "one-point perspective, realistic action, de-emphasis of line, and use of color to model form." Painters were not concerned with developing techniques for illusionist representation; their goal was to be realistic—to draw from directly perceived reality in their local landscape. Thus the subject matter is explicit, descriptive, and documentary.[65]

Painters in the institutional period of the 1930s and 1940s likewise portrayed events with realistic accuracy. The subject matter of artists who studied with Dorothy Dunn at the Santa Fe Indian School included ceremonial subjects, people performing daily activities, highly stylized birds, reptiles, other animals, and plants.[66] Paintings show people, usually women, interacting in positive ways with elements of the landscape. For instance, *Picking Wild Berries* by Eva Mirabel of Taos (1940) depicts three women putting berries into their baskets and aprons. Stylized bushes and trees are shown in the same plane with no background or foreground. Likewise, Mary Ellen (Navajo) painted a Navajo woman working in a garden in 1936, and Lorencita Atencio of San Juan portrayed men clearing an irrigation ditch, women drawing water, and matachina dancers in her first paintings in 1935. Pablita Velarde's first exhibited works in 1933 were titled *Women Baking Bread, Woman Husking Corn, Girl Winnowing Wheat, Woman with Olla, Women Putting on Moccasins, Women Firing Pottery,* and *Mother and Child*.[67] While men's paintings occasionally emphasized violence (war, hunting scenes, and mountain lions attacking deer), paintings by women (with the exception of Eva Mirab-

al) were populated with women's activities and centered on the nurturing aspects of daily life. So detailed and accurate was the work of many of these women that the paintings have been considered valuable ethnographic records.[68]

Beginning late in the institutional period and continuing to the present, the depiction of the landscape in the work of women artists has varied. In some cases, landscape elements have been used to form a definite background for animate main figures, while in others they are merely decorative, identifiable designs. Imaginative as well as realistic landscape is portrayed, especially in the work of Pop-Chalee. Mythological landscapes, often in the form of abstract compositions, can be seen in the work of Helen Hardin. In several instances the medium seems to influence the choice of landscape elements. For example, Pablita Velarde uses realistic landscape elements and Western techniques for painting space in her tempera work. On the other hand, in her "earth paintings" (which consist of locally found, pulverized dry pigments glued to a backing, and casein tempera paints—also of local materials—made into a diluted paint and used to produce the picture), abstractions and symbols drawn from Navajo sandpaintings, pottery designs, kiva murals, and Pueblo mythology are either floated in an undefined space or placed according to Navajo concepts of space as depicted in sacred sandpaintings (fig. 8.9).[69]

Like the weavers of landscape rugs, American Indian painters tend to produce positive and active landscapes that center on places and events in their home communities. Differences in depictions can partly be explained by the requirements of each medium. But there is another difference that has a bearing on the visual landscape of the painter. All Navajo landscape weavers live on the reservation. Some easel artists, on the other hand, live off-reservation in urban areas, although most live in their home communities.[70] These residence decisions create different landscapes on which the painter can draw. If urban artists still want to paint scenes from the reservation, they must draw on a remembered landscape rather than one that is experienced and participated in daily. And some painters, like Helen Hardin, did not grow up on the reservation. She had to study traditional designs and art through the stories of her parents, and this has influenced her work. She says:

> *Rather than painting a subject, I am inspired by that subject to paint what I feel from the idea, the song, the ceremonial, the mask. I paint it as I feel it, rather than as I see it. . . . This is what separates me from traditional painters who paint the actual object or scene. Traditional painting usually tells a story. . . . It depicts a scene, tells what is happening there. . . . Contemporary art leaves you with a feeling rather than a story.*[71]

Hardin uses prehistoric and modern pottery designs and rock art rather than the actual ceremonial and daily activities of the pueblo as her source of motifs. Characteristically, Hardin's paintings are more abstract than the work of her mother, Pablita Velarde, who has been able to draw on daily experience. But both methods allow these women to express their Indian identity.

### The Symbolic Landscape

American Indian artists often use symbolic portrayals of actual landscape features and supernatural entities that inhabit aspects of the landscape in their art. The symbols may

be arbitrarily chosen designs or colors that stand for specific objects, such as yucca, mesquite trees, or mesas, or general concepts, such as directionality or mountainous terrain. These shared symbols clearly represent "an idea commonly understood by the culture in which it is used."[72]

The distinction between designs that are representations of landscape features and the symbolic landscape has caused a great deal of confusion in the literature. Popular Anglo-American notions of American Indians have endowed the designs on commercialized art with symbolism. In response, traders have assigned descriptive labels to designs, calling them "religious symbols" because "symbols" bring higher prices. In most cases, however, art produced for tourists or collectors has little or no symbolic value. Artists have sometimes named designs for convenience but they do not necessarily consider them to be symbolic: neither Apache nor Yavapai basketmakers attach any significance to the human, animal, and plant figures that decorate their baskets. Navajo and Zuni jewelry, Navajo geometric rugs, and Acoma pottery all lack symbolic meaning.[73] This is true of both men's and women's art.

Some of the designs on commercialized items may have had symbolic meaning in the past. In a study of Pueblo pottery, Harry P. Mera notes that "designs originally conceived for ceremonial use may, through popular fancy and repetition, entirely lose their first significance and become mere decoration." Priscilla Namingha Nampeyo, a Hopi potter, thinks that the colors and designs she and other Hopi potters use have meaning, "but my mother and them don't know what it is; they just say clouds and kachinas and use the colors they want." San Carlos Apache basketweavers added a cross and crescent motif to their design repertoire around 1930 as a result of a religious movement.[74] This motif may have served originally as a symbol of a believer's identification with the movement, but for others and for modern basketweavers, it is simply decorative.

Symbolism in the form of elaborate iconographic systems is used primarily in religious art, and its use is governed by supernaturally sanctioned rules. The systems are fully understood only by religious specialists, usually men; women usually know less about the esoteric levels of symbolism than men. When Carl E. Guthe asked San Ildefonsoans for the meanings of their pottery designs, he was told by both men and women to "ask the men, the women don't know."[75] The difference in knowledge stems from the separate spiritual roles assigned to men and women, which are the equivalent of the division of labor by gender discussed earlier. Women give life through their bodies, bearing and nurturing the members of the group, while men give life through the ritual system, ensuring balance and harmony in the world. This situation may account for women's tendency to use fewer religious symbols in their art than men, although such use varies according to Pueblo traditions and history.[76]

Of course, women do use symbolism in their art. Hopi women potters make a broad range of symbolic designs that refer to aspects of the landscape generally concerned with rain, such as clouds and the costumes of the rain-bringing kachinas. Symbolic meanings in women's art, however, tend to be public rather than esoteric. Unless making ceramics for specific rituals, women produce less standardized designs because they do not have to follow supernatural mandates. A woman has a great deal of choice in design combinations, colors, and their arrangement on a wide variety of vessel forms.

In contrast, Hopi men's traditional art contains symbols specific in meaning and standardized in execution. "Hopi embroidery—an art practiced only by men—is governed by very rigid rules. There is nothing in it comparable to the free play of fancy that inspires the women's pottery making."[77]

Pueblo pottery is intimately associated with the processes involved in asking for rain; for example, designs on Zuni vessels reaffirm the constant need for water in this arid environment and, in a sense, communicate prayers for rain. A certain geometric design that almost always appears on the outer rim of food bowls is called the "prayer stick design" or "feathers." Although women cannot make the painted wood and feather prayer sticks used by men in Zuni ritual, they may paint this design on pottery.[78] A water jar described by Matilde Cox Stevenson has "cumulus clouds . . . around the base and near the top [of the] vase. As a result of the rain, vegetation appears which is symbolized by the fan-like designs. The four-pointed star with the rainclouds within symbolizes rain far off at the four regions. The circle in the center signifies the clouds of the zenith." These designs expressed a visualized, unspoken prayer.[79]

A knowledgeable potter of a priestly Zuni family explained to Ruth Bunzel that "every design is significant," with a name and a story referring to a situation or an event rather than an object or an idea. The symbolism used by American Indian women of many cultures is not generally object-oriented but has an allusive association with mythical events and ritual processes that unite mythological time and space with the "concrete present," our "here-and-now." It is easy to see that the bear paw on Santa Clara pottery symbolizes the bear, but the bear's significance lies in the story of Bear, who led the people to running springs during a severe drought.[80] The portrayal of the bear is not merely a commemoration of the event, but an affirmation of the relationship between Bear and Santa Clara. This story itself may be said to be symbolic of the necessary intertwining of human and animal lives, and perhaps of the human responsibility for preservation of the animals and their habitat.

Animals found in the pueblo landscape can also be used to symbolize group identity. Almost all Rio Grande Pueblo women paint birds on their pottery (fig. 8.10). These designs do not represent specific birds, such as eagles and woodpeckers; they are generalized, representing "birdness." All are similar in overall form and colors, but one can usually tell the potter's village by the way she renders her birds. A bird with large, sweeping wings and tail, whose feet grasp the stem of a flower, in effect says, "I am an Acoma woman's bird." Zia birds, in contrast, stand on the ground and have small wings and elaborate crests. The birds symbolize the community on two levels—the unity of Puebloans, and the identity of each individual village.

### The Mythological Landscape

Art is not merely a patterning of the seen, the images of the contemporary external world, but also a patterning of the unseen, the mythological and supernatural world.[81] This world exists in its own landscape, which is often portrayed in art. The features of the unseen landscape are just as real and important as those that can be seen. Most mythological landscape features are derived from origin myths or clan migration legends that link the group's identity with the landscape. Thus, landscape symbols in art are often expressions of a group's relationship with specific places in the world, through

the experiences of ancestors and supernaturals in the landscape of myths. Such depictions are prominent on religious art forms and, if they are not sacred esoteric designs, they occur on secular art as well.

In women's art, the earth and its landscape are reflected in symbolic references to the world's center and its four directions, vital elements in most southwestern Indian world views and mythologies. For example, in Pablita Velarde's series entitled *The Emergence of the Tewa,* she uses the sacred serpent as a symbol for the Rio Grande in the same way that the river is described in the origin myth. She also uses symbols incorporating references to the four directions, the nadir, and the zenith. Linda Lomahaftewa, a Hopi painter, says the colors she uses in her paintings relate to "my tribal colors of the four directions."[82]

Occasionally, features from the physical landscape are transformed into symbols that mirror a mythological landscape feature. These are often sacred places—that is, places where events of great mythological significance are thought to have occurred. An important example is the four sacred mountains of the Navajo, which mark the boundaries of the landscape and the environment that is the provenance of the Navajo. They were created by First Man and First Woman, who placed a girl and boy in each mountain as guardians and assigned each mountain a specific color by referring to a precious stone located within it: in the North is black jet; in the South, blue-green turquoise; in the East, white shell; and in the West, yellow abalone shell.[83] When used in jewelry, these stones express this directional symbolism.

Another example of art incorporating mythological landscapes is Navajo sandpainting, an impermanent form of sacred art, made primarily by men and by women past menopause.[84] Every sandpainting occurs in mythological space and includes symbols identifying the location of the action (fig. 8.11). A sandpainting symbolically portrays an episode in the myth that accompanies each curing ceremony. The action is played out in *Dinetah,* the land of the people, bounded by the four sacred mountains, which are shown in sandpaintings as colored circles placed in the corners between the main theme symbols. Mountains as a generic landscape feature are black ovals on which figures stand. Reading location symbols is like reading a mythological road map. In the center of radial paintings is a locality symbol representing water, a mountain, a house, or the place of emergence. In linear compositions, the locality symbol is the bar placed to the west, beneath the feet of the main figures. In general, locality symbols are important places where mythological events have occurred. Sandpaintings project a very active interpretation of landscape.

In addition to designs and colors reflecting mythological landscape features, the shape and form of women's art is mythologically symbolic. Navajo ceremonial baskets or "wedding baskets" are made in the shape of the universe. According to Rik Pinxten and Ingrid Van Dooren, "the Navajo world or universe consists of a shallow, flat disk in the form of a dish, topped by a similar form which covers it like a lid. The lower part is the Earth, while the upper part (the lid, so to speak) is the sky."[85] The basket is equated with the lower part or the earth, and more specifically with the part of the earth inhabited by Navajos.

Housing and village layout, like other forms of art, reflect the American Indian vision of the actual and mythological universe. For the Navajo, the hogan is both a dwelling

and a center of ritual activity. The hogan mirrors the physical landscape as interpreted in myth, combining male and female domains as well as sacred and secular domains. Its shape is a visual map of the universe, both being circular. Both are divided into male space, the south half, and female space, the north half. Male and female activities take place in their respective zones, and seating for the ceremonies that occur inside the hogan is so designated. The hogan door, like the opening into the Navajo world, always faces east to greet the rising sun. The roof is like Sky Father, and the floor touches Earth Mother. The central fire is like the sun. The hogan's walls, made of the materials of the four sacred mountains, are like trees, mountains, and hills. Thus each Navajo hogan represents the center of the world.[86]

In contrast to the Navajo, the Hopi separate male and female space and the secular and sacred domains more distinctly, but they still represent the mythological landscape in their structures and village layout. Kivas, special ceremonial chambers, are centers of ritual activity, although some rooms in individual houses are also used. Male activities, such as producing art (weaving and kachina doll carving) and socializing occur here. The kiva floor contains a fire hearth and a small round hole called the *sipapu*. The sipapu symbolizes the portal through which the people emerged onto this earth, as well as the sacred spring in the Grand Canyon where the emergence took place. The kiva is the symbolic center of the Hopi world. Complementing this male domain is the family house, the domain of women. The house is the focus of women's activities, such as food preparation, art production, and childcare. Each house within the village is owned by a woman who belongs to the clan of her mother. Each clan is headed by a Clan Mother, who guards the ceremonial paraphernalia used by the males of the clan in her home, which is called the Clan House.[87] Each individual in the village is identified with the house of his or her birth.

Hopi landscape as a whole is mythologically portrayed as socially determined. Each part of the village belongs to one of many clans whose origin, travels, and arrival at the village are recounted in myth. Outside the village, Hopi mythology describes how battles, disasters, migrations, and settlements are associated with particular sites throughout the Southwest. The identity of the land is thus wrapped up with the identity of the Hopi clans and their migrations, as well as with the creation and dispersal of all peoples and animals. The landscape of a Hopi village is, as Yi Fu Tuan suggests for the Zuni, less a pattern of form and color than a pattern of social relationships: women and their husbands, clan networks, and so on.[88] It is a *social landscape*.

Hopi artists, both men and women, put their social and mythological landscapes in their art whenever they use symbolic or direct representation of the landscape, as well as when they collect the raw materials for their art. The artists deal with both the active and the social aspects of land processes, such as the germination and survival of plants, the human life cycle, and the ceremonial cycle.[89] The landscape is inseparable from what goes on in it, and from the lives of the people who inhabit it.

### Life Pathways

In addition to landscape symbols that come from the myths that tie groups to their land, women also use landscape symbols to express visually the trajectories of their individual lives. This is the *life's pathway,* a metaphor for the idea that an individual's life

history has its analogue in landscape. Each person chooses paths that take him or her through the world from birth to death. These paths are often expressed in various ways in women's art but are almost never found in men's art.

One of the best examples of the pathway is the Papago "man in the maze" design used on coiled baskets (fig. 8.12). This design, a tiny human figure at the opening of a maze, may be a fairly recent innovation—it has been commonly used only since the 1940s.[90] The man in the maze design comes from the stories about Elder Brother, the Papago trickster-hero. For the Papago, the design synthesizes traditional myth and Christian ideology. For contemporary Papago weavers, the maze represents an inner, personal landscape, the road a person travels in his or her life.

> *To the Papago the man at the top of the basket symbolizes birth—of the individual, of the family, of the tribe. As the figure goes through the maze he encounters many turns, many changes. Many of the elderly Papago often talk of a turn in their life and liken it to a turn in the maze. Progressing deeper and deeper into the pattern, one acquires more knowledge, strength, and understanding. As the figure nears the end of the maze he sees his death approaching: the dark center of the pattern. It is here that he repents, cleanses himself, and reflects back on all the wisdom he has gained. Finally pure and in harmony with the world, he accepts death.[91]*

Pueblo pottery decoration often includes a distinctive "life pathway" feature known to anthropologists and collectors as the "line break." It is a plain, broken line encircling the interior of a bowl below the rim and the exterior neck of a jar (fig. 8.13). There is good evidence for the prehistoric use of this symbolic device, and it still holds meaning for many Pueblo potters today. Over the past fifty years, use of the line break has fallen off in some pueblos and has disappeared in others, for example at San Ildefonso. It has continued at Santo Domingo, Cochiti, Zuni, Hano, and the other Hopi villages of First Mesa.[92]

Researchers and native artists alike disagree about the meaning of the line break. One interpretation calls it an identifying mark used by certain potters or a design feature associated with specific pueblos. If so, then the line break is not a life pathway but an ethnic marker or a signature of individual artistic style. Potters employ the broken line "because it is the 'way the old people did it,' the 'way it is always done.'"[93] Frank H. Cushing suggested two other interpretations of Zuni pottery that also have wide distribution among the other Pueblos. First, the line break is an "exit trail of life or being" for the spirit of the pot; it allows its indwelling spirit to reach the outside world. If the encircling line were completed, the vessel might be broken by the efforts of the spirit to enter and leave it. Second is that the line break is made to "avert physical misfortune from the potter."[94] This is the interpretation most commonly accepted by anthropologists and potters. For example, Ruth Bunzel notes that the Zuni refer to the line dividing the jar's neck from its body as "the road." This road is identified with the life of the potter and left unjoined to insure her safety. "When I finish it, I finish my road, that is, I end my life."[95]

Related to use of the line break in pottery are basketry techniques that reflect beliefs about the special meaning of open and closed space for women as they move through

their life cycle. These techniques can be seen in Hopi basketry, Navajo basketry, and Navajo weaving. Hopi women in Second Mesa villages make coiled basketry plaques of yucca. The end of the spiral coil is left unfinished by unmarried women and the foundation bundle of grass protrudes. This is called the "flowing gate." Married women cut the grass bundle but leave it exposed. This is the "open gate." Widowed and elderly women cover the cut ends with coiling stitches: "the closed gate." Thus do the women symbolically refer in their art to their childbearing capabilities.[96]

The Navajo coiled ceremonial basket is used in curing ceremonies that reestablish harmony and balance (*hozho*) and in ceremonies to mark beginnings, such as births, namings, weddings, and the blessing of new homes (fig. 8.14). The basket has a black stepped design flanking a red stripe. The pattern is broken on one side and the rim coil ends above the break. The opening allows the singer to orient the opening in the basket design toward the east during the ceremony.[97] The break is necessary so that the Holy People can participate in the ceremony and consecrate the cornmeal in the basket. If the design were closed, the consecration could not take place.

Navajo weavers sometimes break the border of a rug by carrying one or more rows of weft from the inner pattern into the contrasting border and to the edge of the weaving (fig. 8.15). The small stripe, usually located near a corner, is called the mind's road, the mind's pathway, or the mind's gate by many Navajo weavers. Sometimes, these lines may be overlooked by a casual observer, having been subtly woven into the border.[98] The line keeps the weaver's mind from being closed into the design and allows her to move on to new designs and weave new rugs. Also, the weaver could become ill from becoming too involved in the weaving (that is, "overdoing"), especially if the patterns are intricate.[99] The mind's road and the line break keep life and creativity in motion. For the individual's life to continue, for the life of the community and of the earth to continue, creativity must not stop. No gates may be closed.

### Honoring Mother Earth: Interacting with the Landscape

American Indian men and women artists interact with the landscape at all stages of artistic activity, from the collection of raw materials to the final steps in creation. When picking yucca stems or firing pots, the artist shows reverence and respect for Mother Earth by thanking her for the raw materials used in art production and for the creativity with which to produce art. The landscape, personified as Mother Earth, actively gives to the artist, and the artist reciprocates by creating in the traditional manner. These interaction patterns, invisible in the final product, are based in the belief systems of each group. The patterns have been tenacious despite changes in the art itself. Artists have tried to conserve many old techniques and beliefs, even those whose utility is obsolete and which have no visible effects to non-Indians. Many contemporary artists spend a great deal of time and effort in ritual activities before and during the production of pottery, baskets, and weavings. These rituals honor Mother Earth; adherence to them accounts in part for how women perceive the landscape and how their perceptions enter into their art.

The process of creation is more important than the art object itself, just as the processes occurring on the land are more important than its physiognomy. Prepara-

tions (that is, all that goes on prior to the actual construction of the object) are the most important part of the creative process to American Indians. A Navajo filmmaker, Susie Benally, produced a film on Navajo weaving in 1966 that shows a weaver interacting with the landscape. The twenty-one-minute film "showed only about four and a half minutes of weaving, and most of that is at the very end of the film. . . . The main interest in the film seems to be in people moving about over the landscape herding sheep, gathering the various plants to be used for washing and dyeing the wool, preparing the wool by carding, dyeing and spinning." For Benally, the life processes involved in weaving are of more interest than the final product, the finished rug. From a Navajo point of view, the rug and its physical pattern are of less importance than "the interaction with animals, landscape, plants, the mastery of preparation procedures, the knowledge of dyes and the creative imagination that brings forth the patterning."[100]

Artists identify many traditionally used raw materials with the earth. Clay, like earth and mud, is the substance of Mother Earth. For this reason, nowhere is the interaction of women artists and Mother Earth more apparent than in pottery production. Barbara Babcock writes:

> In the Pueblo world view clay like corn is regarded as a godgiven, living and life-sustaining substance which one takes and makes and gives without counting and with thanks and which one never handles lightly. Every stage of pottery-making from digging clay to firing is accompanied by prayers and cornmeal offerings to Clay Mother. [Helen Cordero, Cochiti potter, states] "I don't just get up in the morning and start making potteries. First, I go and talk to Grandma Clay."[101]

For the Pueblos and the Navajo, the earth and the heavens are conceptualized as animate and sapient beings: the Earth is female and the Sky or heaven is male. The Earth is also considered "My Mother," *nahasdzaan shima* in Navajo (fig. 8.11). The Earth lies on her back with her head to the East, her head cushioned by the eastern sacred mountain, and her feet touching the western sacred mountain. Her arms extend sideways toward the northern and southern sacred mountains.[102] The substances that are the raw materials for all art have been placed on and within Mother Earth for the use of the People.

One of Mother Earth's substances, clay, is also thought of as the flesh of a woman and is personified as a being known as Clay Old Woman, Clay Lady, or Grandmother Clay. Clay is female because that which nourishes life is "symbolized by the Zunis as mother."[103] At Zuni, because clay is the flesh of a female supernatural, "clay processes, brickmaking or laying on plastering, and pottery are women's work." Clay Woman "gives her flesh" to potters, and Zuni prayer stick makers "refer in prayers to 'our mothers' Clay Woman, Black Paint Woman, Cotton Woman."[104] Dittert and Plog note that Pueblo potters traditionally ask Clay Woman for permission to take of her being before gathering clay. "When Lucinda of Isleta was learning new styles of pottery from her Laguna neighbor and they went together to get clay, the neighbor taught Lucinda to ask the clay mother for her substance." In addition, specific rituals are performed for her. For example, "at Santa Clara, sacred meal was scattered over the clay gathering site. 'You must treat the clay right; if you do, it will treat you right.' "[105]

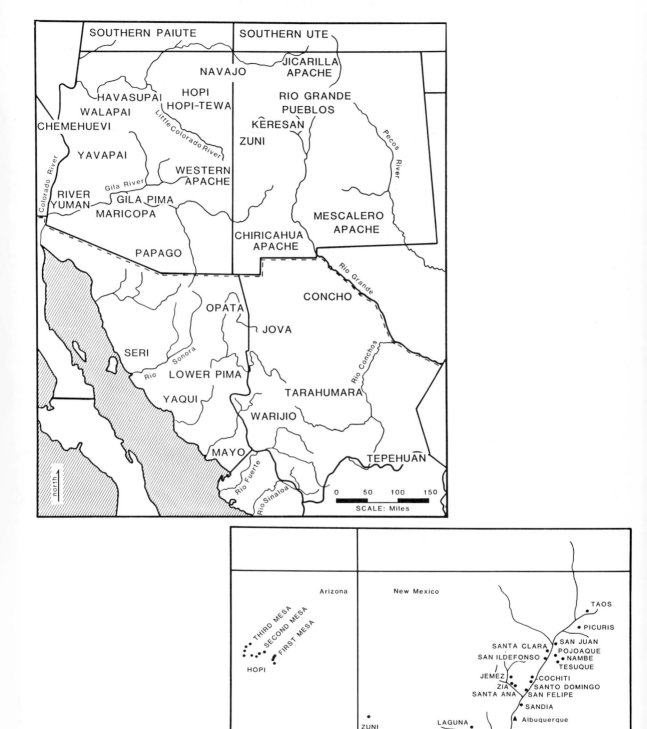

8.1  American Indian Cultures of the Southwest.       8.2  Pueblo Villages.

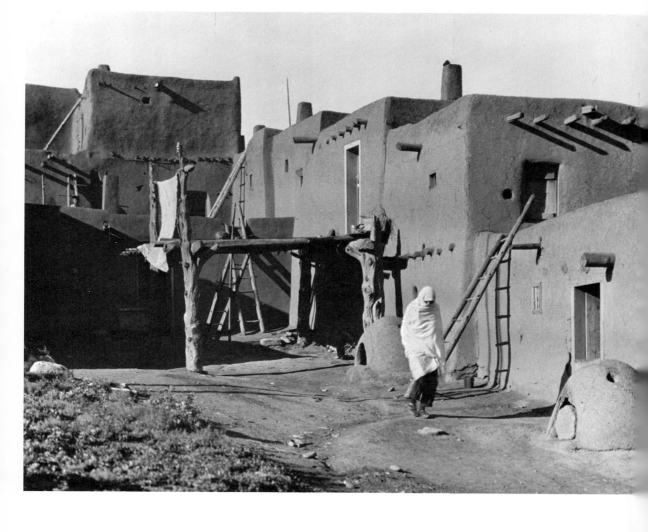

8.3 Forman Hanna, Taos Pueblo street scene, photograph, 1919.
Collection of the Arizona State Museum, University of Arizona, Tucson, Arizona.

8.4 Forman Hanna, Navajo hogan below a mesa on the Navajo reservation, photograph, 1926.
Collection of the Arizona State Museum, University of Arizona, Tucson, Arizona.

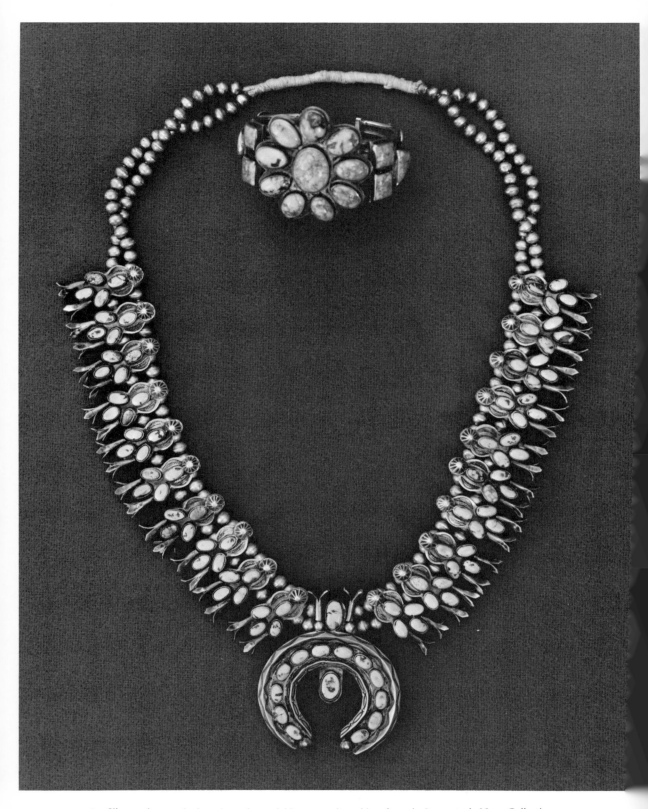

8.5  Silver and turquoise bracelet and squash blossom style necklace from the Lecomte du Nouy Collection, Arizona State Museum, University of Arizona, Tucson, Arizona.

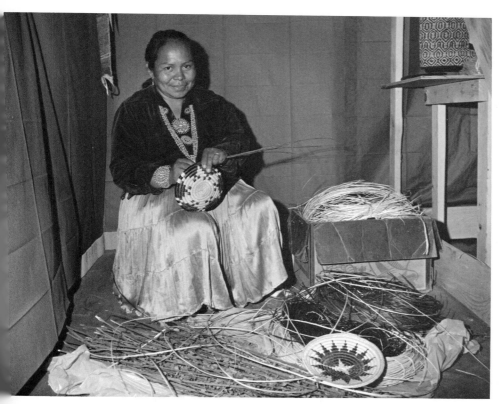

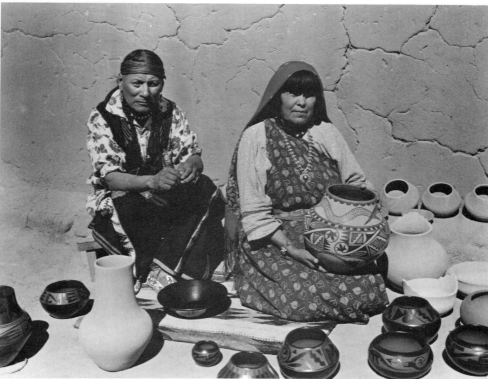

8.6  Navajo basket weaver Katherine Sells from Rough Rock with her raw materials demonstrating the coiled basket technique at the 26th Annual Tribal Fair, Window Rock, Arizona, 1972. Note her Zuni needlepoint jewelry. Arizona State Museum, University of Arizona, Tuscon, Arizona.

8.7  Maria and Julian Martinez of San Ildefonso Pueblo.

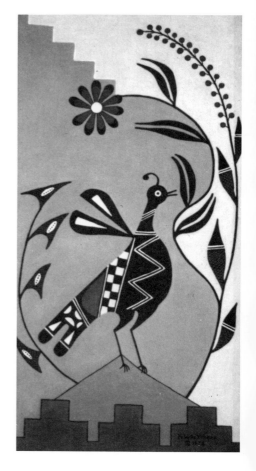

8.8  Alma Hardy of The Gap, Arizona, Navajo landscape rug.

8.9  Pablita Velarde, earth painting. Stylized bird resembles those found on traditional pueblo pottery.
**Santa Fe** Festival Art Show, 1978.

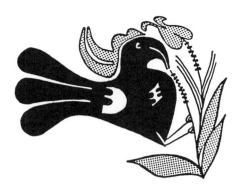

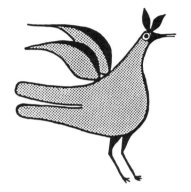

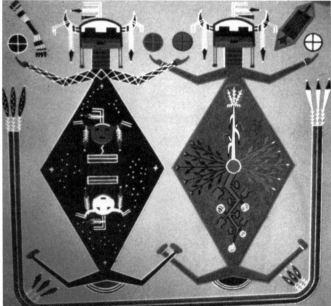

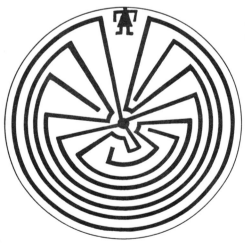

8.10　Pueblo pottery bird designs from Acoma (A) and Zia (B) pueblos.

8.11　Juanita Stevens of Chinle, Arizona, *Mother Earth and Father Sky,* Navajo sandpainting.

8.12　Papago Man in the Maze basket design. Arizona State Museum, University of Arizona, Tucson, Arizona.

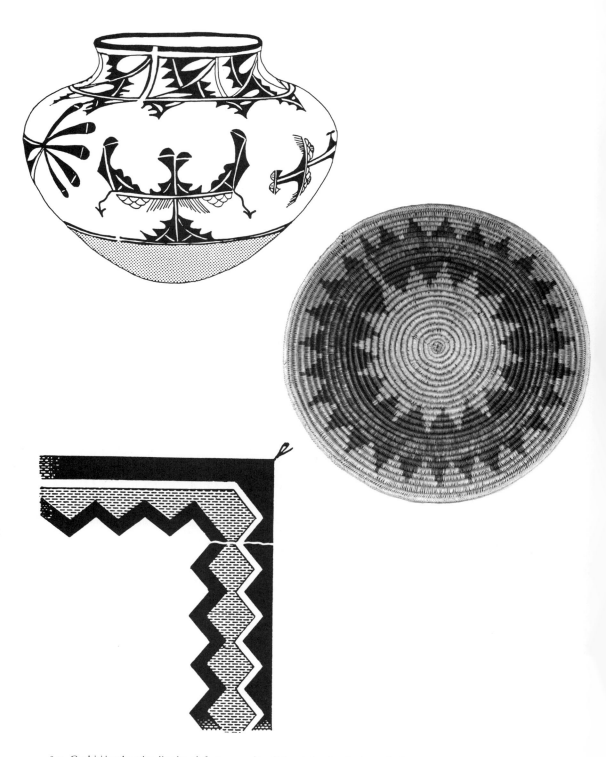

8.13  Cochiti jar showing line break features and traditional cloud and rain symbols.

8.14  Navajo wedding basket, Paiute manufacture. Arizona State Museum, University of Arizona, Tucson, Arizona.

8.15  Mind's road feature. Drawing by Kelley A. Hays.

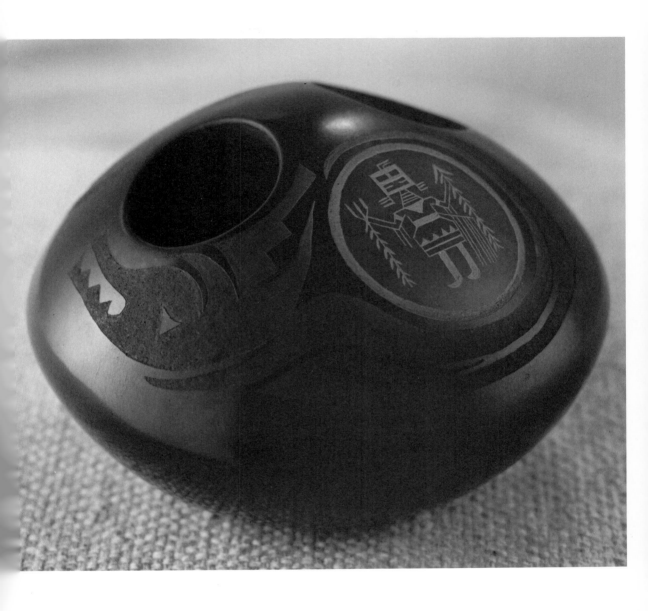

8.16 Grace Medicine Flower and Camilio Tafoya, San Ildefonso black-on-black jar, c. 1970.
Arizona State Museum, University of Arizona, Tucson, Arizona.

8.17 Rosetta Huma of Sichomovi, First Mesa, uncovering pottery she has just fired, 1973.
Arizona State Museum, University of Arizona, Tucson, Arizona.

Rituals that show respect for Clay Woman and Mother Earth are still performed by many potters. However, Helen Cordero, a Cochiti potter, is upset that many of her fellow potters disregard these customs. "Today everything's easy", she says. Young potters "buy their clay, their paint, take them to big ovens in Albuquerque. Grandma Clay doesn't like it and a lot of them don't even know about Grandma Clay. To make good potteries, you have to do it the right way, the old way, and you have to have a special happy feeling inside."[106] Grace Medicine Flower and her brother, Joseph Lonewolf, of Santa Clara, are two contemporary potters who preserve traditional ceramic processes and ideals while producing vessels in an innovative style (fig. 8.16). Medicine Flower states: "My dad told me, once you work with the Clay Lady, well then you have to be dedicated to work with the pottery and you have to enjoy doing it also. . . . I tell the Clay Lady that I want to make her beautiful so that when people buy her, they can appreciate her and give her a good home." They also preserve the old rituals that honor Clay Lady. When her family goes to gather clay, Medicine Flower's father, Camillo Tafoya, says a prayer before the clay can be taken from the earth. Then, "before we leave, we thank the Clay Lady and tell her . . . she's just a piece of clay now, but when we start working on the pottery, we'll try to make her as beautiful as we can." An anonymous Isleta potter and the well-known San Ildefonsans Maria Martinez and her sister Santana made ceremonial offerings to Mother Earth before digging the clay.[107]

Firing pottery also involves interacting with the landscape by honoring Mother Earth (fig. 8.17). Older Pueblo women perform small ritual acts before firing pots. At Hopi, "in firing a large water jar, a miniature jar is cast into the fire to insure even burning." At San Ildefonso, Santana throws cornmeal over the metal grills and license plates she uses to cover her pots in firing as a ritual act to secure blessings and as a gesture of thanks.[108] These are not acts of magic but demonstrations of respect for the potters' materials and heritage.

Men and women produce beautiful art if they use the gifts and resources of Mother Earth properly. When Mother Earth is treated as a sapient being, she communicates with the artist and participates in the creation process. Hopi potter Polingaysi Qoyowayma (Elizabeth White), "lets the clay speak to her," while "clay sings" to Helen Cordero. Joseph Lonewolf shows his respect for Mother Earth by not speaking about a pot until it is completely finished.[109] There is more to pottery than pots, and the connections of the artist to the land can be seen in all stages of manufacture, from gathering clay to decorating and firing the pot. Their relationship to the land is a major form of reciprocity and it is basic to the continued functioning of the world, because artists, like all individuals, can affect the functioning of the natural order of the landscape through their thoughts and actions.

"FROM AN EARTHLY SENSE CAME THE REALITY OF MY WORK"

Direct answers to the questions asked at the beginning of this chapter are not possible given the current state of anthropological research on southwestern Indian perception of the landscape, the art resulting from it, and its relationship to gender. Nevertheless,

what is known about the cultures in question and the roles of men, women, and art objects in each society allows us to discuss several prominent ideas emerging from this collection of available information.

To American Indian artists, land is a dynamic and integrating force connecting religious beliefs and daily activities, and the raw materials that become art. Landscape and the life in it are analogous to the life of the individual and the community. All life needs balance and harmony, a state which people must consciously maintain. Maintaining balance creates beauty, but the approach of men and women to this task leads to some separation based on gender. American Indian women's art—pottery, basketry, and rug weaving—requires close, physical contact with the land, while art done primarily by men—easel art and silversmithing—does not. Women painters, like Pablita Velarde, maintain their connections with the earth by using pigments obtained directly from the land rather than purchased. The artists who continue to rely directly on Mother Earth for raw materials also tend to preserve tradition in the creation of their art.

Women artists, like their male counterparts, demonstrate flexibility toward the nonceremonial use of landscape symbolism. They are willing to combine tradition with Anglo-American inspired innovation when appropriate. Their flexibility reflects ethnicity rather than gender, because American Indian men and women in each culture share a world view and ideas about landscape. Both men and women artists are open to change and innovation; both exhibit creative flexibility in the artistic interplay of the traditional and the new. The pottery designs of Joseph Lonewolf and Grace Medicine Flower exemplify such syntheses.

While the process of including traditional and synthesized landscape symbolism is the same for men and women, the surface expression of the symbols differs. For example, "life pathway" features, referring to cycles in nature and in individual lives, are specific to women's art. For American Indian women, the natural world consists of unending processes that demand flexibility in day-to-day living. This assumes, in addition to cultural flexibility toward change, the ability to take advantage of situations as they arise—in short, to make choices. Men also must make choices in their daily lives, but they do not appear to visualize these choices through landscape symbols. We do not know why there is no "mind's road" in men's art, but perhaps it is because there are more limitations or fewer choices in their art used for religious purposes. The use of landscape symbols as a means of expressing flexibility has emerged here as peculiarly female, in contrast to the goal-directed approach of Anglo males. The American Indian male world view is not goal-directed in the manner of the Anglo man's, but it is analogous, for it involves manipulation of supernatural powers through religious activities such as ceremonies related to curing and the agricultural cycles.

Another specific difference in the visual expressions of men and women is women's emphasis on the ordinary. Women tend to picture the things they see around them in everyday life—women baking bread, horses walking over the land, birds sitting on tree limbs—and the everyday elements in mythological life, turquoise blue and Mother Earth. They also tend to depict women's activities. Men, on the other hand, tend to portray exceptional activities, such as ceremonies.

One pattern that has not changed is the artists' reverence for Mother Earth, which includes showing respect in the procurement and use of raw materials, communicating with Mother Earth while creating, and preserving the richness of the land. The continued reverence for Mother Earth is one of the means by which the artists, while recasting and synthesizing traditional and new ideas, forms, and designs, can maintain the harmony of life. Southwestern Indian artists seem to see themselves as guardians of cultural traditions. Their creative activities are a necessary means of preserving the balance and harmony that maintains life. Fertility rather than eroticism—ensuring the continuation of the life cycle—is the aspect of sexuality emphasized in visual art.

This essay raises as many questions as it has answered. We still need to know more about the gender division of labor in the Southwest, about American Indian concepts of beauty and the land, about American Indian art and how gender enters into art, and about how men and women perceive the landscape and how this perception, in turn, affects their artistic production. We hope the many issues we raise will provide direction for future research. We now know what questions to ask and how to ask them. The artists themselves hold the key to the answers.

*Out of the red rock shadows, I played.*
*Dreamt colored pictures flowing out of my hands.*
*Out of touch with the world's blackness,*
    *created madness, just out of my sight.*
*Overflowing with stories, memories of a thousand voices,*
    *beating strong.*
*From an earthly sense came the reality of my work,*
  *to paint,*
  *to be a reflection,*
  *of life passing through me.*

      *Barbara Emerson Kitsman*
      *Navajo/Cheyenne/Kiowa*

# *Earthy Relations,*
# *Carnal Knowledge*

## SOUTHWESTERN AMERICAN INDIAN
## WOMEN WRITERS AND LANDSCAPE

*Last year the pinons were plentiful*

*It took only a late night phone call*
*listening and laughing in the bedroom dark*
*(her husband was laying right there*
*but one-sided conversations never make sense).*

*And it made no sense right from the beginning*
*(the blue moonlight slid down the long center curve of his back*
*as he got up to take a drink of water).*

*After the phone call,*
*she had snow-laced dreams*
*where she was trying to catch the dark horse*
*and the other watched, chuckling under his breath.*
*She smelled chamisa when she woke and knew what had happened*
           *far away the other was going to feed the horses*
           *beneath Toadlena mountains,*
           *the air was heavy with rainscent,*
           *sage and rabbitbrush.*
*But here the morning light bolted into the room in streaks*
*where her nightgown was a rumpled heap under the bed*
*and she remembered only the phone call*

*and the time she followed him into the trading post,*

*a skinny dog at her heels.*
*He bought her a Coke and they sat on*
*the dusty steps outside, not even talking.*
*The sun was hot and sticky, fine dirt settling on them.*
*That was when he said:*

> *It's better here in the spring.*
> *Maybe you'll come back then.*

*As she drove off, she saw him in the rear-view mirror*
*mounting the dark horse.*
*That was how it was that day.*

*Here she cleaned the house thoroughly*
*and at noon, he called again saying:*

> *Come on out,*
> *the clouds are still real low in the mornings*
> *but it warms up.*
> *We can ride over the mountain if you want,*

*and she did.*
*I have no choice, she told herself,*
*leaving her nightgown on the floor*
*and her husband waiting at lunch.*

> *She took the next Trailways to Gallup*
> *a radio and a can of coffee.*

> *People saw them at the trading post at Newcomb*
> *reading the bulletin board.*
> *They left on the dark horse toward Two Grey Hills*
> *late in the afternoon*
> *and weren't seen again that spring.*

*It doesn't make sense, her husband said,*
*she seemed happy.*
*But happiness had nothing to do with it*

> *and years from now*
> *her grandchildren will understand saying:*

> *Back then, those things always happened.*

*That was last year,*
*the piñons were large*
*and the winter—so cold, so cold*

> *beneath Toadlena mountain,*
> *the white desert*
> *shining with snow.*[1]

Luci Tapahonso

Long before *context* became an academic buzz word, it was a Spider Woman word. It speaks of things woven together, and of understanding the meaning of a thread in terms of the whole piece of goods. For southwestern American Indians, that whole is the land in its largest sense. The land is not only landscape as Anglo writers often think of it—arrangements of butte and bosque, mountain and river valley, light and cloud shadow. For American Indians, the land encompasses butterfly and ant, man and woman, adobe wall and gourd vine, trout beneath the river water, rattler deep in his winter den, the North Star and the constellations, the flock of sandhill cranes flying too high to be seen against the sun. The land is Spider Woman's creation; it is the whole cosmos.[2]

American Indian people—even urban dwellers—live in the context of the land. Their literature thus must be understood in the context of both the land and the rituals through which they affirm their relationship to it. Women and female sexuality are at the center of many of these rituals. The wilderness, American Indian women, ritual, and American Indian women's writing are inextricably woven together. I begin by looking at the relationship between American Indian literature and ritual and then go on to speak of how women and wilderness are part of these.

Like the songs and stories from their ongoing oral tradition, contemporary American Indians' literature is connected with ritual. Even contemporary American Indian jokes often rely on a knowledge of ritual:

*Q. What's a seven-course dinner on the Sioux Reservation?*
*A. A six-pack and a puppy.*

To get the full savor of the joke (or the puppy), you need to understand that puppy meat was valued more highly than dog, as veal is thought tastier than beef, and the Sioux used to serve puppy only as a special treat on ceremonial occasions. A seven-course dinner, including fine wine or champagne, is a white way of marking a special occasion. But contemporary Indians, for cultural and economic reasons, are more likely to pop the top of a beer can than the cork on a bottle of Dom Perignon. Alcoholism is common on reservations. The joke takes in all of this knowledge, and it is, among other things, a reflection both wry and poignant on a lost richness and a present deprivation. But to make the joke at all is to reaffirm the richness of American Indian life and humor, to recall a connection with ritual, with "the way," at the same time as one acknowledges what one contemporary American Indian woman poet, nila northSun, calls "the way things are."[3] Like the joke, contemporary American Indian literature reflects to a certain degree ritual understandings.

American Indian literature involves ritual; ritual is ceremonial action that reaffirms people's connection with the land. Nontribal people often perceive the land as an object, as something faintly or greatly inimical, to be controlled, reshaped, painted, or feared.[4] Tribal people see it as something mysterious, certainly beyond human domination, and yet as something to be met and spoken with rather than confronted. For them, the land is not just collection of objects you do things *to,* nor is it merely a place you do things *in,* a stage-set for human action. Rather, it is a multitude of entities who possess intelligence and personality. These entities are active participants with human beings in life processes, in thoughts and acts simultaneously mundane and spiritual. People and

the land hold dialogue within the structure of ritual, in order to ensure balance and harmony. Ritual is the means by which people, spirits, rocks, animals, and other beings enter into conversation with each other. One major part of people's ritual responsibility is to speak with these nonhuman entities and to report the conversation; American Indian literature records echoes of that ongoing dialogue.

In this literature, that dialogue, the ritual interplay between people and the land, is often presented in sexual terms. Of course, the sexual metaphor for expressing some sort of relationship between people and land is not unique to Native Americans: scholars have remarked the inclination of early European male colonists to speak of the American earth in terms of sexual conquest, envisioning themselves taming and possessing a virgin land or being seduced away from civilization by the wilderness. But as Annette Kolodny has pointed out, imagery that casts the land as a rape victim, a seductress of men, or a compliant virgin ripe for taming by "husbandry" was understandably uncomfortable for colonial women on the Eastern frontiers, even though they, like their menfolk, dreamed of transforming the landscape. Instead of using overtly sexual metaphors, eighteenth-century colonial women wrote about their hopes and plans for sweetly *domesticating* wilderness, for grafting native stock, for planting gardens. Later, when white women found themselves in the open prairies rich with wildflowers, they spoke enthusiastically of discerning natural parklands and gardens ready to respond gratefully to their care.[5]

Eighteenth- and nineteenth-century women's letters and travel diaries, on the subject of the land, recall certain shared archetypes from popular literature, and it is not only biblical passages about *Judea capta* and Goshen that come to mind. One thinks as well of Pamela and Jane Eyre taming, respectively, the wildernesses in Mr. B_____ and Rochester; of the Peggottys and their friends reclaiming Little Em'ly and Martha into the family circle—of all the good men and women of the popular literature of the time who cajole and encourage their sexually undisciplined friends into comfortable, useful, temperate domesticity.

Subduing or training a wild landscape into a kitchen garden one can tend and view with satisfaction through the window is much like Jane's assisting at Mr. Rochester's transformation from an unpredictable creature of passionate energy into a loving (if handicapped) husband, upon whose lap she can perch familiarly as she combs the snarls from his "shaggy black mane." Both acts, even though they suppress the wilder aspects of sexuality, are really assertions of sexual dominance; the domesticator proves more powerful than the now tamed wild thing. Productivity and fertility are not necessarily diminished by either act; domesticated plants arranged in orderly rows bear fruit, even as the Rochesters, we are told, produce children.

And yet something is lost. Though fertile and easier to live with, both the tamed Rochester and the domesticated plants are oddly defused of a particular charge of sexual energy that was at once frightening and intoxicating and quintessential. Rochester and the garden-grown plant are no longer completely themselves. Readers and gardeners alike sense that loss, however dimly. (When I first read *Jane Eyre,* Rochester's blindness and humility disturbed me deeply. And even when my family's loamed beds were thick with hybrid June strawberries, my mother and I walked the field beyond the garden,

parting the grasses to find the small, sparse wild fruit. The wild strawberries weren't ours the way the garden ones were; we couldn't control their growth, couldn't take them for granted, but they were incomparably sweet.)

Southwestern American Indian cultures do not approach wilderness as something to be either raped or domesticated, but they do associate wilderness with sexuality. Indeed, they see wilderness and sexuality as identical. In both traditional and contemporary literatures, wilderness often appears not as mere landscape-backdrop, but as a spirit-being with a clearly sexual aura. That being, who always embodies some aspect of the land, may be either male or female. A male being may abduct a human woman, or a female being may seduce a human man, but subjugation is not the dynamic of either event. In the instances of spirit-men abducting human women, what happens is not a Zeus-style rape, not the ravishing of some hapless girl who's had the dubious luck to encounter a swan or a bull with a knowing leer in his not-quite-animal eyes.

In such comings-together of persons and spirits, the land and the people engage in a ritual dialogue—though it may take the human participant a while to figure that out. The ultimate purpose of such ritual abductions and seductions is to transfer knowledge from the spirit world to the human sphere, and this transfer is not accomplished in an atmosphere of control or domination.

In old stories like the Keres Yellow Woman stories, or in Leslie Silko's contemporary "Yellow Woman," based upon them, the human woman makes little attempt either to resist or to tame the spirit-man who abducts her. Nor do men, in stories where they are seduced by spirit women, attempt to control or dominate them. The human protagonists usually engage willingly in literal sexual intercourse with the spirits who simultaneously walk the land and embody it. This act brings the land's power, spirit, and fecundity in touch with their own, and so ultimately yields benefit for their people.

If their full nuances are taken into account, *to have intercourse with* and *to know* convey something of the sense of what really goes on in those bushes beyond the light of the village fires, of what really happens up there, far to the north where the Ka'tsina has taken you. Unlike Yeats's Leda, the human protagonist does, without question, put on both knowledge and power through the sexual act. Furthermore, the act channels the awesome power and energy of our human sexuality—the preserve of wilderness in human beings—into socially useful channels. The coming together of person and spirit may lead to the birth of magical children, the discovery of rich sources of food or water, or the gift of a specific ceremony.

I want to turn now to two Navajo stories about the connections between the people and the land. The great Navajo chant *Beauty Way* deals with a fruitful coming-together of an earth-surface person—a human being—and a spirit; the *Beauty Way* ceremony itself, which incorporates the story, is given to the Navajo people as a consequence of that event. "The Snake-man," a contemporary short story by Luci Tapahonso, a young Navajo writer, movingly echoes elements of the *Beauty Way* story.

*Beauty Way* concerns the adventures of two sisters, White Corn Girl and Yellow Corn Girl, during the Navajo-Taos Pueblo wars. Corn Man, their uncle, has promised to marry them to the best warriors, but to his dismay the men who prove to be the most

skillful in battle are two strange, sickly-looking elders enlisted as volunteers on the Navajo side. Instead of sticking to his promise, Corn Man tells his nieces to choose husbands for themselves at the victory celebration dance. But, as in the stories of many other cultures, promises have a way of keeping themselves once they are made.

At the dance, the Corn Girls grow overheated and stray away from the dance circle into the cool darkness, where they smell a strangely alluring odor, the sweet pipe smoke of two handsome young men encamped at some distance from the Navajo. The men obligingly share their intoxicating tobacco with the Corn Girls, and each sister falls asleep beside one of the strangers. When the sisters awake, they discover to their dismay that they have not been lying with a pair of handsome young warriors after all, but with the two mysterious old codgers to whom they were originally promised. Their relatives track them down but then, in disgust, leave the two women to the elderly husbands they appear to have chosen for themselves. Unbeknownst to either the Corn Girls or their family, the two old ones are actually Big Bear Man and Big Snake Man.

Finding themselves seduced and abandoned by their family, the Corn Girls run away together from their husbands, covering much of the Navajo country in their flight and pursued from afar by Big Bear Man and Big Snake Man. Eventually, at the Rio Grande, the two girls are separated. Here, the myth branches into what will become *Mountain Way* and *Beauty Way*. The former concerns White Corn Girl, Elder Sister, who eventually finds herself among her husband's Bear People. *Beauty Way* follows Yellow Corn Girl, Younger Sister, who finally arrives ragged and thirsty at a pool atop Black Rock, near Canyon de Chelly. There, a handsome stranger offers her sanctuary beneath the earth. She accepts and slips through a crevice to the underground world—the domain of her in-laws, the Snake People.

In the lower world, the Snake People initially appear to Younger Sister in human form. She does not guess their identity at first, even though they address her kindly as "daughter-in-law" and hold target practice with lightning arrows—a sure clue, for the Snake People are closely associated with weather. Younger Sister's adventures now assume a pattern. Her in-laws give her tasks or set her prohibitions which she bungles each time out of ignorance, absent-mindedness, or impetuous curiosity. Each time, when the Snake People confront her with her errors, she puts up a remarkably realistic adolescent defense, presenting herself as a hapless, put-upon innocent stumbling through life, a girl from whom little should reasonably be expected. "I am someone who's just traveling any old place," she says.

Each time they are confronted with this defense, the Snake People reply, with great forbearance and mild sarcasm, "Yes, we can see that." Their treatment of Younger Sister is delightful in its wise restraint. Even though they often suffer more than she does from her irresponsibility, they and other beings always help her out of her predicaments and are satisfied to let her be punished by the natural consequences of her actions, trusting experience to teach her what she needs to know.

For example, on her first night among them, she is warned not to rekindle the fire once it goes out. The Snake People additionally caution her that, should she catch a clear sight of them, she must remember that their ugliness lies only in their shape. Of course she rekindles the fire, and its light reveals her benefactors as a family of snakes.

Younger Sister leaps wildly among them in panic before she fearfully resigns herself to bedding down again in their midst. In the morning, the Snake People complain that they're sore from being trampled upon, but all Younger Sister suffers is a case of swollen joints, although she's run away from their kinsman and literally walked all over them. Their continuing care of her is the best evidence of their true nature; Snake People, contrary to the old cliché of the Western matinee, do not speak with forked tongues, and that is the lesson she must begin with.

Younger Sister next is entrusted with jars containing wind, hail, male and female rain, and mist. On successive days, when the Snake People are gone about their business, she disobeys instructions and meddles with each jar in turn, unleashing the different kinds of weather. The Snake People are treated to a week of dust storms, floods, hailstones, and pea-soup fog, but each night they sigh "what can we expect?" and again leave her to care for the jars the following morning.

Younger Sister is being gently and skillfully socialized, learning by example the wisdom and forbearance of the Snake People, learning to respect the power of the elements and the need for great care and scrupulous attention to ritual in their presence. Unlike Ulysses and Pandora, her ancient Greek counterparts who against orders let things out of bags or boxes, Younger Sister is given room to err in order to prepare her eventually to take full charge of the weather.

Off and on during Younger Sister's underworld sojourn among the Snake People, she glimpses a shadowy figure who bears some resemblance to the elderly man she has fled, but Big Snake Man stays in the background, allowing his family to socialize his bride. He does not directly enter Younger Sister's experience again until the end of her time among his people, when she is cautioned not to stray from the Snake People's territory. Of course, her eager curiosity moves her to test those prohibitions, with disastrous results. In this, her last forbidden venture, she wanders to the north and joins some rock wrens in a rock-rolling game. Younger Sister, a clumsy novice, is crushed beneath the stones. By the time her body is recovered only her bones remain, but Big Snake Man sings over her and restores her to life.

After all her trials and errors, Younger Sister is at last deemed ready to begin learning *Beauty Way* for herself—though in a sense she has been learning it all along. After a four-year apprenticeship, she masters all the songs and prayers and sand paintings and is entrusted with the ritual paraphernalia of the great chant. At the end of that time, Big Snake Man, now revealed as her husband, performs the full nine-day ceremony for her. But she is told that Big Snake Man will no longer be considered her husband, for neither he nor earth-surface people may perform chants for their own kin. (Elder Sister, who has been having parallel adventures all this time among various spirits who live in the mountains, is simultaneously learning *Mountain Way*.)

After her *Beauty Way* ceremony, Younger Sister leaves the Snake People and the two Corn Girls, reunited, go back to their human family long enough for them to sit their younger brother down between them and teach him both *Beauty Way* and *Mountain Way*. When they have passed on the ceremonies, the sisters return to the wilderness— Elder Sister to the mountains, and Younger Sister to the realm of the Snakes—to take

their places among the Holy People. Back among the Snake People, Younger Sister is again given charge of the jars of weather.[6]

It is important to understand this story and similar ones, like the Keres stories of Yellow Woman, as stories about the relationship between human women and the land and its various embodiments.[7] As a consequence of her initial erotic experience, Younger Sister is socialized but not suppressed; she fares far better than most of the European folk-tale heroines who stray away from their families into the forests. Her encounters with the spirits of the land teach her what she needs to know in order to be an adult woman: to live within a family, to understand and respect the forces of nature, and maintain a ritual relationship with them. The preserve of wilderness within her—her energy, curiosity, sexuality—is not forcibly repressed, as if it were shameful and unnatural, but brought into contact with the outer wilderness. Both inner and outer wilderness are natural and beautiful sources of energy and fertile supply, but the outer wilderness is balanced, and it operates in harmony; balance is what Younger Sister must learn from her time among the snakes. Over a long period of experimentation, she learns to draw on her own inner wilderness and to channel it usefully.

In the story, Big Snake Man is indeed threatening at times, and he remains unfathomably mysterious. But even before he comes together with Younger Sister, he appears as an anonymous benefactor of her people. His alliance with her may involve a little deception, but it is hardly rape. When she flees him, he pursues her at a discreet distance—shooing her, so to speak, in the direction she needs to go, allowing her to find her own adventure. Through most of her time in the lower world, he remains a shadowy figure, working his healing magic when it is needed.

The sisters are not a pair of passive princesses badgered into submissiveness by their husbands and in-laws. They are strongly bonded with one another, and each makes choices that, even when they are in error, result in the getting of wisdom and power. In this story, a woman's exploration of her inner wilderness, and her dalliance with an embodiment of the outer wilderness, do not result in expulsion from paradise or in the unleasing of a stinging swarm of evils. Rather, her adventures end in the gift of a healing ceremony, the knowledge to use that ceremony rightly, and the power to pass it on to her own people. It must make a great difference for a child to grow up with the story of Younger Sister, rather than the stories of Eve and Pandora, as part of her heritage, and such a story must strongly shape her visions both of wilderness and of what it means to be a woman.

Younger Sister's story is a beautiful and useful paradigm for the way many contemporary American Indian women writers deal with the theme of women and the land. As Leslie Silko tells us:

> *You should understand*
> *the way it was*
> *back then*
> *because it is the same*
> *even now.*[8]

"Even now"—in a contemporary Christian boarding school on the Navajo Reservation—the story goes on. "The Snake-man," by Luci Tapahonso, subtly incorporates aspects of Younger Sister's wilderness experience.[9] *Beauty Way* permeates and enriches this brief and seemingly artless short story about little girls who innocently thwart an institution designed to socialize them out of the Navajo way into the white world. In this gentle tale of resistance, the land, embodied in two spirit-beings, one male and one female, helps the children preserve their Navajo identity against great odds.

Tapahonso's loose, easy narrative unselfconsciously shifts tenses and plot order, recalling the style of much American Indian oral literature and giving a strong sense of nonlinear time to the story. What's happening at a given moment to the little girls is of a piece with what often happens, and what has happened before in old-story time. The tale is at once a piece of psychological and sociological realism; though set in modern times, it is an old story, or part of one.

"The Snake-man" centers on the nighttime doings of homesick little girls quartered in a third-floor dormitory room, allowed to see their families only on weekends, who long wistfully "to go to public school, and eat at home every day." The dorm mother sleeps in a separate room down the hall, and her "mothering" amounts to policing them. She is mostly a nuisance to be circumvented, effective neither as a mother nor as a disciplinarian. The institution, though sterile and isolating, does not wholly strip the children of either family or ritual life, for these little girls create both for themselves. Within their barren room, far away from their families, they mother one another, the big girls taking charge of the smaller ones, and pass on what comfort, philosophy, and knowledge they can to one another. When they grow frightened, "They all [sleep] two-to-a-bed, and the big girls [make] sure all the little girls [have] someone bigger with them."

The calmest and most mature girl is an orphan whose parents are buried in the school cemetery. Each night she sneaks down the fire escape to rendezvous at the edge of the graveyard with her mother's ghost. The other children stand guard at the window during her walks and question her eagerly about her mother when she returns. The child draws strength from her trips to the graveyard and sleeps peacefully once she's back in the dorm. The others huddle together in the dark and enjoy scaring themselves with talk about ghosts and about "what the end of the world will REALLY be like." Their speculations muddle Navajo, Christian, and comic-book eschatology, reflecting their cultural confusions, as they talk of the time when "all the dinosaurs and monsters that are sleeping in the mountains will bust out and eat the bad people—no one can escape, either." When she hears this, the little girl who is nurtured by her dead mother only says quietly, "No one can be that bad."

Apart from the benign mother-ghost, the main spirit-person in the little girls' world is a male figure, the Snake-man, said to live in the attic. "There was a man in there, they always said in hushed voices, he always kept the attic door open just a little, enough to throw evil powder on anyone that walked by. . . . Once they even heard him coming down the attic stairs to the door." The Snake-man isn't visible, "cause he's sort of like a blur, moves real fast and all you can see is a black thing go by"—but he steals jewelry from them and "has a silver bracelet that shines and if he shines it on you, you're a goner."

Once, when the girl is in the graveyard and the others are standing guard, they hear a scratching noise outside. Certain "*he*" is making the sound, they rush to the windows trying to catch sight of him, "to get a description of him in case someone asks them," and they station someone on the fire escape "in case he tries to get up here." When the girl returns from the graveyard, the others hysterically tell her about the lurking presence outside. She calmly suggests it's "probably somebody's father trying to see his daughter." This settles the other children down; eventually, after more discussion, they agree the shadowy visitor is most likely the boyfriend of one of the junior high girls on the lower floor. They return to speculating about the Snake-man and finally drift off to sleep, all but one: "The bigger girls slept with the littler ones, and they prayed that God wouldn't let . . . the snake man come to them, and that the world wouldn't end until after their moms came to visit. As the room got quiet and the breathing became even and soft, the little girl got up, put on her house-coat and slid soundlessly down the fire escape."

The children of Tapahonso's story need to learn how to become Navajo women. They must learn, first, to head complex households; second, to deal with their own sexuality; third, to understand and perform their ritual obligations—the same things the two sisters of *Beauty Way* and *Mountain Way* must learn. Consciously or subconsciously, the children are trying to carry out their learning tasks, even within the sterile enclosure of the dormitory. In "The Snake-man," we see them being socialized toward Navajo womanhood, aided, as their Corn Girl ancestors are, by spirit-people who embody different faces of the wilderness.

The spirit figures, the mother-ghost and Snake-man, surround the dormitory and keep alive the connection between the children and the land. Ironically, the walls of the institution are no walls at all; the children bring the frightening power of wilderness right into the dorm attic, and one of them secretly ventures outside each night to encounter its benign, nurturing presence.

The gentle mother-figure is unusual, in that Navajo ghosts of the sort who manifest themselves around graveyards are generally considered threatening; Tapahonso herself has written a number of poems that deal with the notorious ghosts of accident victims who haunt the shoulders of New Mexico Route 666, inflicting their hostile half-lives on unwary travelers. No sane person deliberately seeks them out.[10]

The unseen spirits of dead relatives, however, can be absorbed back into the natural world and become helping presences in people's lives. In "A Spring Poem-Song," Tapahonso tells her children to go outside early in the morning and greet them:

> *They hover waiting*
> *in front of the house*
> > *by the doors*
> > *above the windows*
> *They are waiting to give us their blessing*
> > *waiting to give us protection*
> *go out and receive them*
> *The good spirits in the gentle-bird morning*

*They hover singing, dancing in the clear morning*
*They are singing     They are singing* [11]

The mother-ghost of "The Snake-man" is this sort of spirit, taken back into the natural world and seeing to her orphaned daughter's blessing and protection, even though she takes specific visible form. Moreover, she seems to take on aspects of one of the great Mothering spirits of the Navajo world, Changing Woman, perhaps, or Spider Woman. Certainly, she embodies the nurturing powers of wilderness. The little girl describes her mother waiting outside "at the edge of the cemetery by those small, fat trees. She's real pretty. . . . She waves at me like this: 'Come here, shi yashii, my little baby.' She always calls me that. She's soft, and smells so good." There in the dark of the trees, away from the confining walls—a place a child might normally find terrifying—she gives her daughter knowledge of her roots, destiny, and right conduct, talking to her lovingly "about when I was a baby, and what I'll do when I get big. She always worries if I'm being good or not."

Through her daughter's mediation, the mother-spirit's teaching and tenderness extend to the other girls who remain within the dorm. The Mother's stabilizing presence, among other things, enables the children to confront Snake-man and all he represents. A bogeyman in an Anglo story is often said to be a means for children to objectify and confront their sexual fears; indeed, probably Snake-man *does* have a great deal to do with male potency—a phenomenon doubly mystifying to little girls in a sexually segregated boarding school. Like all snakes, he is phallic—not just because he's longer than he is wide, but also because he is capable of astonishing feats of shape-shifting and sneaking up on you. According to the children, he's also intent on "throwing evil powder on you." This detail may be a displaced image of ejaculation, but it may also derive from Navajo stories about skinwalkers of both sexes, who witch people with corpse powder. Certainly, in his physical movements, Snake-man reminds one of archetypal males in many cultures—a back-door man, a dark blur easing out of sight round a dark corner, a Navajo C.C. Rider, or Speedy Gonzales. When the children seek a "rational" explanation for him, they connect him with sexual males; first they think he's a divorced father, and finally they choose the explanation that is most interesting to them—he's the boyfriend of one of the older girls on a forbidden tryst.

Snake-man, then, in part represents the men the little girls must eventually encounter in their lives as women. But Snake-man is more than any Freudian explanation suggests. He is an embodiment of the wilderness, and his sexuality goes beyond the human, although he encompasses it, for he embodies the wilderness outside people as well as within them. As in *Beauty Way,* he is the agent through which the little girls experience the land, or aspects of it. His presence keeps them alive to the awesome and potentially threatening force of wilderness. It is in part through him that they learn the art of being a family, of nurturing, and of being in a ritual community, for the thrilling fear he excites impels them to bond together and to invent as best they can private rituals that keep them safe without reducing his mystery and power.

In this simple and moving story of resistance, the children create their own nurturing community to substitute for the tribal life they have been denied; the one in touch with

her dead mother becomes a kind of clan mother to the others. The institutional walls do not shut out the wilderness the children must keep touching if they are to learn to be women. Instinctively, they bring the wilderness inside and go forth to meet it in the spirit-figures who directly and indirectly communicate the knowledge the children need most.

Even a story like "The Snake-man," then, which seems to contain little landscape and says little about the land, may center on the relationship between people and wilderness. Certainly one of the most distinctive themes in contemporary Southwestern Indian literature by women is the retelling of the traditional women-abducted-by-wilderness-spirit stories.

Interestingly, this is a theme that these writers' contemporary male counterparts do not choose to retell. American Indian male writers do use images of the Southwestern land that suggest her as female; they address her as "our mother" and convey a clear sense of land as a living entity. Their poems and stories contain human lovers and mothers, daughters and grandmothers, witches and medicine women. But, despite the wealth of old stories about male heroes encountering spirit-women as lovers or platonic helpers, the tales of Grandmother Spider or Changing Woman giving crucial advice to questing heroes are not the tales contemporary men choose to retell.

The figure from oral literature about whom American Indian men of the Southwest write most fondly is Coyote, who appears frequently as a hell-raising buddy or alter ego, or as the symbol of the dogged will to survive—the continuance, despite the odds, of both the wilderness and the tribes.[12] That symbolism is legitimate and moving. But in the last ten years or so, Coyote seems to have become especially an emblem of *male* bonding, *male* elan, *male* cussedness and creativity and survival. Indian women writers in the Southwest, on the other hand, seem far more open to depicting encounters with spirit-figures of both sexes.

This may simply be a reflection of a present-day uneasiness on the part of men toward powerful women that cuts across cultures; after all, few contemporary Anglo men have written modern versions of *She;* there is no musical about The Blessed Virgin Mary Superstar. It may not be a comfortable time for male writers in any segment of American culture to deal with supernatural women of power. But American Indian women writers in the Southwest continue to center some of their finest work on direct encounters with the land in the form of the spirits who embody it, whether Snake-man or Grandmother Spider, Coyote or the angry entity who has been speaking up lately through Mount St. Helen's voice. These women bring astonishingly varied emphases to that common theme; their diversity is not surprising, given their different tribal affiliations and upbringings, ranging from Tapahonso's traditional reservation family life, to the Hopi poet Wendy Rose's adolescence in 1960s Berkeley, to the military-base childhood of Chickasaw writer Linda Hogan. It is that diversity I want to speak of now, and how the encounter with the land is presented in the works of three women writers—Luci Tapahonso (Navajo), Leslie Silko (Laguna Pueblo), and Joy Harjo (Creek).

Tapahonso is the youngest of the three women and had the most traditional upbringing, as one of eleven children born to Navajo-speaking farming people who still live on

the mesa north of Shiprock. Some of her early schooling was off-reservation, at what is now Navajo Academy in Farmington, New Mexico—an experience she draws on for "The Snake-man"—much of her adult life has been spent in urban Phoenix and Albuquerque. As Geary Hobson notes in a recent review, her work often centers on "coming back home to visit . . . or thinking about going back home, or . . . about not being able to go back home, even when one knows that would be the best possible medicine."[13] In her biographical note for her first collection of poetry, she writes, "I know I cannot divide myself or separate myself from that place—my home, my land, my people."[14]

Tapahonso's characters cannot separate themselves from the land, whether they abandon the city, or continually affirm their identity with points west, or simply understand the Albuquerque cityscape as somehow an extension of

> *the whole empty*
> *navajo spaces past*
> *Many Farms      Round Rock*[15]

In the city, they continue to perform ceremonial actions that seal their connections with the land. In the early morning they greet the spirits of relatives, whose presence mingles with the cheerful voices of sparrows on the lawn.[16] They sprinkle cornmeal on the threshold of a daughter's first-grade classroom:

> *remember now, my clear-eyed daughters,*
> *remember now, where this pollen,*
> *    where this cornmeal is from*
> *remember now, you are no different*
> *see how it sparkles*
> *feel this silky powder*
> *it leaves a fine trail skyward*
> *as it falls*
> *        blessing us*
> *        strengthening us*[17]

It is important and restorative for Tapahonso's urban Indians to remember that, beyond the city and within it, beneath and between the pavement, the earth remains herself. After a thunderstorm, a woman expects rainwater to pool in the folds of heavy plastic draped over the family's bikes, but she is pleased instead to see the rain making its way to its natural destination, sliding in streams off the plastic, "absorbed instantly / by the dirt / dirt thirsty in winter."[18]

For Tapahonso, kinship with the land is more than a question of affectionate memory and respect, and it is far more than metaphor. This comes through clearly in "A Breeze Swept Through," about the births of her two daughters, Lori Tazbah and Misty Dawn, who are the earth's daughters as well:

> *The first born of dawn woman*
> *slid out amid crimson fluid streaked with stratus clouds*

> *her body glistening August sunset pink*
> *light steam rising from her like rain on warm rocks*
> > *(A sudden cool breeze swept through*
> > *the kitchen and Grandpa smiled then*
> > *sang quietly, knowing the moment.)*
> *She came when the desert day cooled*
> *and dusk began to move in*
> *in that intricate changing of time*
> > *she gasped and it flows from her now*
> > *with every breath        with every breath.*
> *She travels now*
> > *sharing scarlet sunsets*
> > *named for wild desert flowers*
> > *her smile a blessing song.*
> *And in mid-November*
> *early morning darkness*
> *after days of waiting pain,*
> > *the second one cried        wailing.*
> > *Sucking first earth breath,*
> > *separating the heavy fog,*
> > *she cried and kicked        tiny brown limbs.*
> > *Fierce movements as*
> > *outside the mist lifted as*
> > *the sun is born again.*
> > > *(East of Acoma, a sandstone boulder*
> > > *split in two—a sharp, clean crack.)*
> > > *She is born of damp mist and early sun.*
> > > *She is born again        woman of dawn.*
> > > *She is born knowing the warm smoothness of rock.*
> > > *She is born knowing her own morning strength.*[19]

The babies bear a strong family resemblance to the "Navajo spaces" of their mother and, in the case of the younger child, to her father's Acoma spaces as well; their own small bodies at birth echo the land's appearance at that very moment. Their arrivals are acknowledged not only by their human relatives, but by the land herself, who welcomes them as flesh of her flesh with a breeze of annunciation, a rock splitting clearly in two. The children are named for the land, whose power flows through them in the cycles of their breath.

The characters in Tapahonso's poems can easily lose touch with the blood connections they were born knowing; her poems encompass humorous and tragic glimpses of people, on or off reservation, who are divided, uncentered, helpless, and speak unflinchingly of bars and parking lots, alcoholism, abused women, wrecked cars, and abandoned children. But Tapahonso's great theme is the connection with family and land, or the rediscovery of it. In "Last year the piñons were plentiful," she chooses the

oldest form of story to talk about that relationship, the story of the erotic coming-together of a woman and the land. "It is the same even now" for this woman as it was in the Corn Girls' time, even though the mysterious male figure who inspires her dreams of "the air heavy with rainscent / sage and rabbitbrush" can use Mountain Bell to awaken her need for wilderness, even though she leaves her clean house and steady husband on a Trailways bus.

Her husband is puzzled at her leaving an apparently happy life, but indeed "happiness [has] nothing to do with it." When she rides with the man on the dark horse toward Two Grey Hills and the Chuska Mountains, it is an old-time ritual wedding with the land she has chosen. Whatever happens after we lose sight of them will result in grandchildren who understand her actions better than her husband does. More immediately, what comes of her elopement is a winter that is all a high-desert winter should be—trees heavy with piñon, deep snow to melt in time and ensure more growth, and icy breathtaking beauty.

A better-known and more sophisticated writer than Tapahonso (though not, I think, a more powerful one), Leslie Marmon Silko is of mixed Laguna, Hispanic, and Anglo ancestry. Many members of her family were educated in Indian schools like Carlisle and Sherman Institute, and as a child she attended a private day-school in Albuquerque. Her work reflects the mixed-blood's sense of dwelling at the edges of communities: "We are . . . Laguna, Mexican, White—but the way we live is like Marmons, and if you are from Laguna Pueblo, you will understand what I mean. All those languages, all those ways of living are combined, and we live somewhere on the fringes of all three."[20] That experience of growing up around Laguna life without being fully immersed in it gives Silko's work a certain doubleness, a flexible narrative point of view. At times there's a distance, an ironic edge, a sense that she is writing *about* a tradition as much as *out* of it. Her narratives are more self-conscious than Tapahonso's in that they call more attention to their sources. In "Yellow Woman," a modern heroine thinks about one of the old-time Yellow Woman stories, even as Silva, the man she has met by the river, makes love to her:

> *He touched my neck, and I moved close to him to feel his breathing and hear his heart. I was wondering if Yellow Woman had known who she was—if she knew that they would become part of the stories. Maybe she'd had another name that her husband and relatives called her so that only the ka'tsina from the north and the storytellers would know her as Yellow Woman. But I didn't go on; I felt him all around me, pushing me down into the river sand. . . .*
>
> *"Do you know the story?"*
>
> *"What story?" He smiled and pulled me close to him as he said this. . . . This is the way it happens in the stories, I was thinking, with no thought beyond the moment she meets the ka'tsina spirit and they go.  (55–56)*

This flexible viewpoint enables Silko to take old tales like the ones of woman-abducted-by-wilderness-spirit and treat them simultaneously, or in successive retellings, with high humor, irony, and reverence. This does not always sit well with her critics, white and Indian alike, some of whom seem to expect all American Indian

literature to be as pompously solemn as *Billy Jack* or *Hanta Yo*. But Silko knows that the real stories are large and true enough to contain many stories, to bear many interpretations. In her collection *Storyteller,* Silko juxtaposes a number of pieces that treat very differently the theme of a woman leaving home for the wilderness. "Cottonwood" is a fairly straight retelling of two Yellow Woman stories. In the first, Yellow Woman goes out around the fall equinox to meet the Sun himself:

> *She left precise stone rooms*
> *That hold the heart silently*
> *She walked past white corn*
> *hung in long rows from roof beams*
> *The dry husks rattled in a thin autumn wind.*
>
> *She left her home*
> > *her clan*
> > *and the people*
> > > *(Three small children*
> > > *the youngest just weaned*
> > > *her husband away cutting firewood)*    *(64)*

Her rendezvous with the sun, her willingness to join him, ensures that he will come out of his Sun House; he will not leave the earth locked forever in winter. The second part of the poem deals with her abduction by Buffalo Man; both the Buffalo People and she herself are finally slain by her jealous husband, Arrow Boy, once he discovers that she does not especially want to be rescued, but the end result is the gift of buffalo meat as food in time of drought,

> *all because*
> *one time long ago*
> *our daughter, our sister Kochininako*
> *went away with them.*   *(76)*

*Storyteller* also contains "Yellow Woman," a masterfully ambiguous story, whose heroine, like Yellow Woman, meets a man by the river, a man named Silva (forest, in Spanish), who may be a Navajo cattle thief or the ka'tsina he laughingly tells her he is— or both. Many details in the story parallel the old Keres tales of Yellow Woman and Whirlwind Man or Buffalo Man. But what is most important in the story is the heroine's awakened consciousness of her own sexuality and her acute sensual awareness of the man, the river, and the mountain terrain they travel: "And again he was all around me with his skin slippery against mine, and I was afraid because I understood that his strength could hurt me. I lay underneath him and I knew that he could destroy me. But later, while he slept beside me, I touched his face and I had a feeling—the kind of feeling that overcame me that morning along the river. I kissed him on the forehead and he reached out for me." (58) In letting herself open to Silva, she lets herself open to wilderness in all its wonder, its threat and vulnerability. The description fits her experience of both the man and the mountain.

"Yellow Woman" ends ambiguously. Silva may or may not get shot by a rancher, and he may or may not be a ka'tsina who will one day return for the heroine. Though she decides finally to tell her family only that she's been kidnapped by "some Navajo," what stays with her—and with the reader—is the lyrical evocation of Silva and his terrain: ants swarming over pine needles, the "mountain smell of pitch and buck brush," the danger and beauty she has experienced on those heights.

The heroine of "Yellow Woman" at times admits that hers is an unlikely story, but on the whole both she and the reader are inclined toward the belief in Silva as mountain spirit. Still, we understand there might be ways, in current parlance, to deconstruct that interpretation. Indeed, Silko does not need a critic to perform that task for her, just as the obscene and irreverent antics of Pueblo sacred clowns in a sense "deconstruct" ceremonies without the help of anthropologists.[21] Her poem "Storytelling" begins with a straight-faced recap of the Yellow Woman and Buffalo Man tale, then proceeds in a rapid verbal montage:

> *"You better have a damn good story,"*
> *her husband said,*
> *"about where you have been for the past*
> *ten months and how you explain these*
> *twin baby boys."*
>
> . . . . .
>
> *It was*
> *in the summer*
> *of 1967.*
> *T.V. news reported*
> *a kidnapping.*
> *Four Laguna woman*
> *and three Navajo men*
> *headed north along*
> *the Rio Puerco River*
> *in a red '56 Ford*
> *and the FBI and*
> *state police were*
> *hot on their trail*
> *of wine bottles and*
> *size 42 panties*
> *hanging in bushes and trees*
> *all along the road.*
>
> *"We couldn't escape them," he told police later.*
> *"We tried, but there were four of them and only three of us."*
>
> . . . . . . . . . . . . . . .
>
> *It was*
> *that Navajo*
> *from Alamo,*

*you know,*
*the tall*
*good-looking one.*

*He told me*
*he'd kill me*
*if I didn't*
*go with him*
*And then it*
*rained so much*
*and the roads*
*got muddy.*
*That's why*
*it took me*
*so long*
*to get back home.*

*My husband*
*left*
*after he heard the story*
*and moved back with his mother.*
*It was my fault and*
*I don't blame him either.*
*I could have told*
*the story*
*better than I did.    (95–98)*

Whether deeply moving and ceremonial or slapstick, whether a woman abandons her water jar or her size 42 panties, whether she goes off with Whirlwind Man or the good-looking Navajo from Alamo, Silko conveys the sense that all these stories somehow concern an inevitable human need to go forth and experience wilderness—and the sexual wildness that it encompasses.

There is not space here to do justice to Silko's fine, complex novel *Ceremony;* Paula Allen has already spoken extensively of its treatment of woman and the land.[22] But, if male writers have been reluctant to retell for themselves the old stories of human men and the spirit-women who embody the land, in *Ceremony* Silko does it for them. As part of a healing ceremony that begins long before his birth and his spiritual illness, Tayo, a half-breed Laguna veteran of World War II, must "close the gap between isolate human beings and lonely landscape" brought about through old witchery that has led not only to Tayo's illness but also to World War II, strip-mining, nuclear weapons, racism, and a drought-plagued land. Witchery, not white people, has set a loveless, fearful, mechanistic, death-bent force loose in the world.

Silko does a wonderful job of making us see the Laguna landscape as the nexus of all modern history. The original witches' convention takes place near Laguna; on Bataan, Tayo sees the remote ancestors of his own people dying in the jungle mud; Laguna land

encompasses the uranium fields; Los Alamos lies to the north and Trinity Site to the south. Tayo is not a single shell-shocked veteran suffering from flashbacks but a figure at the geographic and spiritual center of a cosmic illness.

The ceremony to counter the effects of the witchery must face the infectious force of people, both Anglo and Indian, who unbeknownst to themselves are witchery's victims. These people dismiss all ceremony and traditions, whether European or American Indian, as superstition, and they treat the land and one another as objects. The ceremony turns in large part on Tayo's coming together with Ts'eh, a beautiful, mysterious woman he encounters in the mountains beyond the Pueblo. Ts'eh, she tells him, is a "nickname." We know, and Tayo eventually figures out, that it is short for Tse-pi'na— in Keres, "Woman Veiled in Clouds"—the Laguna name for Mount Taylor. She is, she says, "a Montano," and a member of "'a very close family. . . . I have a sister who lives down that way. She's married to a Navajo from Red Lake. . . . Another lives in Flagstaff. My brother's in Jemez.' She stopped suddenly, and she laughed."[23]

She is a mountain spirit, like her brothers and sisters—sacred mountains all. Though she and Tayo are lovers, in scenes among the most erotic in American literature, her sexuality extends far beyond the act of intercourse—she is healer, nurturer, plotter, planter, and she schemes for the good of people and plants and animals. When she spreads her black storm-pattern blanket, snow falls; she she folds it up again—in time to keep the snow-laden branches of fruit trees from breaking—the sky clears. When she bundles up her blue silk shawl with her damp laundry and seedlings and balances it atop her head, Pueblo style, she is Mount Taylor, its blue summit swathed in clouds. She collects, sorts, and transplants herbs and wildflowers, teaching Tayo something of her lore as she works. "She sat flat on the ground and bent close over the plants, examining them for a long time, from the petals, sprinkled with pollen, down the stem to each leaf, and finally to the base, where she carefully dug the sand away from the roots. 'This one contains the color of the sky after a summer rainstorm. I'll take it from here and plant it in another place, a canyon where it hasn't rained for a while'"(235). When she leaves Tayo, she charges him to help carry on her work, to gather a plant that won't be ready for harvesting before she moves on. At the climax of the novel, after he has resisted a brutal final temptation to perpetuate the witchery, Tayo immediately turns his thoughts to her work: "He would go back there now, where she had shown him the plant. He would gather the seeds for her and plant them with great care in places near sandy hills. . . . The plants would grow there like the story, strong and translucent as stars" (266). From Ts'eh, Tayo learns to nurture; through her, he learns to love the land and to recognize the depth of its love for him.

The Ts'eh and Tayo episodes of *Ceremony* are among the most powerful modern recreations of the old stories of women and the land, just as the novel itself is among the most acute evocations of New Mexico landscape. That landscape can be not only mountain and river bottom, but a barroom floor in Gallup, seen through a child's eyes:

> *He lay on his belly with his chin on the wooden floor and watched the legs and the shoes under the tables . . . he searched the floor until he found a plastic bar straw, and then he*

*played with piles of cigarette butts. When he found chewing gum stuck beneath the tables, he put it in his mouth, and tried to keep it, but he always swallowed it. . . . He played for hours under the tables, quiet, watching for someone to drop a potato-chip bag or a wad of gum. He learned about coins, and searched for them, putting them in his mouth when he found them.* (114–15)

This child, or one very like him, will grow up to be Tayo—who knows, even before he meets Ts'eh, how to watch the land with the same intimacy, the same sense of the importance of the small change others might not think worth noticing and treasuring, the same careful regard for the things and creatures others would call trash.

Tayo's sensitivity of eye and heart and his care for the life in things compensate for the precise ceremonial knowledge he has never been given, as a half-outsider. Even before the war, his illness, and his awareness of the ceremony that centers on him, Tayo knows how to see and understands that ritual means holding intercourse with the land. During the prewar drought he seeks out a spring his uncle has shown him, a spring that never runs dry, even in the dust-bowl years. He does not know the proper Laguna way to pray for rain, but, like the little girls in Tapahonso's "The Snake-Man," he does what he can. He "imagine[s] with his heart" the right rituals and simply shakes pollen over the spring and asks for rain. Then he just sits and watches the pool at the source. What he sees suggests the keenness of his sight and insight, the receptivity of his eye: "The spider came out first. She drank from the edge of the pool, careful to keep the delicate egg sacs on her abdomen out of the water. She retraced her path, leaving faint crisscrossing patterns in the fine yellow sand. He remembered stories about her. She waited in certain locations for people to come to her for help" (98).

Tayo is ready to meet Ts'eh; even before their coming together, he knows that the land is alive and beautiful. She awakens his knowledge that the land is not merely alive but endowed with personality and intelligence and capable of evoking and giving back a love that is infinitely personal.

At times Tapahonso and Silko skillfully depict the urban Indian experience, but their work seldom strays much farther than Gallup, Albuquerque, or Phoenix.[24] Joy Harjo's particular poetic turf is cities, especially from the point of view of an Indian woman traveling between them. Her poems are full of planes, cars, pick-ups, borders, and white center-lines; she writes not only of the Oklahoma of her childhood and New Mexico, where she's spent many of her adult years, but of Iowa and Kansas, Calgary and East Chicago, Anchorage and New Orleans, and corrugated tunnels in airports, "a space between leaving and staying."[25] Her work traces the modern Pan-Indian trails criss-crossing the country, no longer trade routes in the old way, but circuits—the pow-wow circuit, the academic-feminist lecture circuit, the poetry-reading circuit. The primacy of travel in her works probably makes her, of the three women I've discussed, the most typical of contemporary American Indian writers. In and out of the Southwest, as Paula Gunn Allen remarks, wandering is an old custom among many tribes.[26] This is perhaps especially true of Oklahoma tribal people, whose wanderings have not always

been voluntary. In an interview, Harjo said, "maybe the people of Oklahoma always have this sense that somehow we're going to have to move again. . . . Somehow, it's not settled, even though we've all lived there since about 1830."[27]

Harjo is also different from Tapahonso and Silko in two other ways. First, her work is more openly concerned than theirs with feminist themes. Second, she has a strong interest in the occult or metaphysical traditions of cultures besides the American Indian: she is an adept Tarot reader and a visionary.

Harjo does have a strong home-base, an acute sense of the red earth and the red people that the name Oklahoma simultaneously signifies. The literal earth is part of her early memory: "I love language, sound, how emotions, images, dreams are formed in air and on the page," she writes. "When I was a little kid in Oklahoma, I would get up before everyone else and go outside to a place of rich dark earth next to the foundation of the house. I would dig piles of earth with a stick, smell it, form it. It had sound. Maybe that's when I first learned to write poetry, even though I never really wrote until I was in my early twenties."[28]

An early poem, "The Last Song," especially affirms that strong childhood bond with a particular patch of southwestern earth that "has sound," that speaks and nurtures:

> *how can you stand it*
> *he said*
> *the hot oklahoma summers*
> *where you were born*
> *this humid thick air*
> *is choking me*
>
> . . . . .
>
> *it is the only way*
> *i know how to breathe*
> *an ancient chant*
> *that my mother knew*
> *came out of a history*
> *woven from wet tall grass*
> *in her womb*
> *and i know no other way*
> *than to surround my voice*
> *with the summer songs of crickets*
> *in this moist south night air*
>
> *oklahoma will be the last song*
> *i'll ever sing*[29]

Here, the land is a mother and a mother of mothers; a singer who gives human singers their songs. This is the poem of a woman who grew up not only playing in the soil, but listening to it. Most of Harjo's poetry does not center specifically on her Creek heritage—or not yet: Geary Hobson speculates that "oklahoma will be the last song / i'll ever sing" may be a promise of the theme Harjo will turn to in time.[30] Meanwhile, the

land does not manifest itself in her poetry in spirit-figures out of her particular tribal tradition, like Tapahonso's Snake-man or Silko's mountain ka'tsinas. What does pulse throughout Harjo's work is a sense that all landscape she encounters is endowed with an identity, vitality, and intelligence of its own. This sense of life and intelligence in the land is quite different from the human emotions an Anglo poet might *project* upon landscape; the life in Harjo's landscapes makes poems written out of the pathetic fallacy indeed seem pathetic by comparison.

"Kansas City" illustrates Harjo's sense of the individual identities of natural things. In that poem, Noni Daylight (a kind of alter ego who appears often in Harjo's works) elects to remain

> *in Kansas City, raise the children*
> *she had by different men,*
> *all colors. Because she knew*
> *that each star rang with separate*
> *colored hue, as bands of horses,*
> *and wild*
>     *like the spirit in her* . . .[31]

Her children of different colors are comparable, in their beautiful singularity, to the each-ness of stars and horses. Noni's children, Noni's men, and Noni herself are singular and vitally connected with that natural universe of stars and horses. Even though they live in Kansas City, they are not alienated from or outside of nature.

Moreover, in Harjo's poems the land acknowledges its connection to people. In "Leaving," the speaker wakes as her roommate gets up to answer a late-night phone call:

> *Her sister was running way from her boyfriend and*
> *was stranded in Calgary, Alberta. Needed money*
> *and comfort for the long return back home.*
>
> *I dreamed of a Canadian plain, and warm arms around me,*
> *the soft skin of the body's landscape. And I dreamed*
> *of bear, and a thousand-mile escape homeward.*   *(28)*

Even the imagined landscape of the Canadian plain, usually considered harsh country and certainly radically different from Harjo's Oklahoma, is like the sisters and friends earlier in the poem who warm and sustain one another. Both the women and the land are soft, comforting, erotic, familiar, associated with the healing and power of the totemic bear, and with home.

Harjo turns to the theme of human erotic connections with spirit figures who embody the land in her many poems about the moon. In them, the moon appears not as symbol and certainly not as background lighting, but as a full, intelligent female person. That the moon should be so important in Harjo's work makes sense given her woman-centeredness and her representation of herself as a woman on the move. The woman-ness of the moon is in almost all cultures, and she can be there for the wanderer in

Anchorage or Hong Kong; like Harjo, she is a traveler too. The moon, that medieval emblem of instability for Western Europeans, is a stable comforter for Harjo; in "Heartbeat," Noni Daylight drops acid and drives through Albuquerque with a pistol cradled in her lap. In the middle of this nighttown horror, "Noni takes the hand of the moon / that she knows is in control overhead." The poem concludes, "It is not the moon, or the pistol in her lap / but a fierce anger / that will free her" (37). Even so, given that Noni has yet to find that anger, the moon is the only entity who remains steady, who reaches out to Noni in a time when "these nights, she wants out."

And yet the comforting moon Harjo knows is also as completely herself and as mysterious as Snake-man or mountain ka'tsinas. Harjo conveys this moon's wildness and independent life beautifully in "Moonlight": "I know when the sun is in China / because the night-shining other-light / crawls into my bed. She is moon." Harjo imagines the other side of the world,

> in Hong Kong, Where someone else has also
> awakened, the night thrown back and asked,
> "Where is the moon, my lover?"
> And from here I always answer in my dreaming,
> "The last time I saw her, she was in the arms
> of another sky."    (52)

What matters most about Harjo's moon is her ability as a living spirit to enter into the sort of dialogue with people that reassures them, no matter where they are, of their own lives and their connection with wilderness. In "September Moon," as Harjo and her children try to cross Albuquerque's Central Avenue in the midst of State Fair traffic, she encounters the moon rising out of the trapped air of the urban Rio Grande Valley:

> I was fearful of traffic
> trying to keep my steps and the moon was east,
> ballooning out of the mountain ridge, out of smokey clouds
> out of any skin that was covering her. Naked.
> Such beauty.
>           Look.
> We are alive. The woman of the moon looking
> at us, and we are looking at her, acknowledging
> each other.    (60)

The land and the person acknowledging each other as living beings, sensate and sensual, their lives inextricably woven together in Spider Woman's web—this is what lies at the heart of American Indian ritual and southwestern American Indian women's writing.

# 10 · ELIZABETH DUVERT

# *With Stone, Star, and Earth*

## THE PRESENCE OF THE ARCHAIC IN THE LANDSCAPE VISIONS OF GEORGIA O'KEEFFE, NANCY HOLT, AND MICHELLE STUART

*I've been told there is very little time left, that we must get all these things about time and place straight. If we don't we will only have passed on and have changed nothing. That is why we are here I think, to change things. It is why I came to the desert.* —*Barry Lopez,* Desert Notes

For many Americans, change itself has become what denies the possibility of change. Our ability to curve, to bend, to exchange—all root meanings of the word *change*—has been called into question by the rapid pace of urbanization, industrialization, and technological expansion. The landscapes where our lives might take place have become remnants of a dream recalled in the midst of a waking nightmare. Even our poets tell us that this is the way things are. Kenneth Patchen:

> *We'd like belonging*
> *Here, where sleep is not of city-kind,*
> *Where sleep is full and light and close*
> *As outline of a leaf in glass of tea; but*
> *Knowledge in the heart of each of us*
> *Has painted rotten eyes within*
> *The head: We have no choice: we see*
> *All weeping things and gaudy days*
> *Upon this humble earth, blending*
> *Taxis' horns and giant despair*
> *With every landscape, here, or anywhere.*[1]

The poet presents us with an image of our own spiritual dis-ease, our reading of the landscape based upon our "knowledge" of the way things are, a knowledge that sickens, covering the eye with decay, the ear with dissonance, and the landscape with the gigantic shadow of our own despair, a despair so great there is no choice, no alternative, no way out or even through the illness which this "knowledge" has cast upon our lives and where we live them. "We'd like belonging," but we don't; and, even if we sensed we did, it would result not from our desire to live but from our desire to sleep, to shut exhausted eyes and sink into some nonexistent world where "unknowing" would prevent our being teased by the possibility of vision as clear as "outline of a leaf in glass of tea." The well-wrought lines of Patchen's poem belie the weakened vision of landscape they contain, while their crafted beauty persuades the reader that the knowledge to which the poet refers is true. And, in a way, it is.

The poem reflects the individual and cultural disjunction between most Americans and the world they inhabit. It also suggests the illness in both individual and culture that has resulted from the predominant attitude to the landscape evident in American cultural history, an attitude, as Frederick Turner makes painfully clear, derived from "the historic Christian fear of becoming possessed" by the natives, by the land, and by the spirits in the land the natives revered.[2] From the first, we have been a nation at war with the earth we inhabit, ignoring for the most part what its earliest inhabitants knew: the necessary connection between the life of the land they inhabited and their own well-being. Such a primal connection was symbolically affirmed, ritually enacted, painted, danced, and sung in the art created by the native tribes of this country, many of whom sought "possession" and its expression through their art in order to be revivified by the ruling spirits of the natural world. A dancer actively sought to become the spirit he was representing; a shaman underwent possession and entered the spirit world in order to be healed and to use that experience to heal others.[3] However, the desire to participate within the larger pattern of the natural order has not been the focus of our national art. The most extensive treatment to date of landscape in American art, Barbara Novak's *Nature and Culture* examines the society in which nineteenth century landscape art was produced, a culture little disposed in its religious beliefs, its political and scientific doctrines, and its nationalistic bent to consider the mythic connections with nature that this land's earlier inhabitants experienced.[4] With the growing environmental concern of the twentieth century, many American artists have begun to express in their landscape visions alternative attitudes to the natural world, ones similar to those expressed in the early art and continuing traditions of native cultures. Much like the priests or shamans of these cultures, contemporary artists offer visions of landscape that express not separation but a continuing connection with the natural processes that have shaped the world we inhabit.

Three of these artists—Georgia O'Keeffe, Nancy Holt, and Michelle Stuart—have been inspired by the landscape of the American Southwest to create works expressing these alternative visions. Their choice of the Southwest is significant, for in this landscape the origins of the earth are revealed. A recent television series produced by the BBC is entitled, significantly, *The Making of A Continent;* the word *making* refers to the

action not of humankind but of the earth itself. The series begins its examination of the making of the North American continent by focusing on the American Southwest, for the story of the making of the earth is embodied in this landscape. Its preservation against the pressures of short-term industrial and technological exploitation, not to mention nuclear devastation, are essential for our knowledge of the place, the continent, the earth we inhabit. For, as the series suggests, it is the earth that *under-stands* our existence, not the other way around. The works of O'Keeffe, Holt, and Stuart renew our awareness of images, rhythms, and processes of the world we have neglected, and they create a regenerative bridge between the archaic and the modern, directing us along a potentially healing path into the future.

*Archaic* derives from the Greek *arkhaikos,* from *arkhaios,* ancient, from *arkhē,* beginning, from *arkhein,* to begin. Knowledge of the beginnings of ancient cultures has expanded greatly in the recent past, bringing to modern attention myths, customs, and artistic forms that suggest other attitudes toward the natural world, attitudes persisting in those few cultures who have maintained ties with their ancient past as well as in so-called primitive cultures around the globe, remnants of which have survived into the present. Many twentieth-century artists have turned to the art of these cultures to articulate symbolically, to restate and re-member a fundamental relatedness between humans and nature, to render nature humanly intelligible "so that people can know how to live."[5]

The presence of the archaic in the landscape visions of O'Keeffe, Holt, and Stuart thus seems appropriate—one might even say religious. The roots of the word *religion* derive from *religāre,* to bind back, from *re,* back, and *ligāre,* to bind or fasten. The archaic in these artists' works not only reconnects us to the origins of the earth and its early inhabitants; it also returns us to the beginnings of art, to the human emulation in the ritual of art of the powers that generated the world. It also invites us to see anew and to read anew what we see, to reconsider the language we have used to name the reality we experience. The word *landscape* itself suggests the experience we name when we speak of the human envisioning of the earth. Yet, just as the words *enchanted* or *entranced* suggest being sung or dreamed into, so with the word *envisioning* might we not imagine that we are the ones being "seen into," we the ones "en-visioned" by the earth itself? "The landscape imagines me," writes the Spanish poet Jorge Guillen. Art begins when with nature we envision, when with stone, star, and earth, we again begin.

✳

*The last thing you will notice will be the stones. . . . They are small enough to be missed . . . but they are the last things to give up the light; you will see them flare and burn like coals before they let go.*—Barry Lopez, Desert Notes

One of the first things one notices in the paintings of Georgia O'Keeffe is the absence of the human figure. Her portrayal of object and landscape, however, has continually been seen as reminiscent of the female body. Most recently, the feminist art critic Lucy Lippard has described O'Keeffe's painting of the Southwestern landscape as having "a voluptuous spareness that unavoidably evokes a female body in contour and surface."

Although O'Keeffe has vigorously denied early critics' interpretation of her paintings as sexual, she has also said: "I am trying with all my skill to do a painting that is all of women, as well as all of me."[6]

Rather than centering our attention on a correspondence between O'Keeffe's forms and female anatomy, perhaps we need to understand that what we are responding to in her art is a vision of the living contour present in all elements of the natural world—human, object, and land alike. Perhaps we have singled out this presence in her work and associated it with the female because it so challenges the dominant mode of perceiving both ourselves and the natural world in which both female and male partake. O'Keeffe's famous sensuous forms are, indeed, permeated with eros, the life-expressive and life-affirming motion of all being. Its presence is wonderfully inescapable, although the tendency in this country has been to escape, to flee, to deny the essential presence of the erotic in all of life, to relegate its expression to the "merely" sexual, to identify it with woman and woman with nature, and nature, as even Ralph Waldo Emerson told us in 1836, is all that is "NOT ME, that is both nature and art, all other men, and my own body." Though Emerson writes "I do not wish to fling stones at my beautiful mother," he describes nature after its absorption by mind as little more than "an outcast corpse" and concludes his essay with a call to every American to establish "the kingdom of man over nature,"[7] citing the Romans as models of successful subduers of nature and users of its powers for the realization of their own wills. We are still suffering the split reflected in Emerson's essay, the divisive imbalance we have made between masculine and feminine, mind and matter, human and nature.

O'Keeffe's paintings confront us with images of the other half of the world we have split in two, the half of ourselves we have sought to subdue and deny, if not forget. Like the archetypal images in myth that Herbert Marcuse describes in *Eros and Civilization*—Orpheus, the poet of song, and Narcissus, the lover of beauty—O'Keeffe's art presents us with an "aesthetic dimension" of human activity that liberates the things of nature as well as those of the human realm to be what they are and, in so doing, to generate "a new mode of being."[8] Who has shown us more clearly than O'Keeffe not so much images of flowers but the nature of *flowering*—its openness and receptivity; its response to the energies of water, soil, and sun; its taking of these energies into itself and transforming them, as Rilke writes and O'Keeffe shows us, into "a body of nothing but light," what the poet calls the "resolve and strength of *how many worlds?*"[9] The access to such a regenerative vision of the world and our lives within it *depends,* Marcuse writes, on the erotic attitude of its human inhabitants. "Trees and animals respond to Orpheus' language; the spring and forest respond to Narcissus' desire. The Orphic and Narcissistic Eros awakens and liberates potentialities that are real in things animate and inanimate, in organic and inorganic nature—real but in the unerotic reality suppressed."[10] Eros offers us a mode of knowing the world and our place within it, a mode directly connected to artistic creativity: "The initial form of the creative process is within, yet combined with a kind of yearning for that which is different from itself, toward the creation of integrated new forms which may be different from anything else the world has ever seen."[11] The archaic world view in which prehistoric and primitive artists created their forms expressed that primal connection and recognized the pres-

ence of eros in the continuity of life. These people emulated in art the powers that generated the world, assuring thereby the continuation of the earth and the life of all its inhabitants.

This attitude appears also in Georgia O'Keeffe's paintings, especially in her attention to the contours of her subjects, therein revealing the presence of the living forces, within and without, that have created their shapes. Contours define; they simultaneously enclose and reveal. They are, as Heidegger has noted, the place "from which something *begins its presencing,*" the place through which the shared life of the elements of the natural world is made known.[12] In paintings such as *Stump in Red Hills* (1940) and *Red Hills and Bones* (1941), O'Keeffe reveals the affinities between forms near and far, small and large, the material and structural responsiveness of wood, earth, and bone to the elemental forces in their common landscape. O'Keeffe's style has varied little over her long career. Its continuity suggests the ritualistic nature of her attitude to painting, an almost religious sensibility. Eleanor Munro suggests: "I think clues to a point of view called 'religious' are to be sought . . . in the obsession with which the artist returns to a particular subject, working it, worrying it, dissecting it, displaying it in its painful contradictions and infrequent but stirring overlappings of form and implied meaning: thus, Cézanne painting the mountain, and O'Keeffe painting the desert."[13]

O'Keeffe's repeated portrayal of the subjects and forms near her home in the Southwest suggests that the ritual of painting has been for her a means of knowing the landscape, of making it her own. She joked about the Pedernal, a mountain visible from her New Mexico home at Ghost Ranch: "It's my private mountain. It belongs to me. God told me if I painted it enough I could have it."[14] This attitude would unravel the problem of ownership implicit in Robert Frost's opening dictum in "The Gift Outright": "The land was ours before we were the land's." Frost describes us as a nation "Possessing what we still were unpossessed by, / Possessed by what we now no more possessed."[15] Even in this century, many American artists have remained "possessed" by European tradition, some struggling to free themselves from its weight while others fled to Europe to study its art. Yet O'Keeffe neither turned to Europe for its tradition nor traveled there until late in her life. She is, as Eleanor Munro calls her, an American original, turning to the land itself for her inspiration, speaking of it even late in her life as if she were the one who had been possessed: "Sometimes I think I'm half-mad with love for this place."[16] Through sustained invocation of its contour and tone in the ritual of art O'Keeffe has, like the shaman, differentiated herself from both possessor and possessed—for the shaman has undergone possession to become a "technician of the sacred," a "master of ecstasy," one who has a vision of the powers that shape the world and whose gift is the controlled use of that power for the community, to heal its illness, restore its balance, and reactivate its energies for the continuation of life.[17] O'Keeffe has been an original in the sense defined by the architect Antonio Gaudí: "originality is a return to origins." O'Keeffe brought to the Southwest a developed style and technique; the southwestern landscape gave her her subject. She was already exploring in her early drawings and watercolors shapes evocative of primal experience. A place geologically and historically connected to the origins of the continent was the perfect mate for O'Keeffe's own originality; her paintings return us to those origins as well.

In that sense, I disagree with Munro's comment about O'Keeffe's choice of subjects: "The skulls, flags, and bright colors are to my way of thinking, just what she says they are: devices to hook public attention."[18] The extent of O'Keeffe's appeal is well known. She has been deluged with mail from admirers; women especially have responded to her paintings. Critics and art historians writing about her frequently end up telling us about the place where she lives and contributing to the myth of O'Keeffe the person rather than informing us about the paintings themselves. Feminists, especially feminist artists have found in the painter a model for their own lives and an inspiration for their art—Judy Chicago grants O'Keeffe a place of honor in her *Dinner Party* while Mary Beth Edelson has placed her at the center of her feminist transformation of the Last Supper. The artists of the 1960s found in O'Keeffe's work parallels to their own innovations in abstraction and color, thus reviving for their generation an interest in the older artist's paintings.

It is time to examine more closely the subjects O'Keeffe has chosen, for not only her style but the content of her paintings is an important part of the extensive response her work has evoked. Contemporary artists are increasingly using the very subjects O'Keeffe has displayed in her vision of the southwestern landscape, images as powerful in their symbolic associations as the famous O'Keeffe style itself. The archaic and archetypal elements so prevalent in contemporary art O'Keeffe had already found in her "empty desert."

*Kachina Doll* (1931), one of O'Keeffe's first paintings inspired by the Southwest, provides a point of entry into the artist's vision of the southwestern landscape (fig. 10.1).[19] The Kachina doll serves to initiate the members of its culture into the proper relationship with the place where they dwell. Since the Hopi who make these dolls reflect more of a continuity in cultural tradition with their prehistoric past than most American Indian tribes, and since the Kachina cult itself may date from prehistoric times, O'Keeffe's choice of the doll as a subject for her art provides a link to this continent's archaic past and to parallels in the prehistory of other cultures as well.[20]

For the Hopi, the Kachina are "rain-bringing spirits," spirit-beings able to cross the boundary between natural and supernatural realms. Like Persephone, the Kachinas spend half the year with the mortal Hopi (from winter solstice to mid-July) and half the year in the underworld with deities or supernatural spirits, thus serving as intermediaries through which the Hopi may communicate with the powers that control natural phenomena.[21]

The Kachina dolls are called *tihus,* a term referring both to the carved and painted figurines and to the masked performers in Kachina ceremonies. As fertility symbols, the dolls are given by the Kachina dancers "particularly to little girls" and to adult women. In the matrilineal/matrilocal Hopi society, the purpose of the male-dominated Kachina cult is to encourage fertility, while the women's societies, whose ceremonies occur in the fall following the harvest, emphasize the benefits of the fertility rather than its stimulation. In a culture where corn is "the Mother of the Hopi," these intentions are similar to those discovered in other prehistoric cultures.[22] In her study of the art of prehistoric European agricultural societies, Marija Gimbutas has found "that the culture called *Old Europe* was characterized by a dominance of woman in society and

worship of a Goddess incarnating the creative principle as Source and Giver of All. In this culture the male element, man and animal, represented spontaneous and life-stimulating—but not life-generating—powers," much as the Kachina cult does in the life of the Hopi.[23]

Only men perform the Kachina dances and make the Kachina dolls. Originally, the dolls were made completely from materials collected from the landscape and then painted to reconnect them symbolically to its powers. Carved from the roots of the cottonwood tree, an appropriate symbol for the water-seeking Kachina cult, the dolls were coated with a primer of white kaolin clay and painted with mineral and organic pigments. The carving was less important than the painting, for "it is the paint that makes a carved figure a *tihu*," that is, a true embodiment of a spirit-being.[24]

The painting links the Kachina doll to the landscape—its colors symbolize the six directions—and denotes the fertilizing powers that animate the landscape. Particularly interesting is the striping used on the earliest Kachina dolls, consisting of a series of vertical red lines on the torso. In a recent exhibition, a large number of the early dolls (especially those identifiable by their carved genitalia as female figures) bear three vertical red lines.[25] More recent male Kachinas tend not to be striped, but striping recurs in modern versions of female *puchtihu*, or cradle dolls, which resemble the earliest surviving Kachina dolls. The meaning of these stripes remains uncertain, though their appearance on the early dolls, on the modern *puchtihu*, and on the maiden and grand-mother shawls that adorn Kachina dancers and dolls suggests an association with the female. An additional possibility is that they are emblems of rain; in association with the female, this points to a powerful conjunction of life-generating forces.[26]

The way O'Keeffe transforms the Kachina doll into her own work of art, taking on the traditional male role of "maker," suggests her grasp of the doll's significance in other prehistoric cultures as well. The English word *doll* derives from *Doll*, the diminutive for *Dorothea*, a woman's name meaning "gift of the gods." Doll-like figurines and effigies have long been associated with rituals of fertility and invocation to the Great Goddess who, to prehistoric peoples, ruled the rhythms of life.[27] Small doll-like stone figurines found in caves, mounds, and earthworks associated with prehistoric ritual have been interpreted similarly. Therein have also been found the bones and antlers of animals, such as the deer and the ox, sacred to the female deity. O'Keeffe said that she "made up" the background for her painting; if so, the elements of her composition possess an intuitive rightness entirely appropriate for a painting of a doll symbolic of fertility.[28] O'Keeffe placed her image of the Kachina doll before a shape clearly identifiable with the oxbone shovel used by neolithic builders in prehistoric Europe to construct landscape forms in honor of the goddess.[29] The deer scapula which the shape resembles also recalls the bones used as musical instruments in Hopi ceremonial dances and as digging implements by Pueblo cultures in the Southwest, thus linking the doll to both the ritual and the agricultural life of this country's native cultures. And, finally, its outline surrounds the doll's vertical shape like a *mandorla* used in art as a symbol of female genitalia.[30] The bright colors used by the Hopi predominate, while the white tones on figure and background unite the two in an intimate space. Nor does O'Keeffe omit the powerful symbolic device of red striping. She has painted these stripes not on

the image of the doll but along the sides of the wooden panel she has chosen as the base of her painting. Her placement of the stripes and her choice of wood rather than canvas confirm that the artist is not merely using bright colors and the figure of a doll to catch our attention. It is as if O'Keeffe were saying, "this is not a Kachina doll; this is a painting," while simultaneously making her painting itself the symbolic expression of the Kachina, itself a spirit-being, its panel of wood transformed through the artistic act into an object of spiritual power.

Other twentieth-century painters have used the image of the Kachina doll to express such power: Emil Nolde, in his series *Exotic Figures,* from his drawings of Kachina dolls in the Berlin Museum für Völkerkunde; Max Ernst, in his figural sculpture pieces based on his own collection of Kachina dolls; and most recently the German artist Horst Antes, whose contemporary paintings transform the image of the Kachina doll into monolithic figures of primal energy and whose tribute to the Hopi resulted in Antes' recent exhibition celebrating "The Year of the Hopi."[31] While O'Keeffe apparently shared these artists' desire to renew Western art with a return to the fecund powers invoked in Native American art, her transformation of her subject uniquely reflects the doll's significance in art once created to honor woman as the "Source and Giver of all."

Andreas Lommel argues that the earliest artist was the shaman who portrayed the "inner images, ideas of a personal or collective kind that have taken on form, images from the mythology of the tribe, of the group, very old traditional ideas." The shaman gives shape to these images, "identifying himself with them, recognizing and using them as real forces, interpreting them artistically." For the primitive, such imaginative activity is essential for life to continue; when mental imbalance interrupts that activity, survival is threatened. The Australian aborigines see such a rupture as interfering with procreation itself and then they say: "we cannot dream any more children."[32] Art makes us remember those inner images, and O'Keeffe's painting confronts us with an image of life-generating forces too long neglected or even suppressed.

Perhaps for many Americans perceiving art as life-regenerative is no longer possible; yet I believe that is a major part of the power of O'Keeffe's vision of the southwestern landscape. The American poet Gary Snyder has written of poetry as an "ecological survival technique"; art at its beginning served this purpose.[33] If such an understanding seems impossible today, one can only ask, what do we have to lose, except a speed that is tearing our lives asunder, a sense of deadness in the spaces we inhabit, an alienation from the products that surround us, our own separation from the natural world of which we are a part? What if instead we considered all the spaces of our lives—the houses we live in as well as those in which we worship—holy and living ground? What if we saw their walls or floors as alive? What if we adopted the reconciliatory attitude expressed in Barry Lopez's *River Notes* and celebrated the spaces of our lives in dance, first removing our shoes out of respect for the trees from which the boards beneath our feet were hewn? These ideas can easily be dismissed as romantic nonsense, else they terrify us with the gap between their potential power and the vapidity of our daily lives. Yet Lopez writes, "I cannot believe it is so far between knowing what must be done and doing it."[34]

The Pueblo Indians of the American Southwest believe that their buildings are alive,

that their walls have flesh like a living being. Their building rituals enact their beliefs, emulating the activities of the first beings and supernaturals who created the world; the structure itself is seen as a place of communication with their powers.[35] When Georgia O'Keeffe first saw Ghost Ranch, there seemed to be no road leading to it, and she remembers thinking, "This is my world, but how to get into it?" When she was at last able to purchase a house there in 1940 and one in Abiquiu in 1945, she not only reconstructed them (O'Keeffe has noted of the latter, "Every inch has been smoothed by a woman's hand") but also created numerous paintings celebrating her homes.[36] She had already begun to paint her house at Ghost Ranch in works such as *The House I Live In* (1937), and she continued to use her homes in subsequent paintings, such as her series of portraits of her patio at Abiquiu and its door, which first caught her eye.

O'Keeffe conveys the sense of the patio's living walls perhaps most simply in *Patio with Black Door* (1955, fig. 10.2). The painting, constructed with a subtle gradation of pale mauve and rose tones, shows the wall from an angle, heightening the sense of its contour, the material with which it is made, and the experience of walking beside it on an even path of carefully placed stones. *In the Patio I* (1946) unites the elements of O'Keeffe's adobe dwelling—earth, sky, and wall, inner and outer space—in a series of interlocking planes of color. Earth tones and bright blues frame an image of the patio wall enclosing an interior space. That space, in turn, frames a view of the sky. The words of the French philosopher Gaston Bachelard perhaps best describe O'Keeffe's image of her adobe home: "Housed everywhere but nowhere shut in, this is the motto of the dreamer of dwellings."[37]

So perfectly has O'Keeffe communicated the blending of inside and outside that it is not surprising that many of her paintings are visions of the landscape seen from the windows of her homes. At the Ghost Ranch, O'Keeffe can see the Pedernal, whose distant contour is a familiar part of her daily life and the subject of numerous works. From her kitchen window, O'Keeffe has a view of a V-shape formed by the meeting of the sky and the red hills of the landscape around her home, their encounter presented simply in *Red Hills and Sky* (1945). She notes that the Southwest is a place where one has more sky than earth in one's world, echoing the words of Willa Cather's Father Latour: "Elsewhere the sky is the roof of the world; but here the earth was the floor to the sky."[38]

Having found a way into her world at Ghost Ranch, O'Keeffe has also painted, in works such as *Road Past the View II* (1964), the view from her Abiquiu home of the road that runs past her house "toward Española, Santa Fe, and the World." Like the Navaho weaver's "pathway"—a small line of yarn the weaver passes through the borders of her rug to assure her continued well-being and the creation of another rug—the road has led O'Keeffe beyond her adobe home to other subjects: the layers of clouds, and the patterns of riverbeds seen from the window of a plane. Rita Donagh has noted of O'Keeffe's aerial paintings: "Flying and the vertical dimension of space, is not only a new subject in the iconography of art, but a uniquely contemporary experience."[39] But shamans have long believed that the first humans were naturally able to fly; the shaman seeks that lost experience of ecstatic flight by inducing a trance during which the soul leaves the body and ascends to the sky. O'Keeffe conveys in modern, abstract paintings

entitled *It Was Red and Pink, It Was Blue and Green,* visions of flight already familiar to the archaic mind (fig. 10.3).

The contour of a wall, the view from a window, a doorway's threshold, the slim ribbon of a familiar road near home, or the patterns of the landscape seen from above—through such images O'Keeffe has shown us how the elements of the environment are alive for the "dreamer of dwellings." A ladder is a familiar object in the New Mexico landscape, placed by the walls of the low, earth-hugging adobe dwellings to use in repairing their roofs. Yet, once climbed, the ladder grants access to a vision of the landscape native cultures have experienced for centuries. O'Keeffe says of her painting *Ladder to the Moon* (1958):

> At the Ranch house there is a strong handmade ladder to the roof and when I first lived there I climbed it several times a day to look at the world all 'round—the miles of cliff behind, the wide line of low mountain with a higher narrow flat top. It is very beautiful—tree-covered with a bare spot in the shape of a leaping deer near the top. One evening I was waiting for a friend and stood leaning against the ladder looking at the long dark line of the Pedernal. The sky was a pale greenish blue, the high moon looking white in the evening sky. Painting the ladder has been in my mind for a long time and there it was—with the dark Pedernal and the high white moon—all ready to be put down the next day.[40]

O'Keeffe's intuitive ability to generate powerful compositions from her everyday environment has once more served her well, for the image of a ladder has long evoked in the human psyche images of visionary experience and spiritual transformation.

The shaman begins the ecstatic journey on a ritual ladder that represents symbolic ascent to the sky or descent to the underworld and promises return to the earth.[41] The mystic ladder appears in Egyptian, Islamic, and Christian religious systems as well as in alchemical lore and in primitive cultures around the globe. In the Pueblo cultures of the Southwest, a ladder is used to enter the sacred space of the underground kiva. A common element in all of these beliefs is the idea that communication with spiritual powers occurs through "some physical means," through the use of a real object as simple perhaps as the wooden ladder leaning against a familiar adobe wall. Mircea Eliade speculates that the desire to experience *in concreto* must be "the inevitable consequence of an intense desire to 'live', that is, to 'experience' on the plane of the body, what in the present condition of humanity is no longer accessible except on the plane of the 'spirit.'"[42] Significantly, the visionary experience O'Keeffe's painting invites is expressed through the concrete forms of her familiar landscape: mountain, moon, sky, and ladder, each of which suggests transition—the dark horizon where earth meets sky, the almost imperceptible gradation of color in the sky from the lighter blue-greens in the lower part of the painting to the darker tones in its upper half, a half-moon at the upper center, and the ladder itself. Emblem of spiritual transition, an ordinary ladder also assures us of a return to the earth, the necessary grounding that Starhawk teaches us must follow all ritual experience, returning us renewed to the places of our daily lives.[43]

A hill is no more unusual than a ladder; yet it too offers to both the body and the

imagination the experience of ascent and an image of the earth's presence and power. O'Keeffe has repeatedly portrayed the hills and mountains surrounding her New Mexico home. In *Hill—Ghost Ranch (New Mexico)* (1935), O'Keeffe fills her canvas with a mound-like shape, the white tones of its painted peak, a bright accent to the stunning colors of its base. The curved lines between the lower left corner and the center lead the eye up the hill's steep slopes, suggesting the possibility of impossible ascent, repeated in the series of similar hills indicated in the background at the right. This is exactly the bodily experience of these hills O'Keeffe describes—"so beautifully soft," "so difficult" to climb. She writes:

> *A red hill doesn't touch everyone's heart as it touches mine and I suppose there is no reason why it should. The red hill is a piece of the badlands where even the grass is gone. Bad lands roll away outside my door—hill after hill—red hills of apparently the same sort of earth that you mix with oil to make paint. . . . You have no associations with those hills—our waste land—I think our most beautiful country.*[44]

Yet, as she has made us look at her flowers, we have looked at her hills, and in so doing, associations have returned. It is not so far from O'Keeffe's 1935 painting to Robert Smithson's large earth sculpture, *Broken Circle/Spiral Hill* (1971), which contains in three dimensions a hill similar to that in O'Keeffe's painting. It was not so long before other artists and viewers alike became conscious of the hill's archaic and mythic form.

Eliade has noted the symbol of ascent embodied in the hill or mountain, its healing power sought by the shaman in dream, its source of power as the center of the world, the place of origins from which life arose. In *The Great Mother,* Erich Neumann traces the associations between hill and mountain and the Great Goddess. According to Neumann, the primeval hill expresses a coming to consciousness, the appearance of the creative principle, born of the Feminine. The Goddess is the mountain itself, as well as the throne through which the beings that rule the world are empowered. Neumann's references to the mountain seat of the Great Goddess and the "Mountain Woman" in mythic thought are not so far from the Navajo legend of Changing Woman, the mythical being whose changes reflect the seasons of the earth itself and one of whose legendary birthplaces is the Pedernal mesa visible from O'Keeffe's home at Ghost Ranch.[45]

In the archaic imagination, landscapes have frequently been associated with a female deity. Just as the Pueblo Indians of the Southwest see within the natural world—in springs, hills, mountains, or caves—places of potential communication with the spirits, O'Keeffe herself has referred to "power points" in the landscape, places that she liked to paint, such as the Black Place or the White Place.[46] The Pedernal is such a place, and in numerous paintings she has combined its image with other elements from her natural landscape themselves steeped in archaic meaning: moon, bone, skull, and horns, all attributes of the Great Goddess.

Vincent Scully directs attention to the repeated pairing of horns and mountain as attributes of the Greek deities worshipped in the landscape; Michael Dames explores the presence of the neolithic goddess and her attributes in landscape forms and natural objects; and Gertrude R. Levy studies similar associations in the art of prehistoric

peoples throughout Europe and the Ancient East. Most recently, Lucy R. Lippard has cited these landscape associations in prehistoric art and their correlates in works by contemporary artists.[47] Once again, O'Keeffe has quietly gone her own way, composing modern paintings from a specific locale that nevertheless evoke the archaic associations described by these writers and used in art throughout the world as emblems of a female deity identified with the natural world.

O'Keeffe's pairing of mountain and antlered skull recurs in numerous compositions: *Ram's Head with Hollyhock* (1935), *Summer Days* (1936), *From the Faraway Nearby* (1937), or the night view, *Antelope Head with Pedernal* (1953–55), which combines mountain, bone, horn, and moon (fig. 10.4). These paintings recall what are now recognized as ancient symbols of "female transformation and sexuality, of the goddess' epiphany." Horns themselves have long been identified with fertility, used as symbols of the moon and rebirth, attributes and powers of the goddess. Even as "symbols of the divine deer's maleness," horns are "the gift of woman," granted by the goddess in her manifestation as the Lady of the Animals.[48] O'Keeffe's *Deer Horns* (1938) celebrates that symbol in a form familiar to her and native to the American landscape. Her narrow, vertical canvas is filled with a plethora of antlers, their white curves and points flame-like in form against the deep vivid blue of the background, itself emblematic of spiritual power.

O'Keeffe's paintings of bones—long thought of as emblems of death—recall the shamanic belief widespread among primitive cultures that "the essential life force animating man and animal resides not in the perishable flesh or vital organs but in the bones." From "bone-seed" both are reborn. Bones are used for divination; symbolizing the "mystery of life in continual regeneration," they can place the shaman in contact with spiritual realities.[49] Bone is seen as the enduring source from which light as well as life springs anew. Bone, like the shaman's "sacred quartz crystal, is the clear body, the diamond body, the bone of emanent light" from which what is dismembered and scattered can be remembered and once again made whole.[50] Even in association with the death aspect of the neolithic goddess—the "winter goddess" or "Bone Lady"— bones are carved with her emblems and placed in graves as regenerative symbols.[51] When O'Keeffe speaks of the desert's "beautiful white bones" and portrays them in *Spring* (1948), hovering in mid-air like a pair of just-spread wings above primrose, antler, and mountain, she celebrates the regenerative powers an archaic imagination long perceived in what modern eyes have seen as the mere bones of death.

And when O'Keeffe invites us to look at the sky through the openings in the pelvic bones of desert creatures, we are once again, through the actual elements of the southwestern landscape, in the presence of the archaic imagination. For O'Keeffe's series of paintings of pelvic bones, such as *Pelvis with Moon* (1943), which combines bone, Pedernal, and moon—recall the ancient eye goddess whose image was once engraved on stone and bone alike (fig. 10.5).

In his exploration of the eye goddess motif in Ancient Eastern cultures and its neolithic manifestation in prehistoric England, Michael Dames has found evidence of a "womb-eye fusion" in archaic art associated with the Great Goddess. He illustrates his idea with a stunning sketch of a third-millenium Sumerian female figurine at the center of whose pelvic triangle an eye is placed. Of this prehistoric fusion of womb and eye, Dames writes:

*The womb-eye synthesis resolves the fundamental split between mind and body, spirit and matter, which has troubled successive European cultures for at least 2,500 years. . . . Significantly, the ancient Greek writers who first postulated the mind-matter split also reflected dim awareness (albeit in distorted form) of an earlier harmony. For example, Plato and Hippocrates, one a philosopher, the other a doctor, both regarded the womb as* physically capable of migration to the head. *They maintained that "This invasion brings the sufferer to extreme distress and causes all manner of disorders," especially hysteria. The name itself derives from the Greek word for womb.*
  *By Plato's time, war had been declared within the human body.*[52]

In her 1944 painting for the cover of *View* magazine, O'Keeffe creates the fusion of womb and eye that Dames describes. She joins, in her image for a magazine about vision, two pelvic bones with their holes paired like the eyeholes of a mask. Animal bones from the desert, yes: but animals once held sacred to a female deity. A playful combination for a magazine cover, perhaps just fun to look through at the sky beyond, maybe; but powerfully combined in the image of a mask, a magical implement possessing transformative powers, enabling the wearer to enact the powers with which, through art, it has been endowed.

O'Keeffe uses a similar evocative image in a 1945 pastel entitled *Goat's Horn with Blue,* and again her composition presents us with archaic imagery in the spiral of the goat's horn encircling the blue of the sky (fig. 10.6). Rams' horns were used as artistic embellishments on ancient altars to the Great Goddess and were sought for ritualistic use because of their spiral form, a natural image of the "springs of creative energy."[53] Not only does O'Keeffe's drawing invite us, like her series of bone paintings, to gaze into an infinite blue—which, the artist tells us, "will always be there as it is now after all man's destruction is finished"—it returns us to the origins of life. For the dominating spiral in her drawing has appeared throughout art as an emblem of generation, a pathway between worlds, the blending of solar and lunar forces, the power of the coiled and sleeping serpent symbolic of healing and creative energy, the primal uroboros, and "the 'Great Round,' in which positive and negative, male and female, conscious and unconscious" intermingle.[54] O'Keeffe has found in the goat's spiral horn a perfect symbol for her own artistic powers, and she has found that form in the very real and natural elements of the landscape in which she has centered her life and her art.

A photograph of O'Keeffe seated in her New Mexico home shows the artist holding in her hand a small black stone that barely fills the span of her palm. O'Keeffe also placed larger stones from the southwestern landscape within and around her homes, and in her series of black rock paintings of the early seventies she has used such a stone to fill her canvas. For O'Keeffe, the stones are a symbol; her painting suggests she identifies with them as well.[55] Their enduring shapes have held powerful associations for humans; Lucy Lippard has gathered an extensive array of meanings for the stones she aptly called "the most basic and most mythic of materials." Stones are associated with magic and luck, healing and fertility. They are planted in fields to assure the fertility of crops; American Indians in New Mexico refer to ancient shrines as "Mother Rocks . . . incised with vulva symbols, male and female figures, seeds, serpents, and rain symbols." Stones are used as markers in ritualistic sites, singly or in circles or

rows. They are believed to possess energy, and their shapes evoke the human figure, inspiring the first artists to create from them figurines of the human body. Stones are known to stand for the individual: they mark human graves. "Invulnerable and irreducible, the stone becomes the image and symbol of being." They are known as the sources of the world and its spiritual power—"upon this rock I will build my church." According to Neumann, "Rock and stone have the same significance as mountain and earth. . . . It is not only the mountain that is worshipped as the Great Mother but also the rocks representing it—and her."[56]

For O'Keeffe, the black rocks she has found near her home have become a symbol "of the wideness and wonder of the sky and the world. They have lain there a long time with the sun and wind and the blowing sand making them into something that is precious to the eye and hand—to find with excitement, to treasure and love." In *Black Rock with Blue Sky and White Clouds* (1972), the colors of O'Keeffe's image—whites, pinks, turquoise, and wine—seem to hold all the light of her desert world within the black stone itself, flaring, burning like coals, "small enough to be missed," but the last thing to give up the light.

Through her vision of the southwestern landscape, O'Keeffe has made us look at the world we inhabit and discover in its ordinary objects an oneiric power, reconnecting us imaginatively with others in different times and different places. The other day I picked up from the ground an artificial white rose, dropped from a funeral bouquet in a graveyard near my home. It lies now on the ledge of a window near my desk. It's not a natural object, hardly native to the midwestern landscape where I live, but it reminded me of O'Keeffe and what her paintings have given me of my own landscapes. When I told a friend about this, she was horrified at the idea that O'Keeffe could have used an artificial flower as the subject of a painting. But she has. Both flowers in *White Rose, New Mexico* (1930) are artificial (fig. 10.7). One is a locally made fabric flower like those that decorate New Mexico's cemeteries; the other, O'Keeffe's painted image. Like her other works, this painting begins with an element native to the southwestern landscape, and through art it is transformed into a portrait of itself, the place from which it came, and perhaps the artist herself, widening our notions of the world and the painter's ability to make us understand our relation with that world. O'Keeffe's painting of the New Mexico rose is art about art, a revelation of the artifice through which the painter has shared her vision of the southwestern landscape. Through her paintings she has made us look, identify with what we see, experience it physically and imaginatively, and perhaps remember. "I have used these things," the artist writes, "to say what is to me the wideness and wonder of the world *as I live in it*." Had she not, I would never have noticed the artificial rose in the graveyard near my home; had she not, I might never have seen the stones.

✳

*From the middle of the desert you can see everything well, even in the black dark of a new moon. You know where everything is coming from.—Barry Lopez,* Desert Notes

The landscape of the American Southwest has appealed to Nancy Holt since her first visit in 1968. Since 1969 it has been the site of several of her outdoor sculptural works, of works now in progress and of others planned for the future.

In 1969–71, she created *Buried Poems,* a series of works created for individual people. At sites in Florida, New Jersey, and Arches National Monument in Utah, Holt buried a poem in a vacuum container and gave the person for whom the piece was done a booklet of maps, a description and history of the site, and directions for retrieving the poem.

In 1981, she erected *Time Span* on the grounds of the Laguna Gloria Art Museum in Austin, Texas, an asymmetrical sculptural work formed by the meeting of two twelve-foot-high stuccoed concrete walls whose top edges slope toward the ground. In each wall there are two lunette-shaped voids (fig. 10.8). Ironwork wheels in the form of concentric circles with spokes from the center to the periphery fill these openings—in the lower one the diameter of a stationary half-wheel is flush with the ground; in the upper opening, a full circle of the ironwork can be rotated by hand on a diametrical axis. A round steel core inscribed with the day and time of the completion of the work is placed in the ground in the center of the shadow cast by the upper wheel's inner ring at that exact time and date each year. From the outer edge of one wall, a chain extends on steel poles across the water of a small inlet of Laguna Gloria to the top of a twelve-foot pole on a nearby peninsula. Holt was attracted to the stucco walls and wrought-iron work she saw in Texas, the circular and semicircular windows in them, and the reflections in the water of the pond near the museum. These place-specific elements—natural and artificial—are brought together in *Time Span,* creating a meditative space in which the human and natural history of the site are related to the larger realm of solar time, a relationship denoted by the work's title.

Currently Holt is working on a project entitled *Solar Web,* to be built on the beach at Santa Monica, California (fig. 10.9). This large work—52 feet in width by 82 feet in length by 16 feet in height, to be made of steel pipe and concrete—takes the form of a twelve-pointed sun-star symbol. The sun-star shape will be made by the pipes, its point held in place by vertical and horizontal supports which lead out from the circular center like the legs of a giant spider. This circle hovers above a black concrete circular slab of equal size, placed at ground level in the exact position of the ring of sunlight cast at solar noon on the summer solstice. Black concrete half-circles, placed at the rim of the site and in specific alignment with the steel structure, will mark the sun's position on the horizon at the solstices and equinoxes. On sunny days throughout the year the pattern of the sun-star shape will be visible not only in the stationary sculpture itself but also in its diurnally changing shadow cast on the sand below, moving through the spider-like construction by means of which the artist has captured the sun's weaving of its solar year.

Each of these works embodies the task of discovery, of finding a place, exploring it, and becoming aware of one's perceptions of it heightened by the focus provided by the work's form, its placement, and its invitation to meditate on the relationships between the local and the universal, the immediate and the distant, the inner and the outer. These concerns permeate Holt's works, creating a continuity between her own present and past—which the artist discovered when, at a publisher's request, she delved into a file of poems from her past, like those she once buried in the Utah desert. She was astonished to find so many of her current ideas in these early "concrete" poems: "It's all here in these early works, and now that I have uncovered to myself the fact of actually

having had a visually recorded 'past' in continuity with a 'present,' I will assume that the roots of my work have always been there waiting for open moments to sprout and push up out of my inner eARTh."[57]

Of her first experience of the land that became the site of perhaps her most well-known work, *Sun Tunnels* (1973–76), Nancy Holt has said: "I didn't sleep for days. My insides and outsides came together for the first time. I had found my landscape."[58] Holt's initial experience of the southwestern landscape, the coming together of inner and outer realms, informs the sculpture she proceeded to place upon the land, a work which has been called an American Stonehenge. Yet the experience her art makes available today parallels not only that of the distant prehistoric Stonehenge but also the vision sought by the early shaman-artists and sun-priests inhabiting the American Southwest, invoking the cosmic powers that ordered their world and assured the continuation of life harmonious within and without.

The landscape Holt found is a bare expanse of desert located in the Great Basin Desert in northwestern Utah, the site of a prehistoric lake whose traces are still visible, its receding level etched on the ring of mountains at the horizon.[59] In those mountains are cave-like recesses once inhabited by the desert's earliest dwellers. Nearby are the Bonneville Salt Flats, a rare place on the globe's surface where, as the artist notes, "you can actually see the curvature of the earth." The age of the site gave the artist an awareness of time as "a physical presence." Holt has written: "Being part of that kind of landscape . . . evokes a sense of being on this planet, rotating in space, in universal time." Through the landscape she also experienced a sense of identity with its first inhabitants: "Out there a 'lifetime' seems very minute. After camping alone in the desert a while, I had a strong sense that I was linked through 1000s of years of human time with the people who had lived in the caves around there for so long. I was sharing the same landscape with them. From the site, they would have seen the sun rising and setting over the same mountains and ridges."[60]

After selecting the site and purchasing it for her sculpture, Holt calculated the precise orientation necessary to place her work in accord with the desert's time. Lined up with the rising and setting of the sun on the solstices, *Sun Tunnels* marks the sun's yearly extreme positions on the distant horizon. The artist writes: "The idea for *Sun Tunnels* became clear to me while I was in the desert watching the sun rising and setting, keeping the time of the earth. *Sun Tunnels* can exist only in that particular place—the work evolved out of its site."

Holt's words detailing the exact dimensions, weight, and placement of *Sun Tunnels* in relationship to its site recall the neolithic attention to measure in "an age when number invariably arose from sensory matter," an age when "number did not possess abstract universality, but *was always grounded in some concrete individual intuition*."[61] Holt's sculpture consists of four cylindrical concrete pipes, 18 feet long with outside diameters of 9 feet, 2.5 inches and inside diameters of 8 feet. Their walls are 7.25 inches thick and cut through across the top with circular holes 7, 8, 9, and 10 inches in diameter. Supported by buried concrete foundations, the pipes weigh 22 tons each. Their color and substance are identical with that of the land upon which they are placed horizontally in an open X, each line of which measures 86 feet (fig. 10.10).

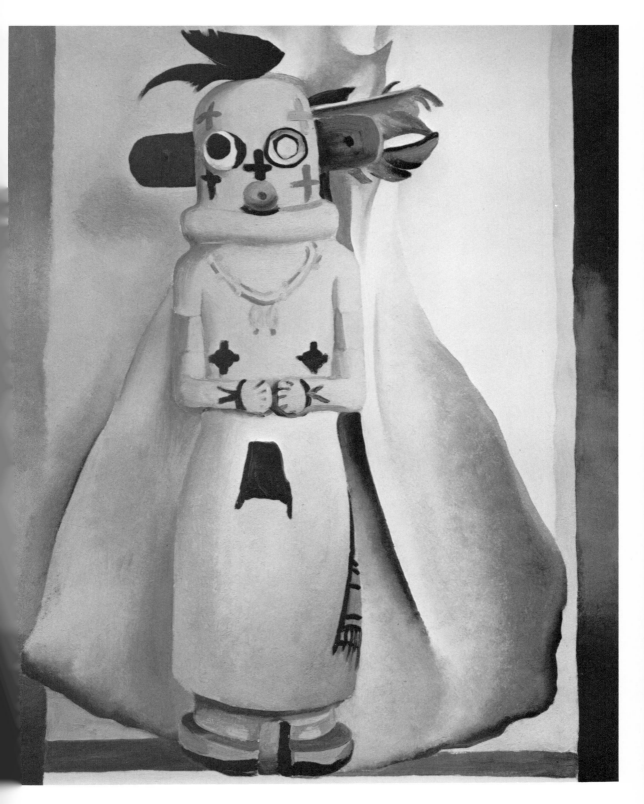

10.1  Georgia O'Keeffe, *Kachina*, 20″ × 16″, oil on canvas, 1930. Collection of Mr. and Mrs. Gerald P. Peters, Santa Fe, New Mexico.

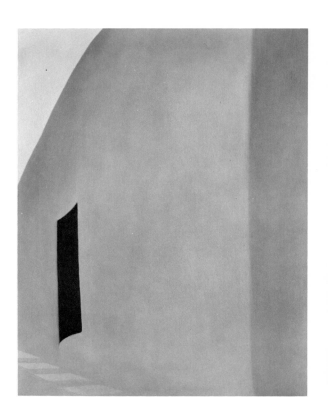

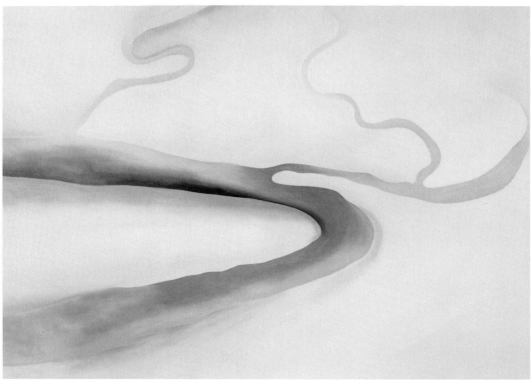

10.2  Georgia O'Keeffe, *Patio with Black Door,* 40″ × 39″, oil on canvas, 1955.
The Lane Collection, Museum of Fine Arts, Boston, Massachusetts.

10.3  Georgia O'Keeffe, *It Was Blue and Green,* 30″ × 40″, oil on canvas, 1960.
Lawrence H. Bloedel Bequest, collection of the Whitney Museum of American Art, New York, New York.

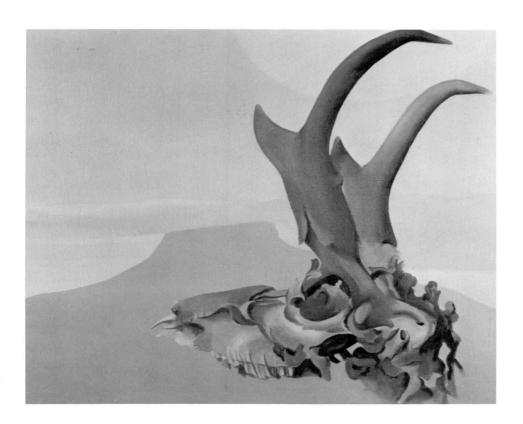

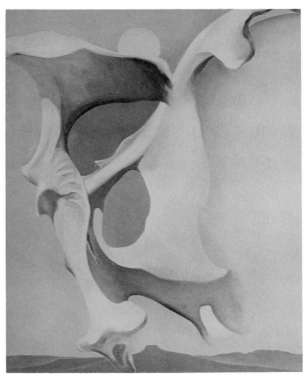

10.4 Georgia O'Keeffe, *Antelope Head with Pedernal*, 20″ × 24″, oil on canvas, 1953–1955.

10.5 Georgia O'Keeffe, *Pelvis with Moon*, 30″ × 24″, oil on canvas, 1943.
The Norton Gallery and School of Art, West Palm Beach, Florida.

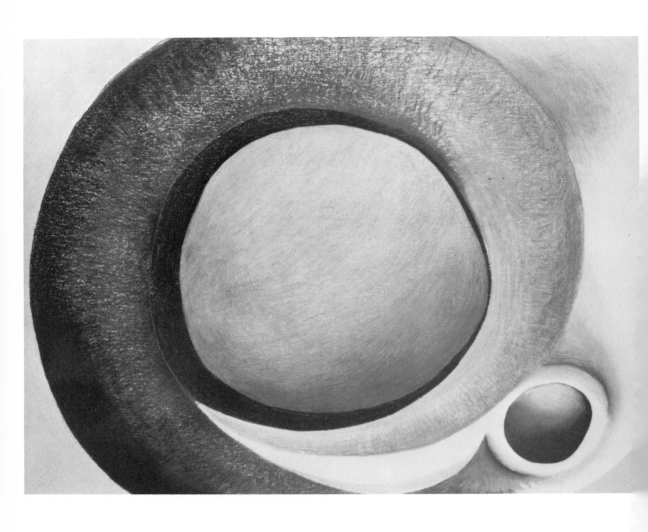

10.6  Georgia O'Keeffe, *Goat Horn with Blue*, 27 ¾" × 35 ½", pastel on paper mounted on board, 1945. Private collection.

10.7  Georgia O'Keeffe, *White Rose, New Mexico*, 30" × 36", oil on canvas, 1930.

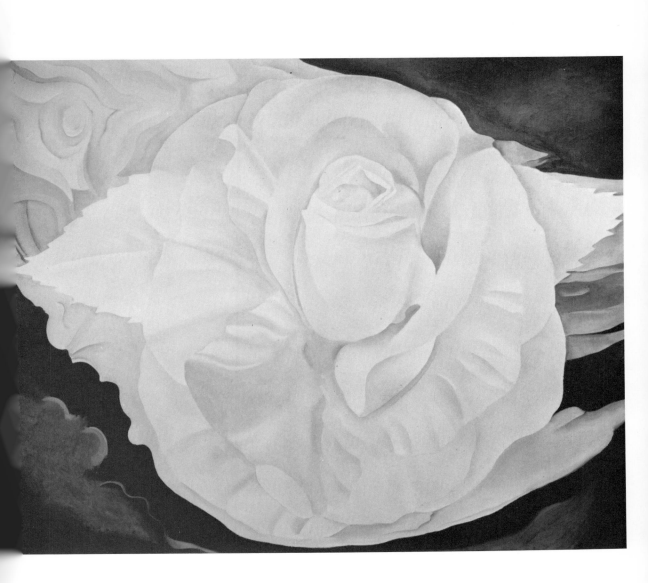

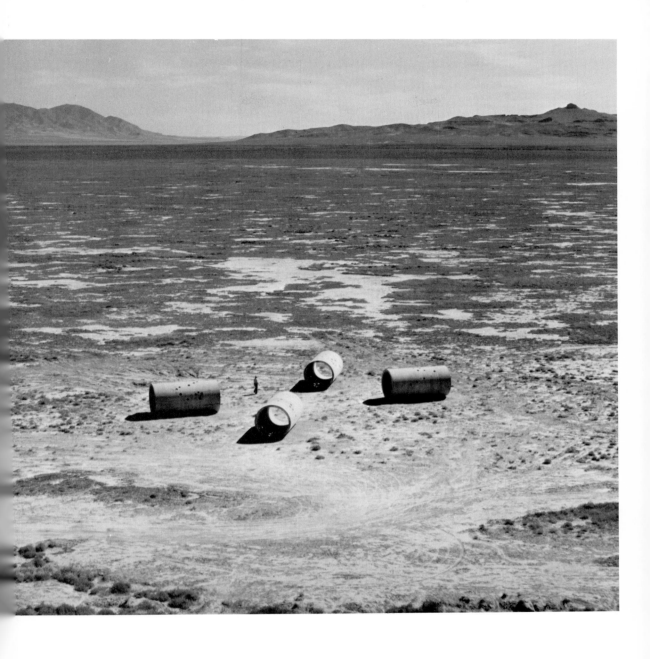

10.8  Nancy Holt, *Timespan*, 7′ × 12′ high, 11′ wide, 50′ long, concrete, steel, and stucco, 1981. Laguna Gloria Art Museum, Austin, Texas.

10.9  Nancy Holt, *Solar Web Model* for Santa Monica Beach, 16′ high, 52′ wide, 82′ long, 1984.

10.10  Nancy Holt, *Sun Tunnels*, 9′ 2 ½″ high, 18′ long, total length 86′, concrete and steel, 1973–1976. The Great Basin Desert, northwestern Utah.

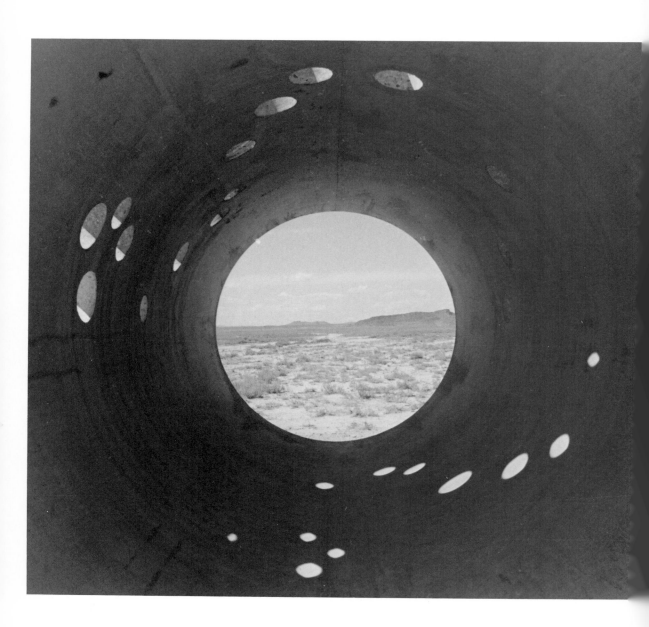

10.11  Nancy Holt, *Sun Tunnels*, detail, tunnel interior, 1973–1976.

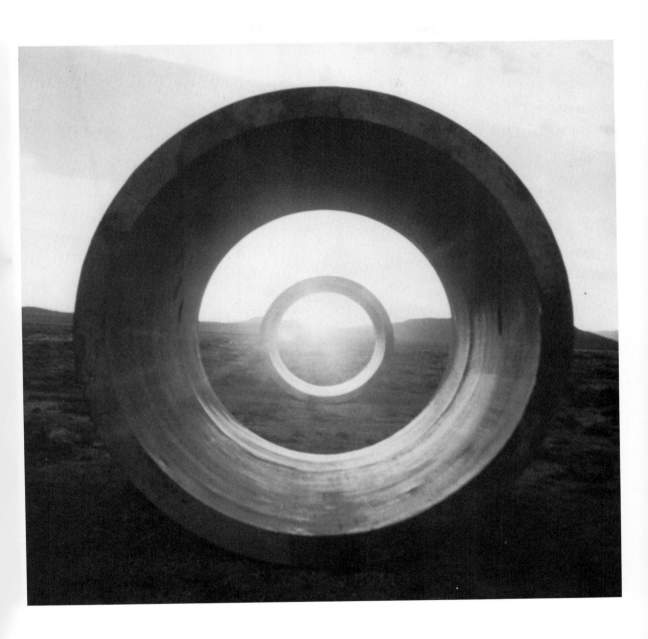

10.12  Nancy Holt, *Sun Tunnels*, detail, sunset, summer solstice, 1973–1976.

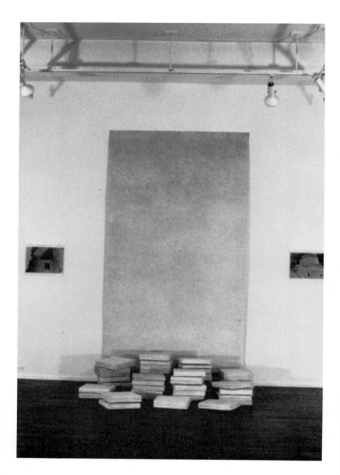

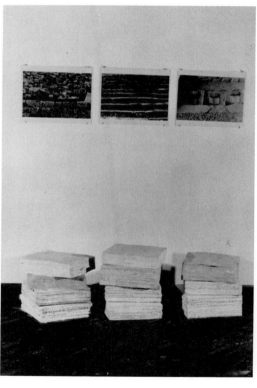

10.13 *(opposite, top)* Michelle Stuart, *Four Corners Nesting Book,* 15 ¾″ × 15 ½″ × 3 ½″, clay, earth, plaster, owl feathers, blue pigment, fabric/handmade paper, 1977–1978.

10.14 Michelle Stuart, *Passages: Mesa Verde,* scroll 108″ × 59″, stacks 12″ × 11″ each, photographs 14″ × 17″ each, earth, photographs, handmade paper, 1977–1979.

10.15 Michelle Stuart, *Records: Copan, Honduras/Quirique, Guatemala/Mesa Verde, U.S.A.,* 56″ high, 35″ deep, 56″ wide, color photographs, earth, handmade paper, 1977–1979.

10.16 Michelle Stuart, *Stone Alignments/Solstice Cairns,* Rowena Plateau, Columbia River Gorge, approximate overall dimensions 1000′ × 800′, circle 100′, cairns 5′ high, 3200 boulders, varying sizes, from foot of Mt. Hood 50 miles up Hood River, 1979. Permanent land work commissioned by Portland Center for the Visual Arts.

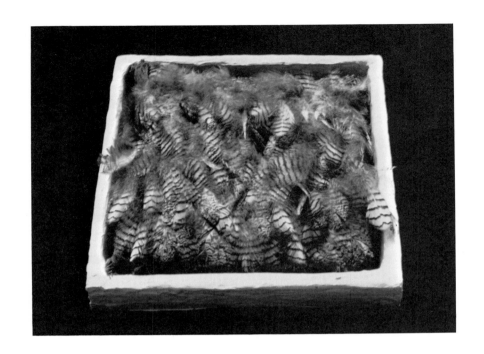

10.17 Michelle Stuart, *Homage to the Owl from Four Corners,* 16 ½″ long × 12 ½″ wide × 2″ deep, earth, handmade paper, owl feathers, string, beeswax, 1985.

10.18 Michelle Stuart, *Dream Cave of Time Regained,* detail, 55″ × 99″, earth, beeswax (encaustic), 1985.

The X-configuration evolved out of the site as well, determined by adjusting the solstice angles at the site's latitude to accommodate the irregular contours of the land and the height of the surrounding mountains. Thus, unlike a number of contemporary earth works by male artists, such as Dennis Oppenheim's *Directed Seeding; Cancelled Crop* (1969) and *Relocated Burial Ground* (1978) or Robert Morris's *Grand Rapids Project* (1974), in all of which an X was cut across the earth's surface, or even Richard Long's X in an English down made by decapitating daisies in an open field,[62] the X-form of Holt's work derived from working with the site itself rather than imposing on it an abstract form, as if thereby one could master the unknown and mark it for one's own.

At the winter solstice, the rising sun is centered in the pipe pointing toward the southeast and can be seen through the pipe at the northwest as well. At sunset, the sun is visible in the southwest. In the summer, the positions are reversed. Throughout the year, Holt's sculpture, itself motionless, serves as a focal point for the landscape's diurnal and seasonal changes marked by moonlight, shadow, sun, and wind—much like the neolithic landscape form of Silbury Hill, which Michael Dames has interpreted as "a topographic deity" nourished throughout the year as an emblem of the synthesis of earthly and stellar powers.[63]

Each of the tunnels is pierced with holes placed in the configuration of four star constellations: Draco, Perseus, Capricorn, and Columba. Holt notes that together, these constellations—some visible only part of the year or only in the southern hemisphere—"encompass the globe." Even so, their choice was determined by aesthetic necessity. The artist wanted only constellations with stars of differing magnitude, and their number and position within a constellation had "to encompass the top half of a tunnel with some holes at eye level on each side, so that the viewer could look through the eye-level holes from the outside and see through the holes on the other side of the tunnel." The viewer's experience, dictated by the size of the human body, was thus primary in determining the work's formal design. Holt confirms this intent: "I wanted to bring the vast space of the desert back to human scale."

This intention has been a continuing concern in Holt's work, from her beginnings in photography and her early gallery installations which emphasized perception, space, focus, and changing light patterns.[64] When she extended her work into the landscape, natural light replaced artificial, and the participation of the viewer, her body moving in space, increased. The artist's use of circular forms that focus attention and her use of moving light have remained constant throughout. In her outdoor works, the landscape as well as the viewer participates; forms and colors constantly alter with the changes of light and position, while the forms the artist sets in place provide "still points" from which change is perceived and experienced.[65]

In *Sun Tunnels* Holt has enlarged her locators so that the human body may enter them. Holt has said that one of her "most basic interests . . . is bringing people into an enclosure and then by means of openings, bringing the horizon into the space so that there is an inside-outside perception going on."[66] Landscape and sky become part of the perception within; "stars are cast down to Earth, spots of warmth in cool tunnels." Circles and ellipses, cast by the light of the sun or the paler moon, slowly spiral around the tunnels' interiors, recreating in miniature an image of their slow procession across

the sky (fig. 10.11). Just as the tunnels encircle the landscape without while the starholes ring the sky above, the body within becomes encircled as well. Within the tunnels, the human body becomes the field upon which the patterns of the universe revolve. Perceptions of night and day, earth and sun, distant star and dark enclosure slowly alter until, ringed by tunnel, landscape, and star, one experiences a sense of being centered at "the still point of the turning world." When the solstice sun breaks on the horizon and its rays flood the interior of *Sun Tunnels,* inner and outer, near and far, past and present merge in a vision of light filling the empty forms and presenting to the eye an image of concentric rings encircling the meeting of earth and sky.

Concentric rings are a recurring motif in the prehistoric art of the American Southwest. Along with other petroglyphs and pictographs found on southwestern rocks, cliffs, mountain caves, and isolated buttes, they have helped recent scholars to associate the region's rock art with the work of skywatchers, sun-priests, and shamans who sought through knowledge of the sky the proper order for their lives. Stories were told, costumes decorated with emblems of the sky—star, circle, and feathered sun—and in nearby caves or rock shelters these images were painted and carved, creating in womb-like spaces shrines wherein at sunrise and sunset on the solstices they found themselves keeping the time of the earth with the stars.

Giorgio de Santillana and Hertha von Dechend, the authors of *Hamlet's Mill,* have suggested that the "most 'ancient treasure' . . . left to us by our predecessors of the High and Far-Off Times was the idea that the gods are really stars."[67] This belief appears in the native cultures of the American Southwest and is figured in their art. Early investigators of the Pueblo cultures refer to "a cult around the Plumed Serpent at Hopi that is a form of sky or sun worship and reportedly derived from the mythic land of Palatkawahi in the south." Its figure is symbolized in Mexico by Venus, the morning star, and reappears in Mogollon art in the cultures of the Southwest. In Rio Grande rock art, stars of all kinds occur, depicted on the bodies of animals, in association with snakes, and in the form of faces. A plumed serpent and a star face combined in a single composition "indicates that this relationship in the rock art is intentional."[68] It was this stellar power emblazoned on the image of god-like beings that the early artist sought to invoke.

In Navajo and Apache rock art, similar ties between celestial bodies and godlike beings recur. The images on rocks and cave walls at isolated ceremonial sites seem to focus primarily on planetaria or star paintings, portraits of supernaturals, and large circle motifs, recently interpreted as images of the sun or moon.[69] Starlore is known to be a major element in Navajo ideology, and its depiction in modern drypaintings suggests that the star ceilings may represent constellations as well. Anthropomorphic figures also occur in the rock art, "commonly portrayed with sunburst headdress motifs, halo devices, or both." These figures have been identified with the archaic shaman, who "may receive . . . power from the sun, and the halo may also designate visionary experience." Sun shamans function in the religion of the Apache, and their images, along with the sun, moon, and mountain spirits, are portrayed on the walls of sacred caves where Apaches go to pray.[70] The conjunction of shaman, shrine, and stellar images in this early rock art has been the focus of recent research into these

images' correlation with the solstices. The Chumash Indians of southern California are known to have a complex ideology involving starlore. The sun was for them the "supreme supernatural being" and is represented in possible solstice motifs throughout the caves and rock formations they used as ceremonial sites.[71]

Particularly interesting are the rock paintings at Burro Flats in the Simi Hills of Los Angeles, identified as decorating the shrine of a tribal shaman. There, investigators have discovered that at the winter solstice the sunlight streams through a "window" in the rock's sheltered space and cuts across "a set of five concentric rings, painted in white, and point[s] toward their shared center." Examples abound of similar shrines marked with spirals and concentric circles and hit by the light entering an aperture at the solstices. Several sites in Los Padres National Forest have been identified as Chumash sun shrines, and Painted Rock Cave has been described by a Chumash informant as "the House of the Sun." Window Cave, also a sacred site, contains a natural window framing a distant mountain. On the cave's interior walls, the solstice sunbeam strikes a "sun symbol"—"a stylized vulva, typically used by the Chumash as a symbol of fertility and the portal of creation." At La Rumorosa, a painted rock shelter in Baja California, the sun's rays at winter solstice play around the image of a shamanic figure, a dagger of light slicing the shaman's face "precisely across the eyes." The shamanic sunwatcher, symbolized on the shelter's wall and most likely represented by an actual shaman skywatcher within the cave, suggests the search for power and renewal, found when the sunlight hits the shaman's eyes. Recently, Anna Sofaer, a contemporary artist, discovered a similar solstice marking in the carved spirals on the sheltered wall of the upper heights of Fajada Butte in New Mexico's Chaco Canyon. There, at summer solstice, the concentric circles formed by the spiral are pierced by what Sofaer has called a dagger of light, directed by slabs of rock intentionally placed to focus the sunlight's path.[72]

The ancient symbol of concentric circles occurs especially in the rock art of Arizona and New Mexico. "Everywhere there are circle designs—small single circles, circles joined by lines, circle clusters, figure eights, circles with central dots, sunbursts, and concentric circles."[73] Concentric circles appear painted in white in the rock shelters beside Arrow Grotto and Feather Cave near Capitan, New Mexico. These have been read as a glyph; the outer rim representing the light around the sun; the second circle, the sun itself; the dot at the center, the sun's umbilicus. Hopis have described the same symbol as representing the earth. Most recently, noting that the sky and earth are inseparable in ancient myth throughout Mexico, investigators have combined these interpretations and designated the site near Capitan as a combined earth and sun shrine.[74]

Perhaps the most frequently reproduced image of Nancy Holt's *Sun Tunnels* is a color photograph—a contemporary memory trace like the archaic symbol painted on rock—taken through the pipes at the summer solstice sunset.[75] The image in the photograph is that of a series of concentric circles whose shared center is the sun just as it meets the horizon of the land and floods the tunnel's interior with light (fig. 10.12). Holt may have known of the symbol of the concentric rings with which native artists traced their experience in the southwestern landscape.[76] With contemporary, abstract forms, she has expressed and made available for others a vision of the landscape experi-

enced and portrayed by the desert's earliest artists. Not only does her sculpture tunnel direct the viewer's vision outward but, as in the work of the Southwest's early shaman-artists, light tunnels inward, illuminating the tunnels' dark interiors, the eye that sees it, the body that receives it.

Holt's work links human beings throughout time in search for what one writer has called "the most profound wisdom: the knowledge of where we are." Placed in the southwestern landscape in accord with the stars, *Sun Tunnels* returns us to an awareness of "the strange hologram of archaic cosmology" through which early humans established order in their earthly life, a sense of where and who they were.[77] With *Sun Tunnels,* Holt renews our sense of being placed and our knowledge of the powers from which everything is coming. With *Sun Tunnels* she achieves

> .   .   .   *concentration*
> *Without elimination, both a new world*
> *And the old made explicit.   .   .* .[78]

*I am not talking metaphors. I am telling you the truth.* —Barry Lopez, Desert Notes

Nature has frequently been interpreted through the metaphor of a book. One speaks of reading the landscape, of deciphering the messages written in nature's text. Nineteenth-century Americans perceived the natural world as "God's Holy Book." Painters approached their task much as Asher B. Durand did: "you can learn to read the great book of Nature, to comprehend it, and eventually transcribe from its pages, and attach to the transcript your own commentaries." William Sidney Mount wrote of "the volume of nature—a lecture always ready and bound by the Almighty." Nature as God's text appealed to a protestant democracy, "For the Holy Book was open to all."[79] Yet what was read therein confirmed the young republic's sense of its own destiny, and nature's "text" was quickly appropriated for nationalistic goals, ironically justifying the destruction of the text itself.

In *River Notes: The Dance of Herons,* Barry Lopez plays upon the metaphor, gently parodying human attempts to capture the meaning of the landscape. His narrator is obsessed with understanding the river's ability to bend, to change its course in response to the land, so that he might imitate it and thereby heal his illness. He approaches his subject through scientific calculation. Order is imposed on the seemingly random, contradictory, and puzzling detail of the natural world; the river's continuous flow is distilled to "a series of elegant equations" that are then recorded in a set of books. But the information compiled is not the knowledge sought. The narrator leaves the books stacked in a corner. Soon overgrown with moss, page sticking to page, the analytic texts begin "to resemble the gray boulders in the river" whose meaning the books pretend to contain.[80] What is written in them is useless; what the narrator seeks is more clearly intimated in the slow, silent changes the unopened books undergo.

Perhaps if one undertook to write a book large enough to encompass the landscape itself:

*In that time, the keeping of records reached such fervor that the history of one state alone took up the whole of a city and the history of a country the whole of a state. As time passed*

*those records were not enough and the professors wrote a history book which was the size of the country itself and its edges coincided with its borders. Less interested in the study of history succeeding generations understood that this enormous history book was useless and they abandoned it to its seasonal destiny. In the deserts of the west some torn and fragmented pages of the book remained, inhabited by animals and lovers.*[81]

Contradictory themes emerge, teasing the mind bent on interpreting. The metaphor expands, exploding the neat correlation between nature and text; the book's pages scatter, inhabited by creatures bound silently through the fragility of their flesh to the equally vulnerable and silent earth.

What if books were inscribed with the motions of bodies, not the words spoken and written by men; what if the marks of their shared life were made not with words on paper but with the earth itself; what if the book were literally identical with its subject, within and without? One might hesitate to break its binding, to slice into its already ragged and frayed sheets, to untie the hemp cords holding it lightly, removing bone, feather, and stone from where they have been so carefully placed. One might wish only to hold it for a while and dream what it dreams, know with one's fingers its textures, and look long at its colors, remembering slowly what it bodily enfolds.

A young girl travels with her father, who is investigating water-rights in the deserts of the Southwest, and she absorbs a geomythology from the places she visits.[82] Steeped in Indian lore, history, and geography, she briefly attends art school while working as a cartographer, tracing the contours of the places she knows. Fragments of the human body appear in her early art, framed in box-like containers. In her search for universal connections, she turns to the moon, exploring in her work the craters and deserts of lunar topography; then she explores the earth—its deserts, its unknown places, the crevices of the past, its folds, layers, and strata. She begins to experiment with surfaces, textures, binding them together, blending part with part to make a new whole.

She decides to dispense with the boxes; and she rubs gigantic sheets of paper, 13 by 5 feet, 20 by 5 feet, with graphite sticks, working until the paper's surface is covered by speckled markings, a continuous, undifferentiated field. She makes a list of words she likes: "space, time, current, continuum, terminals, electromagnetism, gravitation, series, circuits, events, signals, waves"—words that invert "the most usual ways in which we order the world,"[83] suggesting instead a continuity glimpsed, a time unbroken beneath fragmentary perception.

She spreads long rolls of muslin-backed rag paper out along the ground, letting the earth underneath them imprint the paper with its own contours as she rubs their upper surfaces with the graphite sticks. She discards the graphite and reverses the process, using the earth itself to make an impression on the paper's surface, grinding rocks and earth and rubbing them into the paper, polishing them with the palm and side of her hand to a luminous sheen. The light emanating from the now-transformed paper she knows is the breathing of the earth.[84] Her body becomes part of the continuum, moving in a slow ritualistic process until the paper holds the earth's actual contours and tones. Artist and earth meet in the making of the work of art, a visual, wordless record of the blending of the artist's body with that of the earth.

Michelle Stuart's extraordinary art makes tangibly present the processes of the earth

itself, its recording of its own natural history shaped in a time other than the linear one of human progress and discovery, national triumph and military defeat. Her work directs us away from what she calls a "false" history and toward the earth's record of itself, its enfolding of geological rhythms, environmental changes, the succession of plant and animal life, the artifacts of humans who left no written testimony of their lives. Working with the material of the landscape itself, Stuart says of her work: "Matter generates matter in its own image and the surface is real, without illusion."[85]

The predominant forms of her art—book, scroll, and outdoor and installation pieces—become visual texts of an archaic past or possibly a still unknown future, "very old records kept before humans had found or after they had lost the art of writing." Their contents cannot be "read," offering instead the presence of a "sensuous knowledge" which demands a re-visioning of our own relation with its subject, the body of the earth itself.[86]

Many of Stuart's works have been inspired by locations she grew up in or visited as a child—California, Nevada, and Arizona. To these she has added others, especially sites which connote a "spiritual involvement of people with land, in the fact that people have been in the place, chosen it for a particular reason: Mesa Verde, Tikal, the Serpent Mounds in Ohio. . . ."[87] Exhibitions of her site-specific works are frequently accompanied by passages from her ongoing journal, *Return to the Silent Garden*. (The artist notes "I think of nature as the silent garden.")

In *The Fall*, a prose poem interspersed with old stereoptican photos of the waterfalls of Yosemite, Stuart displays a part of herself in the character of Red Poppy, named after the flowers she was surrounded by as a child and which have become for Stuart a symbol of the land, the place, the time, and herself (a poppy appears on her birth certificate; it is also the California state flower). Stuart depicts Red Poppy as if she were a book: "I am a series of messages that appear unrelated . . . I am a bearer of meanings that draw from the spring."[88] The fragility of Red Poppy parallels Stuart's description of the California landscape: "San Andreas . . . delicate wounded space . . . a vulnerable skin . . . a distorted crust marking its fate . . . inscribing the stigmata of the moon on its children." Elsewhere Stuart writes: "The earth lives as we do, elastic, plastic, vulnerable." This perception carries over into the artist's working processes: "As the paper becomes marked, to me it feels like skin, the most delicate, soft, and warmest of surfaces."[89] The perception of earth as body and both as book recurs throughout Stuart's art.

The American Southwest is the subject of a large number of Stuart's works; a recent count by the artist yielded over eighty pieces completed between 1975 and the present. These works include sculptural books made from earth, rock, and objects collected at particular sites in the Southwest; ledgers: large, open double sheets rubbed or imprinted with elements from the site; and works the artist calls "strata," which consist of numerous sheets of earth-embedded paper that hang calendar-like upon the wall, evoking the layers of time readable in the successive layers of the land. Stuart has also made larger works that are composites of scrolls, the artist's own photographs of the site, and stacks of paper that she calls records, depicting in multiple media the life shaped in a particular locale. She has made outdoor sculptural works containing

references to several landscapes and cultures, as do many of her composite works; and, most recently, paintings in which earth is added to the oil or wax which covers the canvas.

The title of a 1975 lithographic suite suggests the affinity Stuart feels with the southwestern landscape: *Tsikomo* is a Tewa word meaning "the place of the rocks" and "the center of it all."[90] The Southwest has served as a center for Stuart throughout her artistic work, and one to which she continues to return. The site names in Stuart's titles reveal the extent of her familiarity with the Southwest and sound in themselves a poetry of place: Chaco Canyon, Chama, Durango, Frijoles, Jemez, Little Wetherill Mesa, Puerto de la Luna, Rio Grande, Salinas, Sandia, White Sands, Ute Mountain, Galisteo. Each work is distinct in color, texture, and form; yet each evokes as well a continuity in the artist's vision of the earth endlessly enclosing and revealing the story of its own making.

Some of her rock books can be opened and paged; others are permanently sealed; all are so fragile as to suggest the need for an alternative approach to the knowledge they contain. The pages of *History of a River: Rio Grande* (1976) are imprinted with a meandering pattern suggesting the river's inscription of its own story in its passage through the land. *Four Corners Nesting Book* (1977–78) refers to an ancient Anasazi settlement. Its cover is almost hidden beneath a layer of owl feathers from a dead bird the artist found in Durango, Colorado, each feather intricately varied in pattern yet contributing to an overall harmony of natural design (fig. 10.13). The book is displayed in a 15.5-inch square form shaped like a miniature adobe stockade and made with plaster from the Taos area tinted with the same blue color that local Indians use on the doors and windows of their adobe homes. The book made of earth that was the nesting site of an early native culture is itself nested within a form evocative of that culture; the bond between culture and nature is reflected in the artwork's shape, texture, decoration, and color—a wordless pattern like that of the life of the Anasazi, readable only in the cliffsides and abandoned ruins of the landscape itself. *Puerto de la Luna History Book* (1980), specific to a New Mexico site, recalls in its title the Spanish-speaking inhabitants of the area, its early culture, and the landscape's magical offering of a doorway to other realms. Made from earth gathered at the site, bound in twine clasping a feather (also from there), this volume has prompted one viewer to write that it "looks as if it were just dug up, rescued from the ruins of some destroyed monastery. In a way it was."[91]

Stuart has conceived of these and others of her rock books being placed within a cave, a repository of knowledge one would enter "nude, vulnerable, new" to experience sensually the knowledge contained not only within cave and book but within one's body as well. Womb-like, the earth would contain Stuart's books, their "body of knowledge" fleshlike and vulnerable like the viewer's body. One would thus experience a sensuous realm of knowledge too long ignored or forgotten, buried in the landscape's unremembered places: "fossil messages sealed in silence . . . secrets hidden in caves . . . dream containers of divine power." "When we return to the root," the artist writes, "we gain the meaning."[92]

The connections between inside and outside continue in Stuart's larger composite

works. In *Passages: Mesa Verde* (1977–79), an earth-rubbed scroll 108 by 59 inches hangs upon the wall between two color photographs of the site while on the floor a set of stacked books or "records"—pages of earth-rubbed paper glued together like fossil beds and resembling stone blocks—refers to the architectural structures at the site as well as to the earth's geological time (fig. 10.14). The photographs above depict windows, an imaginative as well as physical passageway from inside to outside. The whole work plays upon the word *passages* in all its meanings, temporal, spatial, cultural, spiritual. "Everything that the word 'passages' means to me," the artist notes, "is in that piece in the grand sense, a transition from one state to another, a corridor to the harmony of place and time."[93]

In other works, the artist's use of such correspondences connects the Southwest with sites around the globe. Stuart has continued to travel extensively in the Americas as well as in North Africa and Asia, seeking out places where prehistoric and archaic cultures once thrived. Her explorations have suggested to her a parallel between the geologic strata of the earth and its "layers" of tribal habitation, the simultaneous existence of cultures over the globe's surface which undoes "our linear, compartmentalized view of these cultures" as well as our notion of an evolutionary, linear history of human development.[94] Stuart's awareness of the shared time layers of archaic cultures, their widespread distribution, and the similarities in the forms they produced has inspired works such as *Records: Copan, Honduras/Quiriqua, Guatemala/Mesa Verde, U.S.A.* and *Stone/Tool Morphology* (both 1977–79).

In *Records,* three color photographs taken by the artist at each of the sites named in the title are displayed on the wall above three stacks of muslin/rag paper whose earth-rubbed pages are glued together to form both replicas of the earth's strata and the appearance of discarded records evoking the site's history (fig. 10.15). The photograph identified with Mesa Verde shows a stone recess holding three pairs of *metates* and *manos,* the implements with which Indian women grind corn. Stuart associates this photo with the female principle (she associates the Roman-like carved head in the photo from Copan with the male principle, due to its suggestion of the hierarchical power structure maintained by the priestly class, and the third photo of a stairway with access to infinity).[95] The photo of the women's grinding tools (reminiscent of the artist's own mode of working) denotes for Stuart the beginning of settlement and the use of tools as sedentary implements.

*Stone/Tool Morphology* refers to these tools and the pattern of exchange between cultures existing between 400 and 900 A.D. In both idea and form, this work conveys Stuart's concern with imprinting, the formal and ideological traces left upon the surface of the earth and upon cultures inhabiting it as human beings come into contact with nature and other humans. The format of the work articulates aesthetically the interconnected pattern Stuart perceives, a grid of 682 units, 74.5 by 155 inches, in which photographs from eleven archaeological sites in Central and North America, including Mesa Verde and Canyon de Chelly, are interspersed with double images of stone tools used by the earth's early inhabitants. The shape of each tool—which Stuart herself researched, drew, built, and imprinted—appears both in relief and in an intaglio print, conveying formally the concept of imprinting that permeates the piece and emphasizes

cross-cultural ties rather than separation or conflict, the coming together of humans based on "a strong desire," the artist notes, "on the part of [one] particular culture to have what the other culture had. Or exchange for what it has with another culture."[96] Through such works, Stuart blends elements of the American Southwest with those of distant cultures and landscapes, suggesting as well the wholeness of the earth with which and about which her art is made. "We are all parts of a Whole," she writes, "no good/bad facile dualisms . . . all one pulsating force."[97]

The idea of confluence, the place of meeting, is a major motif in Stuart's large outdoor sculpture *Stone Alignments/Solstice Cairns,* 1979 (fig. 10.16). The work is built on a plateau overlooking the Columbia River Gorge in Oregon in the middle of the Oregon/Washington boundary, situated at what the Indians call "the place where the sun meets the rain." Consisting of 3,400 rocks placed in a form reminiscent of the prehistoric medicine wheels found across the North American Great Plains from Texas to Canada, the work marks the sun's rising and setting at the summer solstice, a time at the site, the artist also discovered, when "the moon and the sun were in an embrace."[98] Underneath the central cairn, the artist buried rocks from sites where she has worked: Guatemala, New Jersey, and again, the American Southwest. In a work connecting sky and earth, distant parts of the globe, the prehistoric and the present, Stuart becomes a contemporary version of the Southwest Pueblo people's earth goddess, Hata Wugti, the mythological Spider Woman, weaving her vision of the earth, its inhabitants, and their shared life in the "silent garden" back into modern consciousness through a web of connecting, salutary art.

In a recent large painting, *Time Chart (Hopi Mother Earth)* (1983), Stuart has blended earth with the dark oil pigments covering the canvas and then has carefully incised in its surface ancient symbols that natives of the American Southwest have long revered as emblems of their passage through the earth, its space and time. Beside a figure of a four-footed creature and a graphic sign for mountains—a double M also containing the initial of the artist's name visually identified with the landscape itself—appear a spiral and the Hopi symbol for Mother Earth. In addition to the spiral's symbolic meaning as an emblem of death and rebirth, of the degeneration of time and its restoration, the sun's yearly demise and its new beginning, the spiral is also part of the Hopis' ancient migration symbols, a record of the people's wandering north, east, south, and west until they attained the center they sought, the site in the southwestern landscape which became their home. Their Mother Earth symbol, a square maze-like figure, is an emblem of emergence—the first people from the lower world, the child from the mother's body, the life-sustaining crops from the womb of the earth, "spiritual rebirth from one world to the succeeding one."[99]

Stuart's painting presents us with an image of time different from the way we usually perceive it, and appropriately so, for recent research suggests that the Hopi tend to understand the past and the present as one, the future as separate and to come.[100] One must move close to the painting's earth-darkened surface to perceive on its otherwise unbroken field the delicate tracings denoting ancient perceptions of the potentiality for change, the cyclic emergence from one world to another. Stuart has written how from a mountain plateau in the southwestern landscape she "could see forever, hundreds of

miles into the distant mountains across a vast plain. . . . I saw generations struggle across this magical crystal space."[101] As do all of Stuart's works, *Time Chart (Hopi Mother Earth)* places before us a sensuous presence of the space/time continuum shared by the earth and all of its inhabitants.

If one were to try to identify a continuous theme woven throughout Stuart's work, it would be such universal correspondences and the artist's attempt to uncover them, to make them sensually present for others and for herself as well. Stuart's vision of the southwestern landscape and its many cultural overlays parallels her mode of developing her works, continually exploring their interrelations and extending her knowledge as well as our own of the correspondences they reveal. Different forms have emerged side by side, such as two recent works, *Homage to the Owl from Four Corners* (1985), a book made of earth, owl feathers, string, and beeswax, and *Dream Cave of Time Regained* (1985), a large painting of earth, beeswax, and encaustic, inspired by cave marks and petroglyphs in the Southwest (figs. 10.17–18). Stuart's mode of working connects earlier pieces with later ones to create an ongoing pattern in which each part contributes to the expression of a rich blend of land, culture, and their relations. Pointing as well to connections with other sites and cultures around the globe, this living pattern conveys a sense of multiple continuities and relationships not available through a one-directional, linear reading of the earth's history, the artist's own development, or our own. In this sense, Stuart's use of the archaic in her art offers us not a nostalgia for a lost past but a way to begin anew, based on an increased awareness, in the artist's words, "of the connections of the cosmic whole."[102]

## 11 · VERA NORWOOD AND JANICE MONK

# *Conclusion*

*the bicycle & the sewing machine are*
*wonderful inventions said Gandhi*

*and when the bicycle fails*
*30 mph winds / 7 miles to go*
*up a slow 2-lane road*
*wind across the pastures*
*bending small trees*
*30° / breath of the snow mts*
*raw in yr throat*

. . . . . .

*abate, wind*
*abate / just 1 hour*
*but it doesn't*

*wild sage / beginning to rattle like knives*
*& lead wheels / road of thick water*
*thighs / prisoners on a rack*
*7 miles / against the winds will*
*walking uphill / pumping downhill*
*& walking is easier*

. . . . . .

*abate, wind*
*abate / just 1 damn hour*
*& it won't*

223

*because the wind / wants to know you*
*it wants to know you*

*& when the sewing machine / fails*
*& electricity fails*
*& the easy cloth fails*
*& the nakedness & the beginning / are close*
*chip a stone edge*
*cut a spear*
*hunt thru the mts*
*kill a deer*
*strip its skin / cure the hide*
*clean the rib*
*carve a bone needle*
*twist gut into thread*
*puncture holes*
*pull needle / thru the soft hide*
*make a shirt*
*make pants / make shoes*
*for you to wear*
*to hunt the next deer*

*because the rock / the forest / the animal*
*want to know you*

*because you've come / into their real dream*
*& they want to know you*

Barbara Mor's poem about bicycling through the spring winds and high altitudes around Taos, New Mexico, expresses well the ambiguity and complexity in literary and artistic women's relationships to southwestern landscapes.[1] As Mor suggests, daily life in the region carries a meaning altogether different from the scenic view afforded the tourist through an automobile window. Yet, difficult though the place may be, Mor finds creative strength in the landscape: her art literally springs from it. Furthermore, her poem expresses the feeling, common to the artists and writers discussed in this book, that the Southwest is a world very much alive, growing and changing, requiring from its human inhabitants not dominance but sensitivity. The creative voices of all these women are linked to the reciprocal nature of their relationship with the landscape: their art not only gives human meaning to the environment but also intercepts and transmits messages coming from the landscape.

Cutting across the similarities, however, are differences in the ways women artists and writers relate to the landscape, differences that reflect their cultural heritages and the times and contexts within which they work. For American Indian writers and artists and Hispanic artists of northern New Mexico and southern Colorado, inspiration, materials, themes, and processes of creation often emanate directly from the land.

Chicana writers express a close tie between their people's possession of land and their voice; the few women who wrote before the 1960s mourn their loss of land, language, and culture and hark back to an earlier, idealized, pastoral Hispanic Southwest and their delight in the Spanish language. Recent Chicana writers are reclaiming their cultural identity and claiming the urban landscape of the barrios as their cultural space. Contemporary American Indian writers such as Leslie Marmon Silko and Joy Harjo also demonstrate this capacity to draw inspiration from the urban landscape; like their forebears, they find meaning in all aspects of the landscape.

Anglo women who came to the Southwest in the first half of the twentieth century found in the landscape inspiration, identity, and energy that released their creativity or shaped their work. Mary Austin, for example, experienced in the desert a state of psychic wholeness which prompted her best and most enduring writing. These women found in the landscapes and cultures of the Southwest an idealized model for America's future. In contrast to women from the outside, many native southwestern Anglo writers and photographers, through their familiarity with the land, see patterns of change and continuity, dominance and withdrawal. The region is a historical place for writers Frances Gillmor and Joan Didion and photographers Laura Gilpin and Joan Myers. Second-, third-, and fourth-generation women inhabitants are concerned with accepting the landscape on its own terms and creating arts based on survival within the limitations it establishes. Finally, contemporary artists such as Nancy Holt and Michelle Stuart connect discoveries about the history of the earth and of human habitation in the region to timeless and universal themes that motivate much of their work. As Mor's poem illustrates, the artist integrates the physically experienced landscape into her own dreams of life on the land. Although the dreams and the land may change, the artistic point is their continuous, interdependent relationship.

The chapters of this book amply demonstrate the various ways that specific landscapes of the Southwest have generated creativity among women writers and artists. Considered together, they offer many possibilities for synthesis, but three major areas are most pertinent to our study. First, the book addresses changes in women's voices over a century as both the landscape and women's place in it changed; of particular interest are cross-cultural variations. A second theme is the extent to which gender roles affect women's creative responses to the natural and built landscape. Finally, the book explores the values that women actually find in the landscape and what they say about human responsibility for the world in which we live.

## Temporal and Cultural Variations

Previous studies have shown us the lens through which nineteenth-century Anglo women pioneers viewed the Southwest, but we have understood little about how those views were modified in the twentieth century; neither was much information available about American Indians' and Chicanas' changing response to landscape. Particularly lacking was any sense of women's lives in the rapidly developing urban areas of the region. This book allows us to make some generalizations about all three cultures'

landscape experience in the twentieth century. More important, perhaps, we also can see cultural interrelationships among groups during this century.

First we demonstrate Anglo women's increasingly complex feelings about the Southwest. Although nineteenth century accounts by both travelers and settlers nostalgically refer to the domesticity and garden landscapes of the East, later women like Mary Austin, Willa Cather, and Nancy Newhall brought more to their experiences of the southwestern landscape than familiarity with restrictive nineteenth-century domestic roles. Involved in national and international intellectual and artistic trends of their day, they participated equally with men in defining the region's place in American culture. Sharing male environmentalists' concerns they nevertheless tempered those concerns with an ecological vision of a future in which natural and human worlds would be integrated. For Austin and Luhan, the American Indian and Hispanic populations constituted a part of the landscape which had to be preserved along with the natural environment. Outsiders to the region, they took the cultures of the indigenous populations (who were themselves seen as outsiders in the national context) back to the East and offered them as models for a new national identity—one built on the "prehistory" of the American continent.

But, as they were well aware, the region was developing rapidly. A different pattern emerges if we shift our focus from a snapshot of this singular group to a moving picture of several generations of artists and writers. Then the Southwest becomes a much more complex place, one offering uniquely beautiful visions entrancing to the classicists, but also increasingly symbolizing the difficulty of establishing cultural models at all. For example, rather than providing an environment of ease and promise, the region becomes important for the lessons it offers about the temporary quality of human occupation. Ironically, the urban environment built in the Southwest comes to resemble the natural landscape in that both often depend on shifting sand and easily depleted water resources.

The implications of temporal change become even more crucial as we address questions of cultural transfer among groups in the region. American Indian women's material arts must be considered not only with an eye to tribal affiliations but also with an awareness of the changes wrought as a result of contact with Spanish and Anglo-American cultures. In general, their work, which originally had a utilitarian function within the group, is now often made for sale outside it, and the artists adapt their work to the aesthetic standards of the Anglos. Their art reflects the changing landscape in which it is produced; whereas Anglo conventions such as concrete representation of the landscape had no place in earlier forms, for instance, they may now appear in pictorial rugs. Furthermore, some American Indian women and their male colleagues are moving into the fine arts as, having graduated from university art schools, they recast their traditional world views into totally new formats. Not only are form and technique modified, but the meaning of the original form within the culture changes, resulting in some cases in a loss of symbolic value.

Similar movements are occurring among Chicana artists. Different histories, however, create different senses of place, leading to a diversity of responses among Chicanas. For these women, place and time seem integrally linked: in areas of long Hispanic

tenancy, vigorous art forms using the landscape either directly through materials or indirectly as subject have developed; where such ties are not apparent, the art is much more dominated by Anglo and Mexican fine art and is much less connected to landscape. As the more traditional artists' works become valued in national markets, they, like American Indian art forms, may be affected by Anglo aesthetic impositions.

Chicana writers tell the story of a struggle to re-engage with the land as many people move from rural to metropolitan areas. Just as artists seek a form expressive of urban experience, so too writers attempt to find a voice. Early women documented the loss of traditions as they faced Anglo-American appropriation of old rural landscapes and prohibitions on the use of the Spanish language. Contemporary writers feel freer about switching between languages and cultures; they draw not only from Hispanic sources but from Mexican-Catholic, Aztec, and Toltec world views as well. As a result, they are building a new tradition, integrating the old, rural life and landscape with the developing cityscapes in which they live. Similarly, American Indian writers move their characters into contemporary settings in the Southwest but draw on precontact tales for sustenance. Whereas Chicanas have come to find intrinsic value in urban landscapes, American Indian writers use the remembered past in order to cope with, but not necessarily to accept, the urban present. Just as distinctions of time and place are important for Chicana authors, so too American Indians' landscape visions vary by tribal history, with those more affected by cultural transfer (like Silko's Laguna Pueblo) more conscious of the need to recast old traditions in the light of new experiences.

To the extent that they stress reciprocal relationships between people and the land, contemporary American Indian materials match early twentieth-century writers' concerns about urban (eastern) culture. Georgia O'Keeffe is connected with that earlier group, but her art also points toward the work of a new generation of contemporary Anglo artists. Michelle Stuart and Nancy Holt use imagery that originates in women's culture and ecological philosophy, finding aspects of our future prophesied in the Southwest and questioning contemporary national culture. Unlike Cather, Austin, Henderson, and Luhan, they are not searching for social models of a new America but for universal, almost cosmic concepts. In their interpretations of traditional American Indian belief systems they find connections to pan-cultural patterns for responding to the world, as well as to a set of cultures attuned to a specific place. Thus, they present the Southwest not as unique but as exemplary of the human situation. The Southwest then opens to the world, just as it does for the American Indian poet Joy Harjo, who seeks the help of the full moon to bear her across the crowded highway of a contemporary southwestern city: "We are alive. The woman of the moon looking / at us, and we are looking at her, acknowledging / each other."

## GENDER AND CREATIVITY

Although study of the diversity of women's creative responses to the Southwest carries us well beyond the stereotype of the forlorn frontierswoman appalled by all that

wilderness and pining for a lost domesticity, it does not mitigate the importance of perceived gender roles in shaping what women created, what they valued about women's lives in the region, and, finally, what artistic metaphors and images they used to bind themselves to the place. The most obvious impact of gender roles on creativity is the connection between division of labor and artwork produced by American Indian men and women. Early in the period, not only art forms but also materials followed gender for this group. But, as American Indian arts have become economically valuable outside the culture, old gender divisions are relaxing. The different experience of Chicanas in northern New Mexico and Colorado suggests that we should approach generalization with caution, however, because for these artists distinctions based on gender are not as clear.

How gender is involved in shaping less obvious distinctions in artistic production is also not always clear; but the recurrence of certain patterns in women's art raises intriguing possibilities. For example, Anglo women photographers display an interest in vernacular rather than heroic landscapes. They interpret the landscape as a context or setting for human life rather than as an object for contemplation or manipulation, a stance perhaps best exemplified in Nancy Newhall's description of herself as working always "with the grain under my hand." Although Anglo women's photography offers a good example of concentration on the vernacular, preoccupation with this style crosses cultures and genres. Navajo women, who traditionally wove abstract designs, now incorporate the mundane world of pick-up trucks, sheep, and Coke bottles into their pictorial rugs. Just as Mary Austin turned to local Spanish and Indian usage for naming the landscapes she represented, so Chicanas have turned to folk cultures and the code-switching vernacular language of their people in expressing a cultural tradition. Such association between naming and claiming as a means of asserting the value of women's culture is a major tenet of contemporary feminist theory, as is the aesthetic appreciation of hitherto devalued vernacular forms created by women, such as quilts, diaries, and memoirs; work by southwestern writers and artists in this book thus lends new support to current efforts to define women's art.

One of our most intriguing findings concerns how women artists handle changing role expectations as more of them move from locally based lives in rural communities to more cosmopolitan urban situations. As they adapt to the requirements of the changing landscape they neither completely throw off old domestic roles nor seek total freedom in new ones, rather, they attempt to adjust one to the other. Thus, Joan Didion looks back to her frontier matriarch for advice about how to live in urban Los Angeles, just as Estela Portillo Trambley turns to Nahuatl myths for metaphors of life in the barrio, and Leslie Silko uses Spider Woman to help contemporary American Indians reconcile "the way" and "the way things are." Although each writer finds her voice in female tradition, none is bound by tradition; each feels free to pick only those aspects of tradition that offer liberation and a sense of personal power lacking in contemporary life. For example, Portillo Trambley looks to Nahuatl myths out of a need to reestablish a sexual equality lost in contemporary culture; thus, unlike Chicano writers, she integrates the powerful female voices she finds in the myths into her writing. These female traditions extend across cultures. For example, when Georgia O'Keeffe paints a Hopi

# DATE DUE

12-5

You must show your Denison ID to check out BOOKS and to use RESERVE materials.

## LOAN PERIODS:

**BOOKS** - 21 days with a 7 day fine free grace period.
**RESERVE** - 2 Hours LIBRARY USE ONLY(LUO); 2 Hours LUO with Overnight option if checked out 1 hour before closing;or 3 days.
**SENIOR RESEARCH** - Semester Loan

## RENEWING:

You may renew your books using the "*View Your Circulation Record*" option on CONSORT.

**DENISON** items may be renewed **2 (two)** times, then see Circulation for another Renewal.

**CONSORT** items may be renewed **2 (two)** times, then you must return them.

**OhioLINK** items may be renewed **1 (one)** time. If you need more time, request another copy through OhioLINK ***BEFORE the due date.NOTE: On the 8th day after the due date, the fine will be $4.00 and accumulate $.50 a day thereafter.***

# DENISON UNIVERSITIY
# **LIBRARIES**

Regular semester hours beginning
the first day of classes:
Monday thru Friday  8am - midnight
Saturday  9am - midnight
Sunday  10am - midnight

## **OVERDUE BOOKS**:
Overdue fines are $.50 per day,
maximum $15.00.  Overdue
notices  are sent to the patron
1 day after the due date.
The **FINAL NOTICE** is a
**Replacement Bill.**

*NOTE:  On  the 8th day after the
due date on OhioLINK items, the
fine will be $4.00 and accumulate
$.50 a day thereafter.*

## **OVERDUE RESERVE**:
**Hourly Reserve** - 2 hour grace
period, fines accrue @ $1.00 an
hour after the grace period.
**3 Day Reserve** - $5.00 per day
then a bill.

**NOTICES**  of overdue materials
are a  courtesy  only and do not
exonerate one from his/her
obligation  to return a book on time.
Fines  will be assessed appropriate
to the due date.

*PLEASE " VIEW YOUR*
**CIRCULATION RECORD"** *to
keep track of*  **CHECKED
OUT** *and* **HELD** *items.*

Ask at Circulation for Handouts

kachina doll, we see it placed in a context of female fertility symbols touching on archaic concepts of woman as life-regenerative, concepts also important to Nancy Holt and Michelle Stuart. Original as are all the American Indian, Chicana, and Anglo artists and writers mentioned above, unlike typical male adventurer-artists, they are not interested in facing the world alone and unaided. Perhaps Mary Austin's concept of the *acequia madre* (the mother ditch) as a model of cooperation and sharing in female-centered cultures speaks most clearly to the value many artists place on remaining connected to women's traditions in the Southwest.

Although these artists are in touch with a female heritage, no one tradition, no one way of being female, is pervasive. The diversity of female culture is striking. Within each cultural group are examples of powerful women who embody this characteristic complexity. Joy Harjo's character, Noni Daylight, is constantly on the move, orients her wanderings by a female moon, and contains both the creativity of her different-colored children and the destruction of the gun she carries with her on the urban freeways. Pat Mora's poetry contains the *curandera,* who represents both rational and intuitive knowledge, the chaotic and destructive powers of the witch but also the power to heal and the ability to act as a mediator between these dichotomies, teaching the next generation how to interact with the natural world. Dorothy Scarborough's Cora, embodying "the boundless energy of the plains" in Texas, is one of the first characters in fiction about the Anglo frontier to reject the confines of domesticity and embrace the rigors of life in the arid Southwest. Nor are the visual artists easily domesticated. Georgia O'Keeffe long resisted capture by art critics as a "great female artist," preferring to encourage many readings of her work, to force viewers to recognize their own needs in the interpretations of the landscapes she offers. In works such as *Time Chart (Hopi Mother Earth),* Michelle Stuart extends definitions of the female in her ever-widening explorations of the earth's body. Chicana easel artists in San Antonio reveal a surreal sense of their surroundings much less comfortably domestic than that apparent in the rural craft arts for which Hispanic women have received the most critical attention.

The flexibility and diversity of women artists and writers are reflected in the images and metaphors they use to gain a strong sense of place. The natural and built landscapes of the Southwest offer some of the richest sources for their art. Although landscape has served in various ways to liberate women's creativity, visions of the land as female predominate in their work. Identification of the land as woman has also played an important part in male responses to the various American frontiers. As Annette Kolodny has shown, it is typically conceived of as a virgin to be raped or tamed or as a fruitful mother. The women considered here offer different meanings for the metaphor. For them the female land embodies complexity, power, and worth. Its vast and undominated scale liberates Anglo women in particular from the silencing strictures of femininity. Mary Austin, for example, portrays the desert as a strong woman who cannot be mastered; by implication, neither can the woman who identifies with the desert be tamed. Nor is the metaphor of land as woman confined to a narrow range of experience. For Alice Corbin Henderson the land can be an ancient and peaceful woman, "blinking and blind in the sun . . . who mumbles her beads / and crumbles to stone." For con-

temporary Chicana writers such as Pat Mora, the landscape can also be the old, wise woman of power who mediates between human beings and nature and brings the gift of that power and magic to the writer.

Association of the landscape with woman extends to the built environment. Numerous paintings by Georgia O'Keeffe celebrate her homes at Ghost Ranch and Abiquiu; of the latter she noted that "every inch has been smoothed by a woman's hand." For the writers Carmen Tafolla and Rina Garcia Rocha, the city is a woman. She may be ragged, indifferent, or wicked; she toils, though she is stereotyped as indolent. Southwestern cities offer Chicanas ambivalent images of alienation and childhood happiness, enabling them to undertake their search for identity and to struggle against oppression. For these writers, as for Mary Austin, Margaret Collier Graham, and Joan Didion, the difficulties presented by the landscape, whether natural or built, mirror the difficulties of women's lives. Recognizing that a female landscape can mean something more than the restricted roles traditionally assigned to it, recognizing that women can name their own complex experience by means of landscape metaphors, releases these artists' creativity.

An erotically charged energy that women feel in the land also provides a basis for their expressions. Most forcefully and consistently it infuses the writing of American Indian women. For them the land is sensual and sensate, actively communicating with people and experiencing the critical events of their lives. Sexual encounters with the land serve both to release and to channel the creative wilderness within. Stories of association with the land are essential for personal and cultural survival; they bring about reintegration of the alienated Tayo in Silko's *Ceremony,* for example, and they are carried to the city by Luci Tapahonso.

Erotic and mystical connections with the earth shape the expressions of other women in the Southwest as well. In Willa Cather's *The Song of the Lark,* Thea Kronberg's sojourn in the Indian cliff dwellings leads her to experience the female earth as both a physical and a spiritual body; through this encounter she finds the means by which her own body can give form to her artistic desires, and she accepts her calling to the opera. Land artist Nancy Holt sees the Southwest as the epitome of integration between self and landscape. On first seeing the site where she created the work *Sun Tunnels,* she felt her "insides and outsides [come] together for the first time." Orienting her structures to the rhythms and geometry of the solar system, Holt works in contrast to the many male land artists, who impose abstractions on the earth. For Michelle Stuart, too, artistic creation involves a sensual relation to the earth. Coming to the land nude and vulnerable, not seeking to master, Stuart approaches the earth as a body and a book, creating books from the earth by melding her body with it.

## LANDSCAPE VALUES AND ETHICS

Clearly the southwestern landscape offers women writers and artists much inspiration, a significant portion of which derives from the female qualities they discover there. In conclusion, however, we will ask, not how the landscape engenders their art,

but what values women give to the landscapes they encounter. If, indeed, as Donald Meinig says, "any landscape is composed not only of what lies before our eyes but what lies within our heads," then this book should demonstrate differences in the landscape visions of the three major cultural groups to which the women belong. For example, Anglos have seen in American Indian architecture aesthetically pleasing structures that invite manipulations of volume and shape, light and shadow; while many American Indians perceive the same buildings as a network of social relationships. One must be careful, however, of making simple distinctions between the Anglos and other ethnic groups. For example, although many Anglos have emphasized the exotic and awe-inspiring aspects of the southwestern landscape, a tradition women were instrumental in formulating, other Anglos living in the region have developed attitudes toward landscape similar to those of the American Indians and Chicanas who have dwelt there longer. Mary Austin's celebration of the virtues of a sandstorm in *Land of Little Rain* exemplifies the former, but the latter is evident in Mary Kidder Rak's practical concern for the next rain, a focus congruent with the landscape responses of American Indians and Chicanas.

Nevertheless, several striking differences between Anglo women's landscape perceptions and those of the more established Southwesterners remain. As historians of the West have noted, frontier women tended to locate the paradisiacal landscape, the garden, or middle earth, somewhere outside the Southwest—in a greener environment usually located east of wherever they settled. Second- and third-generation writers continue this tradition in their emphasis on the scarcity of resources in the region: wherever Anglo writers look they see a landscape that, for all its natural beauty and exhilirating freedom, does not permit the possibility of a traditional, reliable agricultural home for themselves (although they do find American Indian women and Chicanas able to build such places within the context of their cultures). They admire the adaptations of their heroines to the problematic landscape of droughts, Santa Ana winds, and crop failures. By contrast, for Chicanas (and probably, but not demonstrably here, for American Indian women), the middle landscape or garden was, and in certain cases continues to be, the Southwest. These findings reveal the importance of considering cultural context in any generalizations about what kind of landscape women value. Contrary to expectations, they also tell the story not of conservative attempts to recreate a past vision but of adjustment to and admiration of a landscape that tests their inherited traditions.

A strong environmentalist theme runs through much Anglo writing and art (for example, that by Austin, Luhan, Newhall, Gillmor, Stuart, Holt), which chastises an audience assumed to be aggressive, dominating, and often explicitly male. An important basis for this theme is some Anglos' readings of conscious environmentalist values into the landscapes created by American Indians and Chicanos. Yet the art by these groups does not appear explicitly environmentalist. One of the few statements in Chicana literature which might be read as such is Fabiola Cabeza de Baca's *We Fed Them Cactus;* Cabeza de Baca is concerned not with preservation, however, but with maintenance of an agrarian life style she believes was lost with the coming of the Anglos. Contemporary artists like Stuart and Holt, who connect an appropriate eco-

logical orientation to archaic life on the land, and thus to preindustrial belief systems, probably represent more accurately the differing landscape responses among southwestern cultures than did earlier writers like Austin and Luhan.

To the extent that Anglo environmentalists see American Indian and Chicana built landscapes as examples of human life closely in tune with nature, they also esteem these artifacts as fit "objects" for cultural preservation. Although some Anglo women share such concerns with male colleagues in the environmental movement, others are more interested in the dynamics of change. When such women envision landscapes evincing appropriate human tenancy on the land, they, like American Indians and Chicanas, value settings in keeping with the requirements of place. They want to understand how people actually live in various environments and how they maintain traditions in the context of late twentieth-century experiences. For example, although Nancy Newhall initially shared with Ansel Adams an appreciation for grand heroic vistas in the West and Southwest, once she became familiar with the life of the people, her view changed. So, while Adams worked to eliminate people from his photographs of Tuscon's San Xavier del Bac, Newhall was interested in the ways people inhabited the church. Such concern for finding examples of life in a vernacular landscape mirrors Patricia Preciado Martin's appreciation of the old house, with its symbolic fig tree, in the midst of Tucson's urban sprawl. Thus, across cultures in the Southwest we find women valuing the ways that various landscapes reflect ordinary people and daily life.

We do not imply that American Indians and Chicanas locate no values in pristine, untenanted nature or that Anglo women's valuation of such a landscape is limited to the parroting of dominant male attitudes. These women feel comfortable in the undomesticated natural world and value it highly, whether they are weavers searching for natural dyes or contemporary land artists searching for construction sites. They do not conform to stereotypes that restrict their movement beyond the confines of local habitation. In fact, among the literary artists in particular, there is a strong tradition in all three cultures for actively seeking experiences in landscapes perceived to be less "safe" for women. Urban environments are one such type, but wilderness seems to be more consistently mentioned as a place for adventure. The adventure women seek in the wild often entails sexual freedom, although cultural differences are evident in the goals of such liberation.

American Indian women writers value the natural landscape surrounding their community as a place for sexual release. As Luci Tapahonso's "Last Year the Piñons Were Plentiful" demonstrates, in wilderness a woman learns both to accept her own sexuality and to control it within socially acceptable bounds. Such a landscape thus plays a significant role in one's education about gender roles within the culture, but it can be useful also as a culturally sanctioned place of release from those roles. Leslie Silko's retellings of the Yellow Woman stories, for example, reveal that Laguna women have a tradition that allows women as well as men to step outside normal sexual restrictions. For the Chicana writer, the wild landscape, particularly the desert, seems to be a place to escape and defy gender roles that restrict her sexually. In wilderness she can reveal and acknowledge aspects of herself not sanctioned by her culture. In contrast to the American Indian, however, the Chicana seems to have few traditional stories that encourage

her to return to society having incorporated this wilderness into her social life. Her cry of freedom in the wilderness remains an aggressive, antisocial statement, healthy for herself but not necessarily accepted by her culture. For example, in Pat Mora's poem "Aztec Princess," the heroine finds room to "breathe" only by physically stepping outside the household, by psychically denying certain restrictive traditions inherited from both Spain and Mexico; there is no sense that those traditions sanction such wildness. Thus, the Chicana writers' views of the value of wilderness do not seem to be shared by the dominant culture in the same way that American Indian women's stories are accepted within their culture.

Finally, Anglo women too seek out uninhabited nature for erotic, sensual experiences, but, rather than cultural reintegration or even defiance, their experience seems to represent a retreat from social proscriptions on their sexuality. The wilderness is neither perceived by their culture as potentially beneficial nor seen as able to liberate them from social expectations; it offers only a sanctuary and momentary space for erotic freedom. They may return to their society with a sense of personal power and a strong creative urge, but they remain alienated from and powerless to change gender roles. Perhaps because cultural proscriptions against liberating female sexuality remain so strong, and because many Anglo writers have not yet returned to their own versions of powerful nature goddesses such as the American Indians' Changing Woman and the Chicanas' curandera, they are not yet able to speak as freely about the wilderness as can their counterparts.

Finally, important similarities exist across the cultures in women's statements about the landscapes they value in the Southwest. Women do not value the landscape for its evidence of human dominance, nor do they seek places in which they can play out the stereotypically masculine game of victory over the environment. Uninterested in leaving a highly individual mark upon a place, they do not overly esteem marks left by others. Although they appreciate different aspects of widely varying landscapes, depending on their cultural background, historical period, and class, on the whole they are remarkably flexible in their response. In part this responsiveness to the world springs from their interest in process over product. Rather than seeking to impose preconceptions on the landscape, they strive to let the subject reveal itself, their actions serving as a ritualistic communion or as a way of fulfilling responsibility to the environment. For the American Indian artist, collecting and molding natural materials is an important element of creation, perhaps a more significant part of artistry than the product. The fusion of body and earth in the constructions of Nancy Holt and Michelle Stuart is also a form of ritualistic communion with the landscape. Furthermore, by emphasizing the vernacular or ordinary in their art, women artists level the hierarchies commonly used to place value on one landscape over another. In this way they proffer visions of harmony in seemingly inharmonious environments. As Laura Gilpin reveals in her photographs of the Southwest, one does not have to concentrate on the heroic wilderness, ignoring centuries of human habitation, to celebrate the natural environment. For her the unique landscape of the Southwest appeared through, not in spite of, human tenancy.

Because they often have been tagged as culture carriers, women have been typecast as

the more conservative sex, resistant to the changing culture men create. This book reveals little evidence of such conservatism. Women artists and writers value change and adaptation as much as stasis and the finished product. Perhaps the best example of their approach to landscapes lies in the Navajo weaver's reluctance to enclose her pattern and, by extension, her mind in a rigid form. The art and literature we have studied almost always contains something similar to the mind's path found in Navajo weaving: Georgia O'Keeffe's regenerative bones, Michelle Stuart's earth-books mirroring the fragility of the landscape, Beverly Silva's brief cactus blooms, Nancy Holt's concrete constructions through which we view the rhythms of the solar system, Leslie Silko's modern Yellow Woman seeking one more opportunity to tell her story, all lead the viewer and reader to contemplate cyclical rather than linear and hierarchical visions of the landscape.

Women, as well as men, seek personal transformation through interaction with the landscape; unlike men, they base such transformation on a sense of vulnerability in the approach. If nothing else, this book should encourage a critical reexamination of the stereotype of women as essentially passive spectators, not themselves engaged in the heroic searches for meaning routinely carried on by men. Women, alienated from their culture, feel lost and seek renewal in the landscape; their search is based not on transcendance but on reciprocity, on personal vulnerability rather than heroic dominance. Nancy Newhall's celebration of the transforming powers of the desert provides a fine summation of women's experience in the Southwest landscape: "Noon in the desert is a vast blaze overhead and a hard glow below. You are shut in by vast distances of light. You walk in the focus of the sun's rays. You are clothed in sun; sun glows in your blood, until even your bones feel incandescent. . . . You feel in your body why the desert wears grey, and why it blooms with such vital brilliance."

# NOTES

*Introduction: Perspectives on Gender and Landscape*

We appreciate the comments of Susan Aiken, Charles Biebel, Nancy Mairs, and Pat Smith on an earlier version of this introduction.

1. Edna Brush Perkins, *The White Heart of Mojave: An Adventure with the Outdoors of the Desert* (New York: Boni and Liveright, 1922), 12–13.

2. Mary Austin, *Lost Borders* (New York: Harper Brothers, 1909), 10.

3. As is evident throughout the book, decisions concerning terminology referring to the various groups inhabiting the Southwest are problematic. In the introduction we use the terms that seem to be the most widely accepted. The most complex terminology is associated with identification of Hispanic, Mexican-American, and Chicana populations.

4. *The Interpretation of Ordinary Landscapes: Geographical Essays,* ed. Donald W. Meinig (New York: Oxford University Press, 1979), 1, identifies landscape as an ambiguous term.

5. These comments draw primarily on writing in contemporary cultural geography. Other meanings have prevailed in the past. See, e.g., Marvin W. Mikesell, "Landscape," in *Man, Space, and Environment,* ed. Paul W. English and Robert Mayfield (New York: Oxford University Press, 1972), 9–15.

6. Meinig, ed., *Interpretation of Ordinary Landscapes,* 2; Edward C. Relph, *Rational Landscapes and Humanistic Geography* (London: Croom Helm, 1981), 57.

7. Peirce Lewis, "Axioms for Reading the Landscape," in Meinig, ed., *Interpretation of Ordinary Landscapes,* 12; Relph, *Rational Landscapes.*

8. Philip Wagner, "Cultural Landscapes and Regions: Aspects of Communication," in English and Mayfield, eds., *Man, Space, and Environment,* 55–68; Carolyn Merchant, *The Death of Nature: Women, Ecology and the Scientific Revolution* (San Francisco: Harper and Row, 1980); William J. Mills, "Metaphorical Vision: Changes in Western Attitudes to the Environment," *Annals of the Association of American Geographers* 72, no. 2 (June 1982): 237–53; Relph, *Rational Landscapes;* and Patricia Clark Smith (in this volume).

9. Classic studies of response to the American landscape include Henry Nash Smith, *Virgin Land: The American West as Symbol and Myth* (New York: Vintage Books, 1950); Hans Huth, *Nature and the American* (Lincoln: University of Nebraska Press, 1957); and Roderick Nash, *Wilderness and the American Mind*, rev. ed. (New Haven: Yale University Press, 1982). Annette Kolodny, *The Lay of the Land: Metaphor as Experience and History in American Life and Letters* (Chapel Hill: University of North Carolina Press, 1975), modifies their interpretations. Peirce Lewis recently reviewed interpretation of the American cultural landscape in "Learning from Looking: Geographic and Other Writing about the American Cultural Landscape," *American Quarterly* 35, no. 3 (1983): 242–61. Other general studies of the American built landscape include David Lowenthal "The American Scene," *Geographical Review* 58, no. 1 (January 1968): 61–88; and John Stilgoe, *Common Landscape of America: 1580–1845* (New Haven: Yale University Press, 1982). Regional studies are exemplified in two collections on the Great Plains: B. W. Blouet and M. P. Lawson, *Images of the Plains: The Role of Human Nature in Settlement* (Lincoln: University of Nebraska Press, 1975); B. W. Blouet and F. G. Luebke, *The Great Plains: Environment and Culture* (Lincoln: University of Nebraska Press, 1979). In *Topophilia* (Englewood Cliffs, N.J.: Prentice-Hall, 1974), Yi-Fu Tuan engages in broad, cross-cultural interpretations. Historical studies tracing the evolution of world views of human relationships to nature and landscape include Clarence Glacken, *Traces on the Rhodian Shore: Nature and Culture in Western Thought from Ancient Times to the End of the Eighteenth Century* (Berkeley: University of California Press, 1967); Carolyn Merchant, *The Death of Nature: Women, Ecology, and the Scientific Revolution*; and Mills, "Metaphorical Vision."

10. Extensive reviews are provided by Thomas F. Saarinen and James L. Sell in "Environmental Perception," *Progress in Human Geography* 5, no. 4 (December 1981): 525–47, and by Thomas F. Saarinen, James L. Sell, and Eliza Husband, "Environmental Perception: International Efforts," *Progress in Human Geography* 6, no. 4 (December 1982): 515–46.

11. Yi-Fu Tuan reviews these factors in *Topophilia* and Lewis discusses studies illustrating various influences on the form of the cultural landscape in "Learning from Looking." Donald W. Meinig, "The Beholding Eye," in Meinig, ed., *Interpretation of Ordinary Landscapes*, 33–48, interprets ten different views of the same scene. Edmunds V. Bunksé, "Commoner Attitudes Towards Landscape and Nature," *Annals of the Association of American Geographers* 68, no. 4 (December 1978): 551–66, draws attention to the role of class in response to landscape. Christopher Mulvey, *Anglo-American Landscapes: A Study of Nineteenth-Century Anglo-American Travel Literature* (New York: Cambridge University Press, 1983), shows how education and cultural background shaped the work of nineteenth-century English travelers writing about the United States and of their American counterparts reacting to English landscapes previously envisioned in their reading of English literature.

12. For a more complete documentation of the issue, see Janice Monk, "Approaches to the Study of Women and Landscape," *Environmental Review* 8, no. 1 (Spring 1984): 23–33.

13. Tuan generalizes that the African Lele speak of the forest with almost poetic enthusiasm in contrast to their distaste for the hot dusty village of the grassland, but closer examination of his material reveals that Lele women, whose domain is the grassland, find the forest dark and vaguely threatening. *Topophilia*, 84–85.

14. Bunksé points out two fairly obvious examples demonstrating the interactions between class and gender in high culture: first, our ideas about the ancient Greeks' love of nature and the landscape tastes of the Romans are drawn from male bucolic poets; second, there are not many hints of women's views of nature in the Sanskrit epics. "Commoner Attitudes Towards Landscape and Nature."

15. J. Frank Dobie, *Coronado's Children: Tales of Lost Mines and Buried Treasures of the Southwest* (New York: Grosset and Dunlap, 1930), x–xi.

16. While there is an extensive literature on the Southwest alone, much commentary describes it as a subregion of the West and assumes that what is true of one subregion in the West is equally true of another. Thus Webb's Great Plains work includes portions of the Southwest. This

book treats the region as separate and distinct, but we also consider work encompassing the entire West when it is pertinent. On Turner's masculine bias and its effect on scholarship see Richard Jensen, "On Modernizing Frederick Jackson Turner: The Historiography of Regionalism," *The Western Historical Quarterly* 11, no. 3 (July 1980): 307–22. Walter Prescott Webb's review of the literature of the Great Plains argues that women have no role in the literature of cattle country, while the literature of the farm country depicts them as defeated and repelled by the region. *The Great Plains* (New York: Grosset and Dunlap, 1931), 463–73. Henry Nash Smith's *Virgin Land* is a classic study of the meaning of the frontier to the development of American culture. While Smith notes the popularization of the cowgirl image (insofar as she becomes like the cowboy) and cites the work of writers such as Caroline Kirkland, the story he tells is of the masculine dominance of nature, as Annette Kolodny has amply demonstrated in *The Lay of the Land*.

17. Larry McMurtry, *In a Narrow Grave: Essays on Texas* (Albuquerque: University of New Mexico Press, 1968), 44; McMurtry goes on to note that such "sexualizing" might be an error. Frederick W. Turner, *Beyond Geography: The Western Spirit Against the Wilderness* (New York: Viking, 1980), 299.

18. Webb, *Great Plains*, 8; Turner, *Beyond Geography*, 173. For a slightly different focus, see Carey McWilliams, *North from Mexico: The Spanish-speaking People of the United States* (New York: Greenwood Press, 1968), which argues that the Spaniards responded to the environment more appropriately than the Anglos.

19. Lawrence Clark Powell, *Southwest Classics: The Creative Literature of the Arid Lands* (Tucson: University of Arizona Press, 1974). Although Powell devotes considerable space to women in his book, he does not address the issue of gender other than to note the importance of wives to men's creative lives. See his comments on Rhodes, Grey, Krutch, Santee, La Farge, Dobie, and Lawrence. See also Patricia Nelson Limerick, *Desert Passages: Encounters with the American Deserts* (Albuquerque: University of New Mexico Press, 1985).

20. McMurtry, *In a Narrow Grave*, xv.

21. Distinctions between classic and counter-classic styles of regionalism are made by Richard Maxwell Brown, who notes that a predominant feature of the "new regionalism" is a tension between classic and counter-classic interpreters. "The New Regionalism in America, 1970–1981," in *Regionalism and the Pacific Northwest*, ed. W. G. Robbins, R. J. Frank, R. E. Ross (Corvallis: Oregon State University Press, 1983), 64. The issue of whether regionalism is de facto anachronistic in its focus has worried theorists. Carey McWilliams argued in 1930 that a regional approach was based on the need to find a "usable past." *The New Regionalism in American Literature* (Seattle: University of Washington, 1930), 35.

22. Gerald Nash, *The American West in the Twentieth Century: A Short History of an Urban Oasis* (Albuquerque: University of New Mexico Press, 1977); Carey McWilliams, *North from Mexico*, and *Southern California Country: An Island on the Land* (New York: Duell, Sloan and Pearce, 1946); *Plural Society in the Southwest*, ed. Edward Spicer and Raymond Thompson (New York: Interbook, 1972); J. B. Jackson, "Looking at New Mexico," in *The Essential Landscape: The New Mexico Photographic Survey*, ed. Steve A. Yates (Albuquerque: University of New Mexico Press, 1985), 8. For a good review of the changing focus in Western history see Jack August, "Recent Interpretations of the Twentieth Century West," paper given at the Western History Association meeting, October 14, 1983, Salt Lake City, Utah. For a view from the Northeast of the developing Southwest see Kirkpatrick Sale, *Powershift: The Rise of the Southern Rim and Its Challenge to the Eastern Establishment* (New York: Random House, 1976).

23. Most work on literature consists of annotated bibliography, plot summary, and some simple analysis. See J. F. Dobie, *A Guide to the Life and Literature of the Southwest* (Austin: University of Texas Press, 1943); T. M. Pearce and Mabel Major, *Southwest Heritage: A Literary History with Bibliographies*, 3d ed. (Albuquerque: University of New Mexico Press, 1972); Walter S. Campbell, *The Booklover's Southwest: A Guide to Good Reading* (Norman: University of Oklahoma Press, 1955); Lawrence Clark Powell, *Southwest Classics: The Creative Literature of the Arid Lands* (Tucson: University of Arizona Press, 1974). More recent works, offering more

sophisticated analysis, are limited to a single theme or a select group. See David Wyatt, *The Fall into Eden: Landscape and Imagination in California* (Cambridge: Cambridge University Press, 1986); Marta Weigle and Kyle Fiore, *Santa Fe and Taos: The Writers' Era, 1916–1941* (Santa Fe: Ancient City Press, 1982); and Cecil Robinson, *Mexico and the Hispanic Southwest in American Literature* (Tucson: University of Arizona Press, 1977). Art history has likewise been limited to the Anglos, with only a few good cross-cultural studies. See Van Deren Coke, *Taos and Santa Fe: The Artist's Environment, 1882–1942* (Albuquerque: University of New Mexico Press, 1963), and *Photography in New Mexico: From Daguerreotype to the Present* (Albuquerque: University of New Mexico Press, 1979); J. J. Brody, *Indian Painters and White Patrons* (Albuquerque: University of New Mexico Press, 1971); Dorothy Dutton, *American Indian Painting of the Southwest and Plains Areas* (Albuquerque: University of New Mexico Press, 1968); Jacinto Quirarte, *Mexican-American Artists* (Austin: University of Texas Press, 1973). Work on craft art forms is extensive. See Bertha Dutton, *Navaho Weaving Today* (Santa Fe: Museum of New Mexico Press, 1963); Anthony Berlant and Mary Hunt Kahlenberg, *The Navaho Blanket* (New York: Praeger, 1972); *Hispanic Arts and Ethnohistory in the Southwest: New Papers Inspired by the Work of E. Boyd*, ed. Marta Weigle, Claudia Larcombe, and Samuel Larcombe, (Santa Fe: Ancient City Press, 1983). Finally, there are studies of the dialectics of cultural interaction and artistic change, which do not fit into any category but offer new paradigms for addressing how art and craft forms reflect changing culture. See Ronald Grimes, *Symbol and Conquest: Public Ritual and Drama in Santa Fe, New Mexico* (Ithaca: Cornell University Press, 1976); and Charles Briggs, *The Woodcarvers of Cordova, New Mexico: Social Dimensions of an Artistic "Revival"* (Knoxville: University of Tennessee Press, 1980).

24. McMurtry, *In a Narrow Grave*, 55–75. For an example of McMurtry's sensitive portrayal of women see *Leaving Cheyenne* (New York: Harper and Row, 1963). William Pilkington praises McMurtry for recognizing that studies of the Southwest have not considered sexual meanings deeply enough. At the conclusion to *My Blood's Country*, Pilkington offers Jean Stafford's *The Mountain Lion* as a harbinger of the future of southwestern novels, because the book encourages a movement away from the innocent past and into the mature, urban future of the region. But he ignores Stafford's radical critique of both the masculine dominance of the environment and the restricted roles of women. *My Blood's Country: Studies in Southwestern Literature* (Fort Worth: Texas Christian University Press, 1973), 188, 191–97. See also Dobie's observation that pioneer women in the chronicles seem desexed (ibid., 188), and Webb's placement of women's response to the Great Plains in a section entitled "Great Mysteries" (*Great Plains*, 505–07).

25. Beverly J. Stoeltje, "A Helpmate for Man Indeed: The Image of the Frontier Woman," *Journal of American Folklore* 88, no. 347 (January–March 1975): 27–31; Annette Atkins, "Women on the Farming Frontier: The View from Fiction," *The Midwest Review*, 2d ser. 3 (Spring 1981): 1–11. Franklin Walker, *A Literary History of Southern California* (Berkeley: University of California Press, 1950), not only includes women's writing throughout his study but also discusses the importance of the feminist movement to the increasing numbers and popularity of women writers in the region at the turn of the century (164–65).

26. Nancy Chodorow, *The Reproduction of Mothering: Psychoanalysis and the Sociology of Gender* (Berkeley: University of California Press, 1978); Dorothy Dinnerstein, *The Mermaid and the Minotaur: Sexual Arrangements and Human Malaise* (New York: Harper and Row, 1976); Carol Gilligan, *In a Different Voice: Psychological Theory and Women's Development* (Cambridge: Harvard University Press, 1982); Carolyn Merchant, "Earthcare: Women and the Environment," *Environment* 23, no. 5 (June 1981): 6–13, 38–40.

27. Susan Saegert, "Masculine Cities and Feminine Suburbs: Polarized Ideas and Contradictory Realities," *Signs* 5, no. 3, suppl. (Spring 1980): S96–S111; William Michelson, *Environmental Choice, Human Behavior, and Residential Satisfaction* (New York: Oxford University Press, 1977); D. N. Rothblatt, D. J. Garr, and J. Sprague, *The Suburban Environment and Women* (New York: Praeger, 1979); Dolores Hayden, *The Grand Domestic Revolution: A History of Feminist Designs for American Homes, Neighborhoods and Cities* (Cambridge: MIT Press, 1981).

28. Catharine Stimpson provides a brief review of this issue in "Where Does Integration Fit? The Development of Women's Studies," in *Toward a Balanced Curriculum: A Sourcebook for Initiating Gender Integration Projects,* ed. Bonnie Spanier, Alexander Bloom, and Darlene Boroviak (Cambridge: Schenkman, 1984), 18.

29. Julie Roy Jeffrey, *Frontier Women: The Trans-Mississippi West, 1840–1860* (New York: Hill and Wang, 1979); Lillian Schlissel, *Women's Diaries of the Westward Journey* (New York: Schocken Books, 1982). Johnny Faragher and Christine Stansell, "Women and Their Families on the Overland Trail, 1842–1867," *Feminist Studies* 2, nos. 2–3 (1975): 150–66, make a similar case. Sandra Myres argues against the maintenance of the Eastern traditions of domesticity in *Westering Women and the Frontier Experience: 1800–1915* (Albuquerque: University of New Mexico Press, 1982). See also Glenda Riley, *Women on the American Frontier* (St. Louis: Forum Press, 1977).

30. Schlissel, *Women's Diaries,* 53.

31. Annette Kolodny, *The Land before Her: Fantasy and Experience of the American Frontiers, 1630–1860* (Chapel Hill: University of North Carolina Press, 1984). Carol Fairbanks' work on prairie women provides more of an intellectual history than a study of landscape perception. *Prairie Women: Images in Canadian and American Fiction* (New Haven: Yale University Press, 1986).

32. The classic essay delineating gaps in research on women's lives in the West is Joan Jensen and Darlis Miller, "The Gentle Tamers Revisited: New Approaches to the History of Women in the American West," *Pacific Historical Review* 49, no. 2 (May 1980): 173–213. Jensen and Miller argue the need for a multi-cultural study of women. Miller's "Cross-cultural Marriages in the Southwest: The New Mexico Experience, 1846–1900," *The New Mexico Historical Review* 57, no. 4 (October 1982): 335–61, is exemplary. Other works that take a cross-cultural perspective on women's lives include Gretchen Bataille, "Transformation of Tradition: Autobiographical Works by American Indian Women," in *Studies in American Indian Literature: Critical Essays and Course Designs,* ed. Paula Gunn Allen (New York: Modern Language Association, 1983), 89–91; Maxine Baca Zinn, "Gender and Ethnic Identity Among Chicanos," *Frontiers* 5, no. 2 (1980): 18–24; and Glenda Riley, *Women and Indians on the Frontier, 1825–1915* (Albuquerque: University of New Mexico Press, 1984).

33. Jensen and Miller, "Gentle Tamers," 176.

34. Donald Meinig, *Southwest: Three Peoples in Geographical Change, 1600–1970* (New York: Oxford University Press, 1971), 3.

35. Leslie Silko, *Ceremony* (New York: Viking, 1977).

36. Meinig, *Southwest,* 7.

37. Joy Harjo, "3 AM," in *Southwest: A Contemporary Anthology,* ed. Karl Kopp and Jane Kopp (Albuquerque: Red Earth Press, 1977), 173.

38. Pat Mora, *Chants* (Houston: Arte Publico Press, 1984), 8.

*1. Re-Naming the Land: Anglo Expatriate Women in the Southwest*

Adrienne Rich, "When We Dead Awaken," *On Lies, Secrets, and Silence,* (New York: Norton, 1979), 35.

1. See Richard H. Frost, "The Romantic Inflation of Pueblo Culture," *The American West* 17, no. 1 (January–February 1980). Adolph Bandelier spent much of the last two decades of the nineteenth century exploring, studying, and describing Pueblo culture. His best-known work, *The Delight Makers* (1890), is a fictionalized account of prehistoric Pueblo society. Though he sometimes views his characters as less culturally advanced than the Anglo society he represents, Bandelier is unusual for his time in treating Indians "as if they were real (that is, white) people struggling in a muddled social world rather than mythical creatures grazing in a long-extinct forest." (Stefan Jovanovich, Preface to *The Delight Makers* (repr. New York: Harcourt Brace

Jovanovich, 1971). Richard Frost calls Hewitt "the leading institutional impressario of the Pueblo mystique." An archaeologist and educator, he founded and directed the School of American Archaeology, established in Santa Fe in 1907. In a variety of other ways, he did much to support, publicize, and promote Pueblo culture, particularly in the West. Charles Lummis' *The Land of Poco Tiempo* (Albuquerque: University of New Mexico Press, 1952), falls within the quaint and picturesque school of regional writing and he tends to emphasize the remote and exotic qualities of the natural and cultural landscape. He wrote eight books on the region between 1891 and 1900. Lummis was Mary Austin's first important mentor. See Augusta Fink, *I-Mary: A Biography of Mary Austin* (Tucson: University of Arizona Press, 1983).

2. In spite of Thoreau's and Muir's scientific interests and acute observations, Nature was most important to them as a mediator. Thoreau saw it as a way to explore the vast "inner geography" of mind and spirit; for Muir, it was a means of access to a supercharged divine light that offered incomparable spiritual refreshment.

Walt Whitman prophesied about the future of the Southwest in terms that anticipated the work of these three women writers. Asked to submit a poem for the occasion of Santa Fe's 333d anniversary, he wrote instead a letter to the town fathers that was filled with the signs of promise that he glimpsed in the future of the Southwest. "We Americans," he informed them, "have yet to really learn our own antecedents. . . . Thus far, impressed by New England writers and schoolmasters, we tacitly abandon ourselves to the notion that our United States have been fashioned from the British Isles. . . . Many leading traits for our future national personality, and some of our best ones, will certainly prove to have originated from other than British stock." Whitman named the "aboriginal Indian" and the "Spanish stock" as two sources that had much to contribute to the growth and development of American culture. Walt Whitman to Messrs. Griffin, Martinez, Prince and Other Gentlemen at Santa Fe, 20 July 1883, in James Kraft and Helen Sloan, *John Sloan in Santa Fe* (Washington, D.C.: Smithsonian, 1981), 19–20.

Michael Castro, *Interpreting the Indian: Twentieth-century Poets and the Native American* (Albuquerque: University of New Mexico Press, 1983), notes that Whitman was the first American writer to break away from the tradition of the brutal/noble savage. Those who followed him found in Native American cultures a "vital resource" that could renew "an insecure American cultural identity . . . connect us to the spirit of the land we inhabit . . . and open us to aspects of ourselves that define our full human identity" (xvii–xviii).

3. Cecilia Tichi, *New World, New Earth: Environmental Reform in American Literature from the Puritans Through Whitman* (New Haven: Yale University Press, 1979), 251–52.

4. Annette Kolodny, *The Land before Her: Fantasy and Experience of the American Frontiers, 1630–1860* (Chapel Hill: University of North Carolina Press, 1984), xiii. Roderick Nash points out in *Wilderness and the American Mind* (New Haven: Yale University Press, 1967) that "for most of their history, Americans regarded the wilderness as a moral and physical wasteland fit only for conquest and fructification in the name of progress, civilization and Christianity" (vii).

5. Alice Corbin Henderson, ed., *The Turquoise Trail, An Anthology of New Mexico Poetry* (Boston: Houghton Mifflin, 1928), xi. Henderson's terminology will be familiar to those aware of the Anglo masculine symbol of the western frontier as a place for personal freedom and escape from civilization. See Henry Nash Smith, *Virgin Land: The American West as Symbol and Myth* (New York: Random House, 1950); and Richard Slotkin, *Regeneration through Violence: The Mythology of the American Frontier, 1600–1860* (Middletown: Wesleyan University Press, 1973). For Henderson, Luhan, and Austin, however, these terms are charged with very different connotative values.

In *Wilderness*, Nash notes the shift in attitudes toward the wilderness in the nineteenth century from a place of moral disorder, confusion, and threat to human life to the view expressed here that became one of the foundations of the preservation movement. In the late nineteenth century, epithets once used to describe wilderness began to be applied to the city, as a place of alienation, savagery, and moral decay.

6. Alice Corbin, "Daphne," *The Spinning Woman of the Sky* (Chicago: Ralph Seymour,

1912), 49. (Henderson used her maiden name when she wrote poetry, her married name when she wrote prose.) See Kyle Fiore, "Alice Corbin: New Mexico Woman Poet," in *Southwest Images and Trends: Factors in Community Development,* ed. Susan Owings and Helen Bannan (Las Cruces: University of New Mexico Cooperative Extension Service, 1979), 171–83, for a discussion of Henderson's early interest in ethnic literature and her struggles to balance her work as a poet with her responsibilities as wife and mother.

7. Alice Corbin, "A Litany in the Desert," *Yale Review* 7, no. 3 (April 1918): 612. This poem also makes explicit the anti-urban, anti-immigration bias the three women shared. Henderson speaks, for example, of the "fierce melting-pots of cities." Austin was anti-Semitic and, along with Luhan, had little sympathy for or interest in Afro-American culture (which was not true of Henderson). For discussion of postwar "expatriation" in the Southwest, see Lois Rudnick, "Mabel Dodge Luhan and the Myth of the Southwest," *Southwest Review* 68, no. 3 (Summer 1983): 205–21. For discussion of the growth of Santa Fe and Taos as cultural meccas for Anglo artists see Kay Aiken Reeve, *Santa Fe and Taos, 1898–1942: An American Cultural Center,* Southwestern Studies, no. 67 (El Paso: Texas Western Press, 1982).

8. T. M. Pearce, *Alice Henderson: A New Voice in Poetry,* Southwest Writers' Series, no. 21 (Austin: Steck-Vaughn, 1969), 20. In her essay on New Mexican literature for the Federal Writers' Project, *New Mexico: A Guide to the Colorful State* (New York: Hastings House, 1940), Henderson wrote that "the soil itself has the power of re-creating the imaginative vision of the newcomers" (135).

9. Alice Corbin, Untitled, *Red Earth: Poems of New Mexico* (Chicago: Ralph Seymour, 1920), 3. (Hereafter cited in text as *RE.*) Note the rejection of the Whitmanesque view of the city.

10. See Robert Frost, "The Gift Outright," *Complete Poems of Robert Frost* (New York: Holt, Rinehart and Winston, 1964), 467.

11. Henderson's choice of the ballad form is probably related to her interest in folk forms. Henderson's daughter, Alice Rossin, informed me that the poem was about her father's trip. William Penhallow Henderson was a painter and architect who founded the Pueblo-Spanish Building Company in Santa Fe. He built private adobe houses, restored historic public buildings, and designed the Museum of Navajo Ceremonial Arts.

12. Alice Corbin, "Song of Sunlight," *Poetry* 13, no. 4 (January 1919): 199.

13. Alice Corbin, "Prayer-Wands," *Turquoise Trail,* 29–31.

14. Mabel Dodge Luhan, *Edge of Taos Desert: An Escape to Reality* (New York: Harcourt, Brace, 1937), 6. (Hereafter cited in text as *ETD.*) For biographical information, see Lois Rudnick, *Mabel Dodge Luhan: New Woman, New Worlds* (Albuquerque: University of New Mexico Press, 1984).

15. Mabel Dodge Luhan, *Winter in Taos* (New York: Harcourt, Brace, 1935). (Hereafter cited in text as *WT.*)

16. Fink, *I-Mary,* 79. Fink points out that in 1885, Austin's first Indian teacher told her of the abuses of Indian women by white men, which fired her advocacy of Native American rights. Austin's hit Broadway play, *The Arrow-Maker* (1911), features a Paiute medicine woman who is empowered with prophetic and healing powers but gives them up in her love for a warrior who later betrays her. Austin's unresolved tension between her commitment to her craft and her yearning for a lover and children (she had one severely retarded child) are expressed by the *chisera,* who is unhappy with her separateness and celibacy. Austin was never able to establish a satisfactory relationship with a male lover.

17. Mary Austin, *The Land of Little Rain* (repr. Albuquerque: University of New Mexico Press, 1974), xvi. (Hereafter cited in text as *LLR.*) In *The Land of Journey's Ending* (repr. Tucson: University of Arizona Press, 1983), Austin informs us that we cannot know New Mexico and Arizona without knowing their "native nomenclature." She provides a glossary for the over eight hundred Spanish words she uses throughout the text. (Hereafter cited in text as *LJE.*)

18. Tinnemaha, a Paiute medicine man, taught Austin a kind of prayer and meditation that provided access to a form of spiritual energy he called "the friend of the soul of man," which could

cure sickness and expand consciousness. See Fink, *I-Mary,* 87. Mary Austin to D. T. MacDougal, 2 January 1922, in ibid., 202.

19. Austin talks about her "pattern-hungry mind" in her autobiography, *Earth Horizon* (Boston: Houghton Mifflin, 1932), 349. (Hereafter noted in text as *EH.*) Austin, *The Flock* (Boston: Houghton Mifflin, 1906), 94; Austin, *California: Land of the Sun* (New York: Macmillan, 1914), 9. (Hereafter cited in text as *C.*)

20. Mabel Luhan noted that Austin always wrote autobiographically, "even when she wrote of rivers and desert." Luhan, "Mary Austin, A Woman," MS, Luhan collection, Beinecke Library, Yale.

21. Mary Austin, *Lost Borders* (New York: Harper and Bros., 1909), 10. (Hereafter cited in text as *LB.*) See Vera Norwood, "The Photographer and the Naturalist: Laura Gilpin and Mary Austin in the Southwest," *Journal of American Culture* 5 (Winter 1982): 1–27. I am indebted to Norwood for the concepts she develops in this article on Austin's views of the female landscape.

22. Austin sometimes resorts to traditional "virgin land" imagery, but she usually resents the land's conquest. For Austin's ambivalence about the development of the West, see Dudley Wynn, "A Critical Study of the Writings of Mary Hunter Austin" (Ph.D. diss., New York University, Graduate School of Arts and Sciences, 1941). This is the best (although overly critical) full-length study of Austin's ideas as a writer and a social reformer. Austin fought the draining of water resources, first from Owens Valley, California, during the 1880s, and later as a delegate to the Boulder Dam Conference in the 1920s, where she argued against the diversion of the Colorado River to supply water to Los Angeles.

23. Nancy Newhall confirmed Austin's prophecy when she wrote that her "impress lies across the whole Southwest. Whoever travels there will find her moving before him—will see a hill move suddenly into the shape of words she gave it, enter with her, through the flicker of saguaros, into the uncanny spell of the desert, hear with her ears the click and patter of aspen leaves." "Mary Austin's Country," *Arizona Highways,* April 1968, 2–9.

24. See Castro, *Interpreting the Indian,* chap. 1, for discussion of early Anglo translators and interpreters of Native American poetry, including Alice Henderson and Mary Austin. Castro points out that they used considerable license in "seeking to capture . . . the hidden meanings and spirit of the originals," and that they thus often lost or distorted the unique cultural assumptions and meanings of tribal imagery. Nevertheless, their writing is permeated with concepts and images of the land that are central to southwestern Native American views. As Paula Gunn Allen writes, in "INYANI: It Goes This Way," *The Remembered Earth: An Anthology of Contemporary Native American Literature,* ed. Geary Hobson (Albuquerque: University of New Mexico Press, 1979), 191–93: "We are the land. To the best of my understanding, that is the fundamental idea embedded in Native American life and culture in the Southwest. More than remembered, the Earth is the mind of the people as we are the mind of the earth. The land is not really the place (separate from ourselves) where we act out the drama of our isolate destinies. . . . It is not the ever-present 'Other' which supplies us with a sense of 'I.' It is rather a part of our being, dynamic, significant, real. . . . It is within this larger being that we are given life . . . that we eat, that we plant, that we harvest, that we build and clean, that we dance, hunt, run, heal, sing, chant and write."

25. Organic metaphors abound in Luhan's description of her relationship with Tony, unlike the electromechanical metaphors that proliferate in her descriptions of previous love affairs.

26. See Luhan, "A Bridge between Cultures," *Theatre Arts Monthly* 9, no. 5 (1925): 297–301, for her discussion of the possibility of building an alliance between Anglo and Pueblo cultures in the Southwest.

27. See *The Land before Her,* where Kolodny describes the domestic fictionalists of the mid-nineteenth century who wrote about an "idealized west to point up the short-comings of a corrupt and corrupting east," and who envisioned a "prairie paradise, generously supporting an extended human family at the center of which stood a reunited Adam and Eve" (9).

28. Mary Austin, *Taos Pueblo* (Boston: New York Graphic Society, 1977). Austin's theory of

village socialism was offered as an alternative to European imports. See "The Indivisible Utility," *Survey Graphic,* 15 December 1925. Austin argues that the natural factors of land and climate in the Southwest have created communities with the kind of environmental awareness, broad social vision, and economic equality that "would fill the self-constituted prophets of all Utopias with unmixed satisfaction." Although she warns against the inertia that has hindered necessary improvements in health care and technology in the Hispanic and Pueblo communities, she concludes her article: "Here, not in the cafés of Prague or the cellars of Leningrad, is the stilly turning wheel on which the fair new shape of society is molded."

29. See Austin, "Understanding America through Her Literature," pt. 2, "Fiction of Home and Business Life," MS, Austin collection, Huntington Library, San Marino, California. Austin lectured on "American Literature as an Expression of American Experience," on 8 January, 1922, before the National Arts Club in New York, where she was being honored by writers and critics from around the country. See Fink, *I-Mary,* 203.

30. Austin especially was subject to confused and often self-contradictory racial typecasting. She believed blacks were culturally inferior, argued against mixing of the races, and admired the "pure" strains of the three cultures that dominated the Southwest, attributing "earthiness" to Hispanics and "drive" to Anglos. Yet she also implies that a "new race" (presumably a superior one) would be formed from the "engrafting" of the Anglo onto the Hispanic and Indian (*LJE,* 442–47).

31. Henderson, "Too Far from Paris," *Poetry* 4, no. 1 (April 1914): 105–11; "Poetry of the American Negro," *Poetry* 10, no. 3 (June 1917): 158–60. *The Path on the Rainbow: An Anthology of Songs and Chants from the Indians of North America,* ed. George Cronyn (New York: Liveright, 1918).

32. Henderson, "In Texas and New Mexico," *Poetry* 14, no. 4 (September 1920): 324–28.

33. Henderson, Introduction to *The Turquoise Trail.* Tributes to her community spirit and fellowship with other poets can be found in "Alice Corbin Henderson: An Appreciation," a special section of the *New Mexico Quarterly Review* 19, no. 1 (Spring 1949): 34–79. The Anglo male expatriates that Henderson, Luhan, and Austin brought to New Mexico shared the women's vision of the land and native peoples, as can be seen from a reading of *The Turquoise Trail.* The most significant differences between male and female writers are that the women were primarily responsible for generating the cultural renaissance that took place in Santa Fe and Taos in the 1920s and 1930s and produced much of the best writing. While D. H. Lawrence is certainly the best known and widely read of the writers who sojourned there, his views of the land and the Indians were as full of fear and loathing as they were of appreciation and admiration. See Lois Rudnick, "D. H. Lawrence's New World Heroine: Mabel Dodge Luhan," *The D. H. Lawrence Review* 14, no. 1 (Spring 1981): 85–111.

34. Alice Henderson, *Brothers of Light: The Penitentes of the Southwest* (New York: Harcourt, Brace, 1937), 49. Henderson also began a history of New Mexico, which she never completed. In her introduction, she explained that where most American history was written East to West, she would reverse the procedure. She took a multi-disciplinary approach with intended sections on geology, archaeology, architecture, demography, and ethnic cultures.

35. For the genesis of Luhan's "new world plan," see Rudnick, *Mabel Dodge Luhan,* 175–82.

36. Luhan to Austin, 22 December 1922(?), in *Literary America, 1903–1934: The Mary Austin Letters,* ed. T. M. Pearce (Westport, Conn.: Greenwood Press, 1979), 171.

37. Smith, "The Feel of the Purposeful Earth: Mary Austin's Prophecy," *New Mexico Quarterly Review* 1, no. 1 (February 1931): 17–33. Austin, *The Trail Book* (Boston: Houghton Mifflin, 1918).

38. Castro, *Interpreting,* points out that Austin was "the central figure in the movement to bring Indian poetry to non-Indian Americans" (5).

39. Austin, Introduction to *Path on the Rainbow; The American Rhythm* (New York: Harcourt, Brace, 1923).

40. Briggs, *Woodcarvers,* 50. Briggs also points out that the Anglo patrons promoted the sale

for secular use of goods that originally had sacred and communal functions, and they encouraged competition among Hispanic artists who had traditionally worked anonymously. The same criticism could be made of their treatment of Indian artists and artisans. Brody, *Indian Painters,* is very critical of Anglo patronage of Indian painters. Discussing the mixed blessing of their support, he writes, "The products were made for and purchased by Whites, but they were produced by Indians, mostly for financial gain but also with pride in the skill that produced them. It was necessary for Whites, and possibly also for the Indians, to romanticize the new and revived arts by supplying them with a history, making them 'authentic' and therefore 'true aboriginal art.' Just as the craft revival produced several exceptional artists and many exceptional works . . . so the new art of painting produced several fine artists and a large body of uniquely Indian pictures. These were a curious blend of White reconceptions of what Indian painting should be and the efforts of Indians to shift their aesthetic sights in response to White desires" (117). Briggs notes that the prehistoric and colonial patterns and designs encouraged during this period have become increasingly important to contemporary Hispanic and Indian artists, who have now asserted hegemony over their own cultural forms.

41. See Lawrence C. Kelly, *The Assault on Assimilation: John Collier and the Origins of Indian Policy Reform* (Albuquerque: University of New Mexico Press, 1983). See also J. J. Brody, *Indian Painters and White Patrons* (Albuquerque: University of New Mexico Press, 1971); and Charles L. Briggs, *The Woodcarvers of Córdova, New Mexico: Social Dimensions of an Artistic "Revival"* (Knoxville: University of Tennessee Press, 1980).

42. Ronald L. Grimes, *Symbol and Conquest: Public Ritual and Drama In Santa Fe, New Mexico* (Ithaca: Cornell University Press, 1976), 34.

43. Annette Kolodny, Commentary on "Interpretations of Landscape," panel presented at the American Studies Association Ninth Biennial Convention, Philadelphia, Penn., 6 November 1983.

44. Austin, "The Indivisible Utility," 305, 327. Earlier in the century, William E. Smythe, in his *The Conquest of Arid America* (1900), conceptualized regional politics in similar terms. Kevin Starr, who calls him the most articulate proponent of the reclamation movement, notes that Smythe saw irrigation and the subdivision of arid land as bound up with "the redemption of the Far West" as well as with America's destiny as a nation. "The cooperation necessary for large-scale enterprise would, Smythe hoped, result in the moral reinvigoration of capital, labor, and government." *Californians and the American Dream* (New York: Oxford University Press, 1973), 203. On contemporary bioregional thinking, see Kirkpatrick Sale, "Bioregional Green," *The Nation,* 16 June 1984, 724–25.

## 2. Desert, Rock, Shelter, Legend: Willa Cather's Novels of the Southwest

1. Eleanor Munro, *Originals: American Women Artists* (New York: Simon and Schuster, 1979), 78.

2. Ibid., 90–91.

3. Georgia O'Keeffe, *Georgia O'Keeffe* (New York: Viking, 1976), #74, *Pelvis III* (1944), reprinted from *An American Place* (1944) [exhibition catalog].

4. Dorothy Eggan, "Hopi Dreams in Cultural Perspective," in *The Dream and Human Societies,* ed. Grunebaum and Callais, cited in Yi-Fu Tuan, *Topophilia: A Study of Environmental Perceptions, Attitudes, and Values* (Englewood Cliffs, N.J.: Prentice-Hall, 1974), 61. Emphasis original.

5. Cf. Kent C. Bloomer and Charles W. Moore's discussion of the importance of *haptic* perception in relation to architectural form in *Body, Memory, and Architecture* (New Haven: Yale University Press, 1977): "To sense haptically is to experience objects in the environment by actually touching them (by climbing a mountain rather than staring at it). Treated as a perceptual system the haptic incorporates all those sensations (pressure, warmth, cold, pain, and ki-

nesthetics) which previously divided up the sense of touch, and thus it includes all those aspects of sensual detection which involve physical contact both inside and outside the body" (34).

6. Gaston Bachelard defines "felicitous space" as that which "concentrates being within limits that protect," and also as that which is vast, opening up unlimited space, or what he calls "intimate immensity." *The Poetics of Space,* trans. Maria Jolas (Boston: Beacon, 1969), xxxii, 183–210.

7. Tuan, *Topophilia,* 51.

8. Willa Cather, *Death Comes for the Archbishop* (New York: Knopf, 1927), 276–77.

9. Willa Cather, *The Song of the Lark* (Boston: Houghton Mifflin, 1915; repr. Lincoln: University of Nebraska Press, 1978), 304.

10. This phrase recurs throughout Cather's writings, for example, when Thea Kronborg understands "the thing that old Dumas meant when he told the Romanticists that to make a drama he needed but one passion and four walls." See Bernice Slote, ed., *The Kingdom of Art: Willa Cather's First Principles and Critical Statements, 1893–1896* (Lincoln: University of Nebraska Press, 1966), 249; William M. Curtin, ed., *The World and the Parish: Willa Cather's Articles and Reviews, 1893–1902,* 2 vols. (Lincoln: University of Nebraska Press, 1970), 1:479, 2:848; Willa Cather, *Not under Forty* (New York: Knopf, 1936), 51.

11. "I find that I have painted my life—things happening in my life—without knowing," wrote Georgia O'Keeffe. "After painting the shell and the shingle many times, I did a misty landscape of the mountain . . . and the mountain became the shape of the shingle—the mountain I saw out my window, the shingle on the table in my room. I did not notice that they were alike for a long time after they were painted." *Georgia O'Keeffe, #52, Shell and Old Shingle VII (Last of Shell and Old Shingle Series),* (1926).

12. This activity, Bachelard suggests, belongs to the phenomenology of the verb "to inhabit": only those who curl up can *inhabit* with intensity. *Poetics of Space,* xxxiv. The old German word for "to build" was *buan* [*sic*], which also means "to dwell," Heidegger reminds us, "that is, to stay, to remain. . . . The word 'bin' (am) came from the old word to build, so that 'I am', 'you are' means: I dwell, you dwell. The way that you are and I am . . . is 'Buan' [*sic*], dwelling. . . . Dwelling is the basic principle of existence." Cited in Christian Norberg-Schulz, *Existence, Space, and Architecture* (London: Studio Vista, 1971), 31.

13. "Passions simmer and re-simmer in solitude," Gaston Bachelard writes. "The passionate being prepares his explosions and his exploits in solitude . . . [and] knows instinctively that this space identified with his solitude is creative; that even when it is forever expunged from the present, when, henceforth, it is alien to all the promises of the future, even when we no longer have a garret, when the attic room is lost and gone, there remains the fact that we once loved a garret, once lived in an attic. We return to them in our night dreams. These retreats have the value of a shell. And when we reach the very end of the labyrinths of sleep . . . we may perhaps experience a type of repose that is pre-human . . . immemorial . . . in the daydream . . . the recollection of moments of confined, simple, shut-in space are experiences of heartwarming space, of a space that . . . would like above all still to be possessed. In the past, the attic may have seemed too small, it may have seemed cold in winter and hot in summer. Now, however, in memory recaptured through daydreams . . . the attic is at once small and large, warm and cool, always comforting." *Poetics of Space,* 9–10.

14. Ibid., 6, 33. Emphasis original. All really inhabited space bears the essence of the notion of home, Bachelard writes. We comfort ourselves by reliving memories of protection, by recapturing an image that moves us at an unimaginable depth. This is the chief benefit of the house: it shelters daydreaming, it protects the dreamer, it allows one to dream in peace.

15. Munro, *Originals,* 91.

16. Ibid., 57, 472. Munro's speculations are based on a study of the works of twentieth-century American women artists, beginning with Mary Cassatt. For a radical feminist perspective on the relationship of women to nature see Susan Griffin, *Woman and Nature: The Roaring inside*

*Her* (New York: Harper and Row, 1978); and Mary Daly, *Gyn/Ecology: The Metaethics of Radical Feminism* (Boston: Beacon, 1978); for the viewpoint of an environmental scientist see Carolyn Merchant, *The Death of Nature: Women, Ecology, and the Scientific Revolution* (New York: Harper and Row, 1980); for the connection of women's artistic expression to primal sources see Lucy Lippard, *Overlay: Contemporary Art and the Art of Prehistory* (New York: Pantheon, 1983).

17. Ellen Moers, *Literary Women* (Garden City, N.Y.: Doubleday, 1976), 258.

18. To proclaim the body, Hélène Cixous writes in "The Laugh of the Medusa," is to invent new texts, new forms: "I have been amazed more than once by a description a woman gave me of a world all her own which she had been secretly haunting since early childhood. A world of searching, the elaboration of a knowledge, on the basis of a systematic experimentation with the bodily functions, a passionate and precise interrogation of her erotogeneity. This practice, extraordinarily rich and inventive . . . is prolonged or accompanied by a production of forms, a veritable aesthetic activity, each stage of rapture inscribing a resonant vision, a composition, something beautiful. . . . I wished that that woman would write and proclaim this unique empire so that other women, other unacknowledged sovereigns, might exclaim: I, too, overflow; my desires have invented new desires, my body knows unheard-of songs. Time and again, I, too, have felt so full of luminous torrents that I could burst—burst with forms much more beautiful than those which are put up in frames." "The Laugh of the Medusa," trans. Keith Cohen and Paula Cohen, *Signs* (Summer 1976); repr. in *New French Feminisms, ed. Elaine Marks and Isabelle de Courtivron (Amherst: University of Massachusetts Press, 1980), 246.*

19. *News Letter*, 12 December 1938, in Stephen Tennant, ed., *Willa Cather on Writing* (New York: Knopf, 1949), 30–32. According to Cather's friend Elizabeth Shepley Sergeant, the classical sonata form was meant literally: "There were to be three parts, every one with Italian musical nomenclature," the first *molto moderato,* "Tom Outland's Story" *molto appassionato. Willa Cather: A Memoir* (1953, repr. Lincoln: University of Nebraska Press, 1963), 203–04.

20. Wetherill displayed some of these artifacts in a booth at the World's Columbian Exposition. Had Cather gone to Chicago in 1893, she might have first seen the Indian pottery in a setting far different from the Southwest!

21. Cather *Not under Forty,* v. In her war novel, *One of Ours,* written between *My Ántonia* and *The Professor's House,* the description of the returned heroes suggests the deep pessimism she felt at that time: "One by one the heroes of that war, the men of dazzling soldiership, leave prematurely the world they have come back to. Airmen whose deeds were tales of wonder, officers whose names made the blood of youth beat faster, survivors of incredible dangers,—one by one they quietly die by their own hand. Some do it in obscure lodging houses, some in their office, where they seemed to be carrying on their business like other men. Some slip over a vessel's side and disappear into the sea." *One of Ours* (New York: Knopf, 1922), 458.

22. E. K. Brown, *Willa Cather,* completed by Leon Edel (New York: Knopf, 1953), 236.

23. In *My Mortal Enemy,* Cather's *novel démeublé* in extremis, there is no plot, no action, only Myra Henshawe dying in a rented room, the passion she once felt for her husband now turned inward and focused upon her mortal enemy, time.

24. E. Relph, *Rational Landscapes and Humanistic Geography* (London: Croom Helm, 1981), 24. Emphasis original.

25. *Landscape* entered the English language in the last years of the sixteenth century along with Dutch scenery, or *landschap,* in painting. By *landschap* the Dutch understood "the traditional territorial *landschaft,* the houses surrounded by common fields and encircled by wildernesses of ocean or swamps. The English garbled the meaning, however, and *landschap* entered the language as *landskip* and meant at first only the Dutch paintings." By 1630, the word, now spelled *landscape,* had come to mean large-scale rural vistas, ornamental gardens objectifying ideals of beauty, and still paintings of rural vistas. John R. Stilgoe, *Common Landscape of America: 1580–1845* (New Haven: Yale University Press, 1982), 24–25.

26. Like landscape as background for an official portrait, the "scene" of a "pose," such visions become fully integrated with the world of make-believe, Yi-Fu Tuan suggests in *Topophilia,* 133.

See also John Brinckerhoff Jackson, "Landscape as Theater," in *The Necessity for Ruins and Other Topics* (Amherst: University of Massachusetts Press, 1980).

27. There is "a remarkable similarity between the detached clarity of the landscape paintings and Descartes's argument for adopting a detached attitude for an understanding of the world and man's place in it," Relph points out. "If Johannes Vermeer and others painted for the fashion of their times, Descartes formulated and focused its philosophical character. This character rested above all on faith in the capacity of disinterested human reason to describe and to account for the order of things." *Rational Landscapes*, 27–28.

28. *Discourse 4*, cited in ibid., emphasis added. This is "the Cartesian dualism which is at the basis of all detached and objective science—the human mind has the role not only of disclosing the mechanical and mathematical character of nature, but also of dominating its surroundings" (28). This is also the basis of the patriarchal domination of nature at the root of our current ecological crisis. See Annette Kolodny, *The Lay of the Land: Metaphor as Experience and History in American Life and Letters* (Chapel Hill: University of North Carolina Press, 1975), and Merchant, *The Death of Nature.*

29. Cf. Raymond Williams: "A working country is hardly ever a landscape. The very idea of landscape implies separation and observation." *The Country and the City* (New York: Oxford University Press, 1973), 120.

30. Willa Cather, *The Professor's House* (New York: Knopf, 1925), 28.

31. See the Professor's exchange with Augusta (*PH*, 99). It is not possible to determine what version of the "Song of Songs" inspires the Professor's musings; his fascination is with the images themselves—the Rose, the Lily, the Tower of Ivory.

32. Cather heard the story from Richard Wetherill's brother. She also read the account of Mesa Verde by the Swedish anthropologist Nordenskjöld. See her letter on *The Professor's House* in Tennant, ed., *Willa Cather on Writing*, 32. For an account of Richard Wetherill, see Frank McNitt, *Richard Wetherill: Anasazi*, rev. ed. (Albuquerque: University of New Mexico Press, 1966).

33. "Memories are dreams, because the home of other days has become a great image of lost intimacy," Bachelard suggests; and "human returning takes place in the great rhythm of human life, a rhythm that reaches back across the years and, through the dream, combats all absence." *The Poetics of Space*, 100, 99.

34. Tom does not mean "possession" in the sense of male possession of the female landscape; rather, he experiences the sense of center expressed in Thoreau's "Where I Lived and What I Lived For" and "Sounds" in *Walden*.

35. Brown, *Willa Cather*, 241.

36. Ibid., 247.

37. Bachelard, *Poetics of Space*, 197, emphasis original.

38. Ibid., 206; Noël Arnaud, cited in Bachelard, *Poetics of Space*, 137. See also chap. 13, "Intimate Immensity."

39. Letter on *Death Comes for the Archbishop*, *The Commonweal*, 23 November 1927, reprinted in Tennant, ed., *Willa Cather on Writing*, 6–12.

40. See *The Dance of Death*, designed by Hans Holbein and cut in wood by Hans Lutzelburger, with introductory essays by Philip Hofer and Amy Turner Montague. (Boston: Cygnet Press, 1974). Hofer discusses the dating and authorship in his essay. "The frequent meditation on death and physical decay was not a superficial exercise resulting in a happy end," Montague writes. "Rather, it was one portion of late medieval devotional practice intended to help men in their daily lives to place in the larger context of eternity the things which concerned them."

41. Montague points out that the earliest recorded instance of the Dance of Death theme is in dramatic form; performed in a church in Normandy in 1393, it was "none other than the famous *danse macabre*." The first known pictorial representation was painted in 1424–25 on the southern wall of the cemetery of the Church of the Holy Innocents. "Inside the wall was a cloister; above the cloister, charnel houses were built. The cemetery doubled as a marketplace, and the cloister

and charnel houses were frequented by Parisians *en promenade*. In such a location, the mural was a familiar sight to the people of Paris." In 1485, the Paris printer Guyot Marchant published the *Danse Macabre* in book form, with four figures to a page, the whole a rendition of the processional on the cemetery wall. Holbein's representation is different: he abandoned the idea of a procession, intending his work as a book, which the reader could study one page at a time. Each of Holbein's pages contains—like Cather's scenes in *Death Comes for the Archbishop*—a single detailed scene that is meaningful on its own.

42. Letter on *Death Comes for the Archbishop*, in Tennant, ed., *Willa Cather on Writing*, 9–10. In the earlier *My Ántonia*, Cather had created a series of "images in the mind that did not fade— that grew stronger with time . . . a succession of . . . pictures, fixed there like the old woodcuts of one's first primer." *My Ántonia* (Boston: Houghton Mifflin, 1918), 397.

43. Ibid., 10.

44. Ibid., 5–6.

45. Rainer Maria Rilke described a similar experience:

> *Space, outside ourselves, invades and ravishes things:*
> *If you want to achieve the existence of a tree,*
> *Invest it with inner space, this space*
> *That has being in you. Surround it with compulsions,*
> *It knows no bounds, and only really becomes a tree*
> *If it takes its place in the heart of your renunciation.*

Cited in Bachelard, *Poetics of Space*, p. 200.

46. For descriptions of these "real" events and places, see Paul Horgan, *Lamy of Santa Fé* (New York: Farrar, Straus and Giroux, 1975).

47. Cather has been criticized for her portrait of Martínez, especially in recent times when the work of revisionist historians compels us to reinterpret the Hispanic—and other—influence on the American Southwest. Cather was, of course, creating not a history, but an imaginative construct based upon legend.

48. In fact, Lamy's cathedral and his other French buildings in Santa Fe—hospital, chapel, school—are not so well suited to the landscape as the adobe buildings he found "primitive." In the novel, however, I think Cather intends no disharmony between structure and place.

49. Bachelard, *Poetics of Space*, 208, 137, 203.

50. See Willa Cather, "My First Novels [There Were Two]" and "The Novel Démeublé" in Stephen Tennant, ed., *Willa Cather on Writing*, 91–97, 35–43.

### 3. *Walking on the Desert in the Sky: Nancy Newhall's Words and Images*

All correspondence between Beaumont and Nancy Newhall and Ansel Adams quoted in this article is in the Archives of The Center of Creative Photography, University of Arizona, Tucson. Quotations from unpublished works of Beaumont Newhall are provided courtesy of Beaumont Newhall; those from the unpublished works of Nancy Newhall are provided courtesy of the estate of Nancy Newhall. Excerpts from letters by Ansel Adams are courtesy of the Trustees of the Ansel Adams Publishing Rights Trust. All rights reserved.

1. Nancy Newhall, Letter to the Massachusetts Society of Mayflower Descendants, 9 June 1964.

2. Letter to John Woodburn, 29 May 1951.

3. First names will be used throughout this essay to avoid confusion about which Newhall or Adams is being discussed and in keeping with the spirit of their own informality and intimacy.

4. Ansel Adams, Letter to Beaumont Newhall, 27 October 1950.

5. Nancy Newhall, Curriculum vitae.

6. Nancy Newhall and Beaumont Newhall, "Against Iconoclasm." *Magazine of Art* 30, no. 3 (March 1937): 136–41.

7. Letter to Ansel Adams, 3 January 1951.

8. Nancy Newhall and Beaumont Newhall, "Horatio Greenough, Herald of Functionalism," *Magazine of Art* 32, no. 1 (January 1939): 12–15.

9. Letter to Gilbert Seldes, 16 February 1939.

10. "The Enduring Moment," 142. This manuscript was meant to be volume 2 of Newhall's biography of Adams; it was never published. *Ansel Adams: Volume I, The Eloquent Light,* appeared in 1963.

11. Ibid., 104.

12. Ibid., 109.

13. *Ansel Adams: Volume I, The Eloquent Light,* (San Francisco: Sierra Club, 1963), 13.

14. "The Enduring Moment," 142.

15. Alfred Stieglitz, "Why I Photograph Clouds," *Amateur Photographer* 56 (19 September 1923): 255.

16. Nancy Newhall, Letter to Paul Strand, n.d.

17. Notes for a biography on Stieglitz, 131–33.

18. Ansel Adams, Letter to Nancy Newhall, 11 June 1942.

19. "The Enduring Moment," 273.

20. Ibid., 264–66.

21. Letter to Ansel Adams, 27 February 1950.

22. Manuscript for *The Enduring Moment,* 273.

23. Letter to Ansel Adams, n.d.

24. "Four Photographs," *Magazine of Art* 36, no. 4 (May 1943): 180–83.

25. "Editor's Foreword," *Time in New England,* (New York: Oxford University Press, 1950): v.

26. "The Enduring Moment," 320. Adams first published his intent that his photographs act as "Equivalents" for Bach and Beethoven in an article: "Problems of Interpretation of the Natural Scene," *Sierra Club Bulletin* (1945): 47–50.

27. Beaumont Newhall, "Southwest Log," unpublished journal, 11.

28. Nancy Newhall, Letter to Ansel Adams, 18 September 1948.

29. "Mary Austin's Country," *Arizona Highways* 44, no. 4 (April 1968): 6.

30. "The Enduring Moment," 719–21.

31. "The Caption: The Mutual Relationship of Words and Photographs," *Aperture* 1, no. 1 (1952): 17–29.

32. "Controversy and the Creative Concepts, part 1," *Aperture* 2, no. 2 (1953): 12.

33. Nancy Newhall and Ansel Adams, "Death Valley," *Arizona Highways* 29, no. 10 (October 1953): 33–34. This article was reprinted as a paperback book: *Death Valley,* (San Francisco: 5 Associates, 1954).

34. Newhall, Foreword to *Time in New England,* v.

35. Newhall and Adams, "Death Valley," 35.

36. "Mission San Xavier del Bac." *Arizona Highways* 30, no. 4 (April 1954): 13, 14. This article also became a paperback book: *San Xavier del Bac,* (San Francisco: 5 Associates, Inc, 1954).

37. "Organ Pipe Cactus National Monument," *Arizona Highways* 30, no. 1 (January 1954): 14–16.

38. "Mary Austin's Country," *Arizona Highways* 44, no. 4 (April 1968): 2.

39. *This Is the American Earth,* (San Francisco: Sierra Club, 1960), ii–iii.

40. Ibid., David Bower, quoted on dustjacket.

41. Ibid., 84.

## 4. Laura Gilpin and the Tradition of American Landscape Photography

1. Laura Gilpin to Edna Bennett, 12 December 1956. All cited correspondence to or from Laura Gilpin can be found in the Laura Gilpin Collection, Amon Carter Museum, Ft. Worth, Texas.

2. "Our Competitions," *American Photography* 10 (November 1916): 615, 632. Biographical

information on Gilpin can be found in Martha A. Sandweiss, *Laura Gilpin: An Enduring Grace,* (Ft. Worth: Amon Carter Museum, 1986).

3. John Szarkowski, *American Landscapes,* (New York: Museum of Modern Art), 1981.

4. See Barbara Morgan and Willard D. Morgan, "Desert Adventuring on Foot," *Camera Craft* 37, no. 4 (April 1930): 177–81; and no. 6 (June 1930): 283–87.

5. Ansel Adams, interview with Therese Heyman, Carmel, California, 24 March 1980, 3. Transcript at the Amon Carter Museum.

6. Peter E. Palmquist, *Carleton E. Watkins: Photographer of the American West,* (Albuquerque: University of New Mexico Press, 1983), 72.

7. Quoted in Peggy James, "Laura Gilpin, Photographer," *Colorado Springs* 2 (March–April 1978): 18.

8. Gertrude Käsebier to Laura Gilpin, 28 October 1924.

9. Laura Gilpin, "Historic Architecture Photography: The Southwest," *The Complete Photographer* 6, no. 31 (July 1942): 1987.

10. New York *Herald,* 20 January 1924.

11. Laura Gilpin, European journal, 21 July 1922. The journals from Gilpin's European trip of 1922 are at the Amon Carter Museum.

12. Willa Cather, *The Professor's House,* (1925; repr. New York: Vintage Books, 1973), 226, 201. Gilpin attempted to contact Cather through a mutual acquaintance, photographer Alice Boughton. Boughton to Gilpin, 21 August 1929.

13. *The Pikes Peak Region: Reproductions from a Series of Photographs by Laura Gilpin,* (Colorado Springs: Gilpin Publishing, 1926); *The Mesa Verde National Park: Reproductions from a Series of Photographs by Laura Gilpin,* (Colorado Springs: Gilpin Publishing, 1927).

14. Gilpin, *Mesa Verde.*

15. Laura Gilpin, *The Pueblos: A Camera Chronicle* (New York: Hastings House, 1941), 7, 23.

16. Cather, *Professor's House,* 242.

17. Ibid., 219; Mary Austin, *Taos Pueblo,* photographed by Ansel Easton Adams and described by Mary Austin (San Francisco, 1930); Gilpin, *The Pueblos,* 38, 106.

18. Gilpin, *The Pueblos,* 123.

19. Laura Gilpin, *The Rio Grande: River of Destiny,* (New York: Duell, Sloan and Pearce, 1949).

20. John Brinkerhoff Jackson, review of *The Rio Grande: River of Destiny, Arizona Quarterly* 4 (Winter 1949): 369.

21. Interview with Laura Gilpin on the Rio Grande, MS, ca. 1949, 1. The Amon Carter Museum.

22. Gilpin, *The Rio Grande,* 128, 76, 147.

23. John Collier, Jr., "Laura Gilpin: Western Photographer," *New Mexico Quarterly* 20 (Winter 1950–51): 485.

24. Gilpin *The Rio Grande,* 236.

25. Laura Gilpin, *The Enduring Navaho* (Austin: University of Texas Press, 1968), 20. Gilpin rejected the spelling *Navajo* because she thought it suggested the corrupting influence of Spanish culture. However, because that is the spelling now used by the Navajo Tribe, I have used it except in direct quotations.

26. *Navaho Means People,* photographs by Leonard McCombe, text by Evon Z. Vogt and Clyde Kluckhohn (Cambridge: Harvard University Press, 1951); Gilpin to Charles A. Pearce, 28 January 1952.

27. Gilpin, *The Enduring Navaho,* vii, 19.

28. Ibid., 91.

29. Ibid., 107, 223, 210.

30. Ibid., 250.

31. Ibid., 246.

32. Laura Gilpin, interview with Eleanor Caponigro, Santa Fe, New Mexico, 1979, 7. Transcript at Amon Carter Museum.

33. Ibid., 11.

34. Laura Gilpin to Charles A. Pearce and Charles Duell, 25 January 1954.

35. On Connor, see Linda Connor, Comments on Landscape Photography at Esalen Arts Symposium, 1982, *Aperture* 93 (Winter 1984): 50; *Linda Connor* (Washington, D.C.: Corcoran Gallery of Art, 1982); "Linda Connor," *California Museum of Photography Bulletin* 2, no. 2 (1983). On Marilyn Bridges, see Felicia C. Murray, "Marilyn Bridges: De Nazca à Monument Valley, vue du ciel" *Cliches* 13 (February 1985): 12–15; Pierre Borhan, "Bridges: Vol au-dessus d'une terre inconnue" *Cliches* 13 (February 1985): 16–23.

36. The New Mexico Photographic Survey with essays by J. B. Jackson, *The Essential Landscape* (Albuquerque: University of New Mexico Press, 1985), 132. The book includes fourteen Rubenstein images.

37. *The Essential Landscape,* 109; Myers' Santa Fe Trail work is reproduced here and in Joan Myers and Marc Simmons, *Along the Santa Fe Trail* (Albuquerque: University of New Mexico Press, 1986).

38. Joan Myers, "Japanese Relocation Camp Series," MS, possession of the author.

39. *The Essential Landscape,* 118. Peck's southwestern landscapes are reproduced here and in Texas Historical Foundation, *Contemporary Texas: A Photographic Portrait,* (Austin: Texas Monthly Press, 1985).

40. See, e.g., Anne Tucker, *The Woman's Eye* (New York: Knopf, 1973).

*5. Crazy-Quilt Lives: Frontier Sources for Southwestern Women's Literature*

1. Julie Roy Jeffrey, *Frontier Women: The Trans-Mississippi West* (New York: Hill and Wang, 1979), 73. See also Johnny Faragher and Christine Stansell, "Women and Their Families on the Overland Trail, 1842–1867," *Feminist Studies* 2, nos. 2–3 (1975): 150–66; Sandra L. Myres, *Westering Women and the Frontier Experience, 1800–1915* (Albuquerque: University of New Mexico Press, 1982); Glenda Riley, *Women on the American Frontier* (St. Louis: Forum Press, 1977); and Lillian Schlissel, *Women's Diaries of the Westward Journey* (New York: Schocken Books, 1982). All these works are concerned with the experience of Anglo women and the bulk of the documents rely on reports of literate, often middle-class women. Myres makes some attempt to address the Hispanic and American Indian populations, but it is highly speculative and really an aside to her primary focus.

2. Annette Kolodny, *The Land before Her: Fantasy and Experience of the American Frontiers, 1630–1860* (Chapel Hill, University of North Carolina Press, 1984). Kolodny's book does not take women past the prairies; she cautions that her findings about the frontiers further West might be different.

3. Joan Didion, "The California Woman," speech given June 4, 1978, to the Friends of the Bancroft Library (Berkeley: Bancroft Library Collection, University of California), 11.

4. On the domestic goal of a built environment see Jeffrey, *Frontier Women,* 106; Schlissel, *Women's Diaries,* 144. While Myres finds less disjunction between male and female roles, she too emphasizes the goal of development (*Westering Women,* 34). Careful reading of these books indicates that most women found some value to the natural environment, but such appreciation is argued to have been of secondary importance to women's need to civilize the wilderness. I review a selection of early writings to show how women's admiration for certain aspects of the natural environment complicated their response to the civilizing of the landscape. Kolodny's *The Land before Her* addresses the importance of integrating women's ideas about their proper social role with their ideas about valuable natural environments.

5. For a good summary of the conflicting visions of the southwestern landscape see William H. Goetzmann, *Exploration and Empire: The Explorer and the Scientist in the Winning of the American West* (New York: Norton, 1966). Goetzman details the debate, throughout the nineteenth century, about the potential for settlement in the Southwest. To some it was a desert, a barrier, an arid land requiring different methods of development; John Wesley Powell's work illustrates this view. To others it was a land of fabulous riches and a great agricultural belt; F. V.

Hayden's booster mentality illustrates this view. See also Patricia Nelson Limerick, *Desert Passages* (Albuquerque: University of New Mexico Press, 1985).

6. Two versions of Parrish's memoirs exist. This quote is taken from an account given to Virginia V. Root and published as *Following the Pot of Gold at the Rainbow's End in the Days of 1850* (Downey, Calif., 1960), 1. The other text, "Westward in 1850," is a manuscript in the collection of the Henry E. Huntington Library, San Marino, California. All further references are to "Westward in 1850" and are cited in the text, with the permission of the Huntington Library.

7. In dealing with these early materials, I use the terms used by the travelers themselves to refer to the three cultural groups in the Southwest.

8. Eveline Throop (Martin) Alexander, "Diary: April 30, 1866–January 17, 1867." (Berkeley: Bancroft Library Collection, University of California), 35.

9. "Diary of Miss Harriet Bunyard, from Texas to California in 1868," *Historical Society of Southern California Annual Publication,* ed. Percival J. Cooney, 13 (1924): 108.

10. Maria Hargrave Shrode, "Overland by Ox-Train in 1870," *Quarterly Publication of the Historical Society of Southern California* 26, no. 1 (March 1944): 20.

11. "Diary of Mrs. Robert Orion, May 30, 1877–August 24, 1877, From Colorado to Arizona" (San Marino: Henry E. Huntington Library).

12. For a good analysis of women's involvement in botany, gardening, bird lore and political conservation work during the nineteenth century, see Carolyn Merchant, "Women of the Progressive Conservation Movement," *Environmental Review* 8, no. 1 (Spring 1984): 57–86.

13. Roderick Nash provides the best single summary of wilderness appreciation in *Wilderness and the American Mind* rev. ed. (New Haven: Yale University Press, 1982). See also Hans Huth, *Nature and the American* (Lincoln: University of Nebraska Press, 1957).

14. Edith M. Nicholl, *Observations of a Ranchwoman in New Mexico* (New York: Macmillan, 1898), 71. All further references are cited in the text.

15. Edward Relph, *Rational Landscapes and Humanistic Geography* (London: Croom Helm, 1981), 41.

16. Relph cites the influence of John Ruskin during the late-nineteenth century: "Seeing landscapes with sensitivity and imagination could provide people with a sense of humility, a feeling of something other than themselves that was profoundly important. . . . To take pleasure in landscape was therefore a sign of moral perception, and to that extent landscape had a moral character." Ibid., 38.

17. Sadie E. Martin, "My Desert Memories" (Tucson: Arizona Historical Society, 1939), 24.

18. Mary Hudson Brothers, *A Pecos Pioneer* (Albuquerque: University of New Mexico Press, 1943), 118. All further references are cited in the text.

19. Mary Kidder Rak, *A Cowman's Wife* (New York: Houghton Mifflin, 1934), 202. All further references are cited in the text.

20. See Henry Nash Smith, *Virgin Land: The American West as Symbol and Myth* (New York: Vintage Books, 1950); Annette Kolodny, *The Lay of the Land* (Chapel Hill: University of North Carolina Press, 1975); and Richard Slotkin, *Regeneration through Violence* (Middleton, Conn.: Wesleyan University Press, 1973).

21. Nash is particularly informative along these lines in his discussion of the cult of wilderness. *Wilderness and the American Mind,* 141–61.

22. May Merrill Miller, *First the Blade* (New York: Knopf, 1938), 577. All further references are cited in the text.

23. Mabel Hobson Draper, *Though Long the Trail* (New York: Rinehart, 1946), 310. All further references are cited in the text.

24. Annette Atkins, "Women on the Farming Frontier: The View from Fiction," *The Midwest Review,* 2d ser. 3 (Spring 1981): 1. Madelon Heatherington comments, "Not even stereotypes, much less archetypes, most women are characters so formulaic, so diluted, so single dimensional that their functions in various novels are usually as interchangeable as assembly-line carburetors." As she notes, most "Westerns" are written by men; one must look elsewhere in fiction to discover

women's voices. "Romance without Women: The Sterile Fiction of the American West," *The Georgia Review* 33, no. 3 (Fall 1979): 645.

25. Patricia Meyer Spacks, *The Female Imagination* (New York: Knopf, 1975), 306–07.

26. Kolodny, *Land before Her,* 112.

27. Spacks, *Female Imagination*, 6. Susan Gubar is also useful here; see "'The Blank Page' and Issues of Female Creativity," in *Writing and Sexual Difference,* ed. Elizabeth Abel (Chicago: University of Chicago Press, 1982), 37–95.

28. Ibid., 296–97.

29. Annis Pratt, "Women and Nature in Modern Fiction," *Contemporary Literature* 13, no. 4 (Autumn 1972): 488. Pratt's findings are supported by the more recent work of Carolyn Merchant on differences between male and female conceptions of nature since the scientific revolution: *The Death of Nature: Women, Ecology and the Scientific Revolution* (San Francisco: Harper and Row, 1980).

30. Using Stanley Fish's assessment of good fiction as "self-consuming artifact," Heatherington faults most western fiction for being too "typical," too self-affirming, particularly in regard to its treatment of heroines ("Romance without Women," 647). The four women's works considered here are not by any means singular. Other comparable fictions include Beatrice Harraden, *Hilda Strafford* (New York: Dodd Mead, 1867); Jean Stafford, *The Mountain Lion* (New York: Harcourt, Brace, 1947); Bobbie Louise Hawkins, *Back to Texas* (Berkeley: Bear Hug Books, 1977); and, of course, Mary Austin's work (particularly *Lost Borders*) and Willa Cather's *Song of the Lark.*

31. Margaret Collier Graham, *Stories of the Foothills* (Freeport, N.Y.: Books for Libraries Press, 1895, rpt. 1969), 66. All further references are cited in the text. For a biography of Graham see Jane Apostol, "Margaret Collier Graham: First Lady of the Foothills," *Southern California Quarterly* 63, no. 4 (Winter 1981): 348–73.

32. Dorothy Scarborough, *The Wind* (New York: Harper and Brothers, 1925), 63–64. All further references are cited in the text.

33. At one point Cora notes that she would see all her children die in order to save Bev, such is her love for him. She is presented as an inadequate mother, less interested in her children than in herself (94, 125).

34. Frances Gillmor, *Fruit Out of Rock* (New York: Duell, Sloan and Pearce, 1940). 27. All further references are cited in the text.

35. See Gerald Nash, *The American West in the Twentieth Century: A Short History of an Urban Oasis* (Albuquerque: University of New Mexico Press, 1977); and Kirkpatrick Sale, *Powershift* (New York: Random House, 1976).

36. Joan Didion, "Notes from a Native Daughter," *Slouching Towards Bethlehem* (New York: Dell, 1968), 177.

37. Joan Didion, *Play It as It Lays* (New York: Bantam, 1971), 209. All further references are cited in the text.

38. Didion, "Los Angeles Notebook," *Slouching Towards Bethlehem,* 221.

39. Kolodny, *Land before Her,* 240–41.

40. Joan Didion, "Why I Write," in *The Writer on Her Work,* ed. Janet Sternberg (New York: Norton, 1980), 21.

41. Elaine Hedges comments in her study of quilts that she experiences "a combination of admiration and awe at limitations overcome and of sorrow and anger at limitations imposed." "Quilts and Women's Culture," in *In Her Own Image: Women Working in the Arts,* ed. Elaine Hodges and Ingrid Wendt (Old Westbury, N.Y.: Feminist Press, 1980), 19.

42. Didion, "A California Woman," 12.

43. Abel, ed., *Writing and Sexual Difference* is a fine collection of essays detailing feminist criticism and indicating this current dialogue. See particularly Elaine Showalter's "Feminist Criticism in the Wilderness" and Carolyn Heilbrun's "Response" in this collection.

44. Heilbrun, "Response," 294.

45. A scathing rebuke of the aspect of this vision that places the burden of the destruction of the American Indian on white women is found in Dawn Lander, "Eve Among the Indians," in *The Authority of Experience,* ed. Arlyn Diamond and Lee R. Edwards (Amherst: University of Massachusetts Press, 1977), 194–211. Those who doubt this willingness to blame white women for the destruction of the environment should read Richard Slotkin's *Regeneration through Violence: The Mythology of the American Frontier.* For an analysis of how masculine bias in literary criticism denies women's creative voice, see Nina Baym, "Melodramas of Beset Manhood: How Theories of American Fiction Exclude Women Authors," *American Quarterly* 33, no. 2 (Summer 1981): 123–39.

### 6. Tradition and Mythology: Signatures of Landscape in Chicana Literature

1. Fabiola Cabeza de Baca, *We Fed Them Cactus* (1954, repr. Albuquerque: University of New Mexico Press, 1979), 66. Throughout this chapter I quote extensively from the creative works under study. Most of these writings are neither widely available in print nor known to a broad audience. One purpose of this essay is to familiarize readers with Hispanic/Chicana writings in order to encourage wider distribution and acknowledgement of their literary achievements.

2. The Chicano Renaissance is a literary as well as social movement that took place in the late 1960s. Participating Chicano writers explored both their social circumstances and their cultural heritage.

3. The terms *Hispanic, Chicana,* and *Mexican-American* mean different things both historically and ideologically. All refer to people of Spanish descent. *Mexican-American* refers specifically to those of Mexican descent who either came from Mexico to live in the United States or who are descended from Mexican parents or grandparents. *Hispanic* is a more generic term used to denote Spanish-speaking or -descended people. New Mexicans who trace their ancestry in the region to colonial times often prefer to be called *Hispanos* or *Nuevo Mexicanos. Chicano* is a relatively new term that came into general use in the 1960s. It is another term for Mexican-American, but it carries with it an ideological sense of pride in many heritages (Spanish, Mexican, Indian, and American) as well as in Spanish and Indian cultures and languages. *Chicano* is a generic term encompassing both sexes, while *Chicana* refers only to women. I have tried to use terms historically or to use the terms the writers use to refer to themselves.

4. C. L. Salter and W. J. Lloyd, *Landscape in Literature* (Washington, D.C.: Association of American Geographers, Resource Paper no. 76–3, 1976), 7. The term *signature* is borrowed from remote sensing imagery. Salter and Lloyd state that signature as "a certain landscape feature . . . may have a specific polychromatic intensity unlike the tones of other features. . . . We use this term because cultural groups and even individuals have 'signed' their own mark upon the surface of the earth and within pages of literature." Examples include the difference between irrigation from a central well and from a revolving pipe system.

5. The Chicano Renaissance resulted in a brilliant outpouring of creative writing and publishing, mostly on the part of men. For women, with a few exceptions, it was a different story. Until the late 1970s, they were published mainly in journals devoted to Chicano literature, such as *The Revista Chicano-Riqueña* and *The Bilingual Review.* They also self-published: Angela de Hoyos with MW Press, Bernice Zamora with Diseños Literarios, Margarita Cota-Cárdenas with Scorpion Press, and others too numerous to mention. Lorna Dee Cervantes is alone in having been published by a major university press (the University of Pittsburgh Press). Similarly, many anthologies of Chicano literature included few works by women, and anthologies of American women writers included no Chicana writers. Dexter Fisher's *Third Woman: Minority Women Writers of the United States* (Boston: Houghton Mifflin, 1980) is a notable exception to the rule. Thus, while some Chicana writers were fairly well known in the West/Southwest, most were writing in relative obscurity and were certainly ignored by mainstream presses and review publications. In the last few years, however, writing and publishing by and about Chicana writers has

virtually exploded. There is also a great deal of interest in research on historical Chicano culture and its contribution to United States culture. Studies are now being conducted all over the West.

6. Chicano writers generally seem to depict a dichotomy between nature and civilization. In New Mexico there is a strong pastoral tradition in oral as well as written literature. The origins of these "symbolic spaces" for many peoples are in part explained by Yi Fu Tuan, who says that wilderness represents the extremity of savage nature, where humanity is confronted with wild beasts (bears, coyotes, jaguars) or peoples. It is a chaotic state where one barely survives; there is no order except what the human manages to piece together for her- or himself. The clearing and planting in the forest, the building of the primitive first dwelling are symbols of human control over the environment. As humans control more and more of this wilderness, it becomes a middle landscape, rural and pastoral, where woman and man live in harmony and unity with cultivated nature. In this utopic landscape, woman is often thought to inhabit a central place as the bringer of culture and civilization. The middle landscape can also exist in another dimension, the "oriented mythical space" of traditional societies where the forces of nature or society are organized and associated with significant locations or places. Woman/man is seen to be at the center of such spaces. Towns and cities are created (in the beginning idealistically) as utopias in which people live together, and are built to represent the cosmic order, inspire societal stability, and keep out chaos. Yet, because of social conditions created by economic misfortunes and the domination of one group of people over another, the civitus/town reaches the other extreme: savage civilization, where humans are alienated and out of harmony with the cosmos and nature. Yi Fu Tuan states, "It is deeply ironic that the city can often seem (and is) a frightening place. Although they are the products of planning, the result is a vast, disorderly labyrinth." Yi Fu Tuan, *Topophilia* (Englewood Cliffs, N.J.: Prentice-Hall, 1974), 66.

7. Nina Otero Warren, *Old Spain in Our Southwest* (New York: Harcourt Brace, 1936), 3.

8. Ibid., 4–5.

9. Raymond A. Paredes, "The Evolution of Chicano Literature," in *Three American Literatures,* ed. Houston A. Baker, Jr. (New York: Modern Language Association, 1982), 56.

10. Cabeza de Baca, *We Fed Them Cactus*, vii. All further references appear in the text.

11. Fabiola Cabeza de Baca, *The Good Life.* (Santa Fe: Museum of New Mexico Press, 1982). It is interesting to note that the landscape, whether real or imaginary/symbolic, may carry the weight of significance of meaning. A sense of the land, a sense of belonging is often viewed as a space that nourishes. Place, according to Yi Fu Tuan, is "an archive of fond memories" and a strong attachment to the homeland can emerge from familiarity and ease, with the "assurance of nature and security, with the memory of sounds and smells, of communal activities and homely pleasures accumulated over time." *Space and Place: The Perspective of Experience* (London: Edward Arnold, 1977), 151. This certainly seems to be the connection between the cookbooks and the landscape.

12. Cleofas Jaramillo, *The Genuine New Mexico Tasty Recipes* (1939, repr. Santa Fe: Seton Village Press, 1942).

13. Cleofas Jaramillo, *Romance of a Little Village Girl* (San Antonio: Naylor, 1955), 167. All further references appear in the text.

14. Cabeza de Baca, *The Good Life*, 14.

15. Ibid., 17–18.

16. This perspective is continued in contemporary Chicano literature, and can be seen in Rudolfo Anaya's trilogy starting with *Bless Me, Ultima* (Berkeley: Tonatiuh International, 1972), with its sense of well-being and unity with the land. We then see what occurs when the family in the second book, *Heart of Aztlán* (Berkeley: Justa Publications, 1976), moves into the city. The move from the centered middle landscape to the urban setting and all its attendant problems shows what befalls a people who are no longer in control of their lives. In *Bless Me Ultima,* the "teacher" figure for the narrator is a curandura, who teaches the young boy how to survive in his own search for identity. Both female and male Chicano writers seem to share perceptions of savage wilderness/savage civilization in the urban setting and the desire for integration with the

environment (both natural and social) via acknowledgement and acceptance of racial, social, cultural, and linguistic heritage.

17. *Del Rancho al Barrio: The Mexican Legacy of Tucson* (Tucson: Arizona Historical Society, 1983); Patricia Preciado Martin, *Images and Conversations: Mexican Americans Recall a Southwestern Past* (Tucson: University of Arizona Press, 1983).

18. Preciado Martin, *Images and Conversations,* 9–10.

19. La Adelita is a Mexican revolutionary heroine commemorated in song and poetry. La Malinche is the Indian woman who translated for Hernán Cortés during the conquest of Mexico.

20. Gina Valdés, *Caracol* 4, no. 12 (August 1978): 4.

21. Angela de Hoyos, *Chicano Poems for the Barrio* (San Antonio: M and A Editions, 1975), 12–13.

22. Ibid., 21–23.

23. Xelina, *Maize* 3, nos. 1–2 (1979–80): 51.

24. Carmen Tafolla, *Get Your Tortillas Together* (n.p., 1976), 30.

25. Rina García Rocha, *Hojas Poéticas* (Tucson: Scorpion Press, 1977), 2.

26. Irene Blea, *Celebrating Crying and Cursing* (Pueblo, Co.: Pueblo Poetry Project, 1980).

27. Beverly Silva, *The Second St. Poems* (Ypsilanti, Mich.: Bilingual Press, 1983), 38–39.

28. Ibid., 53.

29. Evangelina Vigil, *Thirty'n' Seen a Lot* (Houston: Arte Público Press, 1982), 62–63. The last line reads "that her/his name would appear there."

30. Lorna Dee Cervantes, *Emplumada* (Pittsburgh: University of Pittsburgh Press, 1981), 11–14.

31. Patricia Preciado Martin, "The Journey," *La Confluencia* 3, nos. 3–4 (1980): 4.

32. Ibid., 5.

33. Ibid., 6.

34. Ibid. "Grandmother, don't cry. I'm bringing you a little bunch of flowers." (Translation mine.)

35. Tomás Vallejos, *Mestizaje: The Transformation of Ancient Indian Religious Thought In Contemporary Chicano Fiction* (Ann Arbor: University Microfilms, 1980), 271–72. See also María Herrera Sobek, ed., *Beyond Stereotypes* (Binghamton, N.Y.: Bilingual Press, 1985).

36. Rebecca González, *Slow Work to the Rhythm of Cicadas* (Ft. Worth: Prickly Pear Press, 1985), 10.

37. Pat Mora, *Chants* (Houston: Arte Público Press, 1984), 8.

38. González, *Slow Work,* 42.

39. Denise Chávez, *Proximity to Mountain: Conversations with the Esquivel Family* (M.A. thesis, University of New Mexico, 1984), 6–7.

40. Denise Chávez, unpublished poem.

41. Chávez, unpublished poem.

42. Chávez, unpublished poem.

43. Mora, *Chants,* 22.

44. Ibid., 26.

45. Pat Mora, *Puerto del Sol* (Spring 1981), 18.

46. Mora, *Chants,* 9.

47. Mora, *Pawn Review* 5, 54.

48. Ferdinand Anton, *Women in Pre-Columbian America* (New York: Abner Schram, 1973), 18–19.

49. Mora, *Chants,* 28.

50. Silva, *Second St. Poems,* 77.

51. Mora, unpublished poem.

7. Peregrinas *with Many Visions: Hispanic Women Artists of New Mexico, Southern Colorado, and Texas*

Many people assisted with the research for this project, especially the women artists who so graciously cooperated in interviews, supplied slides of their works, and often extended hospitality to me. Many are mentioned in the text, some are not, but I am equally grateful to all—and I regret that time did not permit me to contact many other women whose works are important and interesting. Others who helped include Becky Cloud, Mrs. Bernardo Euresti, David García, Rudolfo De La Garza, Oscar Garza, the Rex Geralds, Shifra Goldman, David González, Juan Pablo Guiterrez, Pat Jaspers, Myra Ellen Jenkins, Eddie Faye McLeod, Manuel Mena, Maria Margarita Návar, Victor Nelson-Cisneros, Irene Peche, Jacinto Quirarte, Terry Reynolds, Pedro Rodríguez, Ricardo Romo, Christine Sierra, Rámon Vásquez y Sánchez, and Alan Vedder. I am particularly grateful to my photographer, Moana M. E. Kutsche; and to those photographers who prepared prints and transparencies for the illustrations and to the museums and collections that permitted use of their works. Judith Fryer was helpful with comments on earlier drafts of this paper. I extend a special thanks to typists Carol Erickson and Sue Rundstrom.

Funding for the research was provided by the Rockefeller Foundation grant to the Southwest Institute for Research on Women and was considerably augmented by grants from the Research and Faculty Development Committees of The Colorado College. Vera Norwood and Janice Monk have helped in their administration of the project and with their patience in shaping the final version of the chapter.

1. Statement by the artist in a privately printed brochure.

2. Compiled from oral and written statements made by the artist. See also Anita Rodríguez, "Las Enjarradoras: Women of the Earth," *New Mexico Magazine* 58, no. 2 (February 1980): 46–47, 58; and Tricia Hurst, "The Enjarradora," *The Continental* 1, no. 11 (December 1985): 45–49.

3. Compiled from oral and written statements made by the artist. See also artist's statement in Shifra Goldman, *Chicana Voices and Visions* (Venice, Calif.: Social and Public Arts Resource Center, 1983).

4. Richard L. Nostrand, "The Hispanic-American Borderland: Delimitation of an American Culture Region," *Annals of the Association of American Geographers* 60, no. 4 (December 1970): 638–61; see esp. map, fig. 7, p. 657.

5. E. Boyd, *Popular Arts of Spanish New Mexico* (Santa Fe: Museum of New Mexico Press, 1974); Nora Fisher, ed., *Spanish Textile Tradition of New Mexico and Colorado* (Santa Fe: Museum of New Mexico Press, 1979); Goldman, *Chicana Voices and Visions;* Jacinto Quirarte, *Mexican American Artists* (Austin: University of Texas Press, 1973); Marianne L. Stoller, *A Study of Nineteenth Century Hispanic Arts and Crafts in the American Southwest: Appearances and Processes* (Ann Arbor: University Microfilms, 1979); Marianne L. Stoller with Suzanne M. P. Martin and Kathryn J. Nelson, "Hispanic Folk Artists: Their Works . . . Their Words," *People and Policy* 2, no. 2 (Summer 1980): 20–31; Marta Weigle, ed., *Hispanic Arts and Ethnohistory in the Southwest* (Santa Fe and Albuquerque: Ancient City Press and the University of New Mexico Press, 1983); William Wroth, ed., *Hispanic Crafts of the Southwest* (Colorado Springs: Taylor Museum, 1977).

6. Goldman, *Chicana Voices and Visions,* and Stoller, "Hispanic Folk Artists" are exceptions; Quirarte, *Mexican American Artists,* includes two women in the twenty-seven artists covered.

7. D. W. Meinig, Introduction to *Interpretation of Ordinary Landscapes,* ed. D. W. Meinig (New York: Oxford University Press, 1979), 2.

8. This rudimentary model and the characteristics that comprise it are generalized from the collection of individual circumstances of each artist, and therefore it neither describes nor represents completely any given individual.

9. A good example is in the account of the first attempt to colonize New Mexico, in Albert H. Schroeder and Dan S. Matson, *A Colony on the Move: Gaspar Castano de Sosa's Journal, 1590–*

*1591* (Santa Fe: School of American Research, 1965). Yi-Fu Tuan et al., *The Climate of New Mexico,* rev. ed. (Santa Fe: State Planning Office, 1973), 4–10, make the same points and review some early accounts of the area.

10. Fray Angelico Chavez, *My Penitente Land* (Albuquerque: University of New Mexico Press, 1974), 24–26.

11. A good comprehensive history of settlement in the Hispanic Borderlands is Oakah L. Jones, Jr., *Los Paisanos* (Norman: University of Oklahoma Press, 1979).

12. Fisher, *Spanish Textile Tradition,* is the most comprehensive study.

13. Bainbridge Bunting, *Early Architecture in New Mexico* (Albuquerque: University of New Mexico Press, 1976), is the best summary.

14. Lonn Taylor and Dessa Bokides, *Carpinteros and Cabinet-makers: Furniture Making in New Mexico, 1600–1900* (Santa Fe: Museum of International Folk Art, 1983), is short but authoritative.

15. Marc Simmons and Frank Turley, *Southwest Colonial Ironwork* (Santa Fe: Museum of New Mexico Press, 1980), is the best work.

16. Boyd, *Popular Arts,* 309; on traditional tin work, see 295–301; on filigree, see 288–90. See also Wroth, *Hispanic Crafts.*

17. The most comprehensive sources are Boyd, *Popular Arts;* José E. Espinosa, *Saints in the Valley,* rev. ed. (Albuquerque: University of New Mexico Press, 1967); Thomas J. Steele, *Santos and Saints* (Santa Fe: Ancient City Press, 1982); and William Wroth, *Christian Images in Spanish New Mexico* (Colorado Springs: Taylor Museum, 1982).

18. Charles L. Briggs, *The Wood Carvers of Córdova, New Mexico* (Knoxville: University of Tennessee Press, 1980), 90, 97, 124–29.

19. Marta Weigle, "The First Twenty-Five Years of the Spanish Colonial Arts Society," in Weigle, ed., *Hispanic Arts and Ethnohistory,* 183–86.

20. Charlene Cerny and Christine Mather, "Textile Production in Twentieth-Century New Mexico," in Fisher, ed., *Spanish Textile Tradition,* 185–87.

21. Frances Leon Swadesh, *Los Primeros Pobladores* (Notre Dame: University of Notre Dame Press, 1974), 178–79. See also Myra Ellen Jenkins, "Some Eighteenth-Century New Mexico Women of Property," in Weigle, ed., *Hispanic Arts and Ethnohistory;* Joan M. Jensen, "Disenfranchisement is a Disgrace: Women and Politics in New Mexico, 1900–1940," *New Mexico Historical Review* 56, no. 1 (January 1981): 5–35; Michael V. Miller, "Variations in Mexican American Family Life: A Review Synthesis of Empirical Research," *Aztlan* 9 (1978); 209–31.

22. Quirarte, *Mexican American Artists,* 52–56.

23. Mardith K. Schuetz and Robert K. Winn, "The Art of the Era," in *San Antonio in the Eighteenth Century* (San Antonio: San Antonio Bicentennial Heritage Committee, 1976).

24. Jacinto Quirarte, "Decorative and Applied Arts at the Missions," MS, Research Center for the Arts, The University of Texas at San Antonio, 1982, 87.

25. Arnoldo DeLéon, *The Tejano Community, 1836–1900* (Albuquerque: University of New Mexico Press, 1982).

26. Kay F. Turner, "Mexican American Home Altars: Towards Their Interpretation," *Aztlan* 13, nos. 1–2 (1982): 309–26; see also Maria Margarita Návar, "Institutional and Folk Religion in a Texas-Mexican Community," MS, kindly supplied by the author.

27. Terry G. Jordan, *Texas Graveyards* (Austin: University of Texas Press, 1982), 70.

28. On the settlement history of Texas including El Paso, see Jones, *Los Paisanos;* Nostrand, "The Hispanic-American Borderland"; David J. Weber, *The Mexican Frontier, 1821–1846* (Albuquerque: University of New Mexico Press, 1982); D. W. Meinig, *Imperial Texas* (Austin: University of Texas Press, 1969); T. N. Campbell, "Coahuiltecans and Their Neighbors," in *Handbook of North American Indians,* vol. 10: *The Southwest,* ed. Alfonso Ortiz (Washington, D.C.: Smithsonian Institution, 1983); Del Weniger, "Wilderness, Farm, and Ranch," in *San Antonio in the Eighteenth Century;* Mario T. García, *Desert Immigrants* (New Haven: Yale University Press, 1981).

29. The folklore and folk music traditions of south Texas are well represented in two works by Americo Paredes: *With His Pistol in His Hand* (Austin: University of Texas Press, 1958), and *A Texas-Mexican Cancionero* (Urbana: University of Illinois Press, 1976).

30. García, *Desert Immigrants,* 65–85, discusses border occupations.

31. Goldman, *Chicana Voices and Visions.*

32. Alfredo Mirandé and Evangelina Enríques, *La Chicana* (Chicago: University of Chicago Press, 1979), chap. 7.

33. Ibid., 24–31.

34. The work of Texas-born California artist Carmen Lomas Garza is an exception to some of these statements: she does portray the nopal cactus and scenes of ordinary life or fiestas from her Texas homeland.

35. Daniel D. Arreola, "Chicano Mural Art," American Geographical Society *Focus* 35, no. 3 (July 1985): 16, 18.

## 8. The Mind's Road: Southwestern Indian Women's Art

The writers wish to acknowledge the assistance of Barbara Babcock, Kathryn Hubenschmidt, Louise Lamphere, Ruth M. Perry, Patricia Hollingshead, and Sue Ruiz.

The epigraph and postscript are quoted in *Women of Sweetgrass, Cedar and Sage,* ed. Harmony Hammond and Jaune Quick-to-See Smith (New York: Gallery of the American Indian Community House, 1985).

1. Factors which have been shown to contribute to heterogeneity within a culture include an individual's age, sex, and life history, intensity of feeling about culture traits, world view, and his or her retention, awareness of the group's history and values, and interaction with other groups, particularly the politically dominant group. Edward H. Spicer, "Plural Society in the Southwest," in *Plural Society in the Southwest,* ed. Edward H. Spicer and Raymond H. Thompson (New York: Interbook, 1972), 21–76; Fredrik Barth, *Ethnic Groups and Boundaries* (Boston: Little, Brown, 1969).

2. But see Alice Schlegel, "Male and Female in Hopi Thought and Action," in *Sexual Stratification: A Cross-Cultural View,* ed. Alice Schlegel (New York: Columbia University Press, 1977), 245–69.

3. A culture area is a contiguous geographical area occupied by a number of societies whose cultures show a significant degree of similarity with each other and at the same time a significant degree of difference with the cultures of other areas. Harold Driver, *Indians of North America,* 2d ed. (Chicago: University of Chicago Press, 1969), 17.

4. The four basic culture groups defined here are those identified by Edward Spicer. Authorities disagree on the exact number of societies inhabiting the Southwest at the time of European contact. Information on southwestern culture groups is derived from basic ethnographies and from Edward Spicer, *Cycles of Conquest: The Impact of Spain, Mexico, and the United States on the Indians of the Southwest, 1533–1960* (Tucson: University of Arizona Press, 1962); Spicer, "Plural Society"; Edward P. Dozier, *The Pueblo Indians of North America* (New York: Holt, Rinehart and Winston, 1970).

5. See Driver, *Indians of North America,* for characteristics of the Great Basin adaptation.

6. Spicer, "Plural Society," 21–27, 41–42.

7. By 1881, the transcontinental railroad extended through the northern part of the Southwest and U.S. political control extended to almost every Indian group. Anglo Americans began settling on the lands between pueblos and encroaching on the newly established reservations. The Indian Bureau organized schools; Christian missionaries built churches and attempted to convert the Indians. Forced assimilation became the government policy. While Indian men began wage work for the railroads and in the growing towns, Indian women began to commercialize their crafts as increasing tourism created a market for regional souvenirs (Dozier, *Pueblo Indians,* 14).

Trading posts introduced Anglo-made goods and Navajo weavers, for example, traded their rugs for coffee, flour, and canned goods.

8. Charles Amsden, *Navaho Weaving: Its Technic and History* (Santa Barbara: Peregrine Smith, 1975), 179—82.

9. Ibid., 235—36.

10. Matilda Coxe Stevenson, "The Zuni Indians: Their Mythology, Esoteric Fraternities, and Ceremonies," in *23rd Annual Report of the Bureau of American Ethnology for the Years 1901–1902* (Washington, D.C.: GPO, 1904), 50; Neil M. Judd, *Archaeological Investigations at Pueblo Bonito, New Mexico*, vol. 77, pt. 2, Smithsonian Miscellaneous Collections (Washington, D.C.: GPO, 1954), 124; Edna Mae Bennett, *Turquoise and the Indian* (Denver: Sage, 1966), 111.

11. Clara Lee Tanner, *Prehistoric Southwestern Craft Arts* (Tucson: University of Arizona Press, 1976), 147—77.

12. John Adair, *The Navajo and Pueblo Silversmiths* (Norman: University of Oklahoma Press, 1944), 6.

13. Margery Bedinger, *Indian Silver: Navajo and Pueblo Jewelers* (Albuquerque: University of New Mexico Press, 1973), 132.

14. Ibid., 156. Around 1898, Lanyade passed his skills to the Hopi. This is the common mechanism for the diffusion of new crafts in this period.

15. Adair, *Navaho and Pueblo Silversmiths*, 9. Navajo-style jewelry was the model and inspiration for Zuni jewelry of the late nineteenth and early twentieth century.

16. Ibid., 134; Bedinger, *Indian Silver*, 141—42. Navajo smiths continued to emphasize silver rather than the stones, and many Navajos began to import Zuni pieces, while the Zuni continued to trade for Navajo styles.

17. Adair, *Navaho and Pueblo Silversmiths*, 135.

18. Edmund J. Ladd, "Zuni Economy," in *Handbook of North American Indians*, vol. 9, *Southwest*, ed. Alfonso Ortiz (Washington, D.C.: Smithsonian Institution, 1979), 495.

19. Bedinger, *Indian Silver*, 194.

20. J. J. Brody, "The Creative Consumer: Survival, Revival, and Invention in Southwest Indian Arts," in *Ethnic and Tourist Arts*, ed. Nelson H. H. Graburn (Berkeley: University of California Press, 1976), 74.

21. Kate Peck Kent, "Pueblo and Navajo Weaving Traditions and the Western World," in ibid., 91—92; Frederic H. Douglas, "Acoma Pueblo Weaving and Embroidery," "Weaving in the Tewa Pueblos," "Weaving of the Keres Pueblos, Weaving of the Tiwa Pueblos and Jemez," Denver Art Museum Leaflets 89, 90, 91 (Denver: Denver Art Museum, December 1939).

22. Brody, "Creative Consumer," 74.

23. Charles H. Lange, *Cochiti* (Austin: University of Texas Press, 1959), 158.

24. George Wharton James, *Handbook of Indian Basketry: Their Origin and Symbolism* (Los Angeles: Kovach, 1945), 227; Clara Lee Tanner, *Apache Indian Baskets* (Tucson: University of Arizona Press, 1982), 72.

25. Brody, "Creative Consumer," 74; Carl E. Guthe, *Pueblo Pottery Making: A Study at the Village of San Ildefonso* (New Haven: Yale University Press, 1925), 13; Kenneth M. Chapman, *The Pottery of San Ildefonso Pueblo* (Albuquerque: University of New Mexico Press, 1970), 48.

26. Traders also requested new forms—boxes, salt and pepper shakers, letter openers, ashtrays. La Rayne Parrish, "The Stylistic Development of Navajo Jewelry," in *Southwest Indian Silver From the Doneghy Collection*, ed. Louise Lincoln (Austin: University of Texas Press, 1982), 34.

27. Bedinger, *Indian Silver*, 172—73. Indian artists were also experimenting independently to see what sold well while simultaneously satisfying their individual and cultural criteria of beauty.

28. "Through the Santa Fe Studio, Miss Dunn became the single most influential individual for an entire generation of Indian painters. . . . Virtually all of the important Indian painters of her generation came under her guidance or were taught by her students, and in turn they taught

most Indian artists of the succeeding generation." J. J. Brody, *Indian Painters and White Patrons* (Albuquerque: University of New Mexico Press, 1971), 128–29.

29. Lucy R. Lippard, "Double Vision," in Hammond and Smith, eds., *Women of Sweetgrass, Cedar and Sage.*

30. Basketmakers no longer use a green-colored yucca leaf because "it does not sell well to tourists." Joyce Mori and John Mori, "Modern Hopi Coiled Basketry," *The Masterkey* 46, no. 1 (January–March 1972): 9–10, 13.

31. Brody, "Creative Consumer," 76–77. Continuing Hopi traditions have a similar effect; see Mori and Mori, "Modern Hopi Coiled Basketry," 14.

32. Kent, "Pueblo and Navajo Weaving Traditions," 94–97.

33. There is a worldwide tendency for men to carve, work with metals, manufacture musical instruments, work in stone, bone, horn, and shell; and for women to make pottery, weave, and produce clothing. Tanning, leather goods, mats, and baskets are the work of either sex world-wide. George P. Murdock and Caterina Provost, "Factors in the Division of Labor by Sex: A Cross-Cultural Analysis," *Ethnology* 12, no. 2 (April 1973): 203–25; Michael Burtin, Lilyan A. Brudner and Douglas R. White, "A Model of the Sexual Division of Labor," *American Ethnologist* 4, no. 2 (May 1977): 231; Daniel J. Crowley, "Crafts," *International Encyclopedia of the Social Sciences,* vol. 3, ed. Edward L. Sils (New York: Macmillan, 1968), 431–32. Within the Southwest however, these generalizations do not universally hold true.

34. W. W. Hill and Charles H. Lange, *An Ethnography of Santa Clara Pueblo New Mexico* (Albuquerque: University of New Mexico Press, 1982), 162–64. Women made their stone grinding slabs and piki ovens and spent most of their time grinding corn for both daily and religious use. Men, because of their daily activities, produced tools, weapons, shields, ceremonial equipment, musical instruments, and wearing apparel. Men also mined for turquoise and made beads.

35. Spanish records state that men in almost every Rio Grande pueblo produced cotton and wool mantas. Variation existed in embroidery and production of woven sashes. Hopi men wove, knitted, crocheted, and embroidered; women made sashes. In Acoma and the Tewa villages, women occasionally embroidered wool or cotton mantas and sashes. Ruth Underhill, *Pueblo Crafts* (Washington, D.C.: Dept. of the Interior, BIA, Div. of Education, 1944), 47, 76. By the 1890s, most Rio Grande Pueblos traded for Navajo blankets and Pendleton robes and the art of weaving disappeared with a few exceptions; for example, Lange recorded one woman and one man from San Felipe still weaving prior to World War II (*Cochiti,* 163–64). Today, Hopi men produce most of the weaving used in all pueblos, particularly ceremonial costumes. Recently, San Juan women have begun weaving and embroidering cloth. Kate Peck Kent, *Pueblo Indian Textiles: A Living Tradition* (Santa Fe: School of American Research Press, 1983), 21. At some Rio Grande pueblos, men made undecorated winnowing baskets or carrying baskets. Maria Chabot, "Basket Making Among the Indians of the Southwest," *Indians at Work* 3 (June 1936): 27; Lange, *Cochiti,* 163. Generally, a man made a basket only if he were going to use it himself.

36. Matilda Coxe Stevenson, *Zuni and the Zunians* (Washington, D.C.: privately printed, 1881), 12.

37. Underhill, *Pueblo Crafts,* 106.

38. The Emergence Myth of the Navajo is analogous to the Bible. It delineates all basic categories of the universe, including sex specific roles and duties. Franciscan Fathers, *An Ethnologic Dictionary of the Navajo Language* (St. Michael's, Ariz.: St. Michael's Press, 1910); Clyde Kluckhohn, W. W. Hill, and Lucy Wales Kluckhohn, *Navajo Material Culture* (Cambridge: Belknap, 1971), 425–29.

39. In addition, it is commonly held that a woman should not have intercourse with her husband while working on a ceremonial coiled "wedding basket," lest she hurt him. Harry Tschopik, Jr., *Navajo Pottery Making: An Inquiry into the Affinities of Navajo Painted Pottery,* Peabody Museum Papers vol. 17, no. 1 (Cambridge: Peabody Museum, 1941), 446.

40. Franciscan Fathers, *Ethnologic Dictionary,* 292. Throughout the Southwest, transvestites

were accepted as women and were often outstanding artists. These men had rejected the male hunter/warrior role, preferring women's work. Elsie Clews Parsons, "The Last Zuni Transvestite," *American Anthropologist*, n.s. 41, no. 2 (April-June 1939): 338; William B. Griffen, "Southern Periphery: East," in *Handbook of North American Indians*, vol. 10, *Southwest*, 335.

41. Lange, *Cochiti,* 169.

42. Underhill, *Pueblo Crafts,* 79.

43. Hill and Lange, *Ethnography of Santa Clara Pueblo,* 139, 165.

44. Nancy Parezo, *Navajo Sandpaintings: From Religious Act to Commercial Art* (Tucson: University of Arizona Press, 1983).

45. Research interview by Nancy Parezo.

46. Clifford Geertz, "Art as a Cultural System," *Modern Language Notes* 91 (1976): 1475; Bedinger, *Indian Silver,* 105.

47. John Adair, "The Cultural and Economic Context of Navajo Jewelry," in *Southwest Indian Silver From the Doneghy Collection,* ed. Louise Lincoln (Austin: University of Texas Press, 1982), 23.

48. Clyde Kluckhohn, "Expressive Activities," in *People of Rimrock: A Study of Values in Five Cultures,* ed. Evon Z. Vogt and Ethel M. Albert (Cambridge: Harvard University Press, 1966), 294.

49. Gary Witherspoon, *Language and Art in the Navajo Universe* (Ann Arbor: University of Michigan Press, 1977); Gary Witherspoon, "Self-Esteem and Self-Expression in Navajo Weaving," *Plateau* 52, no. 4 (December 1981): 28–32.

50. Witherspoon, "Self-Esteem," 32. Conversely, anything nonfunctional, that is, worn out or harmful, like disease or witchcraft, is considered "ugly." Kluckhohn, "Expressive Activities," 283.

51. Louise Lincoln, "Navajo Silver, Navajo Aesthetics," in Lincoln, ed., *Southwest Indian Silver,* 40–41.

52. Because of the lack of direct research on American Indian perceptions of the landscape, these statements are initial impressions.

53. Robert Young and William Morgan, *The Navajo Language: A Grammar and Colloquial Dictionary* (Albuquerque: University of New Mexico Press, 1980), 493, 515.

54. Kluckhohn, "Expressive Activities," 283.

55. Quoted in Lippard, "Double Vision."

56. Witherspoon, *Language and Art,* 49; see also Young and Morgan, *The Navajo Language;* and Bernard Haile, *Starlore Among the Navajo* (Santa Fe: William Gannon, 1977).

57. Raymond Firth, *Elements of Social Organization* (London: Watts, 1951), 173.

58. H. P. Mera, *Pictorial Blankets,* (Santa Fe: Laboratory of Anthropology, General Series Bulletin no. 6, 1938); Charlene Cerny, *Navajo Pictorial Weaving* (Santa Fe: Museum of New Mexico, 1975).

59. Steve Getzwiller, *The Fine Art of Navajo Weaving* (Tucson: Ray Manley Publications, 1984), 26.

60. H. P. Mera, *Pictorial Blankets,* 1; Joe Ben Wheat, Foreword to Cerny, *Navajo Pictorial Weaving,* 3.

61. Cerny, *Navajo Pictorial Weaving,* 6.

62. Mera, *Pictorial Blankets,* pls. 3–4.

63. Cerny, *Navajo Pictorial Weaving,* 8.

64. Brody, "Creative Consumer," 77–79.

65. On early male painters, see Edgar L. Hewett, "Native American Artists," *Art and Archaeology* 13, no. 3 (March 1922): 106. On Tonita Pena, see Clara Lee Tanner, *Southwest Indian Painting* (Tucson: University of Arizona Press, 1973), 132; Lange, *Cochiti,* 179. See also Brody, *Indian Painters and White Patrons,* 100.

66. Dorothy Dunn, "The Study of Painting, Santa Fe Indian School," *El Palacio* 67, no. 1 (February 1960): 19; Anne Forbes, "A Survey of Current Pueblo Indian Paintings," *El Palacio* 57, no. 8 (August 1950): 242.

67. Dorothy Dunn, "Pablita Velarde: Painter of Pueblo Life," *El Palacio* 59, no. 11 (November 1952): 336.

68. Arthur Silberman, ed., *100 Years of Native American Painting* (Oklahoma City: Oklahoma Museum of Art, 1978), 101.

69. Mary Carroll Nelson, "Pablita Velarde," *American Indian Art Magazine* 3, no. 2 (Spring 1978): 55.

70. Brody, *Indian Painters and White Patrons*, 111.

71. Lou Ann Faris Culley, "Helen Hardin: A Retrospective," *American Indian Art Magazine* 4, no. 3 (Summer 1979): 69.

72. Chapman, *Pottery San Ildefonso*, 12. Because shared meaning is lacking, "personal symbols" created by individual artists are not considered symbols here.

73. Bert Robinson, *The Basket Weavers of Arizona* (Albuquerque: University of New Mexico Press, 1954), 83; Ales Hrdlicka, "Notes on the San Carlos Apache," *American Anthropologist*, n.s. 7, no. 2 (April–June 1905): 483; Bedinger, *Indian Silver*, 112; Ruth Bunzel, *The Pueblo Potter: A Study of Creative Imagination in Primitive Art* (New York: Dover, 1972), 71; Gladys A. Reichard, *Navajo Shepherd and Weaver* (Glorieta, N.M.: Rio Grande Press, 1968), 148. A popular example of mistaken symbolism is the squash blossom necklace. The beads that resemble the flower of the squash plant were copied by Navajo silversmiths from the pomegranate blossom ornaments on Spanish-Mexican trousers and jackets. Adair, *Navajo and Pueblo Silversmiths*, 44.

74. Quote from H. P. Mera, *The "Rain Bird": A Study in Pueblo Design* (Santa Fe: Laboratory of Anthropology Memoirs vol. 2, 1937), 5. Nampeyo cited in *Master Pueblo Potters* (exhibition catalog, New York: ACA Galleries, 1980), 23. See also Helen H. Roberts, *The Basketry of the San Carlos Apache*, Anthropological Papers vol. 31, pt. 2 (New York: American Museum of Natural History, 1929), 205.

75. Guthe, *Pueblo Pottery Making*, 85–86.

76. Barbara Babcock, " 'We're all in there, in the clay': Stories, Potteries, Identities," *Proceedings of International Society for Folk Narrative Research* (Bergen, Norway, 1984). At Cochiti, potters may freely use the many religiously derived fertility symbols that are forbidden on secular pottery in all other pueblos. Frederic H. Douglas, "Modern Pueblo Pottery Types," Denver Art Museum Leaflets 53–54 (Denver: Denver Art Museum, February 1933), 11.

77. Barbara Aitken, "A Tewa Craftsman—Leslie Agayo," *El Palacio* 17, no. 5 (September 1924): 94.

78. Bunzel, *The Pueblo Potter*, 70, Margaret Ann Hardin, *Gifts of Mother Earth: Ceramics in the Zuni Tradition* (Phoenix: Heard Museum, 1983), 32. See Bunzel, *The Pueblo Potter*, 72, on the use of prayer stick design in pottery.

79. Matilda Coxe Stevenson, field notes from the National Anthropological Archives, quoted in Hardin, *Gifts of Mother Earth*, 32. As a Zuni potter told Bunzel in 1924: "We paint the deer so that our husbands may have good luck in hunting. . . . We like to paint the water birds because they live in the water, and so the jar will never be empty." Bunzel, *The Pueblo Potter*, 94–96.

80. Bunzel, *The Pueblo Potter*, 69, 29.

81. See Firth, *Elements of Social Organization*, 180.

82. Nelson, "Pablita Velarde," 57. Lomahaftewa is quoted in Jamake Highwater, *The Sweet Grass Lives On: Fifty Contemporary North American Indian Artists* (New York: Lippincott and Crowell, 1980), 138.

83. Clyde Kluckhohn and Dorothea Leighton, *The Navajo*, rev. ed., Lucy H. Wales and Richard Kluckhohn (Garden City, N.Y.: Natural History Library, Anchor Books, 1962), 204; Leland C. Wyman and Harrison Begay, *The Sacred Mountains of the Navajo in Four Paintings by Harrison Begay* (Flagstaff: Northland, 1967); Rik Pinxton and Ingrid Van Dooren, *The Anthropology of Space* (Philadelphia: University of Pennsylvania Press, 1983), 10–11.

84. See Parezo, *Navajo Sandpaintings*.

85. Pinxton and Van Dooren, *The Anthropology of Space*, 9.

86. Ibid., 9–11; Susan Kent, "Hogans, Sacred Circles and Symbols—The Navajo Use of

Space" (Santa Fe: Museum of New Mexico Papers, no. 17, 1982): 130–31; Yi Fu Tuan, *Topophilia* (Englewood Cliffs, N.J.: Prentice-Hall, 1974), 69.

87. In addition, each Hopi village is metaphorically conceived of as a house. Schlegel, "Male and Female," 252–53.

88. Tuan, *Topophilia,* 69–70.

89. Patricia Janis Broder, *Hopi Painting: The World of the Hopis* (New York: Dutton, 1978), 29.

90. The date of origin of this design is unknown. Kissell's 1916 study of designs on Pima and Papago baskets does not mention the man in the maze. Breazeale in 1923 noted the use of the maze by younger Pima basket weavers. Margaret Shreve's 1943 University of Arizona M.A. thesis, "Modern Papago Basketry," has no mention of the man in the maze. It may have started in 1937 as a result of the influence of the Indian Arts and Crafts Board or the Civilian Conservation Corps. The design is now the Papago tribal crest and is widely used by basket weavers and also by Hopi silversmiths, who claim the Hopi have had the design for a long time. Mary Lois Kissel, *Basketry of the Papago and Pima,* Anthropological Papers vol. 17, pt. 4 (New York: American Museum of Natural History, 1916); James Frank Breazeale, *The Pima and His Basket* (Tucson: Arizona Archaeological and Historical Society, 1923).

91. Terry DeWald, *The Papago Indians and Their Basketry* (Tucson, 1979), 4.

92. Kenneth M. Chapman and Bruce T. Ellis, "The Line-Break, Problem Child of Pueblo Pottery," *El Palacio* 58, no. 9 (September 1951): 282; Chapman, *Pottery San Ildefonso,* 13; Kenneth Chapman, *The Pottery of Santo Domingo Pueblo* (Albuquerque: University of New Mexico Press, 1953), 33.

93. Chapman and Ellis, "The Line-Break," 273.

94. Frank H. Cushing, "A Study of Pueblo Pottery as Illustrative of Zuni Culture-Growth," *Annual Report of the BAE 1882–3,* no. 4 (Washington, D.C.: GPO, 1886), 510; also cited and discussed in Chapman and Ellis, "The Line-Break," 251, 274–75, 283. See Chapman, *Pottery Santo Domingo,* 33, for data on persistence of Cushing's first interpretation.

95. Bunzel, *The Pueblo Potter,* 69.

96. James, *Handbook of Indian Basketry,* 194.

97. Washington Matthews, "The Basket Drum," *American Anthropologist* 7, no. 2 (April 1894): 202–08. Navajo sandpaintings likewise have openings at the east, also necessary for the transference of power during curing ceremonies.

98. Noel Bennett, *The Weaver's Pathway: A Clarification of the "Spirit Trail" in Navajo Weaving* (Flagstaff: Northland, 1974), 28. Bennett, one of the few researchers to ask American Indian women what they think and feel about their art, presents much data on this feature, discrediting the traders' terms "spirit line" and "devil's road" and the idea that the line allows the spirit of the rug or its design to escape.

Not coincidentally, some of the most intricate weaving styles, such as Two Gray Hills and Tec Nos Pas, always use borders. Before 1900, Navajo weavings were always unbordered designs of horizontal stripes. There is no evidence that the "mind's road" is or was used on weavings without borders; the device is unnecessary in a design that has no danger of closure.

99. Witherspoon, "Self-Esteem," 29.

100. Barre Toelken, *The Dynamics of Folklore* (Boston: Houghton Mifflin, 1979), 128. The film was directed by John Adair and Sol Worth.

101. Barbara Babcock, quoting Helen Cordero of Cochiti, in "Modeled Selves: Helen Cordero's 'Little People,'" in *The Anthropology of Experience,* ed. E. Bruner and V. Turner (Urbana: University of Illinois Press, 1985).

102. Pinxton and Van Dooren, *Anthropology of Space,* 11.

103. Matilda Coxe Stevenson, "A Chapter of Zuni Mythology," in *Memoirs of the International Congress of Americanists, Chicago, 1893,* ed. C. Staniland Wake (Chicago: Schulte, 1894), 318–19. The idea that clay is the flesh of a woman is found at Santa Clara according to Hill and Lange, *Ethnography of Santa Clara Pueblo,* 84, and at Zuni, Cochiti, Laguna, Isleta, according to Elsie Clews Parsons, *Pueblo Indian Religion,* vol. 1 (Chicago: University of Chicago Press, 1939),

table 2. It seems also that for the Hopi, other raw materials used by women, such as the plants of basketry, are associated with femaleness. Schlegel, "Male and Female," 261.

104. Elsie Clews Parsons, "Waiyautitsa of Zuni, New Mexico," in *American Indian Life,* ed. Elsie Clews Parsons (New York: Huebsch, 1922), 171; Parsons, *Pueblo Indian Religion,* 195–96.

105. Alfred E. Dittert, Jr. and Fred Plog, *Generations in Clay* (Flagstaff: Northland, 1980), 26; Hill and Lange, *Ethnography of Santa Clara Pueblo,* 84.

106. Barbara Babcock, "Clay Changes: Helen Cordero and the Pueblo Storyteller," *American Indian Art Magazine* 8, no. 2 (Spring 1983): 38.

107. Grace Medicine Flower in "American Indian Artists" ser., segment "Joseph Lonewolf and Grace Medicine Flower" (Tempe, Ariz.: KAET-TV Production, 1976). Likewise, Hopi potters left miniature vessels at clay gathering pits. Parsons, *Pueblo Indian Religion,* 317. Byron Harvey III, "Is Pottery Making a Dying Art?" *The Masterkey* 38, no. 2 (April–June 1964): 61–62; Maggie Wilson, "The Beauty Makers," *Arizona Highways* 50, no. 5 (May 1974): 37; Susan Peterson, *The Living Tradition of Maria Martinez* (New York: Harper and Row, 1977), 220.

108. Hill and Lange, *Ethnography of Santa Clara Pueblo,* 84, note that if pottery cracked in firing or drying, lack of technical skill, not ritual lapse, was blamed at Santa Clara. Parsons, *Pueblo Indian Religion,* 316; Peterson, *The Living Tradition,* 220.

109. Tanner, *Prehistoric Southwestern Craft Arts,* 126; Babcock, "Modeled Selves"; Joseph Lonewolf, "Joseph Lonewolf and Grace Medicine Flower."

*9. Earthy Relations, Carnal Knowledge: Southwestern American Indian Women Writers and Landscape*

This chapter was conceived and outlined with Paula Gunn Allen, and we jointly drafted the first few pages. When other commitments made it necessary for Allen to withdraw from the project, I went on to write the bulk of the essay, and responsibility for errors rests with me. But the ideas here derive from our initial collaboration.

1. Luci Tapahonso, "Last year the piñons were plentiful," in "A Sense of Myself" (M.A. thesis, University of New Mexico, 1983), 9.

2. I focus here on traditional and contemporary material from southwestern American Indians, but my broader observations about the relations between human beings and wilderness apply to most American Indian cultures. The best book on American Indian religion is Peggy V. Beck and Anna L. Waters, *The Sacred: Ways of Knowledge, Sources of Life,* (Tsaile [Navajo Nation], Ariz.: Navajo Community College Press, 1977). Two good anthologies of essays on the subject are *Seeing with a Native Eye,* ed. Walter Holden Capps (New York: Harper and Row, 1976); and *Teachings from the American Earth: Indian Religion and Philosophies,* ed. Barbara Tedlock and Dennis Tedlock (New York: Liveright, 1975).

3. nila northSun, "the way and the way things are," *diet pepsi and nacho cheese* (Fallon, Nev.: Duck Down Press, 1977), 13.

4. *Often* is, of course, a key qualifying word in this sentence; certainly there are and have been non-Indian people able to perceive the land as something other than an object.

5. See Annette Kolodny, *The Lay of the Land* (Chapel Hill: University of North Carolina Press, 1975), and *The Land Before Her* (Chapel Hill: University of North Carolina Press, 1984).

6. My principle sources for *Beauty Way* are Father Berard Haile, O.F.M., and Lelan C. Wyman, *Beautyway* (New York: Pantheon, 1957); and Clyde Benally, *Diné ji Nákéé' Naahane';  A Utah Navajo History* (Salt Lake City: University of Utah Press, 1982). There are several versions of *Beauty Way,* and this essay contains only a summary of a sacred text of great complexity and beauty.

7. Yellow Woman (Kochinako, or Kochininako), in Keres tradition "the mother of us all," is closely associated with the north, with hunting, and with rain; she is often described as an intercessory figure. In many of the stories, she appears as a human woman who makes alliances

with male spirit figures, from whom she obtains gifts that benefit her people. See John M. Gunn, *Schat-Chen: History, Traditions, and Narratives of the Queres Indians of Laguna and Acoma* (Albuquerque, 1917), 184–89; Franz Boas, *Keresan Texts* (New York: Publications of the American Ethnological Society, no. 7, pts. 1–2, 1928), 56–59; Hamilton A. Tyler, *Pueblo Animals and Myths* (Norman: University of Oklahoma Press, 1975), 28–29, 100, 105–06, 213, 227, 229. Of contemporary authors, Leslie Silko draws most often on the Yellow Woman stories.

8. Leslie Silko, "Storytelling," *Storyteller* (New York: Seaver, 1981), 94. Hereafter this volume cited parenthetically in the text.

9. Luci Tapahonso, "The Snake-man," in *The Remembered Earth*, ed. G. Hobson (Albuquerque: University of New Mexico Press, 1981), 308–10.

10.

> . . . *They say*
>               *you should never pick up*
> *strangers or injured animals*
> *on dark reservation roads*
>
> *you'll be safe if*
> *you do not brake for animals*
>               *on lone moonlight nights*
> *They say*
> *the deeds of day*
> *have no disguise from*
>               *the darkness of night and truth*
> *so they say*
> *never leave the pollen behind and*
>               *always know a medicineman.*

Tapahonso: "This is a warning," in *One More Shiprock Night* (San Antonio: Tejas Art Press, 1981), 90. For other Tapahonso road-ghosts, see "She Sits on the Bridge," in *Earth Power Coming*, ed. Simon J. Ortiz (Tsaile, Ariz.: Navajo Community College Press, 1983), 222; and "They Are Together Now," "A Sense of Myself," 24.

11. Tapahonso, "A Spring Poem-Song," in "A Sense of Myself," 30.

12. See Patricia Clark Smith, "Coyote Ortiz: Canis latrans latrans in the Poetry of Simon Ortiz," *Studies in American Indian Literature*, ed. Paula Gunn Allen (New York: Modern Language Association, 1983), 192–210.

13. Geary Hobson, "Blood Connections," *Contact II* 6, nos. 30–31 (1983–1984), 64.

14. Tapahonso, *One More Shiprock Night*, 94.

15. Tapahonso, "For Earl and Tsaile April Nights," in "A Sense of Myself," 7.

16. Tapahonso, "A Spring Poem-Song."

17. Tapahonso, "For Misty Starting School," in "A Sense of Myself," 27.

18. Tapahonso, "The lightening awoke us," ibid., 12.

19. Tapahonso, "A Breeze Swept Through," ibid., 16.

20. Leslie Silko, "Contributors' Biographical Notes," in *Voices of the Rainbow: Contemporary Poetry by American Indians*, ed. Kenneth Rosen (New York: Seaver, 1975), 230.

21. "The sacred Clowns of North American tribal people are direct evidence that the sacred ways of tribal people are not inflexible, self-important and without humor." Beck and Walters, "Sacred Fools and Clowns," in *The Sacred*, 306. See also Barbara Tedlock, "The Clown's Way," in *Teachings from the American Earth*, 105–18.

22. Paula Gunn Allen, "The Feminine Landscape of Leslie Marmon Silko's *Ceremony*," in *Studies in American Indian Literature*, 127–33.

23. Leslie Marmon Silko, *Ceremony* (New York: Viking, 1977), 234. Hereafter cited parenthetically in the text.

24. The major exception is Silko's brilliant short story "Storyteller," which grew out of time spent in Ketchikan, Alaska.

25. Joy Harjo, "White Bear," *She Had Some Horses* (Chicago: Thunder's Mouth Press, 1983), 27.

26. Paula Gunn Allen, review of Harjo's *What Moon Drove Me to This?* in *The Greenfield Review* 9, nos. 3−4 (Winter 1981−82): 12.

27. Joy Harjo, in conversation with Paula Gunn Allen, August 1983.

28. Harjo, "Bio-poetics Sketch," *The Greenfield Review* 9, nos. 3−4 (Winter 1981−82): 8.

29. Harjo, "The Last Song," *What Moon Drove Me to This?* (New York: Reed, 1979), 67.

30. Geary Hobson, review of *What Moon Drove Me to This?* in *Greenfield Review* 9, nos. 3−4 (Winter 1981−82): 15−16.

31. Harjo, "Kansas City," *She Had Some Horses,* 33. Hereafter this volume cited parenthetically in the text.

*10. With Stone, Star, and Earth: The Presence of the Archaic in the Landscape Visions of Georgia O'Keeffe, Nancy Holt, and Michelle Stuart*

I wish to thank Nancy Holt and Michelle Stuart for their generosity and their time in sharing and discussing their work. For assistance in obtaining illustrations, grateful acknowledgment is also due Jonathan Bergen, Barbara Mathes, Gerald Peters, Peter Rathbone of Sotheby's, Theodore Stebbins of the Museum of Fine Arts in Boston, and the staffs of the Norton Gallery and School of Art and the Whitney Museum of American Art. For their hard work and thoughtfulness throughout this project, I am grateful to Janice Monk and Vera Norwood. Finally, for her suggestion that I write this chapter, I extend special thanks to Judith Fryer.

The epigraphs heading the four sections of this chapter are from Barry Holstun Lopez, *Desert Notes: Reflections in the Eye of a Raven* (New York: Avon/Bard, 1976), 3, 27, 34−35, 111.

1. Kenneth Patchen, "We Must Be Slow," *Collected Poems* (New York: New Directions, 1979), 37.

2. Frederick Turner, *Beyond Geography: The Western Spirit against the Wilderness* (New Brunswick, New Jersey: Rutgers University Press, 1983), 236.

3. For further discussion of this topic, see Turner's chapter entitled "Possession," ibid., 231−54. For elaboration of the roles of priests and shamans in planter and hunter societies, see Joseph Campbell, "The Shaman and the Priest," in *The Masks of God: Primitive Mythology* (New York: Viking, 1959), 229−42; and for a discussion of Euro-American misconceptions of the native approach to the land and its "precarious balance between the visions of the shaman and the hunter," see Richard Slotkin, *Regeneration through Violence: The Mythology of the American Frontier, 1600−1860,* (Middletown, Conn.: Wesleyan University Press, 1973), 559−60.

4. Barbara Novak, *Nature and Culture: American Landscape and Painting, 1825−1875* (New York: Oxford University Press, 1980).

5. Guy Davenport, "The Symbol of the Archaic," in *The Geography of the Imagination* (San Francisco: North Point Press, 1981), 28. For contemporary artists' use of archaic forms, see Lucy R. Lippard, *Overlay: Contemporary Art and the Art of Prehistory* (New York: Pantheon, 1983); see also Gloria Feman Orenstein, "The Reemergence of the Archetype of the Great Goddess in Art by Contemporary Women," *Heresies* (Spring 1978): 74−84.

6. Lippard, *Overlay,* 50. O'Keeffe is quoted in Laurie Lisle, *Portrait of an Artist: A Biography of Georgia O'Keeffe* (New York: Seaview Books, 1980), 190.

7. Ralph Waldo Emerson, "Nature," in *The American Landscape: A Critical Anthology of Prose and Poetry,* ed. John Conron (New York: Oxford University Press, 1973), 579, 601, 599, 608.

8. Herbert Marcuse, *Eros and Civilization: A Philosophical Inquiry into Freud* (Boston: Beacon Press, 1955), 169.

9. Rainer Maria Rilke, *Sonnets to Orpheus,* trans. M. D. Herter Norton (New York: Norton, 1962), 81, 79.

10. Marcuse, *Eros and Civilization,* 165.

11. David Bakan, "Eros and Knowledge," *Chicago Today* 5, no. 2 (Summer 1968): 53.

12. Martin Heidegger, "Building Dwelling Thinking," in *Poetry Language, Thought,* trans. Albert Hofstadter (New York: Harper and Row, 1971), 154.

13. Eleanor Munro, "Letter to the Editor," *Woman's Art Journal* 4, no. 1 (Spring/Summer 1983): 61.

14. Quoted in Lisle, *Portrait of an Artist,* 235.

15. *Robert Frost: Selected Poems,* edited by Ian Hamilton (New York: Penguin Books, 1973), 202.

16. Leo Janis, "Georgia O'Keeffe at Eighty-Four," *Atlantic Monthly* (December 1971).

17. See Mircea Eliade, *Shamanism: Archaic Techniques of Ecstasy,* trans. Willard R. Trask (New York: Pantheon Books, 1964); Andreas Lommel, *Shamanism: The Beginnings of Art* (New York: McGraw Hill, 1967); Joan Halifax, *Shamanic Voices: A Survey of Visionary Narratives* (New York: Dutton, 1979); and Stephen Larsen, *The Shaman's Doorway: Opening the Mythic Imagination to Contemporary Consciousness* (New York: Harper and Row, 1976).

18. Munro, "Letter," 61.

19. Apparently, O'Keeffe has used a Kachina doll as a subject of a number of paintings. *Kachina Doll* (1939) is reproduced in black and white in Rosamund Frost, *Contemporary Art: The March of Art from Cezanne until Now* (New York: Crown, 1942), 171. In "The Circles and the Symmetry: The Reciprocal Influence of Georgia O'Keeffe and Alfred Stieglitz" (MFA thesis, University of New Mexico, Albuquerque, 1977), 104, Meridel Rubenstein, who has interviewed O'Keeffe and has seen the artist's notebooks and reproductions of her work, refers to O'Keeffe's "first 'Kachina' painting." O'Keeffe herself says of this painting: "It was the first painting of an Indian doll I made. It was the first doll I owned." Quoted in Mahonri Sharp Young, "American Painting on Parade," *Apollo* (June 1979): 479.

20. Frederick J. Dockstader, "The Hopi World," in *The Year of the Hopi: Paintings and Photographs by Joseph Mora, 1904–06* (Washington, D.C.: Smithsonian Institution, 1979), 7; Jon T. Erickson, *Kachinas: An Evolving Hopi Art Form?* (Phoenix: Heard Museum, 1977), 10.

21. Barton Wright, "Hopi Ritual," in *The Year of the Hopi,* 17; Erickson, *Kachinas,* 10. While Kachinas are believed to be spirits of the ancient Hopis (Jesse Walter Fewkes, *Hopi Kachinas Drawn by Native Artists,* Smithsonian Institution, Bureau of American Ethnology 21st Annual Report, 1903, 18), they are also seen as personifications of the powers in "plants, animals, clouds, abstract forms, stars and sky" (Barton Wright, *Kachinas: A Hopi Artist's Documentary,* Flagstaff: Northland Press, 1973, 2). According to a native Hopi, the doll enables the child to identify with the Kachina so that as an adult performer in the Hopi ceremonies he can, upon donning the Kachina mask, lose his personal identity and become the spirit he represents. He performs then not only for the audience but especially for himself, attempting to enact his own understanding of the spiritual ideals he perceives in the Kachina. Emory Sekaquaptewa, "Hopi Indian Ceremonies," in *Seeing with a Native Eye: Essays on Native American Religion,* ed. Walter Holden Capps (New York: Harper and Row, 1976), 39.

22. Clara Lee Tanner and John F. Tanner, "Contemporary Hopi Crafts: Basketry, Textiles, Pottery, Kachinas," in *Hopi Kachina: Spirit of Life,* ed. Dorothy K. Washburn (Seattle: University of Washington Press, 1980), 80; Wright, "Hopi Ritual," 73, 17.

23. Marija Gimbutas, *The Goddesses and Gods of Old Europe,* (Berkeley and Los Angeles: University of California Press, 1982), 9.

24. Erickson, *Kachinas,* 55–56.

25. Ibid., 56.

26. No explanation for these stripes has been found in the available literature. Laura Holt at the Laboratory of Anthropology in Santa Fe confirmed that, except for a brief reference by Fewkes to a possible use of body markings to indicate feathers, little attention has been given to explaining them. Terence Honvantewa at the Hopi Cultural Center at Oraibi suggested that the markings on the earliest extant dolls, whose bodies consist of a flat piece of wood rather than a rounded torso carved with legs, might indicate body parts such as trunk and legs. However, there is no explanation of the use of the stripes on the early dolls whose bodies have been clearly carved to indicate torso, legs, and arms, or on the maiden and grandmother shawls of more recent dolls.

Ronald Spielbauer at the Miami University Anthropology Department suggested that the stripes might be rain symbols, though he preferred not to assert a single explanation for what he sees as a potentially multivalent emblem. Gimbutas has identified the series of vertically incised and painted lines on the torsos of prehistoric goddess images in Old Europe as symbols of water and most likely connected to "the ritual of rain invocation" (*Goddesses and Gods*, 114–17), an appropriate symbolism for the rain-seeking Kachina.

27. See, for example, Michael Dames, *The Silbury Treasure: The Great Goddess Rediscovered* (London: Thames and Hudson, 1976) and *The Avebury Cycle* (London: Thames and Hudson, 1977).

28. Young, "American Painting," 479.

29. See Dames, *Avebury Cycle*, 112.

30. Eric Neumann, *The Great Mother: An Analysis of the Archetype*, trans. Ralph Manheim, Bollingen ser. 47 XLVII (Princeton: Princeton University Press, 1963), 145.

31. See Andreas Franzke, "Kachina in der Kunst des 20. Jahrhunderts," in *Kachina-Figuren der Pueblo Indianer Nordamerikas aus der Studiensammlung Horst Antes* (Karlsruhe: Badisches Landesmuseum, 1980).

32. Lommel, *Shamanism*, 10, 73.

33. Gary Snyder, "Poetry and the Primitive: Notes on Poetry as an Ecological Survival Technique," in *Earth House Hold: Technical Notes and Queries to Fellow Dharma Revolutionaries* (New York: New Directions, 1969), 117–30.

34. Barry Holstun Lopez, *River Notes: The Dance of the Herons* (New York: Avon, 1979), 6.

35. See David G. Saile, "Making a House: Building Rituals and Spatial Concepts in the Pueblo Indian World," *Architectural Association Quarterly* 9. no. 2/3 (1977): 72–81.

36. Quoted in Lisle, *Portrait of an Artist*, 182, 260. Adobe brick-making was introduced by the Spanish. Hispanic forms in the culture of the Southwest are an additional influence in O'Keeffe's art not explored here.

37. Gaston Bachelard, *The Poetics of Space*, trans. Maria Jolas (Boston: Beacon Press, 1969), 62.

38. Willa Cather, *Death Comes for the Archbishop* (New York: Vintage 1971), 232.

39. Noel Bennett, *The Weaver's Pathway: A Clarification of the "Spirit Trail" in Navajo Weaving* (Flagstaff: Northland Press, 1974), 34–35; Rita Donagh, "Georgia O'Keeffe in Context," *The Oxford Art Journal* (April 1980): 44.

40. Georgia O'Keeffe, *Georgia O'Keeffe* (New York: Viking, 1976), unpaged. Quotations from O'Keeffe not otherwise cited are from this text.

41. Eliade, *Shamanism*, 58, 126.

42. Ibid., 487–94.

43. See Starhawk, *Dreaming the Dark: Magic, Sex and Politics* (Boston: Beacon Press, 1982), and *The Spiral Dance: A Rebirth of the Ancient Religion of the Great Goddess* (New York: Harper and Row, 1979).

44. Quoted in Lloyd Goodrich and Doris Bry, *Georgia O'Keeffe* (New York: Praeger, 1970), 22.

45. Eliade, *Shamanism*, 269; Neumann, *Great Mother*, 240–41; Lisle, *Portrait of an Artist*, 235.

46. Quoted in Eleanor Munro, *Originals: American Women Artists* (New York: Simon and Schuster, 1979), 490, n. 8. David G. Saile notes that for the Pueblo Indians "'Large and small' . . . do not seem as important as 'powerful and weak' or 'concentrated and diffused'. A mountain top seems to be important because it can concentrate power at a point and because it centers or transcends levels rather than because of its formal characteristics. Particular forms may become significant when they are associated with actions of ancestors or gods" ("Making a House," 77).

47. Vincent Scully, *The Earth, the Temple, and the Gods* (New York: Praeger, 1969); Dames, *Avebury Cycle* and *Silbury Treasure;* Gertrude R. Levy, *The Gate of Horn* (London: Faber and Faber, 1948); Lippard, *Overlay*.

48. Lippard, *Overlay*, 68; Peter T. Furst, "The Roots and Continuities of Shamanism," *Arts Canada* 184–87 (December 1973–January 1974): 50–51.

49. Furst, "Roots of Shamanism," 48; Eliade, *Shamanism*, 165.

50. Halifax, *Shamanic Voices,* 14.

51. See Dames, *Avebury Cycle,* 44–46.

52. Dames, *Silbury Treasure,* 70.

53. Levy, *Gate of Horn,* 10.

54. Neumann, *Great Mother,* 18.

55. O'Keeffe's identification with the stones lies not only in their color, her familiar black, but in her use of objects to depict relationships intensely personal. She once called a 1944 pastel of two rocks *My Heart,* and she portrayed pairs of trees and leaves as images of herself and Stieglitz. See *Birch and Pine Tree—No. 1* (1925) and *Red and Brown Leaf* (1921), which Stieglitz cited as a portrait of him and O'Keeffe. Herbert J. Seligmann, *Alfred Stieglitz Talking* (New Haven: Yale University Press, 1966), 73.

56. Neumann, *Great Mother,* 44; Mircea Eliade, *The Forge and the Crucible* (New York: Harper and Bros., 1962), 44. See also Lippard's chapter "Stones," in *Overlay,* 15–39.

57. Nancy Holt, "Notes on a Few Coincidences of Art and Life and Four Early Concrete Poems, 1969–1972," *Chelsea* 39, Ambimedia issue (1981): 171–86.

58. Quoted in Kay Larson, "New Landscapes in Art," *New York Times Magazine* (13 May 1979), 23. This landscape so appealed to Holt that in addition to the *Sun Tunnels* site she purchased two other sites because they suggested to her large sculptural works she plans to undertake in the future.

59. *Sun Tunnels* is located just east of the Nevada border, near the small town of Lucin.

60. See Holt's own article on *Sun Tunnels,* in *Artforum* 15, no. 8 (April 1977): 32–37. Unless otherwise cited, quotes from the artist come from this article.

61. Dames, *Silbury Treasure,* 118; Ernst Cassirer, *Philosophy of Symbolic Forms,* vol. 2 (New Haven: Yale University Press, 1953–57), 142.

62. See Lippard, *Overlay,* 51–52.

63. Dames, *Silbury Treasure,* 119, 147ff.

64. In *Views through a Sand Dune, Narragansett, R.I.* (1972), Holt's objective was to create a view through a circular steel pipe embedded horizontally in a sand dune so that the normally obscured view of sea and coast beyond the dune could be seen encircled by the pipe. In *Missoula Ranch Locators—Vision Encompassed* (1972), eight 12-inch-long pipe viewers were placed in a 40-foot circle in an open field, four positioned toward the cardinal directions, the other four in intermediate positions. One can look through them from the outer perimeter of the circle to its center or out to the surrounding landscape. In *Hydra's Head* (1975) in Artpark, Lewiston, New York, Holt placed six concrete pipes, each three feet long, vertically into the earth and filled them with water. Their surfaces are level with the earth and they reflect the sky, sun, passing clouds, moon, and stars. Their placement follows the configuration of the six stars in the head of the constellation *Hydra,* an appropriate choice next to the rushing waters of the Niagara River.

65. Quotations from the poetry of T. S. Eliot appear in Holt's writings about her work: see her article on *Sun Tunnels* and her tribute to Robert Smithson, "The Time Being (for Robert Smithson)," in *Arts* 52, no. 9 (May 1978): 144.

66. Quoted in Ted Castle, "Art in Its Place," *Geo* (September 1982): 75.

67. Giorgio de Santillana and Hertha von Dechand, *Hamlet's Mill: An Essay on Myth and the Frame of Time* (Boston: Gambit, 1969), 177.

68. Polly Schaafsma, *Indian Rock Art of the Southwest* (Santa Fe: School of American Research, 1980), 238, 265. "Star faces may represent the Star Kachina . . . or the Heart of the Sky God, a figure known at Hopi as Sotuqnang-u, who has the personality and attributes of Quetzalcoatl" (296).

69. "In drypaintings the sun and moon are often shown as circles both with and without feathers and horns; and there is reason to believe that these celestial beings are also present in circle form in the rock art." Ibid., 308.

70. Ibid., 324, 339, 341.

71. Travis Hudson and Ernest Underhay, *Crystals in the Sky: An Intellectual Odyssey Involving Chumash Astronomy, Cosmology and Rock Art* (Santa Barbara: Ballena Press, 1978), 51.

72. E. C. Krupp, *Echoes of the Ancient Skies: The Astronomy of Lost Civilizations* (New York: Harper and Row, 1983), esp. 129–37, 152–56. See also Lippard, *Overlay,* 100–01.

73. Schaafsma, *Indian Rock Art,* 88.

74. See Florence Hawley Ellis and Laurens Hammack, "The Inner Sanctum of Feather Cave: A Mogollon Sun and Earth Shrine Linking Mexico and the Southwest," *American Antiquity* 33 (1968): 25–44.

75. See the cover of Lippard's *Overlay.*

76. In "Artworks on the Land," *Art in America* 64, no. 1 (January/February 1976): 92–96, Elizabeth C. Baker notes that primitive cultures appeal to all of the land artists working in the American Southwest and that "all [of the artists] are rather knowledgeable in Indian lore."

77. Martha McWilliams Wright, "Review," *Art International* 21, no. 1 (January 1978): 62; de Santillana and von Dechend, *Hamlet's Mill,* 346.

78. T. S. Eliot, "Burnt Norton," in *T. S. Eliot: Collected Poems, 1909–1962* (New York: Harcourt, Brace and World, 1963), 178.

79. Novak, *Nature and Culture,* 3, 9, 14.

80. Lopez, *River Notes,* 25.

81. Michelle Stuart, *The Fall* (New York: Printed Matter, 1976), unpaged.

82. Robert Hobbs has used the term *geomythology* in reference to Stuart. See "Michelle Stuart: Atavism, Geomythology, and Zen," *Womanart* 1, no. 4 (Spring/Summer 1977): 6–9, 20–22.

83. Lawrence Alloway, "Michelle Stuart: A Fabric of Significations," *Artforum* 12, no. 5 (January 1974): 64.

84. See Corinne Robins, "The Paper Surfaces of Michelle Stuart; Traces of Matter = Marks of Light," *Art International* 23, no. 8 (December 1979): 63.

85. Quoted in *Art: A Woman's Sensibility* (Feminist Art Program, California Institute of the Arts, 1975), 72.

86. Corinne Robins, "Michelle Stuart: The Mapping of Myth and Time," *Art* 51, no. 4 (December 1976): 85; Lucy R. Lippard, "Points of View: Stuart, DeMott, Jacquette, Graves," *From the Center: Feminist Essays on Woman's Art* (New York: Dutton, 1976), 112.

87. Eleanor Munro, "Michelle Stuart," in *Originals,* 445.

88. In discussing this correlation, Lippard has also noted the reversal of the metaphor "if the book is seen as a body and the earth as a book as well as a body." *Strata: Nancy Graves, Eva Hesse, Michelle Stuart, Jackie Winsor,* exhibition catalog (Vancouver, Can.: Vancouver Art Gallery, 1977), 20.

89. Quoted in Lippard, "Points of View," 111.

90. See Lawrence Alloway, "Michelle Stuart," exhibition catalog (Fine Arts Center Gallery, State University of New York College at Oneonta, 1975), 8.

91. Philip Larson, "Good Books, Good Looks," *The Print Collector's Newsletter* 12, no. 5 (November/December 1981): 143.

92. Quoted in Lippard, *Strata,* 20; and Hobbs, "Michelle Stuart," 20.

93. The artist's idea for the book stacks come from Tibet's Thousand Buddha Caves, which contain rolls and stacks of text, knowledge recorded and then buried, the artist notes, "to be picked up in a thousand years. Then one idea is shared by all cultures. Here were these miles of caves with the idea of the sutras saying basically one thing: that we go on, that we are one." Quoted from a 1982 interview with the artist by Graham Beal, included in the exhibition catalog *Michelle Stuart: Place and Time* (Walker Art Center, 1983), unpaged.

94. Ellen Lubell, "Michelle Stuart: Icons from the Archives of Time," *Arts* 53 (June 1979): 122.

95. Ibid., 123.

96. Quoted in *Michelle Stuart/Paperwork,* exhibition catalog (London: Institute of Contemporary Art, 1979), 8.

97. Quoted in Hobbs, "Michelle Stuart," 7.

98. Quoted in *Michelle Stuart/Paperwork,* 13.

99. See Frank Waters, *Book of the Hopi* (New York: Penguin Books, 1977), 23.

100. See Evan Hadingham, *Early Man and the Cosmos* (New York: Walker, 1984), 134.

101. From the artist's journal, "Return to the Silent Garden," quoted in Alloway, "Michelle Stuart," 8.

102. Conversation with the artist, August 1984.

*Conclusion*

1. Barbara Mor, "the bicycle & the sewing machine are / wonderful inventions said Gandhi," *Southwest: A Contemporary Anthology,* ed. Karl Kopp and Jane Kopp (Albuquerque: Red Earth Press, 1977), 240–41.

# INDEX

Abiquiu, 205, 230
*Acequia madre,* symbolism of, 21, 229
Acoma pueblo, 164
Adams, Ansel: relation with Nancy Newhall, 47, 48, 50, 56; perceptions of landscape, 51, 53, 56, 60, 63, 71, 232; *Taos Pueblo,* 53
Adams, Virginia, 50, 53
Adelita, La, 106
Adobe: significance of, 20, 78, 205, 219; adobe builders, 125–26, 129–30
Aesthetic values, 147–48, 154, 159, 161, 226–27, 228–29, 262n50. *See also* Landscape; Southwest landscape
Albuquerque, images of, 9, 186, 196
Alienation: Anglo women's perceptions of, 15, 35, 36–37; Chicana perceptions of, 98, 107–12, 137, 140, 230; American Indian women's perceptions of, 191, 192; in American culture, 197–98, 204
American Indian art and literature, 3, 6, 9; Anglo response to, 22, 146, 147, 154, 227; influences on, 146, 147, 150, 151–54, 172, 185–88 passim, 226, 227, 244 n 41; gender differences in, 146, 151–58, 164, 172, 185, 191, 228, 261 n 34; cultural meaning of, 147, 151–54, 159, 169–70, 172, 226, 259 n 7, 265 n 50; changes in, 148, 151–54; intracultural variation in, 148–51, 185, 226, 227, 259 n 1, 265 n 2. *See also* Southwest landscape
American Indian myth and religion, 24, 152–53, 164–67 passim, 176–77, 182, 184, 209, 214–15. *See also* Ritual
American Indian women: cultural influences on, 182–84 passim, 187, 227
American Indian women and landscape: depic-

tions, 160–69, 185, 234; interaction, 160–71, 181, 233
—valuation, 151, 163, 176–77, 186–87, 192–94, 224–25, 231–34, 242 n 24, 264 n 103; of wilderness, 173–76 passim, 178, 181–91 passim, 232; of cities, 186, 193, 195, 196. *See also* Landscape; Southwest landscape
*American Rhythm,* 24
Anglo women: and frontier, 11, 50, 74, 75, 82, 86, 254 n 24; and environmentalism, 11–12, 26, 48, 53, 68–69, 89–90, 199, 226, 231, 232; relation to American Indian and Hispanic cultures, 19–25, 44–45, 58–59, 66–72, 75–78, 81, 202–05, 214–15, 219, 221–22
—perceptions of Southwest landscape: as place of spiritual experience, 11, 15, 16, 43, 59, 198, 209–19 passim; as land of limitations, 13, 44, 75–76, 78, 84, 86, 87, 231; as place of connection with past, 15, 29–34, 66, 71–72, 198–99, 209–212 passim, 217–19; as resistant to human effort, 16, 17, 75–79 passim, 84, 87, 90, 94; as source of creativity, 29, 34, 57; as place of contradiction, 33, 43, 48, 58, 75, 76, 78, 80, 87; as determinant of human life, 66, 67, 91; as place of opportunity, 75, 76; as source of wealth, 75–76, 90, 91; as home, 78, 88; as solace, 82, 88; as place of impermanence, 89, 91–92, 226, 234
—valuation of Southwest landscape: model for new America, 10, 11, 19, 24; adaptation, 17, 18, 26, 92–93, 231, 234; the vernacular, 22–25, 59, 66–73 passim, 228; domesticity and naturism, 25–26, 84–95; survival, 70, 73, 76, 92–93, 225; ambivalence, 75–78, 82–84, 231; cross-cultural sim-

273

## DATE LOANED

| | | | |
|---|---|---|---|
| | | | |
| | | | |
| | | | |
| | | | |
| | | | |
| | | | |
| | | | |
| | | | |
| | | | |
| | | | |
| | | | |
| | | | |
| | | | |
| | | | |